LIBRARY OF ART HISTORY

H.W. JANSON, General Editor

19th and 20th Century Art

19th and 20th Century Art

PAINTING · SCULPTURE · ARCHITECTURE

GEORGE HEARD HAMILTON

Director, Sterling and Francine Clark Art Institute, Williamstown, Massachusetts
Professor of Art, Williams College

PRENTICE-HALL, INC., *Englewood Cliffs, N.J.*
and HARRY N. ABRAMS, INC., *New York*

H. W. Janson—General Editor
Milton S. Fox—Editor-in-Chief

ISBN 0-13-622639-6
Library of Congress Catalogue Card Number: 70-100401

Printed and bound in Japan

EDITOR'S PREFACE

The present book is one of a series. *The Library of Art History* comprises a history of Western art in five volumes, devoted respectively to the Ancient World, the Middle Ages, the Renaissance, the Baroque and Rococo, and the Modern World. The set, it is hoped, will help to bridge a gap of long standing: that between one-volume histories of art and the large body of specialized literature written for professionals. One-volume histories of art, if they are to be books rather than collections of essays, must be—and usually are—the work of a single author. In view of the vast chronological and geographic span of the subject, no one, however conscientious and hard-working, can hope to write on every phase of it with equal assurance. The specialist, by contrast, as a rule deals only with his particular field of competence and addresses himself to other specialists. *The Library of Art History* fits in between these two extremes; written by leading scholars, it is disigned for all those who are neither beginners nor professional art historians—educated laymen, upper-class undergraduates, and scholars in other fields who do not need to be introduced to the history of art but are looking for an authoritative guide to the present state of knowledge in the major areas of the discipline.

In recent years, such readers have become a large and significant group. Their numbers reflect the extraordinary growth of the history of art in our system of higher education, a growth that began in the 1930s, was arrested by the Second World War and its aftermath, and has been gathering ever greater momentum since the 1950s. Among humanistic disciplines, the history of art is still something of a newcomer, especially in the English-speaking world. Its early development, from Vasari (whose famous *Lives* were first published in 1550) to Winckelmann and Wölfflin, took place on the Continent, and it became a formal subject of study at Continental universities long before it did in England and America. That this imbalance has now been righted—indeed, more than righted—is due in part to the "cultural migration" of scholars and research institutes from Germany, Austria, and Italy thirty years ago. The chief reason, however, is the special appeal of the history of art for modern minds. No other field invites us to roam so widely through historic time and space, none conveys as strong a sense of continuity between past and present, or of kinship within the family of man. Moreover, compared to literature or music, painting and sculpture strike us as far more responsive vessels of individuality; every stroke, every touch records the uniqueness of the maker, no matter how strict the conventions he may have to observe. Style in the visual arts thus becomes an instrument of differentiation that has unmatched subtlety and precision. There is, finally, the problem of meaning in the visual arts, which challenges our sense of the ambiguous. A visual work of art cannot tell its own story unaided. It yields up its message only to persistent inquiry that draws upon all the resources of cultural history, from religion to economics. And this is no less true of the remote past than of the twentieth century—if we are to understand the origins of nonobjective art, for instance, we must be aware of Kandinsky's and Mondrian's profound interest in theosophy. The work of the art historian thus becomes a synthesis illuminating every aspect of human experience. Its wide appeal is hardly surprising in an age characterized by the ever greater specialization and fragmentation of knowledge. *The Library of Art History* was conceived in response to this growing demand.

H. W. Janson

Contents

19th and 20th Century Art

Romantic Classicism

The history of Western art from the gradual decline of the Baroque and Rococo styles after 1750 to the development a century later of new forms of expression symptomatic of modern experience can be examined in terms of two protracted artistic investigations. One was the search for architectural forms capable of embodying new social institutions as well as new ways of living. The other was the discovery through painting and sculpture of forms which would give a more intensive meaning to individual experience. Because of differing economic conditions, a building being far more costly to produce than a painting or sculpture, the first was primarily a public search requiring exchanges of opinion, often at considerable length, between the architect and his client, who might be a group or corporation rather than a single person. Painting, on the contrary, and sculpture to a lesser degree, may be practiced on one's own, so to speak. They permit more experimentation and a privacy of expression which is denied the architect. His building, once erected, is there for all to like or not. The painter may keep his secrets to himself. The beginning of both investigations may be traced to the renewed enthusiasm for the art of antiquity which occurred throughout Europe toward the middle of the eighteenth century. It was supported by a more systematic study of ancient monuments

than had yet been undertaken, and stimulated by events for which there were no recent historical precedents to provide appropriate symbols. The use of Greek and Roman forms for symbolic as well as functional purposes, which was a continuous and often dominant tendency in Western art for a century after 1750, has been called the Classic Revival, or Neoclassicism, and can be divided into two periods, with a Roman phase conspicuous until 1815 and a Greek one thereafter. The use of such forms was not always chronologically successive. Since this was not the first occasion on which elements of antiquity had been introduced into contemporary art, and since emotional as much as intellectual concepts determined their selection, the term Romantic Classicism is often used to indicate the blend of fact and feeling which many of the monuments present. Certainly the study and recovery of the ancient European past, which by the turn of the century embraced even prehistory in the attention finally paid to the majestic monoliths at Stonehenge, was hastened by archaeological discoveries, but it was not at first a strictly scientific or intellectual pursuit. The monuments of Rome had captivated pilgrims and travelers for centuries. Immense and timeless, they imposed their spell quite as much upon the poet as upon the historian, but the eighteenth-century traveler was interested in struc-

tural principles as well as visual effects. This can be seen in the engravings of the Italian architect, Giovanni Battista Piranesi (1720–1778), whose best-known works, the *Carceri*, or *Prisons*, first published in 1750, are extraordinarily imaginative inventions on themes suggested by the cavernous vaults of Roman ruins. Such statements of cultural catastrophe, the visual counterparts of Gibbon's *Decline and Fall of the Roman Empire* (1776–1788), contributed significantly to the widespread nostalgia for a glorious but tragic past. This led occasionally to the creation of new ruins in the gardens and country estates of French and English landowners. The most extraordinary of these "follies," as they were appropriately called because of their cost, and the most truly Piranesian, was a house designed as the broken shaft of a colossal Corinthian column, now sadly reduced to an actual ruin, in the Désert de Retz, a private park near Chambourcy in France (plate 1).[1]

1. *Country House Designed as a Broken Column, "Désert de Retz," Chambourcy.* c. 1785. Wash drawing.
Nationalmuseum, Stockholm

Piranesi's engravings of existing buildings were even more relevant to contemporary problems. Among his *Vedute*, or *Views of Rome*, issued at intervals from 1746, the interior of the Pantheon (plate 2) communicates the mixture of awe and curiosity with which the intelligent traveler approached such a building. He might be dwarfed to insignificance by its grandeur, but he could still account for the number, position, and style of the columns. Did one wish to build again in the Roman manner, such an illustration could show the way to do it quite as much as the effect one might hope to achieve. The circulation of Piranesi's prints throughout Europe, as well as the knowledge of the actual monuments which many artists and men of taste acquired during their travels in Italy, fostered a more scholarly interest in antiquity.

The exhibition and publication after 1748 of the paintings, sculptures, and household furnishings discovered at Pompeii and Herculaneum, the Roman towns near Naples destroyed by the eruption of Vesuvius in A.D. 79, revealed the character of ancient life more accurately and more vividly than it had been known before. In 1751 the English architects James "Athenian" Stuart (1713–1788) and Nicholas Revett (1720–1804) visited Greece and later published their drawings of the principal monuments as *The Antiquities of Athens* (4 vols., 1762–1830). It is worth noting that these included not only views of the sites in their then dilapidated condition, but also what we would now call reconstructions of the buildings to approximately their original state. Another English architect, Robert Adam (1728–1792), went to Dalmatia to study the largest surviving example of Roman domestic architecture. His *Ruins of the Palace of the Emperor Diocletian at Spalatro (sic; 1764)* contains engravings of Roman decorative designs upon which much of his own later work was based. Either of these works, or any of a number of others, might well have been found in the library of any eighteenth-century gentleman who was interested in architecture and who, before the days of architectural and engineering schools, might design a building himself. The coherence and quality of architectural design throughout the century are telling indications of the effect of educated patronage upon the art.

Simultaneously research advanced in other ancient arts. In 1764 the German archaeologist Johann Joachim Winckelmann (1717–1768) published his *Geschichte der Kunst des Altertums (History of the Art of Antiquity)* in which, for the first time, ancient sculpture was presented in relation to historical and environmental conditions. So consistent was his method and so keen his insight that he made the discovery—all

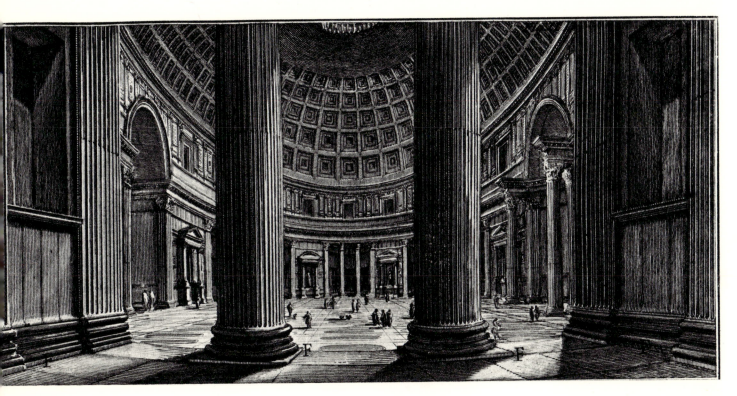

the more remarkable in that he had seen no actual examples of Greek sculpture—that the Roman marbles so long admired in Europe were in fact commercial and inferior copies of Attic originals. The premium later placed upon Greek art at the expense of Roman was of considerable consequence during the second stage of Romantic Classicism.

In France after 1750, and more frequently during the reign of Louis XVI (1774–1792), whence the term *style Louis Seize*, a preference for simpler and more unified forms and spaces appeared. Already in the Petit Trianon, a small pleasure house in the park at Versailles built in 1762 by Jacques-Ange Gabriel (1698–1782) for Louis XV, there was scarcely a curved line. The whole building is immediately apprehended as an unbroken cubical mass, although the sculptured decoration has still much eighteenth-century grace. A consistent adaptation of Classic forms to modern functions first appeared in interior decoration and subsidiary structures such as garden pavilions. Chairs, tables, and other objects of the Louis XVI style were often patterned after Roman bronzes discovered at Pompeii, although mahogany and other

fine woods adorned with gilt-bronze reliefs were preferred to metal. In the gardens of French and English country houses, small examples of antique architecture began to appear. The first accurate imitation of Greek architecture was a small temple front in the garden at Hagley in Worcestershire, built in 1759 by "Athenian" Stuart (plate 3). That these structures were sometimes designed as if already ruined proves that the appeal of

3. JAMES STUART. Doric Temple, Hagley Park, Worcestershire, England. 1759

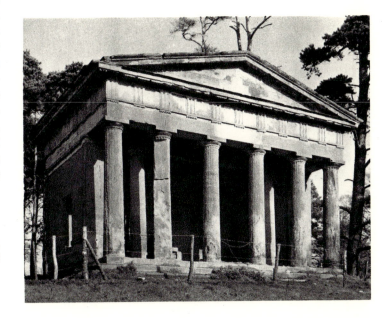

things Classic was at first just as emotional as it was intellectual. And that garden houses were also designed as medieval ruins (there was one at Hagley in 1747), and even as Chinese pagodas and Indian teahouses, indicates that the continuity of European style had been decisively interrupted. When style became a matter of choice, when architect and client could pick and choose from the past, whether near or far, native or exotic, then a change in style could no longer be explained by the development of stylistic principles inherent in the forms themselves. Since nothing of the sort had preceded the example at Hagley, so radical a manifestation as a Greek temple in an English park can be explained only by a non-formal, even essentially nonartistic decision. Here lay the seeds of Eclecticism, the dominant stylistic manifestation during the middle years of the nineteenth century, when historical styles were selected and even combined, sometimes with distinction but often without, usually in ways quite unhistorical in relation to their original functions.

In England the break with the Baroque and Rococo past may be seen soon after 1760 in one of the first works of Robert Adam. He and his brother James (1730–1794) are better known for the exquisite Pompeiian elegance of their later small-scaled interiors, but in completing an earlier scheme for Kedleston, the country seat of Sir Nathaniel Curzon in Derbyshire, Robert Adam achieved an imperial and quite Roman magnificence (plate 4). On the south front of the house he placed four colossal Corinthian columns, each with a section of entablature, reminiscent of a Roman triumphal arch. Above a rectangular attic is a low dome that resembles the Pantheon's. Within, the huge central hall was flanked by alabaster Corinthian columns twenty-five feet high, and the walls behind were lined with niches for a collection of antique sculpture. Only the fireplaces in the center of each long wall betrayed the fact that such a grandiose interior, reminiscent of Piranesi's view of the Pantheon, had also a domestic purpose. This room and others like it designed during the remainder of the century, less pompous but just as classic, could evoke a heroic past whose emulation lent luster to the present. They help us to understand how the men of the eighteenth century, conscious of history, could cast themselves in historical roles. Thus we can interpret John Adams' report of his conversation in 1776 with General Henry Knox. It was an anxious moment when the British were landing at Throgs Neck near New York, yet Adams and Knox, who were dining in a tavern in the city with Washington and other high officers, "talked of ancient history, of Fabius who used to raise the Romans from the dust; of the present contest, etc."[2] On that occasion Knox first suggested the award of a badge to those who "had fought in defense of their liberties," an idea which led to the formation of the Society of the Cincinnati, whose members were Washington's former officers.

Even George Washington himself, so consummately the eighteenth-century soldier-statesman, could strike a Classic pose (plate 5). In his portrait as President his plain black suit scarcely disguises the imperial gesture of Caesar haranguing his troops, a familiar motif in Roman portrait sculpture. The presidential chair and the table to the left are examples of Neo-classic furniture, fitted with symbols of republican state. But in all else Washington's image remains contemporary inasmuch as Gilbert Stuart (1755–

4. ROBERT ADAM. Kedleston Hall, Derbyshire, England, south front. After 1760

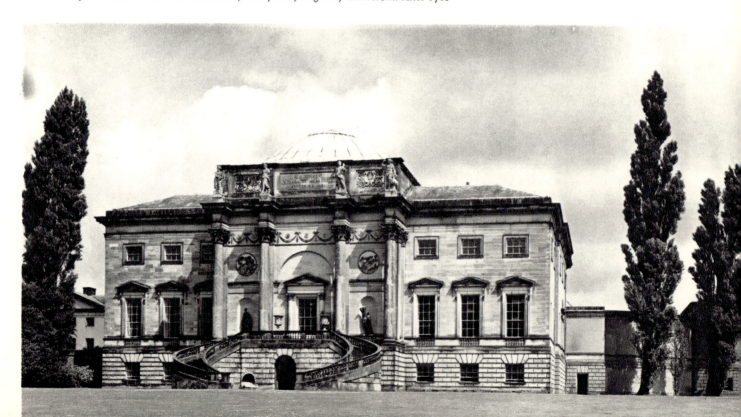

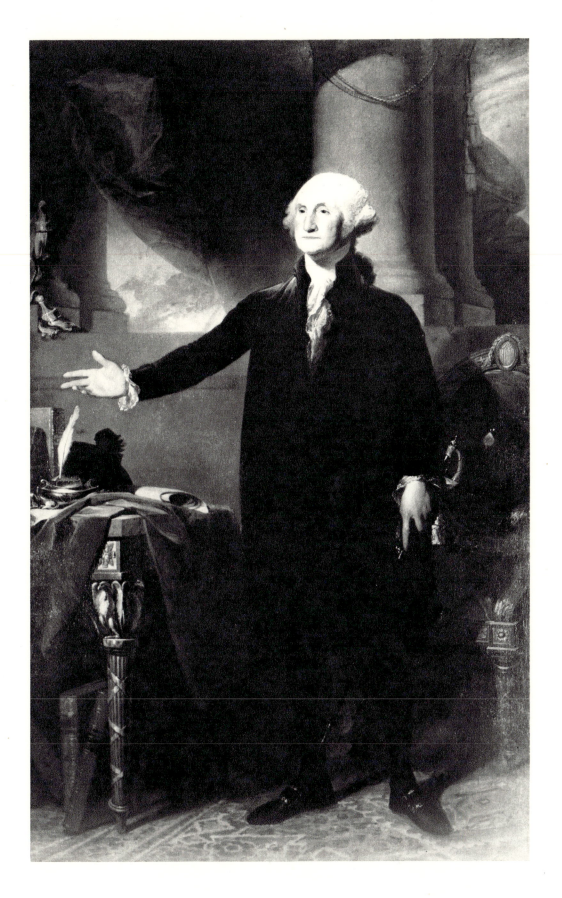

5. GILBERT STUART. *George Washington as President.* 1796. Oil on canvas, 96 × 60″.
The Pennsylvania Academy of the Fine Arts, Philadelphia

1828), the most accomplished American portraitist in the early years of the Republic, never renounced the restless, realistic brushwork and lively Baroque contrasts of light and shade which he had learned in London as a pupil of Benjamin West.

Because such men could think of themselves as Romans, it was inevitable that as statesmen they should shape our government as a republic, name the senior legislative house the senate, and establish it in a capitol. The first building to be so called in modern times, and the first since antiquity specifically intended for republican legislative functions, was the State Capitol in Richmond, Virginia (plate 6), designed by Thomas Jefferson (1743–1826) in 1785. Jefferson, who was then in Paris as our first minister to France, chose as the model for his building a small Roman temple in Nîmes known as the Maison Carrée. Although he knew it only from engravings he thought it, sight unseen, "very simple, noble beyond expression," and later described it as "the most perfect model existing of what might be called cubic architecture." Two years later he was in Nîmes and found himself "gazing whole hours at the Maison quarée [*sic*], like a lover at his mistress," as he wrote to a friend who shared his love for "whatever is Roman and noble."[3] Jefferson's enthusiasm is typical of early Neoclassic taste; it is a mixture of sentimental rhapsodizing, a belief that certain artistic forms can express ethical values, and a new, anti-Rococo taste for unadorned surfaces and geometrical shapes.

After deciding to use the Maison Carrée as a model for the Virginia statehouse, Jefferson hired a gifted French designer, Charles-Louis Clérisseau (1722–1820), who had been with Adam in Spalato and would

6. THOMAS JEFFERSON. State Capitol, Richmond, Virginia. 1785–89

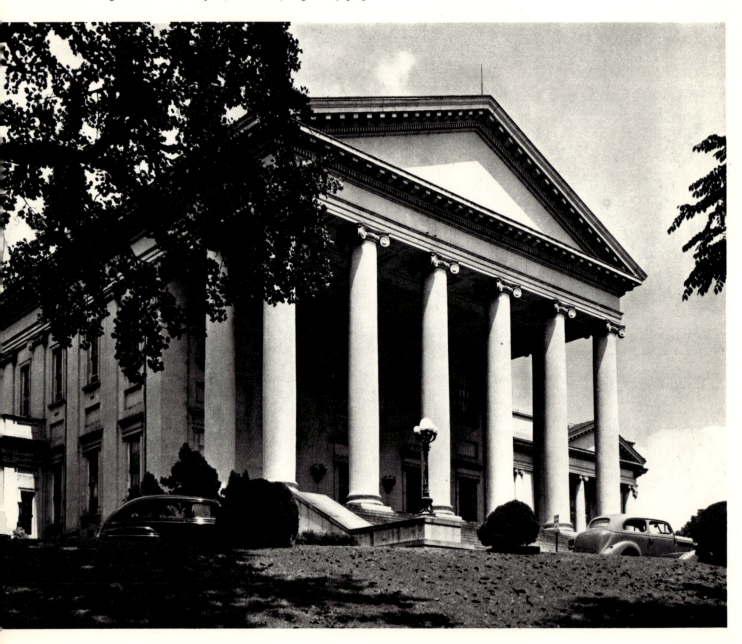

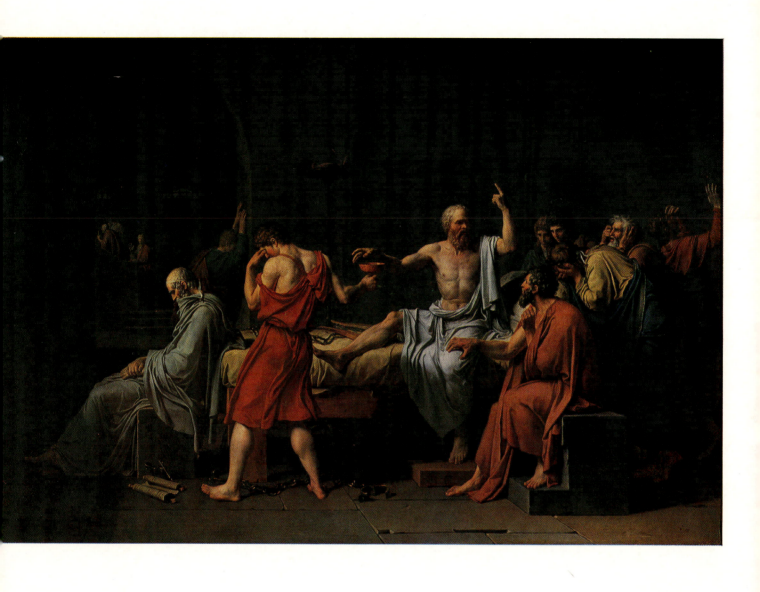

Colorplate 1. JACQUES-LOUIS DAVID. *The Death of Socrates*. 1787. Oil on canvas, 51 × 77 1/4″. The Metropolitan Museum of Art, New York

Colorplate 2. THOMAS U. WALTER and NICHOLAS BIDDLE. Biddle Residence, Andalusia, Pennsylvania. 1833

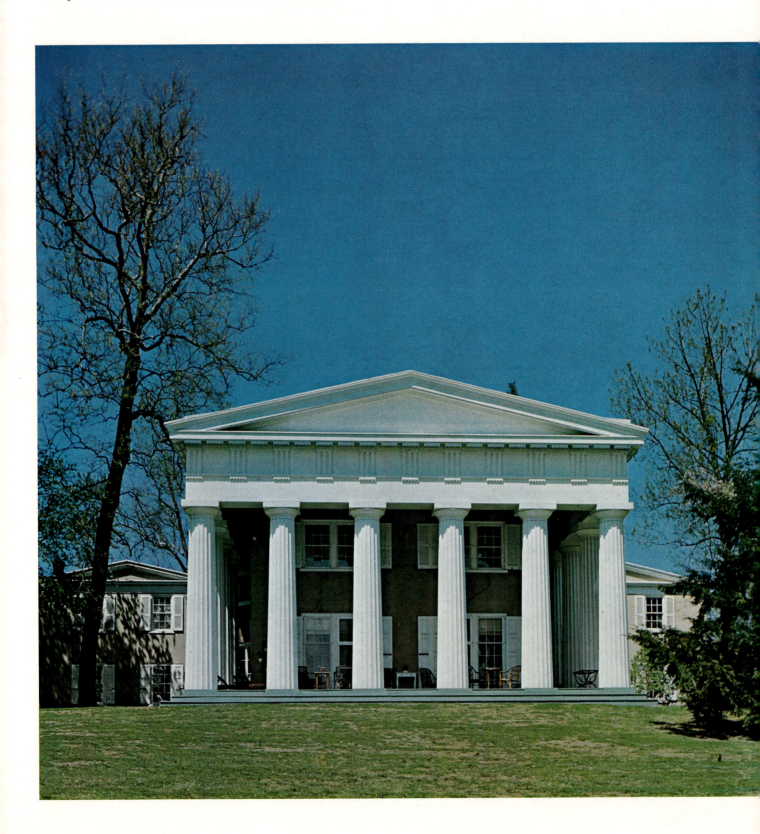

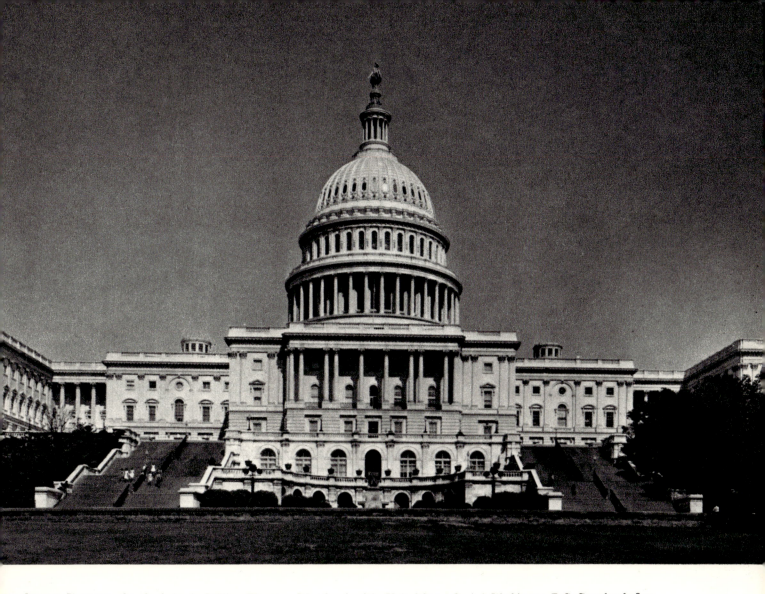

7. CHARLES BULFINCH, after the design by William Thornton. West façade of the United States Capitol, Washington, D.C. Completed 1827

later carry Neoclassic principles to Russia, to prepare a model while he himself fitted spaces for a bicameral legislature and supreme court into the one-room temple form. Translated from stone into stucco and brick and enlarged to its present size, with an Ionic order instead of the original's Corinthian, this was the first building of considerable size in the revived Roman style here or abroad. It set the precedent for many other American statehouses, usually more Greek than Roman, which were built after 1800, and it is more consistently Roman than the National Capitol in Washington. There, so many architects and engineers had a hand in developing the design by Dr. William Thornton (1759–1828), a physician and amateur architect, that the final result is stylistically inconsistent. The exterior with its pilastered façades is essentially late Baroque, but the Corinthian portico two columns deep on the west façade, completed in 1827 by the Boston architect Charles Bulfinch (1763–1844), is impressively Roman (plate 7). On the interior the semicircular old House of Representatives, now the cluttered Statuary Hall, by Benjamin Latrobe (1764–1820), is the finest Roman interior in this country. A screen of handsome columns closes the arc of the circle, and a richly coffered ceiling is pierced with a central oculus in the manner of the Pantheon. Latrobe would also have placed the low Pantheon dome above the immense central rotunda, originally intended for joint conferences of the Senate and House. The present tall dome, derived from St.

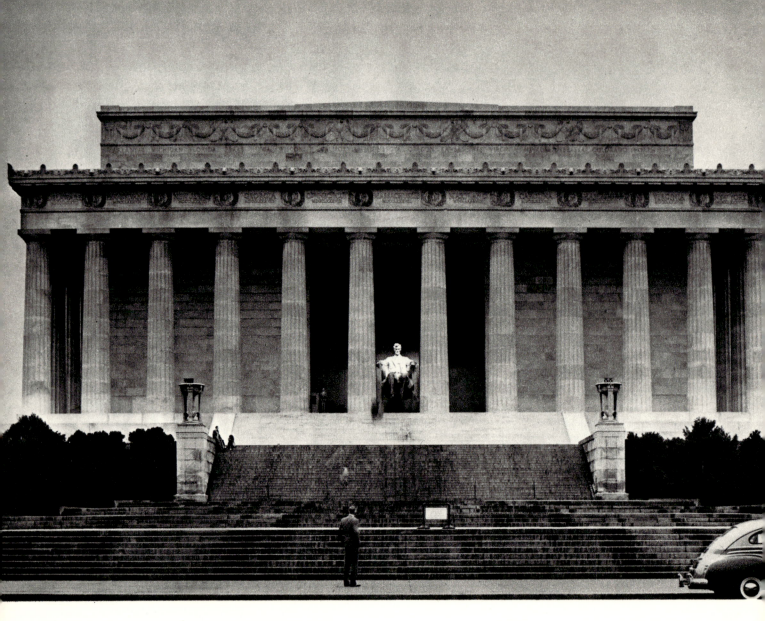

8. HENRY BACON. Lincoln Memorial, Washington, D.C. 1914–21

Peter's in Rome, was erected in 1851–1865, when the new wings were added for the Senate and House. It is in scale with the building but almost smothers Thornton's original structure.

The Capitol was from the first conceived as a principal element in the comprehensive plan for the new city. The planner, Major Pierre-Charles L'Enfant (1754–1825), a French military engineer and architect, provided a grandiose design with broad avenues which radiated like those in the park at Versailles and which, connected by squares and rectangles, the favorite geometrical motifs of the period, were imposed upon a regular gridiron of secondary streets. After the first government buildings had been constructed, including the conservative Anglo-Palladian

White House (1792–1800) by James Hoban (c. 1762–1831) and the Ionic Treasury (1836–1842) and Doric Patent Office (1839; now the National Portrait Gallery), both by Robert Mills (1781–1855), the classic order of L'Enfant's plan, which perhaps had always been more apparent on paper than in actuality, was obscured by a host of undistinguished structures. Since 1900 attempts have been made to recover something of the grandeur which L'Enfant envisaged, but fortunately there is still a splendid classic prospect along the Mall, which stretches from the Capitol past Mills's Washington Monument (designed 1833) to the Lincoln Memorial (1914–1921) by Henry Bacon (1866–1924), perhaps the last truly monumental Neoclassic structure in this country (plate 8).

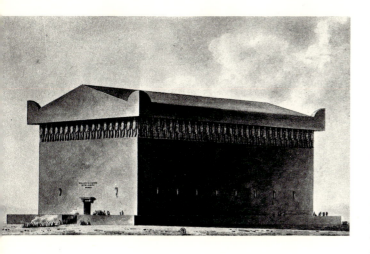

others who were more fortunate in the quantity of their executed work (plate 9). Claude-Nicolas Ledoux (1736–1806) had at first handled the delicate Classicism of Louis XVI with great restraint. In his Theater at Besançon (1776–1784) he emphasized the cubical mass and avoided extraneous ornament. More formidably Roman were Ledoux' tollhouses for the gates of Paris, erected on the eve of the Revolution. Most of them have been demolished, but in the surviving Barrière de la Villette (1784–1789) he created a powerful composition of almost completely abstract masses (plate 10). This was truly "cubic architecture," ready for the heroic actions which were soon to occur.

In 1804 Ledoux projected his conception of the moral significance of architecture in a volume of designs and executed works. The title, *L'Architecture considérée sous le rapport de l'art, des moeurs et de la législation*, suggests the utopian morality characteristic of much Neoclassic expression. Although many of his

In France, meanwhile, a more rigorous, programmatic, and radical development had begun. In architecture much remained on paper because the projects were too costly or too impractical to execute during the troubled times at the end of the century. Nevertheless, the designs of Étienne-Louis Boullée (1728–1799) for vast monuments and public buildings, based on combinations of a few severely unadorned geometrical elements, represented the highest flights of Neoclassic imaginative design and influenced

10. CLAUDE-NICOLAS LEDOUX. Barrière de la Villette, Paris. 1784–89

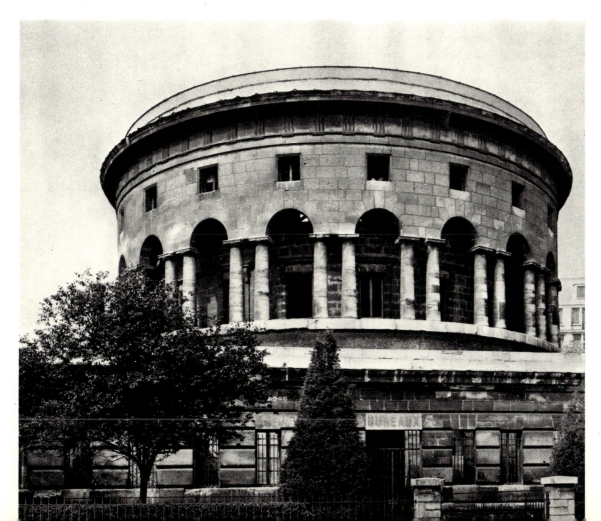

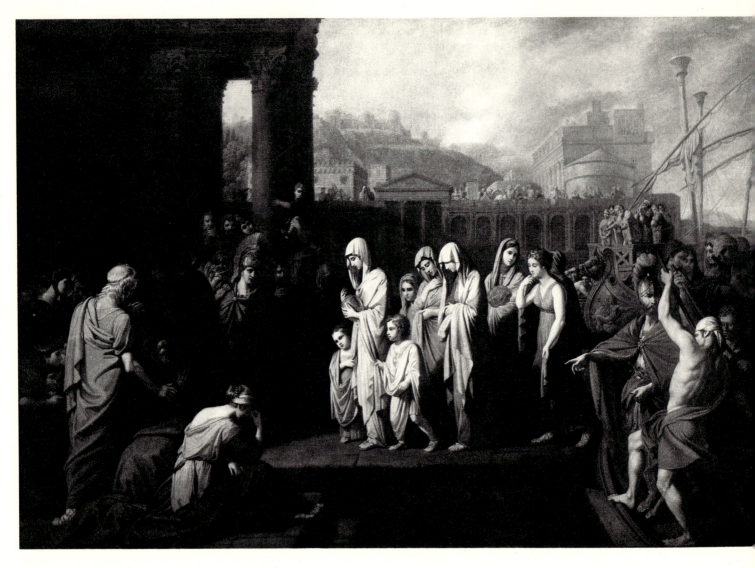

11. BENJAMIN WEST. *Agrippina Landing at Brundisium with the Ashes of Germanicus*. 1768. Oil on canvas, 64 1/2 × 94 1/2″. Yale University Art Gallery, New Haven, Conn. Gift of Louis M. Rabinowitz

ideas were too visionary to be executed, or too symbolical to be comfortable if they had been, such as the tunnel-like house for a river surveyor through which the river was to flow, others were more practical and more profound. His designs for a factory, partially constructed at the government saltworks at Arc-et-Senans (1775–1779), and his plans for an industrial town, his "Ville Idéale de Chaux," are among the earliest instances of rational planning for modern urban life.

Jacques-Louis David (1748–1825) was the foremost master of Neoclassic painting. Others had earlier attempted to recast the Baroque history picture, which usually depicted mythical or legendary events as well as scenes from ancient and Biblical history, in a Classic manner, but none of David's predecessors, not even the Anglo-American Benjamin West (1738–1820), the Scottish Gavin Hamilton (1723–1798), or his own master, Joseph-Marie Vien (1716–1809), had succeeded in welding content and form, subject matter and technique, into a new and revolutionary style. Despite togas and temples their compositions remained Baroque. In his painting on so nobly Roman a theme as the widowed Agrippina returning to Italy to confront the Senate with the ashes of her murdered husband, the generous Germanicus (plate 11), West took the trouble to compose the central group of women and children after one of the

surviving fragments of the Ara Pacis, but he allowed the subsidiary figures, strongly colored in contrast to the marmoreal white of the central group, to move freely in a deep atmospheric space.

By birth and education David himself was heir to the decorative elegances of the mid-century; he was a distant relative of François Boucher, and he had been educated at the École des Beaux-Arts in Paris when the Rococo tradition was still strong. When he left Paris in 1775 after winning the highest government award, the Prix de Rome, which entitled him to spend four years at the French Academy there, he declared that he would not be corrupted by antiquity. But for David, as for most of the painters of his generation, the spell of the past was inescapable. During the four years in which he filled his notebooks with drawings after Classic sculpture, his line became firmer, his forms more solid, and his modeling confined to bold oppositions of light and dark. The result of this self-education appeared in three severe and solemn paintings; *The Oath of the Horatii* of 1784 (Louvre; smaller version of 1786 in the Museum of Art, Toledo, Ohio); *The Death of Socrates* (1787; colorplate 1); and *The Lictors Bringing to Brutus the Bodies of His Sons* (1789; Louvre; small study in the Wadsworth Atheneum, Hartford). In each picture the qualities of valor and virtue, familiar allegorical generalizations in earlier painting, were presented in terms of actual events in Roman and Greek history. When such paintings were seen at the Academy's exhibitions in the great hall, or Salon, of the Louvre (whence the term *Salon* for subsequent official or large exhibitions, wherever held), the public read them as tracts for the times, as comments on the failure of the civic will, on the refusal of the king and his ministers to subordinate their own well-being to the common good. That this was possible was in large measure the result of David's new style, for the subjects themselves were not uncommon, and were generally familiar in an age when the Classic authors were known to every schoolboy. In each painting the figures are seen in crisp relief, forcefully highlighted against the simplest backgrounds. The few accessories, a table or a bench, are reduced to the barest cubical volumes, emphasizing the geometrical character of the shallow space across which the figures are placed as in an antique bas-relief. Each figure is boldly set apart from its neighbors by the uniform color of its draperies: unbroken reds, blues, purples, and greens enhance the solemnity of the drama. Today we can see that David, unlike his imitators, never forgot that living bodies are not made of stone; even in the prison stillness of the *Socrates*, he makes the flesh seem soft and warm, as if blood were flowing through the veins.

Upon the fall of the Bastille on July 14, 1789, David sided with the Revolution and became an implacable foe of the artistic institutions of the monarchy. As a Jacobin and deputy to the Convention he voted for the abolition of the Academy and the suppression of its schools; as artistic arbiter of the Revolution he took charge of its festivals and ceremonies, which he arranged in an antique spirit, marshaling thousands of participants whom he dressed in Classic garments and set marching through Paris as if it were a new Rome. His finest hour came in 1793 when within a few months two members of the Convention were assassinated and he was commissioned to paint commemorative pictures for the assembly hall. For Le Peletier de Saint-Fargeau, a nobleman who had forsworn his class to vote the death of the king, David planned a Roman funeral with the naked corpse exposed on a bier. His painting of the body in this position subsequently disappeared and is known only from an engraving, but it served as a preliminary exercise for his exalted memorial to a greater victim. On July 13, 1793, the revolutionary leader Jean-Paul Marat was assassinated by Charlotte Corday as he sat in a bathtub filled with a medicinal solution prescribed for a painful skin disease. In one sense David's painting (plate 12) is a true report of the actual event; in another it is one of the most abstract symbols of patriotic virtue ever painted. David had seen Marat in his tub the evening before and he sketched the head of the murdered man a few hours after the event. But the sordid circumstances, even the "long new table knife," have been transformed and infused with the "noble simplicity and silent grandeur" which Winckelmann insisted were the essential characteristics of Greek art. Against the gray-green wall the white sheets establish the funereal note and provide the subtlest of linear transitions between the slow curves of the body subsiding in death and the simple geometry of inkpot, wooden block, and papers, symbols of Marat's dedication to the people's welfare.

Through the remainder of a long and brilliant career in which he was honored as the leading contemporary painter of Europe, David never again achieved so concentrated an expression of antique virtue. His later historical pictures, *The Sabine Women* (1799; Louvre) commemorating the restoration of peace and order after the Terror and *Leonidas* (1814; plate 13), which may refer to Napoleon's darkening fortunes, are studiously Classic, the one Roman, the other Greek even to the improbably nude Leonidas and his warriors defending the pass of Thermopylae,

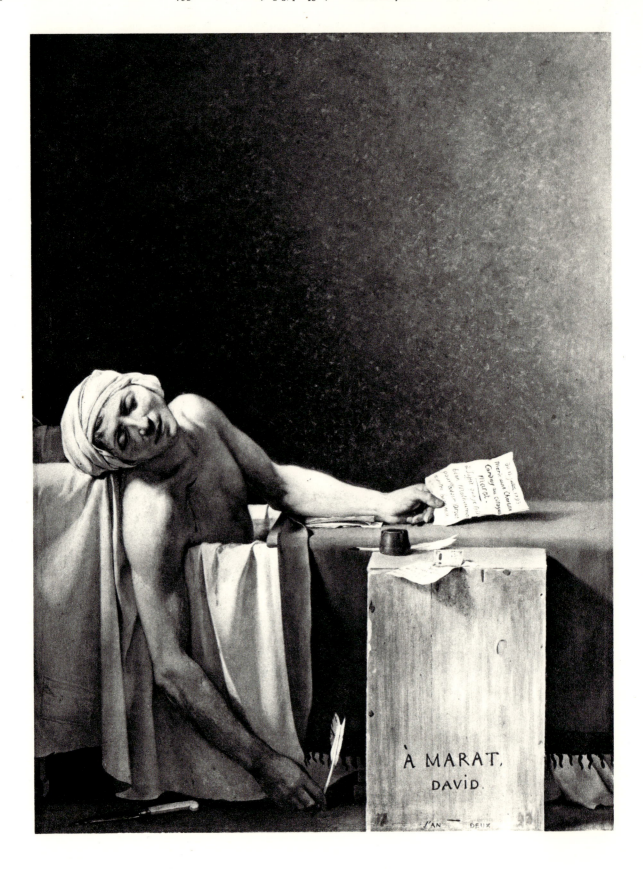

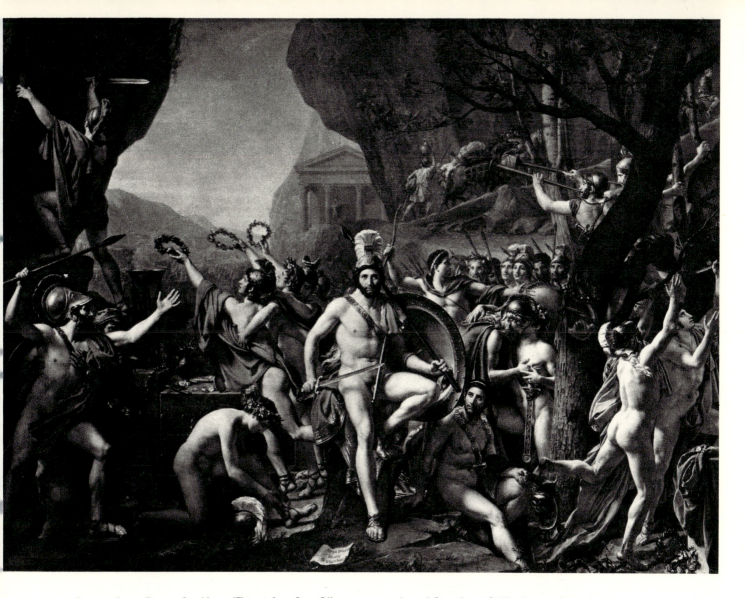

13. JACQUES-LOUIS DAVID. *Leonidas at Thermopylae*. 1814. Oil on canvas, 12' 10 1/4" × 17' 5 1/2". The Louvre, Paris

but the compositions are confused and strained. With the downfall of the Empire, David, who had been Napoleon's First Painter, went into exile in Brussels and ignored all inducements to return to France. He was the first but not the last artist in modern times to mix paint and politics, but he was the only one whose political actions were consequential for his country's art, the only one whose greatest work was truly revolutionary, in form as well as in content.

The rapid growth of the principal European cities, especially the national capitals, toward the end of the eighteenth century provided many opportunities for architects and planners to create a Classic urban environment. In three cities in particular capitals of countries engaged for a decade in the Napoleonic Wars, extensive developments suggest that the

Classic Revival had become a truly international style, whose elements, immune to regional variations, could be used almost interchangeably for symbolic or utilitarian purposes. Only in Russia and the United States did differences in building materials lead to conspicuously national variations.

During his short reign (1804–1814) Napoleon could only begin the reconstruction of the ceremonial center of Paris, but his successors, notably King Louis-Philippe (reigned 1830–1848), not unmindful of the prestige of the Napoleonic projects, completed his unfinished works. Among the first designs were certain straightforward imitations of Roman architecture. The bronze column in the Place Vendôme (completed 1810) carries a spiral relief in imitation of Trajan's Column in Rome. The Arc du Carrousel (1806–1808) by Charles Percier (1764–1838) and

P.-F.-L. Fontaine (1762–1853), Napoleon's favorite architects and the principal creators of the decorative style of the Empire, is a reduced version of the Arch of Constantine. It now stands alone in the Tuileries Gardens but originally served as a gateway to the vanished palace. Nearby at the head of the Rue Royale stands the Church of St. Mary Magdalene (La Madeleine; plate 14), begun in 1806 by Pierre Vignon as a temple of honor for Napoleon's armies, but adapted to a church before its completion in 1842. One of the largest and most sumptuous of all Roman Revival buildings, it is a free-standing structure on a high podium with a complete Corinthian colonnade on all four sides. Opposite it, across the Place de la Concorde and the Seine, a long blank façade with a portico of twelve Corinthian columns was added to the older Palais Bourbon—which had become the seat of the legislative assembly—to bring it into harmony with the Roman scheme. This classic ensemble was concluded at the far end of the Champs-Elysées by a more original structure, the Arc de Triomphe de l'Étoile (plate 15) by J.-F.-T. Chalgrin (1739–1811) and others. The proportions of this huge arch were derived from François Blondel's much smaller Porte Saint-Denis in Paris (1671–1672), but the effect of the whole is neither Baroque nor Antique. The contrasts of rectangle, square, and semicircle, of plain wall and carved relief, of massive piers and richly ornamented attic (redesigned after Chalgrin's death), are in the tradition of David's harsh and dramatic Classicism. Not the least interesting aspect of this monument, which concludes the long vista from the Louvre and the Arc du Carrousel, is that almost alone among modern structures it seems to have been designed in relation to the city as a whole.

Napoleon's most important buildings, with the

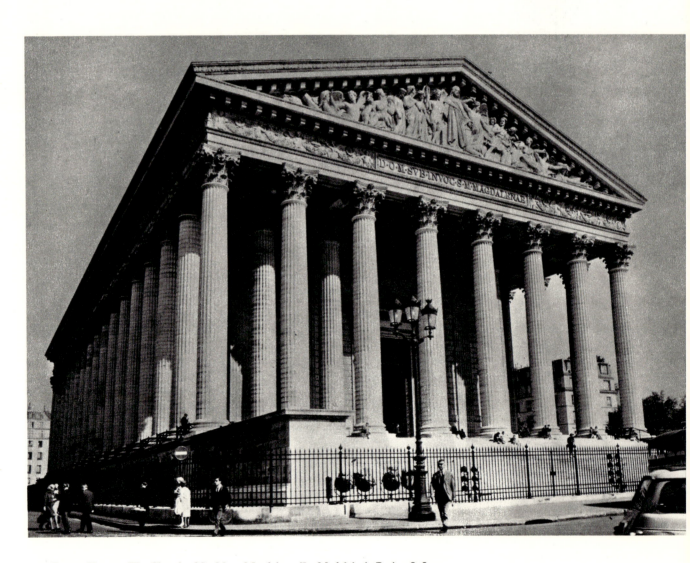

14. PIERRE VIGNON. The Church of St. Mary Magdalene (La Madeleine), Paris. 1806–42

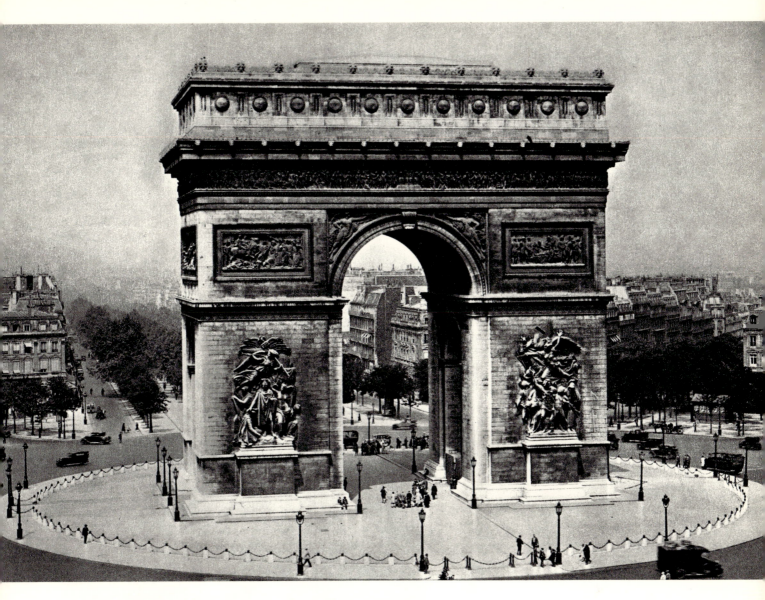

15. J.-F.-T. CHALGRIN and others. Arc de Triomphe de l'Étoile, Paris. 1806–36

exception of his columned Bourse, or Stock Exchange, and the new Rue de Rivoli facing the Tuileries Palace (now the Gardens), were correctly Roman and their functions more symbolic than practical. In other cities where the ceremonial centers were less developed, where major governmental structures had still to be built, or where the institutions peculiar to modern society were more advanced, architects could treat Classic precedents with greater freedom. In London, for instance, the rapid growth of the British economy required the rebuilding of the Bank of England, undertaken in two campaigns by Sir John Soane (1753–1837). The windowless exterior included a Tivoli Corner recalling the circular Roman temple at Tivoli, but for all the recollections of Piranesian space the interiors were remarkable improvisations on Classic themes. And they were English as well as Roman, with the slender, domestic-scaled proportions of Robert Adam purged of Adam's lavish decoration. From the first Soane stressed open, clearly articulated spaces enclosed by what appear to be the thinnest of walls and vaults (his vaults were actually very light, made of fireproof clay pots) and lit by clerestory windows or broad, low cupolas (plate 16). Soane eschewed archaeological pedantry and suppressed such structurally unnecessary members as capitals

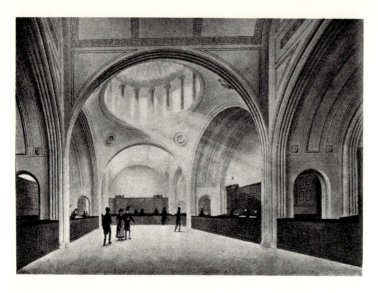

16. SIR JOHN SOANE. *Interior of the Bank of England,
London.* 1826–27. Engraving

and entablatures so that his arches swung uninter-
ruptedly from floor to crown, their directions defined
by continuous grooves and ridges which underlined
the geometry without introducing irrelevant reminis-
cences. The structural and functional clarity of such
interiors would have made them seem modern still,
had they not been demolished or irrevocably altered
in the 1930s when the bank was enlarged.

Soane was an architectural aristocrat, aloof and
eccentric, but even at his most idiosyncratic, as in his
own house in London where he worked magic with
the tiniest of interior spaces, he was always sensitive
and refined. His contemporary John Nash (1752–
1835) was an architectural commoner, more a builder
and planner than a designer, adept at devising large
urban schemes which lack refinement and invention
in their parts, but which determined the character of
much of modern London. Nash was a favorite of the
Prince Regent, later King George IV (reigned 1820–
1830), for whom he developed the Crown lands lying
to the north of Oxford Street. Regent's Park and the
terraces or rows of houses surrounding its southern

17. JOHN NASH. Cumberland Terrace, Regent's Park, London. 1826–27

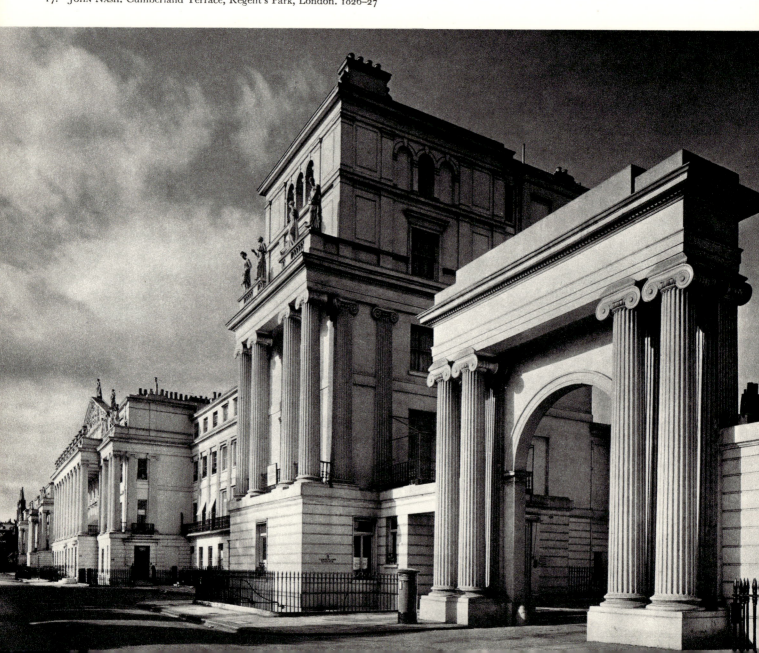

half are still there; so, too, is the spacious avenue leading to the Regent's now vanished residence, Carlton House, on the Mall. The confrontation of the symmetrical terraces, adorned with columns, porticoes, pediments, and connecting arches (plates 17, 18), with the freely landscaped park suggests that a quite un-Classic feeling for nature had begun to intrude into town life. Regent Street itself, despite the fact that its façades have been almost all rebuilt, is still a noble thoroughfare, London's finest for the period and comparable to the best on the Continent.

The grandest of all Neoclassic cityscapes in the Roman taste is still to be seen in Leningrad. Founded as St. Petersburg by Peter the Great in 1703, it had no medieval or Renaissance past to handicap its planners and builders, who from the first thought in terms of broad avenues (in the manner of Versailles), huge squares, and spacious buildings prominently placed along the canals and rivers. The earlier structures were designed by foreign architects in several eighteenth-century styles, but by the end of the century a generation of Russian-born and Russian-trained architects was ready to give the city its ultimate Neoclassic splendor. The Cathedral of the Virgin of Kazan (1801–1811; plate 19) by A. N. Voronikhin (1760–1814) was one of the first and the most unmitigatedly Neoclassic of all. It was an adaptation of St. Peter's in Rome, with curving Corinthian colonnades supporting a heavy attic and ending in large pavilions. The whole is singularly hard and cold, but undeniably powerful. The quadrant of the General Staff (1819–1829) by K. I. Rossi (1775–1849) faces the Rococo Winter Palace across an enormous square in which stands the largest of all Neoclassic trophies, the monolithic Alexander Column of red Finnish granite (1829) by A. A. Monferran (1786–1858), a Frenchman whose professional life was spent in Russia. The cultivated taste of the Emperor Alexander I (reigned 1801–1825) has given the title *Alexandrine Classicism* to the best work of his reign. The most typical example of this phase of the style in St. Petersburg (now Leningrad) is the New Admiralty (1806–1815; plate 20) by A. D. Zakharov (1761–1811).

18. JOHN NASH. *Plan of Regent Street and Regent's Park, London*

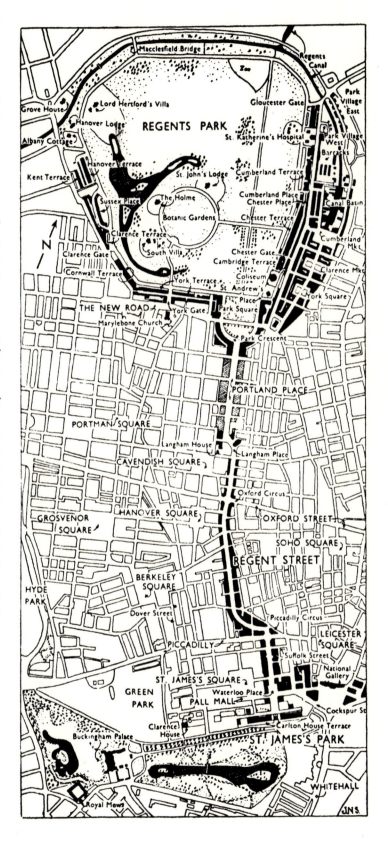

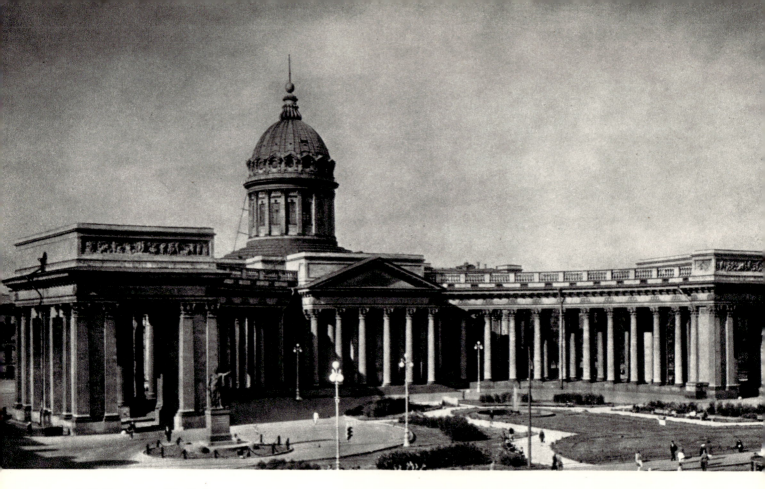

19. A. N. VORONIKHIN. The Cathedral of the Virgin
of Kazan, Leningrad. 1801–11

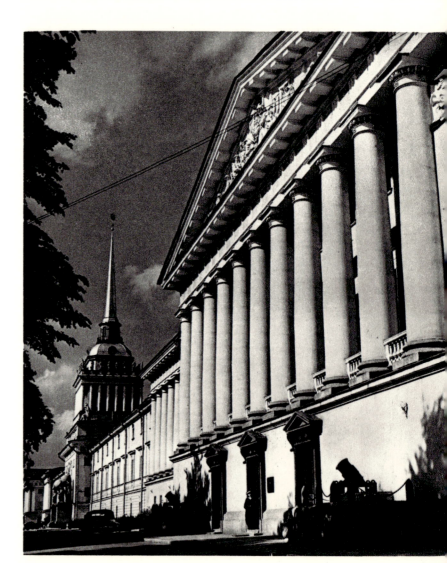

20. A. D. ZAKHAROV. The New Admiralty,
Leningrad. 1806–15

Despite its length of almost a quarter of a mile, Zakharov avoided monotony by a skillful alternation of temple-fronted pavilions with stretches of windowed walls. The steeple in the center owes its needle-like proportions to a traditional verticality stemming from the fortress church of SS. Peter and Paul (1714–1726). The pavilions which conclude the wings toward the river are unusually elegant examples of Russian Classicism.

After the Napoleonic Wars this delicate, small-scaled Classicism appeared throughout European Russia, not only in cities and towns but also in country houses. Under Alexander's successor, Nicholas I (reigned 1825–1855), a reactionary political regime supported less inventive and finally quite eclectic architectural programs. But because the classic architecture of St. Petersburg—and of Moscow in the buildings erected between 1790 and 1840—was associated with political authority, it acquired a symbolical value which has never been entirely forgotten.

The earlier Neoclassic buildings in Russia are distinguished from those in other countries by their great size and color. Since there was a scarcity of good stone, many were built in inexpensive brick. The stucco which covered the brick had to be painted, but instead of the uniform white or cream-colored paint preferred elsewhere, as in the United States and Britain, a variety of colors provided a contrast to the prevailing white of the long Russian winter. During the later nineteenth century many buildings were repainted in dark red and brown after industrial soot had smudged the lighter tints, but since 1946 the most important buildings have been restored to the original hues of pale blue, green, pink, or yellow (like the Admiralty), with columns, doors, and cornices picked out in white.

Unlike Jefferson's State Capitol in Richmond of 1785, in which the functions of modern government had been compressed within a uniform Classic shape, Zakharov's symmetrical but varied masses suggested a multiplicity or at least a differentiation of internal functions brought into harmony by the repetition of similar elements. The range of design, from the careful imitation of ancient architecture to the free manipulation of Classic elements in buildings entirely new in plan and purpose and for which no ancient prototype could be imagined, occurs also during the Greek Revival, although freedom of invention was hampered by the respect paid the Parthenon as the supreme example of Greek architecture. This meant that if the designers were to stick to their text, they had to make do without such structural advantages as the arch, the vault, and the dome, familiar in Rome but unknown in Greece. That they did not forego these forms but, rather, discovered ingenious ways to use them accounts for much of the vitality of the Greek Revival.

The dominance of Greek design after about 1815 can be explained in different ways. For many people the Roman Revival had been closely associated with the revolutionary years which had reached a climax in the first French Empire. But dislike of Napoleon could go hand in hand with a feeling that Roman forms were already old-fashioned, even too "eighteenth-century." Another factor was the Greek War of Independence (1821–1827), during which modern Greece won its independence from Turkey. The reluctance of the European powers to assist the Greeks made their plight the more pathetic, and the death of Byron—whose fame was equaled only by Goethe's—at Missolonghi, where he had gone to volunteer his services, seemed the supreme intellectual sacrifice of the modern world to the ideals of Greek culture. Above all, the increased understanding and knowledge of the character of Greek art encouraged the study and reproduction of Greek forms. From the time of Winckelmann's treatises, of which the first had been entitled *Thoughts on the Imitation of Greek Works* (1755), and of Piranesi who in his old age engraved the temples at Paestum, the qualitative superiority of Greek art had become universally recognized. But the process took longer than we might think. The Parthenon sculptures, which Lord Elgin had brought to London, were ignored or dismissed as Hadrianic copies when first seen in 1806. Not until 1816 were they purchased by the government and removed to the British Museum. By then British architects were ready to work in the Greek manner. Downing College at Cambridge (1806–1811; plate 21) by William Wilkins (1778–1839) is the first example of the Revival in England. The several buildings were designed to stand freely detached from each other, each a relentlessly correct interpretation of the Erechtheum Ionic. The British Museum itself, completed in 1847 by Robert Smirke (1781–1867), was faced with forty-eight immense Ionic columns extending not only across the portico but also around the projecting wings.

In Germany, where Napoleon's imperialism had brought so much trouble to the separate states, Greek architecture was preferred to Roman. In Berlin the Brandenburg Gate (1789–1793) by K. G. Langhans (1733–1808), suggested by the Propylaea in Athens, had been precociously Greek. Further along Unter den Linden in the governmental center of the city, the

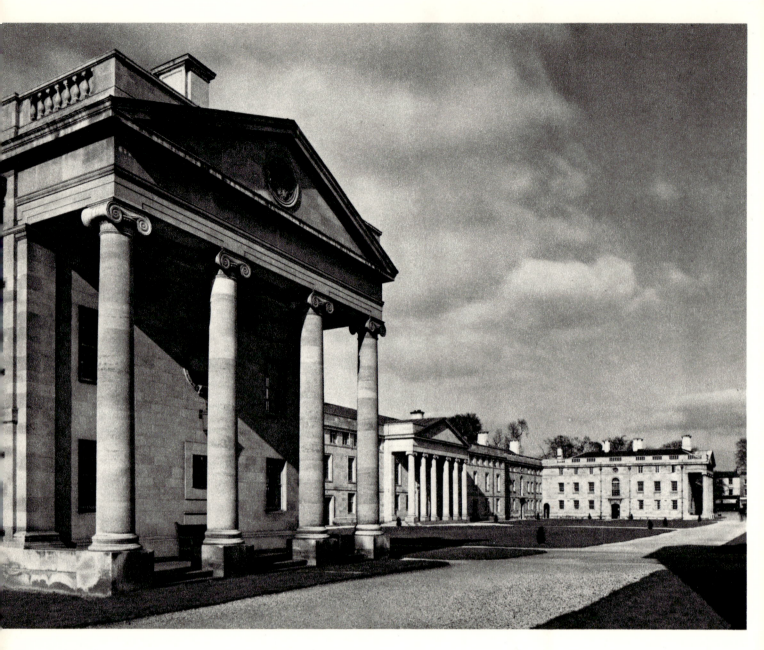

21. WILLIAM WILKINS. Downing College, Cambridge, England. 1806–11

Neue Wache, or Guardhouse (1816), and the Altes (Old) Museum of 1824–1830 in the Lustgarten (plate 22) by Karl Friedrich Schinkel (1781–1841), Germany's greatest Neoclassic architect, were powerful examples of Greek motifs adapted to modern purposes. The Doric order of the Neue Wache and the superb range of eighteen Ionic columns against the Museum's windowless wall not only were stylistically correct but also were treated as almost abstract elements in designs which owed little to the familiar temple form. In his Schauspielhaus, or State Theater (1819–1821),

Schinkel freely combined temple forms and pierced their walls with large windows to accommodate quite un-Classical functions.

In Munich Schinkel's contemporary Leo von Klenze (1784–1864) had a heavier hand, but his buildings on the Königsplatz for the Grecophile king of Bavaria, Ludwig I, are so placed as to create an important Neoclassic urban center. The type building of the period, the museum, received a grand if solemn treatment in the Glyptothek (Neo-Greek for "repository of sculptures"), to house the antique marbles

collected by the King. They included one of the great treasures of Greek art, the early fifth-century pedimental sculptures from Aegina, unfortunately repaired and recut by the sculptor Thorvaldsen (see below, p. 39). The exterior with its windowless walls and Ionic portico belied the richly coffered and painted interiors, certainly not very Greek but perhaps the most sumptuous Greek Revival rooms anywhere until their destruction by bombing in 1945. The Königstor, or Royal Gate (1846–1863), on the same square, one of the last Grecian buildings in Munich, is another but slacker version of the Athenian Propylaea.

In Edinburgh the New Town was completed at the height of the Greek enthusiasm. The citizens had long thought of their city as the "Athens of the North," and it now began to look like it. The High School (begun 1825) by Thomas Hamilton (1785–1858), the Royal Institution (now the Royal Scottish Academy), and the National Gallery (1850–1854) by W. H. Playfair (1789–1857) were all severely Greek. Edinburgh was even to have its Parthenon, begun as the Scottish National Monument on its own "Acropolis," Calton Hill (plate 23). It was begun in 1826 by the English architect Charles Robert Cockerell (1788–1863) and William Playfair of Edinburgh, but construction had to be abandoned three years later when the funds were exhausted. The still-unfinished portico, exemplifying in Playfair's words the "pride and poverty of Scotland," is as picturesque as a real ruin.

The imaginative reality which Greece had become for Americans in the 1830s can still be seen in the buildings associated with the career of Nicholas Biddle of Philadelphia (1786–1844), one of the most cultured and widely traveled men of his day. At eighteen, when he had served as secretary at the American Ministry in Paris, he witnessed that most magnificent of all Romantic Classic events, the coronation of Napoleon on December 2, 1804, when the interior of the medieval cathedral of Notre Dame was concealed, to the height of the triforium gallery, by a temporary screen of Classical arches and pilas-

22. K. F. Schinkel. Altes Museum, Berlin. 1824–30

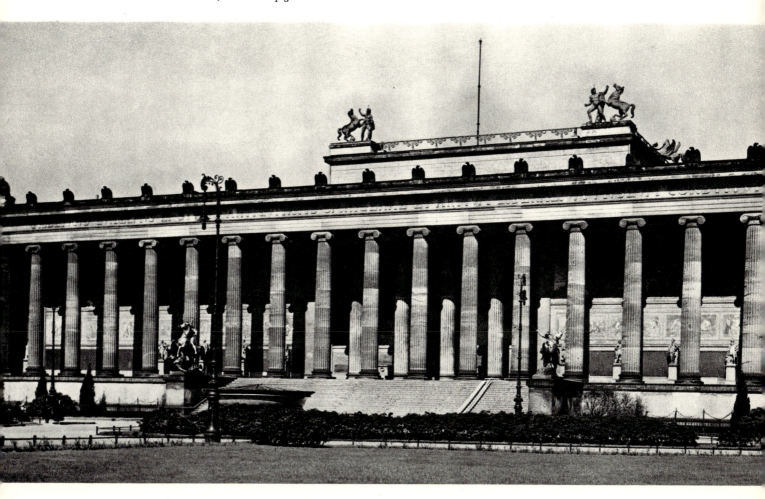

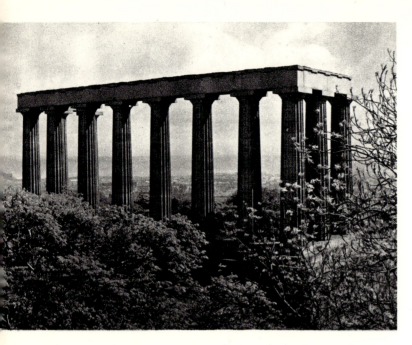

23. C. R. COCKERELL and WILLIAM PLAYFAIR. The Scottish National Monument, Edinburgh. 1826–29

ters. Two years later he traveled in Italy and Sicily, and in Greece where he visited not only Athens but remoter parts of the country. As director of the Second Bank of the United States in Philadelphia from 1819, he helped carry to completion (1818–1824) the handsome Doric temple designed by William Strickland (1788–1854), one of the ablest architects of the Greek Revival in the United States. Strickland fulfilled the requirement of the government's competition that the building be "a chase[*sic*] imitation of Grecian architecture in its simplest and least expensive form." He chose the Doric order of the Parthenon, copying it from the second volume of Stuart's and Revett's *Antiquities*, but confined it to the porticoes on the north and south façades. The Ionic interior was quite un-Greek, being vaulted and admirably illuminated for banking purposes.

For his country home, Andalusia, on the Delaware River, Biddle had Thomas U. Walter (1804–1887) surround an older house with a Doric colonnade in wood (colorplate 2), the favorite material of the domestic architecture of the Greek Revival in America. Biddle was also responsible for the choice of a grandiose Corinthian order for the massive colonnaded temple with interior vaulted classrooms which Walter designed for Girard College in Philadelphia (1833–1847). Walter later designed the new Senate and House wings (1851–1859) and the dome for the Capitol in Washington (1851–1865), but the heavier proportions and the more luxurious but coarser details were signs that the Revival was nearing its end.

At Andalusia the colonnade was carefully executed, and a feeling for the sturdy poetry of Doric architecture survived the translation of stone forms into painted wood. In less costly houses, columns and pediments were combined and modified in countless and unexpected ways, down to a pair of Doric or Ionic columns framing the entrance of the otherwise severely plain rowhouses which were being built in quantity in the expanding cities of the East. Westward through the plains states, in the new county seats and even in smaller towns there was usually at least one building which was indubitably Greek and which lent a gauche but convincing dignity to those remote and lonely places. Many of the new state capitols were Grecian. For Connecticut's co-capitol in New Haven, Ithiel Town (1784–1844) designed the first and purest Doric temple (1827–1831; demolished 1888). But the dome of the Capitol in Washington had by this time become so fixed in the popular mind as a symbol of legislative authority that the architects of other statehouses were obliged to place a dome on a pitched roof, structurally and visually illogical as this might be. Notable examples of this combination of dome and Doric portico may still be seen at Montpelier, Vermont (1833–1837; plate 25), by Ammi B. Young (1798–1874) and at Raleigh, North Carolina (1833–1840), by Alexander Jackson Davis (1803–1892). At Columbus, Ohio, an ingenious solution was reached when a pilastered cylinder without a dome was placed above a broad, well-proportioned block articulated with pilasters and Doric porticoes flush with the façades (plate 24). The original design to which the landscape painter Thomas Cole (see below, p. 70) contributed, was modified by Davis and by a Cincinnati architect, Henry Walter, who super-

24. THOMAS U. WALTER and others. State Capitol, Columbus, Ohio. 1839–61

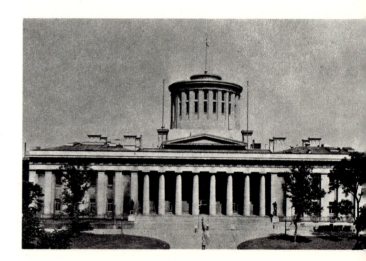

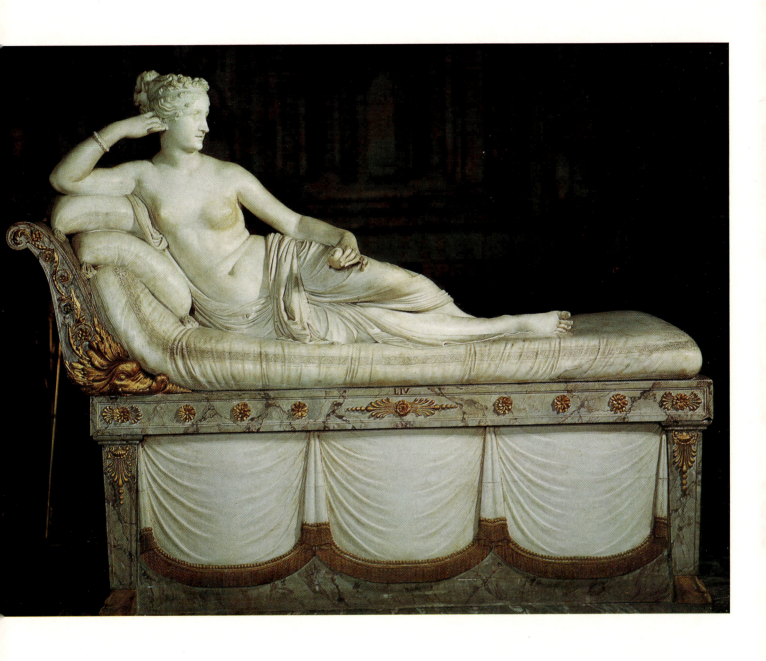

Colorplate 3. ANTONIO CANOVA. *Venus Victrix* (*Princess Pauline Bonaparte Borghese as Venus*). 1808.
Marble, 62 7/8 × 78 3/4″ (including bed). Museo Borghese, Rome

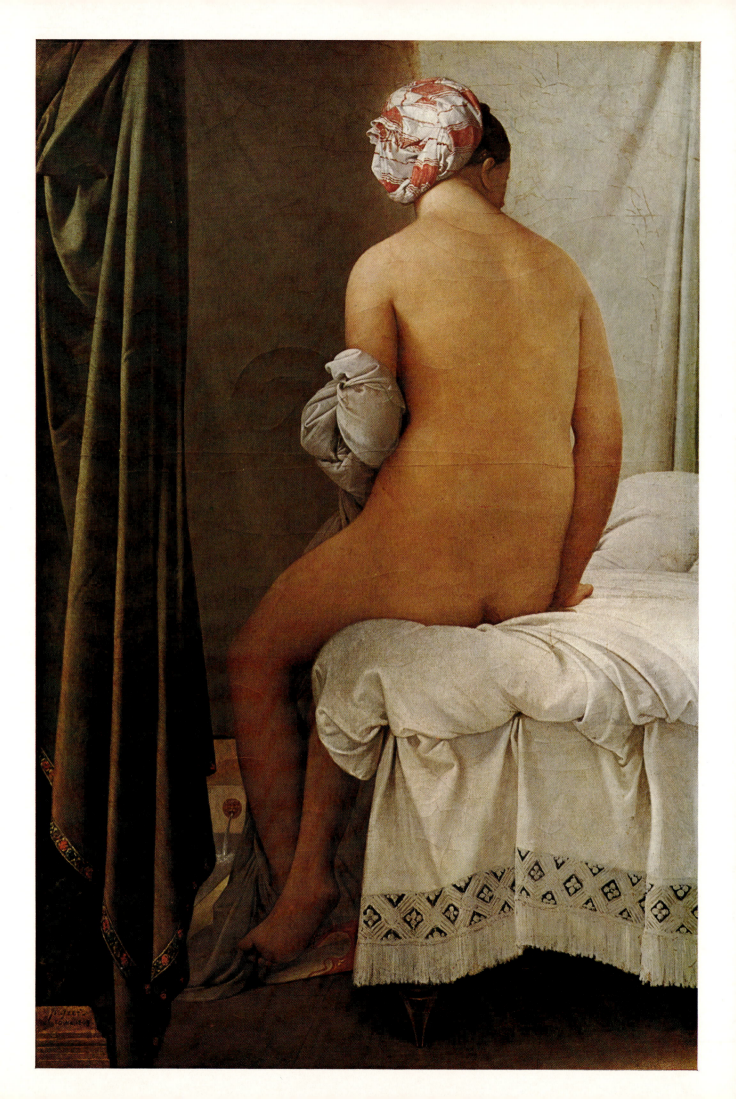

25. AMMI B. YOUNG. State Capitol, Montpelier, Vermont. 1833–37

vised the construction. The distinction of the Ohio capitol rests in the fact that Classic precedent no longer controlled the total form, which at last was more suggestive of its function; there was, however, no loss of the monumentality which the Classic geometrical elements permitted.

The end of Greek Revival architecture, as of Neoclassicism generally, came by the middle of the century. There were too many different things to do, and they could no longer be physically accommodated or symbolically expressed by Classic forms. The Tremont House in Boston (1828–1829) and the Astor House in New York (1832–1836) were among the first large modern hotels, but they were also among the last large structures to display correct Greek porticoes, because several-storied structures could no longer be equated with a one-room temple. So it was with the railway station, a new nineteenth-century building type which urgently required an architectural as well as an engineering solution. One of the first American stations, in New Bedford, Massachusetts (before 1840), was Egyptian, one of the infrequent instances of the revival of such exotic forms, of which the most commanding example was the enormous obelisk designed by Robert Mills as the Washington Monument in Washington, D.C. (1833; completed 1884; plate 26). In London the traffic approaching Euston Station had to squeeze through a pair of handsome but symbolically, as well as functionally, inexplicable Doric columns (1839; now demolished). Like the hotels, these stations were the first and the last of their kind. By 1860 new interests as well as new needs had pushed Classic architecture aside.

Neoclassic sculpture is less interesting than the architecture and painting. Since the sculptor's commemorative and idealizing functions were relatively unaffected by modern life, he was more tempted to repeat Classic forms than to revise them. The art of the ablest of all the Neoclassic sculptors, the Italian Antonio Canova (1757–1822), was, like David's, rooted in the Rococo tradition. Even his most classicizing surfaces never quite lost the sensuousness we have noticed in David's painting. He had worked first in Venice but in the early 1780s was in Rome, where Gavin Hamilton and other enthusiasts for antique statuary turned his eyes to the Classic past. By 1801 Canova had so thoroughly mastered not only the principles of Neoclassicism but also the essence of Classic art that his *Perseus* (a second version is in the Metropolitan Museum of Art), commissioned by Pope Pius VII to fill the niche in the Belvedere left vacant when Napoleon removed the famous *Apollo*

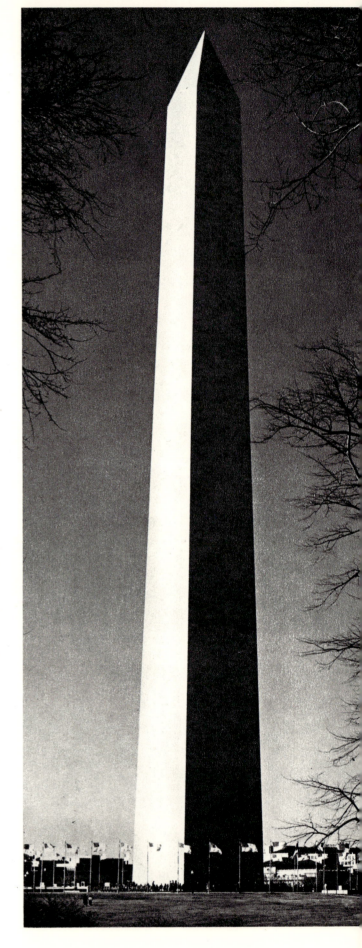

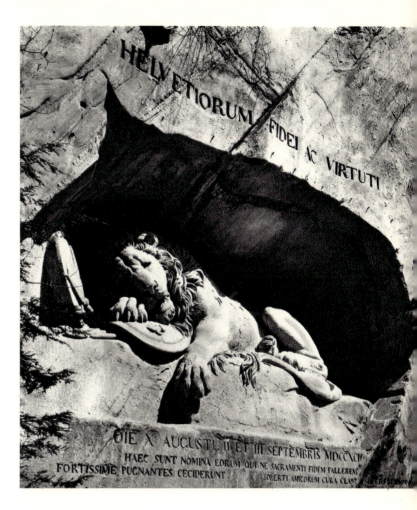

27. BERTEL THORVALDSEN. *The Lion of Lucerne*. 1818–25. Height 30'.
Lucerne, Gletscherpark

to Paris, is a surprisingly adequate substitution for the Hellenistic original, more dignified and heroic than the intricately erotic group of Cupid and Psyche (1793; Louvre) which had made Canova's European reputation. The ambiguous character of his Classicism, in which archaeological reminiscences were often only a thin disguise for the sensual vitality of his figures, appears at its best in the portrait of Napoleon's sister Pauline, wife of the Roman prince Camillo Borghese (colorplate 3). Her posture as the *Venus Victrix* is impeccably antique, but the individuality of the face and the realistic treatment of the mattress and draperies make the arrogantly lovely torso seem disconcertingly alive.

The Danish sculptor Bertel Thorvaldsen (1768–1844), who succeeded to Canova's position as the leading Neoclassic sculptor, was a far more consistent interpreter of Neoclassic taste. In his stiff and chilly marbles, the last graces of the eighteenth century were extinguished; they survived only in his preliminary clay models which have an almost Baroque spontaneity, reminiscent of the similar quality in the wash drawings which preceded Poussin's paintings. Thorvaldsen's best-known work, the *Lion of Lucerne* (1818–1825; plate 27), carved from the living rock in a wooded grotto near the city as a memorial to the Swiss Guards who fell at the Tuileries in August, 1792, is by its location and associations quite as Romantic as Classic. His works may be seen in quantity in the Thorvaldsen Museum in Copenhagen, an abstractly geometrical Neoclassic building erected in 1839–1848 to hold Thorvaldsen's collection and his own sculptures which had brought a momentary international prestige to Denmark.

In America sculpture was the last of the three major arts to arouse any general public interest (John Adams had hoped we would never have much use for it), but in time marble figures of the Classical Revival, however dreary and monotonous, accounted for our first distinctly American school. There had always been carvers in the colonies, whose gravestones, shopsigns, weathervanes, and ships' figureheads, of local stone, metal, and wood, have had to wait until quite recently for their "primitive" merits to be recognized. But only a very few individuals can be distinguished from the innumerable anonymous craftsmen. Samuel McIntire (1757–1811), the designer of some of the finest late eighteenth-century

houses in Salem, made decorative reliefs for his buildings and is known to have carved a few busts in a tentative Baroque manner. In Philadelphia William Rush (1756–1833) became the first American to undertake monumental sculpture for public buildings. His *Comedy* and *Tragedy* for the Chestnut Street Theater are awkward but jauntily Baroque allegories, and his *Water Nymph and Bittern* of about 1809, now preserved in a bronze cast (all three in the Philadelphia Museum of Art), was a first and commendable attempt to suggest the nude body beneath light clinging drapery. Rush, however, worked only in wood. Marble, the more respectable and traditional material, proved recalcitrant to the untrained. The portrait busts by John Frazee (1790–1852) in the Boston Atheneum and the group of *Jephthah and His Daughter* (1833; plate 28) by Hezekiah Augur (1791–1858) at Yale University are among the first marble sculptures by Americans, but they have a bookish look and, indeed, Augur's was derived from engrav-

Romantic Classicism / 39

ings. By then it was apparent that young Americans would have to go abroad to acquire professional experience. This meant Italy, and if possible the studio of Thorvaldsen, who was a generous teacher. One visitor there was Horatio Greenough of Boston (1805–1852), whose colossal seated *George Washington* (plate 29) was the largest as well as the most paradoxical of all American Neoclassic figures. Congress had commissioned it in 1832, but Greenough, who was living in Florence, did not deliver it until 1841; two years later it was moved to the East Lawn of the Capitol in Washington after its great weight threatened the floor of the rotunda for which it had been designed. Out of doors, this half-nude image of the first president as the Olympian Zeus could not survive the ridicule it attracted, and in 1908 it was banished to the Smithsonian Institution. But Greenough's figure is not entirely ridiculous; it has a solemn dignity, perhaps of purpose more than of realization, but as an attempt to impose an alien and improbable

symbolism upon American experience it is the more puzzling, because Greenough himself was an astute critic of American life and of our declining artistic standards toward 1850.

To modern eyes the principal defect in American Neoclassical sculpture is the uniformly monotonous and impersonal treatment of stone. Between one sculptor and another there is little to choose in the way of technical expression. This can be explained if not condoned by the fact that probably almost none of the marbles was ever begun and few ever finished by their nominal authors. The sculptors worked only in clay or plaster and left the actual execution to skilled Italian craftsmen. Skilled they were, and to them must go whatever credit is due for certain rare felicities, like the delicate reliefs on the throne of Greenough's *Washington*.

In David's paintings before 1800 the climax of the earlier, moralizing Neoclassicism had been reached. His later pictures and the work of those who accepted

28. HEZEKIAH AUGUR. *Jephthah and His Daughter.* 1833. Marble, height of the male figure 41 1/2″. Yale University Art Gallery, New Haven, Conn. Gift of a group of subscribers, "The Citizens of New Haven," 1837

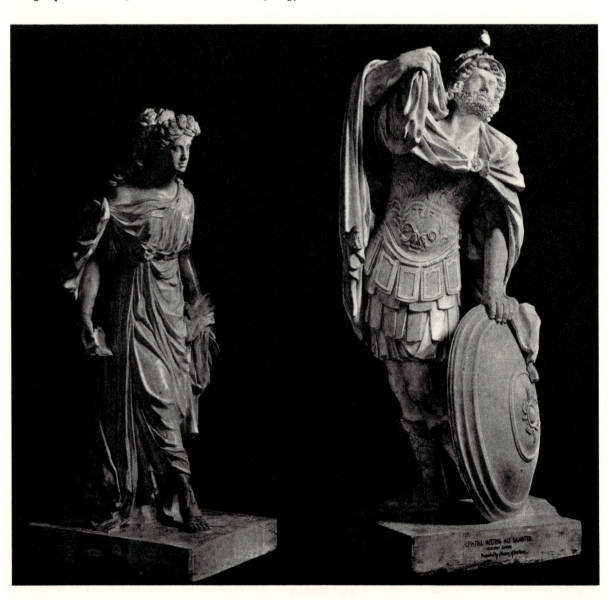

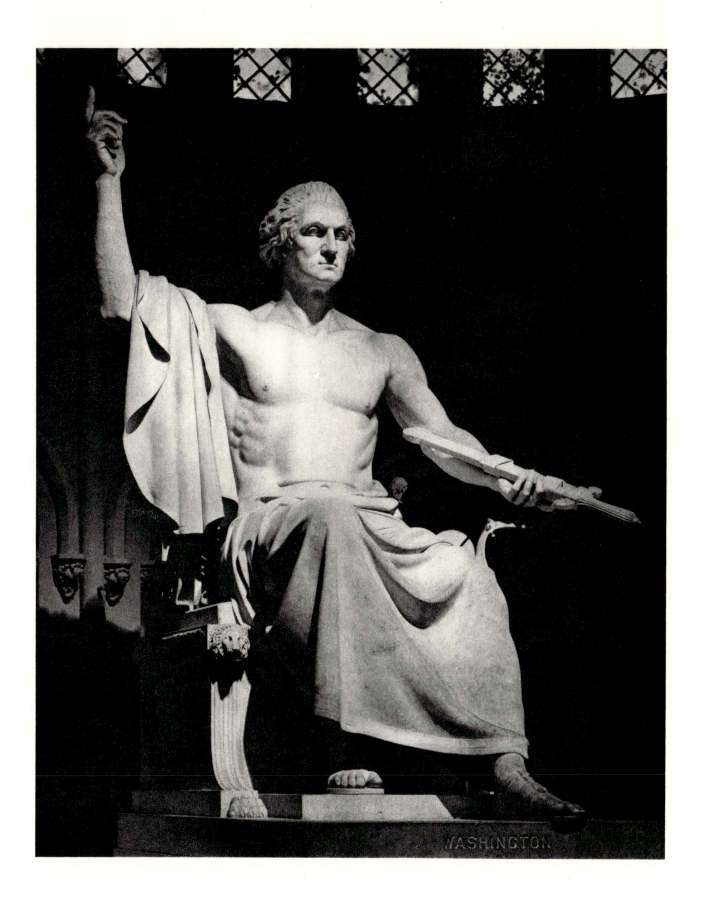

29. HORATIO GREENOUGH. *George Washington*. 1832–41. Marble, height 11′6″.
The Smithsonian Institution, Washington, D.C.

30. PIERRE-PAUL PRUD'HON. *Study of the Nude*. c. 1820.
Black crayon heightened with white chalk, 23 1/2 × 13 1/4".
Museum of Fine Arts, Boston. Forsyth Wickes Collection

his influence deviated in varying degrees from the lofty ideals of moral order toward different and finally quite anti-Classic pictorial purposes. The most important of these became the principal ingredients of Romantic painting after 1815, but they had long been present in European art, and their disruptive actions can be traced from the middle of the eighteenth century. Three factors were particularly important for the decline of Neoclassic painting: a renewed interest in the objective character of external nature, as well as the individual's subjective experience of natural phenomena; a declining interest in the two-dimensional delineation of antique sculpture as a source for pictorial design (the complementary awareness of the expressive and spatial properties of color emerged subsequently); and a conviction that individual experience is valid even if it runs counter to the prevailing ideals of public social responsibility. This change in taste can be observed in the work of Pierre-Paul Prud'hon (1758–1823), the only French painter of outstanding talent of the generation active between 1800 and 1825 who had not studied with David. To a considerable degree he had gone it alone, admiring Leonardo and Correggio rather than inferior Roman sculpture and Raphael. That he knew and appreciated the virtues of antique art we can see in his immaculate chalk and charcoal drawings (plate 30). In this one the model is carefully posed in the Classic manner, but the less formal view of her back and the play of light and shadow caressing the body as if it were flesh, not marble, are anti-Classic, reminding us again how much was lost when the Rococo style was condemned. Yet such a drawing would have been unthinkable at any other time than the early nineteenth century. In its structure it is not Rococo, or even Baroque, for the play of light and shade is firmly controlled by the contours which never disappear from sight and are held to a single plane. The subjects of Prud'hon's major paintings also escaped the limitations of the Neoclassic repertory. Instead of history he treated myth, as in his very Rococo *Rape of Psyche* (1808; Louvre), and allegory, as in *Crime Pursued by Vengeance and Divine Justice* (Louvre), commissioned in 1808 for the Palais de Justice in Paris. Here the beauty of the classically nude male body lying in the foreground is a foil for the malevolent murderer and his ghostly pursuers in the moonlit mountain pass.

In England there was a similar progression from the studious imitation of Classic forms to their use for quite un-Classic purposes. John Flaxman (1755–1826) is remembered now as a designer of low-relief decorations for Josiah Wedgwood's pottery (plate 31), but in his lifetime his monumental sculpture was admired by Canova. His most original contributions to the Classic Revival were outline drawings for Homer, Aeschylus, and Dante, which were published as

31. JOHN FLAXMAN. *The Apotheosis of Homer*. After 1780. Blue and white jasper plaque by Wedgwood and Bentley, 7 3/4 × 14 3/4".
The Walters Art Gallery, Baltimore

32. WILLIAM BLAKE. *Christ Accepting the Office of Redeemer.* 1808
Watercolor, 19 1/2 × 15 1/2″. Illustration for *Paradise Lost.*
Museum of Fine Arts, Boston

engravings in 1793 and earned him a European
reputation. Today his line may seem listless and
slack, strangely inappropriate for the "sublime"
subjects he had chosen, but his elimination of all but
the figural essentials and his reduction of forms to a
single plane are the pictorial counterparts of the
"primitivism" of Ledoux' architecture.

We can follow the influence of Flaxman's simplified
Classicism on two of his friends. William Blake (1757–
1827) has always been better known as a poet, but his
paintings, which were not only illustrations for his
poems but visual metaphors for his mystical ideas,
are remarkable instances of the extent to which
Neoclassic forms could accommodate profoundly
subjective, even idiosyncratic, feelings. The secret lies
in the fact that Blake based his style less on the study
of antique sculpture than on Michelangelo's Man-
nerist elongations and figural distortions which he
knew from engravings. Since Blake was primarily
concerned with illustrating his own writings, or those,
like the Book of Job, which he could interpret in his
personal idiom, it has always been impossible to
judge his art by the standards of objective nature, as
his friends and contemporaries tried hard to do. A
comparison of Prud'hon's drawing of the nude with
one of Blake's watercolor illustrations for *Paradise Lost*
(plate 32) will show how he saw more with the inner
than with the outer eye. In each there is the same clear
division of the forms of the body, but Blake's articula-
tions are more fluid and schematic (recalling the
conventions of the engravings he admired); in each
the contour creates a continuous linear rhythm, but
Blake's line is simplified and repeated to set his
immaterial figures swaying in celestial space. In each
the forms are so convincingly visualized that we must
believe that we are looking at a reproduction of the
image in the artist's eye, for Blake looked upon sights
presented to him by those "Messengers from Heaven"
who, so he said, visited him by day and night. Only
thus could he have left the studio, where Prud'hon's
nude so firmly stands, to journey to the very throne of
grace. How else, we might ask, could he have illustrat-
ed so exalted and essentially un-visual an event as the
majestic Miltonic colloquy between Father and Son
when Christ accepts His redemptive mission.

John Henry Fuseli (Johann Heinrich Füssli; 1741–
1825) was a Swiss who had taken part while still a
young man in the earliest manifestations of German
Romanticism. In 1788 he settled in London, re-

nounced political and poetic activity, and in 1799
became the respectable if eccentric professor of
painting at the Royal Academy. He prided himself on
his passionate temper and furious pictorial energy;
but he was less irascible than he thought, and his
vaunted energy was his undoing as a painter, since he
never took time to acquire any firm control of drawing
or brushwork. His art, based like Blake's on Italian
Mannerism with a strong mixture of Classic attitudes,
was another factor in the dissolution of the Neoclassic
world. Despite the lip service he paid to Neoclassic
doctrine, his work was filled with intimations of secret
and even frightening emotions. In his contributions to
Boydell's Shakespeare Gallery, a series of paintings
commissioned by a London bookseller and published
as engravings, he interpreted the plays with a poetic
frenzy quite beyond the capacities of the eighteenth-
century stage. He also illustrated Milton (Milton and
Dante, it may be noted, were Christian poets and
thus quite un-Classic authors) and exhibited his
paintings in his own Milton Gallery in 1799. It was
not a success and many of his pictures have disap-
peared, but in *Solitude—Morning Twilight* (plate 33),
a painting which Blake thought "too tame," his

and that such Beauty could only be approximated by the combination of perfect parts selected from an otherwise imperfect Nature, his finest paintings are those in which Nature, not Idealism, has the advantage. His early *Bather* (colorplate 4) is not Greek or Roman, or even Renaissance, but an image of the model as Ingres saw her in his studio, supplied with a few Turkish accessories to indicate that the scene is laid in a land remote in space, if not in time, from the commonplace intrusions of everyday life. Yet what counts is not the masquerade but the intense visual truth of what Ingres saw, and which he has communicated by the miraculous contour which follows every shifting plane, even as it moves in and out of the light, and by the luminous, gray-pink modeling of the flesh which Ingres loved so much more than marble. The perfect accord between line and color in works such as this belies Ingres' constant derogation of color as only "the handmaiden" of drawing. Certainly for him drawing was, as he often said, the "probity," or proof, of art, but his clear and distinct colors were right for his purpose. That his purpose did not grant color the independence from drawing which it achieved with the Impressionists, and after his lifetime, is no reason to argue that his kind of color was therefore unnecessary or negligible.

In his portraits, from the hard-pencil drawings he made as a young man in Italy to the later images of eminent men and women of Paris, he revealed his devotion to visual truth by seeing and setting down even the vulgarities of mid-nineteenth-century costume and interior decoration so long as such truths

Mannerist furor and bravura have subsided in silence and sleep. The figure is essentially a relaxed version of the decorative nudes of the Sistine ceiling, exemplifying the shepherd Lycidas about to waken "under the opening eyelids of the morn," a moment Fuseli conceives as softly illuminated by the crescent moon.

This turning inward upon oneself, or toward worlds other than those of immediate sense perception, were two of the paths which the truly Neoclassic artist could not take. Another, leading to the direct study of nature conceived primarily as embodied in the human figure, was followed by the very painter who inherited David's position as the champion of Neoclassicism. Jean-Auguste-Dominique Ingres (1780–1867) had studied with David at the turn of the century; he won the Prix de Rome in 1801 but was prevented by the Napoleonic Wars from leaving France until 1806. He spent eighteen years in Italy, and was there again from 1834 to 1841 as director of the French Academy in Rome. Throughout his long life he never wavered in his dogmatic and reiterated assertion that the arts of Greece and of the High Renaissance, especially Raphael's, were the supreme artistic achievements of the human race, but simultaneously he pursued the close study of nature itself. His theory, indeed, was more logical than its application, for although he maintained that nature must be corrected at every point where it falls short of the Ideal Beauty of which the mind alone has knowledge,

34. J.-A.-D. INGRES. *La Comtesse d'Haussonville*. 1845.
Oil on canvas, 51 7/8 × 36 1/4".
© The Frick Collection, New York

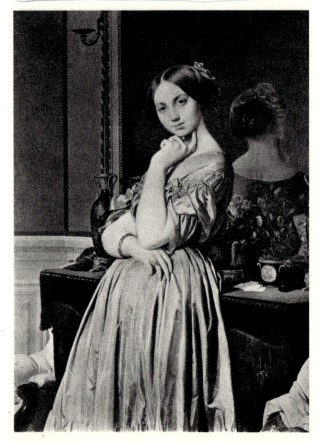

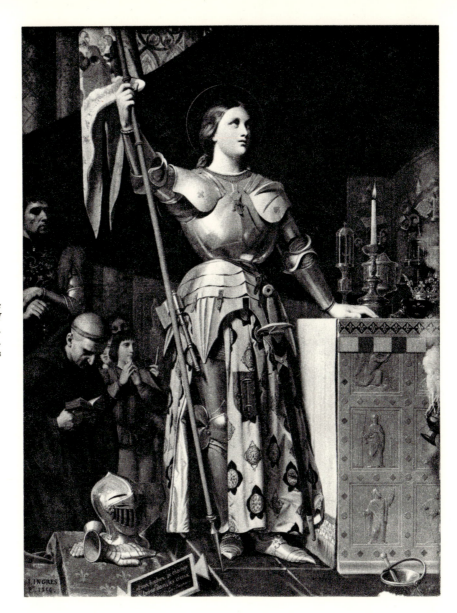

35. J.-A.-D. INGRES. *Joan of Arc
at the Coronation of Charles VII
in the Cathedral of Reims.* 1854.
Oil on canvas, 94 7/8 × 70".
The Louvre, Paris

supported the greater truth of character. The young *Comtesse d'Haussonville* (1845; plate 34) has taken the stance of a Roman muse, a posture easily recognized at that time, but she is preeminently a woman of the modern world. Her hair, her dress, the ornaments on her mantelpiece are as "real" as in a photograph (one suspects that Ingres learned much from daguerreotype, the first truly photographic process, which became known in 1839). But this almost photographic vision is held in control by a strict aesthetic. We do not actually see all that there was to see, else the folds of the dress would have been less perfectly subordinated to the head and arms, and the contour of the foreshortened right arm a less dazzling demonstration of Ingres' ability to project a full, even weighty shape by means of a contour surrounding an almost unmodeled mass.

Ingres' greatest gift was his ability to create a deeply poetic synthesis of Neoclassic forms with the new, modern concern for material truth. His most perceptive but not entirely friendly critic, the poet Charles Baudelaire (1821-1867), understood this when he remarked of the *Comtesse d'Haussonville*, when it appeared at the Salon of 1846, that it was a work of "deeply sensuous rapture." Ingres' failures, and they are not few, usually occur in his historical pictures, such as the *Joan of Arc* (plate 35), where the imaginative demands of a noncontemporary subject could not be satisfied by prolonged observation of what lay before his eyes. His successes, which must be numbered among the last and greatest achievements of Neoclassicism, are probably his many portraits in which he conferred a splendid formal dignity, the dignity he revered in Classic art, upon modern life.

Romanticism and Romantic Art

It has become almost a commonplace of criticism to remark that Romanticism is by definition indefinable, so various are the forms of art, the styles and techniques of expression, which were current throughout the Western world in the first half of the nineteenth century. Indeed, at first glance there might seem to be no single stylistic, technical, or formal reason to group together such visually incongruous objects as that implausible architectural fantasy Fonthill Abbey (plate 37), William Rimmer's *Dying Centaur* (plate 65), which is patently a Classic subject, and John Constable's *Weymouth Bay* (colorplate 9), in which the facts of nature have been set down with the precision of a botanist and meteorologist. Yet each of these polar terms of Romantic art exemplifies an element common to all forms of Romantic expression. This is the belief in the validity of individual, private experience, the belief that the world without us as well as the world within, time present as well as time remembered and time foretold, are known and desirable to the degree that one's self knows and desires them. From this premise we can trace not only the multitudinous and even contradictory aspects of Romantic expression, but also follow the Romantic artist as he explores those specific values of individuality which the Neoclassic artist ignored, the values of intuition, instinct—even the more inaccessible aspects of feeling which reach

and exceed the boundaries of reason. In this process the Romantic artist exchanged the public discourse of Neoclassicism, those symbolic forms which like a common currency enjoyed universal recognition, for speech so private that certain artists seemed to address their soliloquies entirely to themselves.

The philosopher Hegel had described all artistic expression since the end of the Middle Ages as Romantic, but his statement that "in Romantic art the form is determined by the inner idea of the content or substance which this art is called upon to represent,"[1] can be taken in the narrower chronological sense as a description of the art of the early nineteenth century. For Hegel music was to be the fulfillment of Romantic experience. That it did become so supreme a form of Romantic expression, rivaled only by poetry, and that architecture, the dominant Neoclassic art with its many checks on the extravagance and intensity of personal expression, is less important during this period than painting, which easily and instantly responds to changing intensities of feeling, suggests the aptness of Hegel's conception of Romantic form developing according to the necessities of its content. Merely to name the greatest masters of Romanticism is to realize how intensely and profoundly private feeling was revealed in music—by Beethoven, Schumann, and Berlioz—and in poetry by Goethe, Heine,

Pushkin, Byron, and Shelley, sometimes years before a pictorial solution had been discovered by Géricault or Delacroix.

By insisting upon the importance and truth of his own experience, the Romantic artist so often found himself at odds with the social, political, and intellectual conditions of the day, that by 1847 the image of the rebellious artist who chose to live apart from society, preferring hunger and obscurity to submission to bourgeois conventions, had been formulated by Henri Mürger, from whose novel, *Scènes de la vie de bohème*, comes the word *Bohemian* to characterize the typical artist's life. Although this Bohemia was rarely chosen voluntarily as exile or refuge by the artist himself, nonetheless in his disgust with contemporary materialism—in his desire to escape from his surroundings in space to faraway lands, or in time to the past—he often had to journey alone, for only so could he find himself, affirm his individuality, and release his creative powers. The conception of the artist as a lonely, misunderstood genius, fortified by the tragic examples of Leonardo, Michelangelo, Dante, and Ariosto (episodes from whose lives were painted by both Ingres and Delacroix), fostered the conception of the artist as a superior individual whose powers were godlike and thus immune to critical authority. But unfortunately cause and effect became compounded. By arrogating to himself an authority which society denied him, the artist further alienated the very sources of support which might have helped him. In return for freedom of self-expression society granted him the right to starve.

The artist's conception of himself as a hero battling the forces of social indifference and obscurantism led also to the exaltation of the heroic act and emotion. The eighteenth century had cut its great men down to size (Washington in his best black velvet suit is as much man as statesman), but the Romantic artist chose the subject, the moment, the protagonist who most heroically stood apart from and above the everyday world. He depicted imaginary heroes like Byron's Manfred, who served as subject for Schumann's and Tchaikovsky's music, or living men who appeared to their contemporaries as almost more than human—Napoleon, whose immortality was only momentarily dimmed by Waterloo (plate 52), or Lafayette, one of the last surviving authors of American independence (plate 59).

Another rejection of the immediate circumstances of modern life is seen in the Romantic cult of nature. Leaving the city and the society of his fellows, the artist discovered in nature scenes and circumstances which reflected, reinforced, or confirmed his own feelings. "To him," the American poet William Cullen Bryant wrote, "who in the love of Nature holds communion with her visible powers, she speaks a various language."[2] Pathetic as this fallacy may be, it constitutes one of the earliest and most continuous aspects of Romantic art, from Rousseau's delight in the gardens at Ermenonville to Beethoven's *Pastoral Symphony*, from Wordsworth's poetry and Constable's close study of natural phenomena to the landscape painting of the American wilderness (plate 60). By 1840, toward the end of the High Romantic period, when gods and heroes no longer mattered so much, it was also the means whereby Romanticism became transformed into Realism, into the study of nature for itself rather than for the human affections it had been supposed to embody.

The historical origins of Romanticism, like those of Neoclassicism in its most romantically classic aspects, can conveniently be traced to the eighteenth-century attitude toward landscape, seen first in the gardens and parks of the great English country houses (whence the name *jardin anglais* for similar gardens abroad), where the formal patterns of seventeenth-century landscape design were replaced by carefully casual groupings of trees and paths arranged to disclose unexpected and more "natural" views. In such a picturesque environment (the eighteenth-century adjective indicates how carefully the new landscape effects were based on painting, especially on the landscapes of Claude and Salvator Rosa), the artificial medieval ruin was as common as the Classic temple, the principal difference being that the temple became the paradigm for a universal and international public architecture. The revival of medieval architecture developed more hesitantly, passing first through the hands of private persons who could gratify their tastes for the picturesque and the remote. The first extensive use of Gothic for a modern residence was Horace Walpole's remodeling of a small villa, Strawberry Hill, at Twickenham near London (plate 36). Over the years between 1749 and his death in 1797, Walpole added rooms and redecorated the interiors in a highly sophisticated but dubious manner—sophisticated because Walpole sincerely admired and studied the English medieval past, and dubious because the uses to which he put his enthusiasm and learning were less architectural than they were sentimental and literary. In adapting tombs at Canterbury and Westminster Abbey for fireplaces, he not only ignored the relation between medieval forms and their functions but also provided sanctions for much hit-or-miss application of the past to the present later on. His interest in decorative effects was so ar-

36. PAUL SANDBY. *Strawberry Hill from the Southeast.* c. 1774. Drawing with watercolor, 11 3/4 × 17 1/2". Lewis Walpole Library Collection, Farmington, Conn.

removing the choir screen and tidying up the tombs, could never quite rise to the imaginative grandeur that Beckford envisaged, but his preliminary study (plate 37) shows that he could create a picturesque arrangement of subsidiary elements at the base of the colossal tower. The spire was never constructed, although the tower eventually rose to a height of 276 feet, but the choice of so ecclesiastical a motif for a country residence is indicative of the associational rather than functional intentions of Gothick design. It was primarily intended to provoke in the spectator sensations of sublimity and awe, even of melancholy and alarm, all of which must have been felt to the full in the extraordinarily lofty and drafty central octagon, 120 feet high, at the base of the tower from which the halls and galleries extended.

At Fonthill, as at Strawberry Hill, which Beckford considered a mere "Gothic mousetrap," there was a disturbing discrepancy between intention and execution. The tower of Fonthill, built of wood and plaster at stupendous trouble and expense between 1796 and 1800, fell twice during its construction and finally collapsed on a winter's night in 1825. The most correctly medieval stone forms will look wrong if executed in paint and plaster, but the large areas of plain wall and the concentration of decorative detail along the edges proved that the architects of these first structures were still feeling, even if they were not thinking, within the Neoclassic aesthetic of geometrical design. This may be seen by comparing Neoclassic and Neo-Gothic designs for the same buildings by the same architects. In Benjamin Latrobe's for the Roman Catholic Cathedral in Baltimore (1805), the Classic

chaeologically superficial that it encourages our use of the eighteenth-century spelling "Gothick" to signify this first phase of the medieval revival in which ornament meant more than structure.

Another man of letters, William Beckford (1760–1844), created the largest of the Gothick mansions. Fonthill Abbey, high on a hill in Wiltshire, was begun as an artificial ruin to which its owner might repair from his father's old-fashioned Palladian house in the valley below. Its architect, James Wyatt (1746–1813), who had recently "restored" Salisbury Cathedral,

version, which was accepted, is more three-dimensional, more robust, than the flatter and plainer medieval one.

The existence of alternative choices between two such apparently antagonistic styles is a symptom of increasing Eclecticism. Ithiel Town, author of the Doric statehouse in New Haven, had erected only a little more than a decade earlier a typically late Baroque meetinghouse for the Congregationalists and a Gothick church, one of the first in the United States, for the Episcopalians—all within a few yards of each other. His younger partner Alexander Jackson Davis was just as adept, turning from Greek statehouse and columned mansions to a medieval residence such as the Harral-Wheeler House in Bridgeport, Connecticut, which survived until 1958 with its original interior furnishings, including a Gothick bedroom, intact (plate 38). These first neomedieval structures are perhaps of little architectural or artistic importance, but as attempts to translate literary sensations into three-dimensional terms they comprise the most distinctive architectural aspect of early Romanticism. The meaning of such a structure as the Harral-Wheeler House for its first inhabitants must have been as much associational as formal, leading them to think themselves participants in a romantic tale by E. T. A. Hoffmann or Edgar Allan Poe.

The shift of interest from antiquity to the Middle Ages was part of the increasing historical sophistication of the wider public, whose knowledge of medieval art and life was enriched by the growing vogue for historical romances. After Walpole's *Castle of Otranto* and the melodramatic tales of Mrs. Radcliffe came the more accurate and more sensitively imaginative historical reconstructions of Sir Walter Scott, whose *Waverly* (1814) gave its name to the famous series which included *Ivanhoe*, *Quentin Durward*, and *The Talisman*.

After 1830 two developments occurred which quite altered the character of neomedieval design. The liturgical movement within the Church of England, which was directed toward recovering pre-Reformation and originally Catholic forms of worship (hence the term *Anglo-Catholic*), led to a careful study of medieval monuments in order that new churches might be ritually correct. The architectural theories of this Oxford Movement (so called because its first leaders were members of that university) were expressed in a series of publications by the Camden Society in its journal, *The Ecclesiologist* (1841–1868). The appeal for more serious, even devout, attention to the architectural truths of medieval buildings was supported from another quarter by a passionate demand

38. ALEXANDER JACKSON DAVIS. Harral-Wheeler House, Bridgeport, Connecticut. 1846. Demolished 1958

for a new architecture which would provide moral as well as liturgical solutions to the problems of contemporary society. This point of view was expressed by the architect and fervent Catholic convert A.W.N. Pugin (1812–1852). In his *Contrasts, or a Parallel Between the Architecture of the 15th and 19th Centuries* (1836), he indicted the architects of the Classical Revival for their failure to create buildings either functional or symbolically expressive of modern life. In "parallel" drawings he contrasted the blank and empty forms of Neo-Roman and Neo-Greek buildings with the amplitude and diversity of medieval structures, but he stacked the cards rather unfairly when he compared a modern "Grecian" workhouse with a medieval almshouse. Pugin believed that because Gothic architecture had been the creation of an age of faith it was the only proper architecture for a Christian society, and that its revival would recover for the modern age the social virtues which had been extinguished by the Industrial Revolution. He abhorred the obviously false and papery Gothick and believed that the structural principles of the Middle Ages should be revived and directly expressed in the form of each building.

Pugin was associated in the execution of the largest and most prominent, as well as the most successful, example of the Gothic Revival in Britain, the Houses of Parliament (1840–1865; plate 39), designed by Sir Charles Barry (1795–1860) after the old Palace of Westminster burned in 1834. The choice of Gothic for the nation's most important governmental building suggests that the earlier literary and religious connotations of the style had taken a more nationalistic

37. JAMES WYATT. *Fonthill Abbey from the Northwest*. 1798. Original watercolor study, 26 1/4 × 41 1/4″.
Collection Paul Mellon, Upperville, Va.

49

39. SIR CHARLES BARRY and A.W. N. PUGIN. Houses of Parliament, London. 1840–65

turn. Gothic, which then meant the late, enriched, fourteenth- and fifteenth-century phase of English architecture (now usually known as Perpendicular), was preferred because it seemed to be the native English style best capable of projecting into the present the virtues of the national past (Britain's Roman past, of course, had scarcely been "English"). Barry's preference for symmetry accounts for the plan of the building, arranged along axes extending from a central octagon somewhat in the manner of Fonthill, and for the precise phalanx of the river front with its double towers at either end. This dry and really quite un-Gothic equilibrium is happily disturbed by the towers which interrupt the horizontal skyline, among them the handsome Victoria Tower to the west and its counterpart, the clock tower (probably by Pugin) with its more original profile to the east. Upon Barry's façades and interiors Pugin lavished a wealth of Gothic detail in wood and stone which is astonishingly fresh and inventive, given the size of the building and the vast number of rooms it contains.

Through the regularity of their design, the Houses of Parliament stand midway between the earlier Classicistic Gothick and the later, more elaborate Gothic of the High Victorian phase of the middle of the century. Excellent examples of the latter are the Law Courts in London by George Edmund Street (1824–1881), designed in 1866 but not completed until 1882, and the Town Hall in Manchester by Alfred Waterhouse (1830–1905), designed in 1869. The most sumptuous example of the High Victorian urban church is All Saints', Margaret Street, London (1849–1859), by William Butterfield (1814–1900). Every surface of the interior is enriched with colored brick, stone, marble, mosaic, or painting, and a wealth of ecclesiastical furniture, all newly designed in the medieval taste, fills the chancel. The visual effect creates an unequaled impression of nineteenth-century material luxury (plate 40).

Pugin's moral ardor was reinforced by the writings of John Ruskin (1819–1900), whose interpretation of the "moral and imaginative aspects" of Gothic

architecture was less pragmatic than Pugin's but, couched as it was in splendid and persuasive prose, had far greater influence. In *The Seven Lamps of Architecture* (1849) Ruskin analyzed the "lamps," or spiritual principles, which he believed essential to "this magnificently human art of architecture." The very names of the principles—Sacrifice, Truth, Power, Beauty, Life, Memory, and Obedience—indicate the evangelical character of his argument. Soon afterwards, his prolonged study of actual examples of Italian medieval architecture and his reflections on the conditions of their production, especially of the carved ornament which interested him most, led him, in *The Stones of Venice* (1851–1853), to declare that the superiority of medieval craftsmanship was a result of the more humane and individualistic conditions of

medieval economy. Ruskin's contention that contemporary methods of mass production were intellectually and spiritually degrading could not be questioned, but his insistence that industrial design could be reformed by returning to the medieval guild system was illogical and anti-historical. Nevertheless, his belief in the superiority of medieval art and his liberal proposals for social reform were adopted and developed by his disciples, chiefly by William Morris (1834–1896), an equally devoted medievalist and a fine poet in his own right. Morris put Ruskin's ideas into practice, founding workshops for the production of furniture, tapestry, textiles, wallpapers, and hand-printed books after his personal but still medievalizing designs. His example encouraged the development of the Arts and Crafts Exhibition Society, which

40. WILLIAM BUTTERFIELD. Interior of All Saints', Margaret Street, London. 1849–59

from 1888 promoted public interest in hand-made objects and provided wholesome and usually handsome antidotes to the degraded commercial productions of the day. But the ideas of Ruskin and Morris were not destined to effect a truly modern decorative style. Their social theories could neither reverse nor deflect the development of modern technology and methods of industrial production. Their medievalism was too retrospective, too tied to English literary aestheticism, to become more than an element, and far from a determining one at that, in the Art Nouveau of the 1890s, the first of the truly modern styles to break with the past. But their work persuaded a large public that Gothic art was, *ipso facto*, of a higher ethical order than other styles and that its use would lead to a more moral life. This point of view was the justification for the widespread use of Gothic in collegiate institutions in the early twentieth century. The Harkness Memorial Quadrangle at Yale University (now Branford and Saybrook Colleges), by James Gamble Rogers (1867–1947), the most studied, the most expensive, and most archaeologically imitative of all these efforts, was constructed as late as 1917–1921 (plate 41).

The Gothic Revival was primarily an English phenomenon, extending to America with such architects as Richard Upjohn (1802–1878), whose

41. James Gamble Rogers. Harkness Memorial Quadrangle, Yale University, New Haven, Connecticut. 1917–21

Trinity Church at the head of Wall Street in New York (1839–1846) is one of the best of the earlier examples, although Pugin would have disapproved of its plaster vaults. The Connecticut capitol in Hartford, begun in 1873 by his son Richard M. Upjohn (1828–1903), is the only mid-century statehouse in the developed neomedieval style, but as a translation of the conventions of a domed building into Gothic, it is heavy and gauche. In Washington the Gothic erupted in the midst of the Mall when the Smithsonian Institution (colorplate 5) was begun in 1848 by James Renwick, Jr. (1818–1895). A few years later Renwick showed in his St. Patrick's Cathedral in New York (1859–1879) that he could rework thirteenth-century French Gothic with scholarly correctness but without much life. In the Smithsonian he was closer to the foolish but picturesque Gothic of the early revival. In Canada, the government buildings at Ottawa by Fuller & Jones and Stent & Laver (1861–1867), dramatically placed high above the river, have a peculiar character, their High Gothic design having been executed in an exceptionally dour granite (plate 42). The polygonal library toward the river and the entrance tower were vigorous creations, but the tower unfortunately was rebuilt in a taller and less rugged form after a fire.

On the Continent, isolated and interesting examples of a revived Gothic were constructed during the century, but there was not such general enthusiasm for the style. The Rathaus (Town Hall) in Vienna (1872–1883) and the Rijksmuseum (State Museum) in Amsterdam (1877–1885), like the Houses of Parliament in London, indicate a desire to reinforce the present through recollections of the national past. Similarly, the Votive Church in Vienna (1856–1879) and Ste-Clothilde in Paris (1846–1857), like Renwick's St. Patrick's, prove that by the middle of the century the progress of archaeological studies enabled architects to handle medieval forms correctly but, on the whole, uncreatively. Fortunately, at just this time the early work of an American architect, Henry Hobson Richardson (see below, pp. 161–62), was to demonstrate that in the hands of a powerful and original designer the study of medieval architecture could lead to a more truly modern art.

The pervasive Romantic theme which recurs in the Gothic Revival is the flight from the present to an ideal past, whether for literary, spiritual, historical, or moral reasons. In addition to the difficulties caused by the attempt to adjust Gothic forms to modern functions, there is in much Romantic painting a continuous and occasionally dominant realism—the direct appraisal of modern life in its appearance, its

THOMAS FULLER, CHILION JONES, and others. Parliament House, Ottawa. 1861–67

actions, and its significance. Indeed, this realistic element is what appears most strongly in the work of the first and one of the greatest of all Romantic painters, Francisco José de Goya y Lucientes (1746–1828). Like his exact contemporary, David, he had early learned the graces and coquetry of the Rococo, the stylistic point of departure for his first considerable undertaking, the gay tapestry cartoons of contemporary Spanish life executed in Madrid between 1776 and 1791. But he also knew the great Baroque masters of Europe and Spain—Rubens, Titian, and Rembrandt, whose paintings he would have seen in the royal collections, and Velázquez, from whom he learned how to handle light. These painters were great portraitists, and it was as a portraitist that Goya found royal favor, becoming first court painter in 1799. His court portraits, especially the group of Charles IV and his family (1800; Madrid, Prado), are universally accepted as astonishingly analytical statements of special human situations. But since his portraits were accepted without question by his sitters, it would be too easy to assume that Goya was caricaturing his royal patrons. The works themselves should convince us that he was first of all a realist who set down what he saw, and what he saw were these singularly inept or unattractive persons who let the destiny of Spain slip through their fingers. There is every reason to believe that the queen was quite as unlovely as she looks, as toothless and cynical, yet as keen-sighted and undeniably regal (plate 43). Her physical appearance must have been as accurately presented as were her costume and the magnificent

43. FRANCISCO GOYA. *Queen Maria Luisa of Spain.* 1800. Oil on canvas, 32 7/8 × 26 3/8″. The Taft Museum, Cincinnati, Ohio

diamonds and emeralds, which Goya painted not as substances but as reflections of light, the truly visual truth of all appearances.

In this way Goya continued the realist tradition of Baroque art. We may also think of him as a product of the Enlightenment which had filtered into Spain under "the best of Bourbons," Charles III (reigned 1759–1788), and until 1805 or so his work properly belongs to the history of eighteenth-century art. But Goya was also aware that appearances are not the whole truth and that reality is not what it seems or is seen to be. After a severe and mysterious illness in 1792 which left him totally deaf, cut off from the theater and music he loved, strange elements began to appear in his work. His portraits became more introspective as he grew more interested in character than in costume. His sitters seem less at ease than they would like to be; a nervous glance or the twist of a hand hints of a half-hidden apprehension. The flattened silhouette of a great lady suggests that Goya saw her as a manikin, moved by strings she could not herself control.

In his deafness and isolation from society Goya turned more and more to drawing, and from his drawings made the famous series of prints in which he traced the strings that control us to their sources in the all-too-human maladies of pride, superstition, ignorance, cruelty, and fear—fear of others and of ourselves. His first set of eighty prints, a combination of etching and the newly developed technique of aquatint which enabled the artist to preserve the tonal effect of wash drawing, was published as *Los caprichos* (*The Caprices*) in 1799. In them, criticism of social and political customs, including allusions to the morals of the court, alternated with visualizations of the follies produced by superstition and fear.

In 1808 Napoleon placed his brother Joseph on the throne from which he had forced Ferdinand, Charles IV's son, and in 1809 the British under Wellington invaded the Iberian Peninsula and the country knew the horrors of foreign occupation and civil war. Goya's large paintings of two episodes early in the conflict, *The Second of May* portraying the uprising of the civilian populace at the Puerta del Sol in Madrid on May 2, 1808, and *The Third of May* (plate 45) showing the execution of the ringleaders on the outskirts of Madrid before dawn the following day (both painted in 1814 and now in the Prado), witness his concern for the fate of his fellow Spaniards. They are also magnificent examples of his powers of composition, the first being a recapitulation of the age-old theme of mounted horsemen in conflict, in descent from Leonardo's *Battle of Anghiari*, the second a more direct description of the execution of civilians by a French firing squad by lamplight.

The horrors of the occupation, in which the French mercilessly slaughtered even the civilians they thought guilty of guerilla warfare, were commemorated by Goya in eighty-five etchings, *Los desastres de la guerra* (*The Disasters of War*), of which eighty were published posthumously in 1863. Even today one cannot examine these plates without disgust, so truthfully has Goya stated the bare facts of sudden death, rape, plunder, and mutilation. Under one plate he wrote, "I saw this," and under another, "One can't bear to see such things" (plate 44). But just as often he rose above the documentary evidence of the local tragedy to summarize in the image of one man's fate his brief against man's inhumanity to all men. The power of these small prints, which resides in their economy of line and wash, in the dramatic contrast of light and dark, and in the concentration on episodes of individual suffering and conflict, was among Goya's lasting legacies to modern art. Even those who cared as little for his humanitarian protest as Manet and Toulouse-Lautrec were susceptible to his creative energy, especially as they saw it in the purer formal relations and the dazzling play of light and shade in his prints

44. FRANCISCO GOYA. *"One can't bear to see such things."* c. 1814. Etching, aquatint, and drypoint, 5 3/4 × 8 1/4″. From the series *The Disasters of War*. The Hispanic Society of America, New York

45. FRANCISCO GOYA. *The Third of May, 1808.* 1814. Oil on canvas, 8′ 8 3/4″ × 11′ 3 7/8″. The Prado, Madrid

46. FRANCISCO GOYA. *"A Picador Is Unhorsed and Falls under the Bull."* 1816. Etching, aquatint, and drypoint, 9 5/8 × 13 7/8″. From the series *La Tauromachia*, plate 26. The Hispanic Society of America, New York

dealing with episodes from the bull ring (plate 46).

In the intensity of his protest Goya was most truly Romantic, for his passion exceeded the limits of eighteenth-century propriety, and the individual human being was always central to his images and his concerns. Nor are his demons and hobgoblins merely the startling specters that might have trod the battlements of Fonthill Abbey or peopled the stories of Hoffmann and Poe, only to wither with the coming of the light. Goya's ghostly creatures are realities of the imagination, even of our own; thus his demonism is not only Romantic but modern. Fuseli and Blake were also painting nightmares and visions, but from such hallucinations one might recover in one's waking moments. Goya's dreamworld is both psychological and critical. He seems to say that this is the way we are and that we must heal ourselves before we can heal others.

His last series of prints, the eighteen *Disparates* (*Strange or Uncanny Things*) which were innocuously entitled *Proverbs* when they were first published in 1864, were more extravagant, mysterious, and in a sense more incommunicably personal than the *Caprichos*. Many were imbued with that feeling of mass emotion which also occurs in the enigmatic "black paintings" with which he decorated the Quinta del Sordo (House of the Deaf Man), where he lived after the restoration of Ferdinand VII in 1814 (plate 47). He was by then in his seventies and more alone than ever. Renouncing the brilliant colors of his eighteenth-century beginnings, which had reached a dazzling climax in his light-struck frescoes for the Church of San Antonio de la Florida in Madrid (1798), he worked with the darkest tones, reaching toward

black, only fitfully illuminated with sparks of smoldering color. These fantasies, in which demonic, almost inhuman, creatures set out on unimaginable and meaningless journeys, are his link with the tormented painting of our times—with Ensor, Munch, Nolde, and the Surrealists.

In France, the elements of a Romantic and quite anti-Classic attitude toward human suffering entered Neoclassic painting as subsidiary episodes in the battle pictures of Baron Antoine-Jean Gros (1771–1835). In *Napoleon Visiting the Plague Hospital at Jaffa* (1804; colorplate 6), perhaps the finest of a series of large military subjects extolling Napoleon's consular and imperial exploits, Gros portrayed the specific conditions of the campaign in the Near East—heat, pestilence, fear, and pain—with extraordinary imaginative truth, the more so in that his drawing was as impeccably linear as David's, his colors were as abstractly bright, and that his tormented nude soldiers in the darkened foreground were given Michelangelesque postures of despair. For such excesses Gros was castigated by the conservative faction and enthusiastically hailed by younger painters as one come to deliver them from Classic rigor. When David went into exile he pronounced him his heir, but Gros could find no satisfactory compromise between David's Classic formulas and his own interest in contemporary truth. When his later works were ridiculed by young and old alike, he drowned himself in the Seine, one of Romanticism's first victims to the incompatibility of public and private taste.

After Waterloo, when hope of participating in the exciting events of living history vanished under the rule of the restored Bourbons, heroic action became possible only in the imagination, a situation which encouraged the development of Romantic painting. The sense of frustration on the part of a generation which had so narrowly missed its chance can be felt in the work of Théodore Géricault (1791–1824). His earliest important painting, the *Officer of the Chasseurs Charging* (1812; Louvre), is a Baroque and bravura equestrian figure; but in the *Wounded Cuirassier* (1814; Louvre), with the soldier and his horse obliged to leave the battlefield, there is the odor of defeat. The theme of disaster, engendering extremes of physical and emotional despair until at the last moment a faint hope of salvation provokes hysterical joy, is the subject of Géricault's *Raft of the "Medusa"* (plate 48), the huge painting which established his reputation at the Salon of 1819. The episode was based on a recent calamity, the rescue of the survivors of the brig "Medusa," which had foundered in a storm while transporting colonists to Africa. The choice of such

47. FRANCISCO GOYA. *The Pilgrimage to the Miraculous Spring of San Isidro* (detail). c. 1820–22. Fresco transferred to canvas, 17 3/8 × 37″. The Prado, Madrid

a subject could have been read as a criticism of the government of Louis XVIII, because it was known that the boat had been in poor condition and shamefully overloaded. Géricault spared no pains to make his depiction as actual, even as realistic, as possible; but his realism supported a mighty Baroque composition based upon the intersection of two pyramidal masses developing upward through the mast at the left and through the figures straining toward the Negro youth standing on the cask at the right. The somber color scheme, related to dark reds and greens, emphasizes the Caravaggesque contrasts of light and dark. Within this essentially traditional design are nude figures, Neoclassic in the perfection of their drawing, as, for example, the dead youth held by his father. Beyond the dead and dying, others try to attract the attention of the ship which appears far down on the horizon and which may be their only hope of rescue.

Their frenzy introduces the crowning Romantic aspect of this composite painting; their emotions transport us from the weary commonplaceness of the present to a moment, once near in time but distant in space, in which the integration of action and feeling was crucial.

The *Raft of the "Medusa"* was Géricault's most successful synthesis of the artistic stresses which he experienced in his own lifetime. On the one hand, he was aware—as who could not be who lived during the lifetime of David—that great art depended upon a knowledge of the great masters. He made the journey to Italy, and in some of his compositions, especially his studies of Classical horse tamers, there are reminiscences of antique sculpture and of Michelangelo. But he was also aware of modern times and excelled all others of his generation in the description of the immediately perceptible. His watercolors and litho-

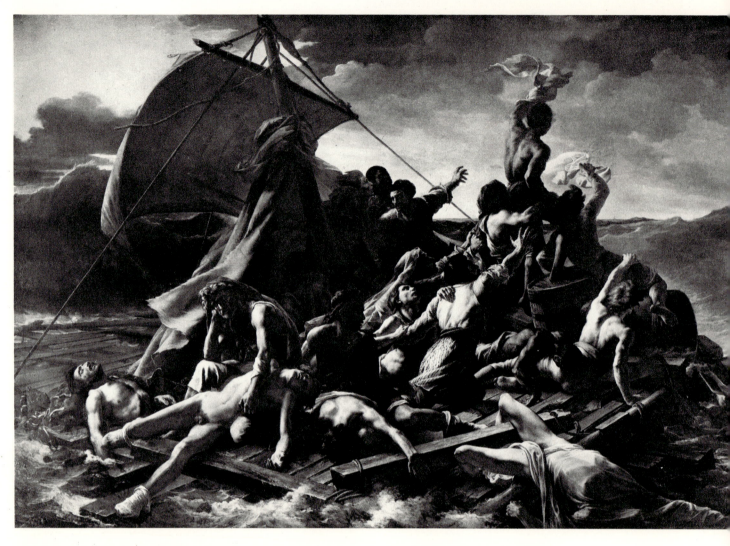

48. THÉODORE GÉRICAULT. *The Raft of the "Medusa."* 1819. Oil on canvas, 16′ 1″ × 22′ 11 1/4″. The Louvre, Paris

graphs depicting the plight of the lower classes in London, made during a trip to England in 1820, are more directly observant, more documentary, so to speak, than anything since Hogarth, and his painting of a horse race at Epsom Downs (1821; Louvre) is remarkable for his observation of the English climate. Yet Géricault is remembered neither for his Classicism nor for his realism, but for the supremely Romantic qualities of the military pictures and of the "*Medusa,*" and for a series of portraits of the criminally insane (plate 49). These were painted to illustrate the theories of a medical friend, Dr. Georget, one of the first physicians to undertake a clinical study of the mentally deranged. Georget's treatise is among the most important incunabula of psychoanalytical

literature; Géricault's paintings are among the earliest objective pictorial statements of the physical effects of psychic distress.

After Géricault's untimely death in 1824, his place as leader of the younger generation was taken by Eugène Delacroix (1798–1863), the greatest of all French Romantic figure painters. He had attracted attention from the first at the Salon of 1822 with his *Dante and Vergil in Hell* and in 1824 with *Scenes from the Massacres at Chios* (both in the Louvre). The subjects of these pictures, taken from Dante's medieval epic and from contemporary accounts of Turkish atrocities during the Greek War of Independence, were typically Romantic in their emphasis on mental and physical suffering. Pain, humiliation, and violent death were

49. THÉODORE GÉRICAULT. *Insane Kidnapper*. 1822–23. Oil on canvas, 25 1/2 × 21 1/4". The Springfield Museum of Fine Arts, Springfield, Mass. The James Philip Gray Collection

50. EUGÈNE DELACROIX. *The Fanatics of Tangier*. 1857. Oil on canvas, 18 1/8 × 22". The Art Gallery of Ontario, Toronto

recurrent elements in Delacroix' iconography, as indeed they were in much Romantic literature.

Because for Delacroix the feelings which demanded pictorial expression were usually provoked by his reading, his art is in the literal sense literary. Few of his major paintings have no source in poetry or prose, and his most typical works are his interpretations of Dante and Shakespeare, and of the great Romantic writers—Goethe, Scott, and Byron. For this reason much of his art is not accessible in an age when such literature is little read. The holocaust depicted in *The Death of Sardanapalus* (1827; colorplate 7), the climactic example of his literary enthusiasms, remains inexplicable unless we know that at the conclusion of Byron's verse tragedy the Assyrian king summoned his slaves and concubines and ordered his treasures heaped around his bed in order that everything he prized might perish by fire rather than fall to the invaders already at the palace gates. If we know at least that much then we can understand how Byron's poetry could stimulate Delacroix' pictorial imagination.

For all its brilliant frenzy, however, the *Sardanapalus* is not Delacroix' most successful composition, the figure of the king being curiously diminished and the relation of the foreground figures to the space

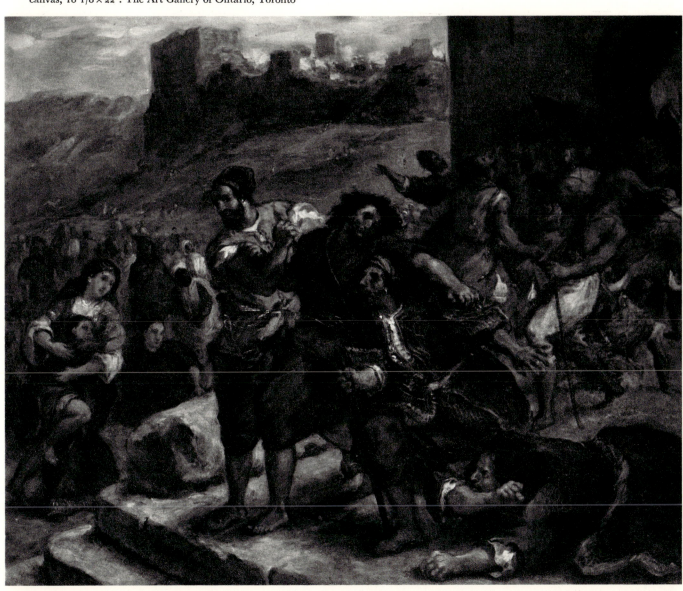

51. EUGÈNE DELACROIX. *A Mounted Arab Attacking a Panther.*
c. 1840. Graphite pencil on white paper, 9 1/2 × 8″.
Fogg Art Museum, Harvard University, Cambridge,
Mass. Bequest of Meta and Paul J. Sachs

year provided ineradicable memories of a primitive way of life which was, he felt, visually and spiritually closer to antiquity than to the present. But the "oriental" subjects he painted thereafter were often as violent and sensuous as those he discovered in his reading: the clash of hunters and wild beasts in the hostile African landscape, the frenzy of religious fanatics at Tangier (plate 50), the animal voluptuousness of women imprisoned in a harem, the magnificent panoply of the Sultan of Morocco on parade.

In the pursuit of his expressive purposes Delacroix discovered new potentials in artistic means. To his contemporaries he seemed a clumsy draftsman, but no one else could communicate so much through line alone. Drawing for him was not merely the description of a contour but a means of expressing physical and emotional energy revealed in swift continuous movement (plate 51). No one, he told Baudelaire, could be considered a draftsman until he could draw a man falling from a third-story window before he reached the ground. Similarly, he did not settle for the descriptive or connotative properties of color, as did Ingres. Knowing that colors have lives of their own, he used them to reveal the lives of objects. The color schemes of his paintings, like his lines, express the passion quite as much as the subjects.

Of Romantic sculpture there is less to be said, perhaps because the sculptural processes inhibit the unexpected intuition, the particular caress of the brush or modulation of a line with which the Romantic painter could, in Lord Byron's words, endow with form his fancy.[3] Nevertheless, the figural tradition which was so notable a characteristic of French Romantic painting is dominant in the work of one exceptional sculptor, François Rude (1784–1855). He was a native of Dijon, where an almost complete collection of his plasters and early casts permits a better understanding of his art than can be gained elsewhere. His relief on the right pier of the Arc de Triomphe, *The Departure of the Volunteers in 1792* (1835–1836), also known as *La Marseillaise*, is rightly recognized as a stirring formulation of patriotic emotion. The stiff relief of *The Apotheosis of Napoleon* by Jean-Pierre Cortot (1787–1843) on the opposite pier throws into the strongest contrast Rude's abilities to infuse nude warriors, who otherwise might have stepped from David's *Leonidas*, with Romantic energy. More Romantic still, as an evocation of past glories, is his *Napoléon Awakening to Immortality* (1845–1847; plate 52), commissioned by an admirer of the Emperor for his garden. This eerie representation of Napoleon rising from his coffin, like the more macabre examples of seventeenth-century tomb sculpture, re-

behind unclear; but it surpasses all his other works in the furious Baroque movement which permeates each inch of the vast canvas. Like Géricault, Delacroix looked for formal inspiration to the masters of the seventeenth century, especially to Rubens, rather than to the painters of the High Renaissance, and although his handling of Baroque design was on the whole traditional, it was an important factor in the revival of Baroque forms throughout the nineteenth century.

The *Sardanapalus* was little liked at the time and its author, whose previous contributions to the Salon had been purchased by the state, was threatened with loss of government support, upon which, before the days of dealers and museums of contemporary art, most artists depended for their living. That he refused to change his style is typical of the Romantic artist's belief that his responsibility was not to others but to his art.

In 1832 Delacroix was invited to accompany a diplomatic mission to the Sultan of Morocco. The weeks he spent in North Africa in the spring of that

60

Colorplate 5. James Renwick, Jr. Smithsonian Institution, Washington, D.C. 1848–49

Colorplate 6. ANTOINE-JEAN GROS. *Napoleon Visiting the Plague Hospital at Jaffa*. 1804. Oil on canvas (reduced variant of the original in the Louvre), 46 3/4 × 64 1/2″. Museum of Fine Arts, Boston

Colorplate 7. EUGÈNE DELACROIX. *The Death of Sardanapalus*. 1827. Oil on canvas, 12′ 11 1/2″ × 16′ 3″. The Louvre, Paris

Colorplate 8. JOSEPH MALLORD WILLIAM TURNER. *Keelmen Heaving in Coals by Moonlight*. 1835. Oil on canvas, 36 1
48 1/4″. National Gallery of Art, Washington, D.C. The Widener Collection

minds us that after his death Napoleon, who had cast himself in the supremely Neoclassic role of the new Caesar, became a symbol for the political and intellectual aspirations of those who were dissatisfied with the *status quo*.

The animal sculptor Antoine-Louis Barye (1796–1875) was a friend of Delacroix' and encouraged the painter in his studies of animals in the Jardin des Plantes (the Paris zoo). The small size of Barye's works and the recent decline of interest in his subjects have obscured his abilities. A profound student of anatomy, he modeled his animals with incomparable realism, but he was not a realist sculptor. Like Delacroix he was obsessed by images of passionate action,

and his most typical works are those in which ferocious beasts (including unusual and exotic animals) are locked in deadly combat. His few figural works were often of Classic inspiration, such as a small *Theseus and the Minotaur* (1849–1852) in which he anticipated the later interest in archaic Greek sculpture. Unique among his works, and a most curious yet symptomatic example of Romantic taste, was an immense bronze *surtout de table* modeled in 1834 for the Duc d'Orléans, the eldest son of Louis-Philippe and a patron of Ingres' and Delacroix' as well. Around the central element which represented an elephant hunt were four smaller groups of huntsmen and wild animals.[4] The bull hunt with its horsemen in armor is

typical of the "troubadour" style, the term used in France to describe the more sentimental and domestic aspects of medievalism (plate 53). But the fine modeling of the animals and the broken silhouettes, resembling Delacroix' interruptions and changes of direction, prove Barye's ability to endow even table ornaments with Romantic enthusiasm.

Through the first half of the nineteenth century the French remained masters of figural painting. Elsewhere, however, painters of landscape revealed profoundly meaningful aspects of Romantic experience through the contemplation and interpretation of natural phenomena. The degree to which a more direct and intimate view of landscape could disclose new qualities of nature considered the source and explanation of much human experience can be seen in the work of the German artist Caspar David Friedrich (1774–1840). His small landscapes embodied perceptions which the contemplation of nature can produce in the human soul. In many of his paintings two or three figures, or sometimes only a solitary wanderer, are seen looking at the sunset, at the moon rising through mist, or perhaps lost in thought upon some eminence in mountainous country. Often one of the figures is seen from the back, a posture which heightens the spectator's identification of himself with these beings transfixed by the solemnity of the natural occasion. The mood projected by such works can be called transcendental in the sense that the least manifestations of nature are considered aspects of the Great Being that pervades the whole. This point of view, which for Friedrich had melancholy overtones of the transience of human life in the presence of nature's endurance, pervades his one actually religious painting, the *Tetschen Altar* (*The Cross in the Mountains*) (1807; plate 54), in which an attenuated cross thrusts

high above pine woods into an opalescent evening sky. The unexpected point of view, with the Christ turned toward the unseen distance, reinforces the spectator's feeling that nature is the revelation of God's continual presence. Such landscapes were Friedrich's most original contribution to German painting. In other scenes he played with more familiar Romantic phenomena—a monk's funeral in a ruined abbey, or a chieftain's grave under falling snow—but always he enclosed his landscapes in infinite silence.

In Dresden, where he lived for more than forty years, Friedrich was the center of a group of kindred spirits which included the poet Ludwig Tieck, generally regarded as Goethe's successor, and a number of artists of more modest talents who continued something of his manner in landscapes and genre scenes. Their sensitive treatment of interiors is the counterpart of the contemporary Biedermeier style of decoration, notable for its small-scale proportions and sensitive colors. One of this group, the physician and amateur painter Carl Gustave Carus (1789–1869), is remembered less for his paintings than for his analysis of the Romantic concept of nature in his treatise of 1831, *Neun Briefe über die Landschaftsmalerei* (*Nine Letters on Landscape Painting*).

Philipp Otto Runge (1777–1810), of Hamburg, died too young to find a satisfactory compromise between his pedantically minute treatment of detail and his vision of an art that would transcend painting by embracing aspects of poetry and music (a premonition of the *Gesamtkunstwerk*, the collective or all-inclusive work of art conceived by Wagner and exemplified by his operas). In Runge's *Rest on the Flight into Egypt* (plate 55), the first rays of dawn reveal the awakening Christ Child. The traditional religious iconography was thus interpreted in terms of contemporary tran-

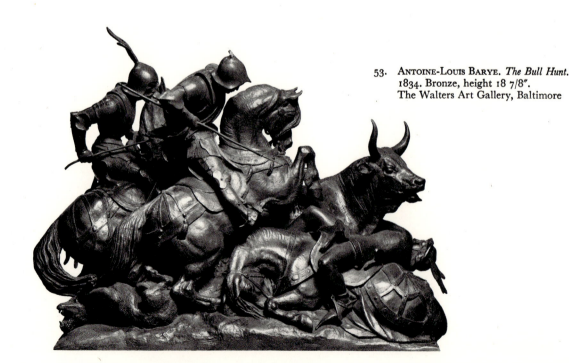

53. ANTOINE-LOUIS BARYE. *The Bull Hunt.* 1834. Bronze, height 18 7/8". The Walters Art Gallery, Baltimore

scendental pantheism. But if in his allegorical work the abstractions of spiritual conditions are weakened by excessive natural details, in his portraits such details support strong psychological characterizations. Runge knew Goethe and, like the great poet, made important contributions to the knowledge and theory of color.

Although Friedrich and Runge were Germany's most gifted artists of the Romantic period, they attracted less attention at the time than did a group of young painters, then at the Vienna Academy, who on July 10, 1809, founded the *Lucasbund* (Guild of St. Luke) and who became better known as the Nazarenes after they moved to Rome at the end of the year. Both terms indicate their opposition to current academic doctrine, their typically Romantic nostalgia for the technical methods as well as the figural styles of the later Middle Ages and early Renaissance, and their determination to devote themselves seriously to religious painting. On the last two counts they were both unfortunate and misguided, for their talents were unequal to the task they had set themselves, and the

54. CASPAR DAVID FRIEDRICH. *Tetschen Altar* (*The Cross in the Mountains*). 1807. Oil on canvas, 44 7/8 × 34 1/4″. Gemäldegalerie, Dresden

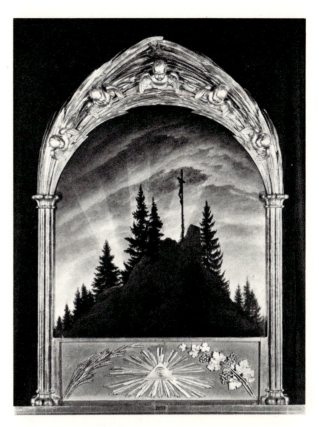

55. PHILIPP OTTO RUNGE. *Morning—The Rest on the Flight into Egypt.* 1806. Oil on canvas, 38 1/2 × 52″. Kunsthalle, Hamburg

task was irrelevant in an age which had less and less use for religious art. But their opposition to the conventions of academic instruction encouraged numerous artists later in the century to dispense with routine, particularly the English Pre-Raphaelites, whose program was in several respects like theirs (see below, pp. 79–80). Many of their paintings now seem merely an implausible pastiche of Raphael and Dürer, but the less pretentious works of painters like Johann Friedrich Overbeck (1789–1869), Franz Pforr (1788–1812), and Julius Schnorr von Carolsfeld (1794–1872) exhibit an occasional devout or domestic simplicity reminiscent of Gozzoli or Primaticcio.

The rival, and one might think irreconcilable, claims of the artistic traditions of northern and southern Europe, which so obsessed the Nazarenes, are stated in Overbeck's *Italia and Germania* (plate 56), where the figures, reminiscent in type and costume of Raphael's and Dürer's, are seated before landscapes typical of Italy and Germany. Peter Cornelius (1783–1867) had a gift for large-scale mural painting, but in the Munich of Ludwig I, where he was called upon to decorate the Glyptothek, his talent was vitiated by the necessity of adapting Christian feeling to the

56. FRIEDRICH OVERBECK. *Italia and Germania.* 1811–28. Oil on canvas, 37 3/4 × 40 7/8". Bayerische Staatsgemäldegalerie, Munich

royal passion for antiquity, as in his large mural of the *Last Judgment* for the Ludwigskirche (1836–1839).

The culmination of Romantic landscape painting occurred in England where two painters, who were almost exact contemporaries, extended and intensified both the imaginative interpretation and the visual analysis of nature. The genius of Joseph Mallord William Turner (1775–1851) was recognized early on; his dramatic seascapes, especially of fishing boats in heavy weather, won him full membership in the Royal Academy at the age of twenty-seven. On the other hand, the intimate observations of rural nature by John Constable (1776–1837) went long unregarded; he became an associate of the Academy only in 1819 and a full member ten years later, and the proper estimation of his art had to wait until nearer the close of his life. Behind the work of both artists stretches the long tradition of English topographical painting and a love of the English scene, fortified by the admiration of several generations of English collectors for seventeenth-century Franco-Italian and Dutch landscapes. The compositional principles of Claude and Hobbema, of Poussin and Van Ruisdael, and of the Dutch marine painters persist, and were at times explicit, in Turner's and Constable's work. Turner bequeathed his estate to the nation providing that his *Embarkation of the Queen of Sheba* and his *Sun Rising Through Vapor* hang always in the National Gallery beside two Claudes, and Constable's views of East Anglia were often phrased in terms of a Claude owned by his patron Sir George Beaumont. Yet, rooted in the European landscape tradition though they were, both artists were unmistakably English painters, and Romantic painters at that. Turner's preoccupation with the most dramatic and awesome, in eighteenth-century aesthetics the most "sublime," aspects of nature infused his stormy seas and alpine vistas with vast cosmic force. Yet he was so keen an observer of natural truth that his wildest episodes were ultimately derived from actual, not imaginary, experiences. A seascape of a snowstorm exhibited at the Academy in 1842 carried the circumstantial subtitle *Steamboat Off a Harbor's Mouth Making Signals in Shallow Water and Going by the Lead. The Author Was in This Storm on the Night the Ariel Left Harwich* (London, National Gallery). And it is known that the elderly artist had himself tied to the deck that night so that he could study the effects of the snowstorm. By then Turner had begun to abandon the Classical and mythological properties which had supported his earlier landscapes in which actual vision had been transformed by his heroic imagination. In an earlier snowstorm of 1812, the sun suddenly pierces the tempestuous alpine atmosphere to surprise the minute forms of *Hannibal and His Army Crossing the Alps* (London, Tate Gallery).

Turner was primarily a painter of light and atmosphere, and in the manner of Claude he brought the source of light gradually into the very center of his picture. The views of *Mortlake Terrace* (1826–1827; New York, Frick Collection, and Washington, National Gallery) are saturated with early morning or evening light. In his *Keelmen Heaving in Coals by Moonlight* (1835; colorplate 8), the moon rises directly ahead. By then Turner had seen the pleasant pastures of preindustrial England soiled by factory soot and the skies stained by flaring furnaces, but his imagination could embrace even the atmospheric effects of industrialism with unrivaled dramatic scope. In the manner of his more famous *Fighting Téméraire* (1839; London, Tate Gallery), in which the old ship of the line of Trafalgar is towed to her last mooring by an ugly little steam tug, Turner contrasts the stately sailing ships on the left with the noise, confusion, and raw energies expended by the keelmen at the right. In between, the tides of the river Tyne ebb and flow in the opalescent moonlight.

Constable neither commanded nor desired so dramatic or so panoramic an experience. For him the world was centered in East Anglia, where he had been born and to which he returned from London whenever he could. If Turner's sumptuous visions can be equated with Byron's grandiloquent landscape images in *Manfred* or *Childe Harold*, Constable's patient examination of the smallest incidents of rural life—sunlight on summer foliage after rain, or the look of damp moss on rotting stumps—may remind us of Wordsworth's search for eternal meaning in the vernal wood. All four artists, the painters as well as the poets, were Romantic in that the knowledge of nature extended their spiritual experience, but Constable pursued its study with a dispassionate inquiry in keeping with the new and more objective science of his day. It has been said that tomorrow's weather might be predicted from the skies in his pictures, and certainly the many small studies of clouds (now in the Victoria and Albert Museum, London) are as accurate as a meteorologist's reports—even while they convey a love for nature's transient aspects charged with poetic feeling, as were Wordsworth's verbal notations.

Constable's principal paintings were the large landscapes he exhibited at the Academy, of which *The Hay Wain* (1821; London, National Gallery) enjoyed unusual success at the Paris Salon of 1824. These are now less interesting than the more broadly brushed preliminary studies, where the effects of nature seem more immediate and more deeply felt. In small land-

scapes like *Weymouth Bay* (colorplate 9) the question of man's relation to nature is as closely examined and as deeply felt as in Turner's bravura *Keelmen*, but the answer is to be seen in the quieter harmonies of skies and fields swept slowly by the sea air and the sun. Before such a painting, we can understand how Constable, toward the end of his life, could think of landscape painting as a "branch of natural philosophy, of which pictures are but the experiments."

In America, similar reverence for heroic action and for the wonders of nature pervades the painting of the first half of the nineteenth century. The relation of this attitude to European painting can be followed in the work of Washington Allston (1779–1843), who was in London, Paris, and Rome between 1801 and 1808. From his studies with Benjamin West and his observations in the Louvre and the museums of Italy he acquired a taste for monumental figural compositions, of which the most notable example was his huge *Belshazzar's Feast* (Detroit Institute of Arts), begun in Europe during a second visit in 1817 and considered by Allston's contemporaries (when he brought it to Boston the next year) as the prophetic beginning of a new movement in American art. Allston, however, could never finish the painting, frustrated possibly by the narrower artistic surroundings of Cambridgeport where he lived, but perhaps more so by having no real gift for controlling such large compositions in the manner of the Venetian masters. With fewer figures he was not much more successful; but in *Jeremiah Dictating His Prophecy of the Destruction of Jerusalem to Baruch the Scribe* (plate 57) there is an aura of mysterious dignity strangely at variance with the chunky Neoclassic modeling. Romantic Classicism might indeed be the proper denomination for this picture, since the view through the archway suggests that Allston had seen the interior of Soane's Bank when he was in London. More successful and more influential were his landscapes. They were often dramatic, like *The Rising of a Thunderstorm at Sea* (1804; Museum of Fine Arts, Boston), with its small craft tossed about by the raging waters; yet on occasion they showed an awareness of climate and time of day in circumstances which had been observed rather than imagined. The composition of his late *Landscape, American Scenery: Time, Afternoon, with a Southwest Haze* (plate 58) may be traditional, but the long title indicates a new attitude toward nature in which the Romantic artist's awareness of the poetry of the seasons was combined with a clear eye for the truths of natural appearance.

The Romantic attitude toward heroic action can be felt in the portrait of the *Marquis de Lafayette* (plate 59), begun by Samuel F. B. Morse (1791–1872) when the French patriot returned for his triumphal visit to this country in 1824. Morse had also studied in London with West, and there is much in this painting which recalls British art of the late eighteenth and early nineteenth centuries, such as the same restless play of light and shade which Stuart had used in his *Washington* (plate 5); but Morse achieved a more monumental and dramatic effect by extending the landscape out and downward and by lowering the point of view so that the figure towers over the spectator. For the unchanging light of the studio Morse substituted a specific time of day—dawn, with the sun reddening the east and gilding the busts of Washington and Franklin as if symbolizing the emerging greatness of the nation Lafayette had helped to establish. Morse was an able painter and a penetrating portraitist, but he was also an inventor whose scientific experiments eventually left him no time for his art. He is remembered as the first professor of art at New York University, appointed in 1832, and thus one of the pioneers of art education in this country.

The country itself, as the population expanded westward from the seaboard, excited the enthusiasm of several generations of landscape painters whose works are usually included under the general title of the Hudson River school. Although they actually painted in many other places, the title still suggests the excitement with which painter and spectator alike looked, as if for the first time—as indeed in some instances they did—on the American landscape. From the "awful sublimities" of Niagara Falls, which were admired as early as 1804, and the majestic sweep of the Hudson to the less overwhelming beauties of the Berkshires and the White Mountains, the artists followed the adventurous travelers in discovering the character of a landscape pristine in its natural beauty. Although for the European visitor it lacked vestiges of a historic past, devoid as it still is of Classic ruins or moldering medieval castles, for the first generation of nineteenth-century Americans it had not only beauty but meaning as a revelation of the divine purpose which had created a new paradise for mankind. This transcendental attitude toward nature, so marked in the poetry of William Cullen Bryant, was first expressed pictorially by Thomas Cole (1801–1848), who came to this country from England when he was eighteen. Although almost self-taught as a painter, he had earlier studied to be an engraver, and the meticulous treatment of trees and foliage in his landscapes testifies to his training. Cole settled in New York as a professional painter in 1825, and from then until his premature death he was recognized as the principal

57. WASHINGTON ALLSTON. *Jeremiah Dictating His Prophecy of the Destruction of Jerusalem to Baruch the Scribe.* 1820. Oil on canvas, 89 3/4 × 74 3/4″. Yale University Art Gallery, New Haven, Conn. Gift of Samuel F. B. Morse

58. WASHINGTON ALLSTON. *Landscape, American Scenery: Time, Afternoon, with a Southwest Haze.* 1835. Oil on canvas, 18 1/2 × 24 3/4". Museum of Fine Arts, Boston

interpreter of the American scene. His earliest landscapes were among his best. In *Schroon Mountain* (1833; plate 60) his drawing reveals the shape and structure of the American forests; but in his vision of the grandeur of the wilderness he subordinated details to the thrust and sweep of the mountains, so true to the contour and profile of the Appalachian range. A more sentimental attitude toward American life is conveyed by the tiny Indians skulking through the foreground underbrush; they remind us that the inhabitants of the forests, who had seemed little like Noble Savages to the pioneers of the eighteenth century, were being celebrated just then for their heroic qualities by the novelist James Fenimore Cooper in the *Leatherstocking Tales.*

The inexhaustible resources of the American wilderness also attracted enthusiastic scientific study, which reached an unusual combination of objective observation and romantic identification with the life of wild creatures in the work of John James Audubon. Audubon (1785?–1851), who was of French descent, had tried his hand as a millowner before his love for birds led him to undertake a visual record of the birds and animals of America. Although he was not a trained naturalist and indeed discovered no new species, his colored engravings, after his watercolors, were a landmark in nineteenth-century natural history. To compensate for the expense of publishing the engravings, Audubon produced a number of oils based on his drawings. In the *Red-Tailed Hawk* (plate 61) the needs of science were satisfied by displaying both the male and female in different positions, but the hawks are endowed with a Romantic life of their own by being shown in pursuit of their prey. Below and in the

Colorplate 9. JOHN CONSTABLE. *Weymouth Bay*. c. 1817. Oil on canvas, 22″ × 30 1/4. Museum of Fine Arts, Boston

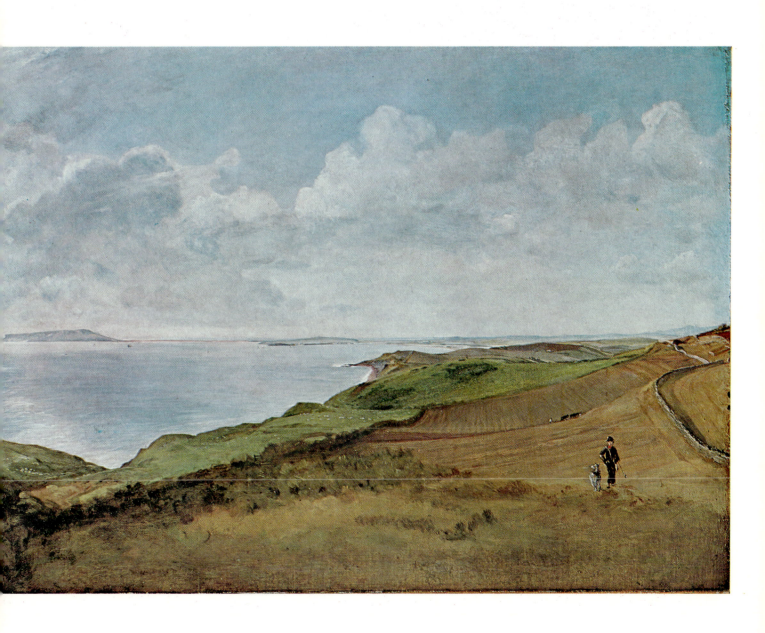

Colorplate 10. CAMILLE COROT. *Ville d'Avray, Wooded Bank of the Pool, with a Woman Gathering Faggots.* c. 1871–74. Oil on canvas, 28 3/8 × 22 1/2″.
The Metropolitan Museum of Art, New York. The Mr. and Mrs. Isaac D. Fletcher Collection. Bequest of Isaac D. Fletcher, 1917

59. SAMUEL F. B. MORSE. *Le Marquis de Lafayette*. 1824–26. Oil on canvas, 96×64″. City Hall, New York

60. THOMAS COLE. *Schroon Mountain.* 1833. Oil on canvas, 39 3/8 × 63″. Cleveland Museum of Art

distance the smoke of a solitary campfire drifts across the immense American plains.

To the Mississippi and beyond, America stretched westward, offering for the adventurous painter ever more splendid visual experiences. Life on the western rivers was the subject matter of George Caleb Bingham's most enduring works. Largely self-taught, except for a short spell at the Pennsylvania Academy in 1837, Bingham (1811–1879) was able to communicate the specific qualities of the frontier environment, social as well as atmospheric. In his *Raftsmen Playing Cards* (1847–1850; plate 62), the misty river landscape provides a properly spacious setting for the figures whose carefully studied postures are curiously Poussinesque. Bingham could have known Poussin's work from engravings and his choice was not inappropriate, for these, in their own frontier way, were also shepherds in Arcady. Among the other painters of frontier life, many rarely rose above a kind of stirring but journalistic documentation. George Catlin (1796–1872), whose work was admired by Delacroix when it

was shown in Paris, is remembered for his vivacious depictions of Indian life, an effort, as he put it, "to rescue from oblivion the looks and customs of the vanishing races of native man in America."

The last of the painters whose panoramic vision can

61. JOHN JAMES AUDUBON. *Red-Tailed Hawk.* c. 1825. Oil on canvas, 37 3/4 × 25″. Yale University Art Gallery, New Haven, Conn. The Mabel Brady Garvan Collection

be traced to the concepts of the Hudson River school were Albert Bierstadt (1830–1902) and Thomas Moran (1837–1926). Their views of the Rocky Mountains and the areas which are now the national parks were often of enormous size and included such dramatic excitements as glaciers, thunderstorms, and Indian encampments. The great sweep of land and sky in the panoramic paintings of Frederick Edwin Church (1826–1900) emphasized the artist's concept of the heroic innocence of the primal American wilderness. Church also traveled further afield than the others. Among his most popular paintings were large, carefully observed views of the mountains of Mexico and South America and of the ice fields of Labrador (plate 64). His house above the Hudson, opposite the Catskills, was designed by a leading architect of the medieval revival, Calvert Vaux (1824–1895), in a consistently Moorish manner. Church furnished it with the spoils of his travels on four continents until "Olana" became, despite its late date, the outstanding example of the Romantic American artist's dwelling.[5]

Just as the life of George Inness (1825–1894) spanned the decades between Romanticism and the naturalistic aesthetic of Impressionism, so in his work he passed from early landscapes, shaped as much by his respect for Poussin and Claude as by his romantically American infatuation with Italian scenery, to a concern in his later years with the slightest nuances of climate and time of day observed at his home in Montclair, New Jersey. A view of the Delaware Water Gap (plate 63), painted in the early 1860s, shows him midway between the extremes of nineteenth-century landscape

62. GEORGE CALEB BINGHAM. *Raftsmen Playing Cards*. 1847–50. Oil on canvas, 28 × 36″. City Art Museum, St. Louis, Mo.

practice. The panoramic view is spatially Romantic, but the close study of detail, even of such supposedly unromantic intrusions as the steam-train puffing along the riverbank at the left, shows that he had a truly modern respect for the truths of contemporary life.

As in Europe, so, too, in America there was little specifically Romantic sculpture, but there was one man whose thwarted ambitions might symbolize the plight of the gifted artist isolated in an unsympathetic society. William Rimmer (1816–1879) was a physi-

63. GEORGE INNESS. *On the Delaware*. 1861–63. Oil on canvas, 28 3/8 × 48 1/4″. The Brooklyn Museum, New York

64. FREDERIC EDWIN CHURCH. *Cotopaxi*. c. 1863. Oil on canvas, 35 × 60″.
The Reading Public Museum and Art Gallery, Reading, Pa.

cian in Boston, where literary culture had long been
in advance of plastic expression. His few stone carv-
ings, the *Alexander Hamilton* of 1865 on Common-
wealth Avenue, for example, are stiff and awkward, as
if he had been daunted by the obdurate granite. Clay
came easier to him and in two works, the *Fighting
Lions* and the *Dying Centaur* (plate 65), both probably
modeled in 1871 but not cast until after Rimmer's
death, his professional knowledge of anatomy served
a Romantic iconography of passionate struggle and
defeat. Such themes, which are even more explicit
in his drawings and which would have been impossi-

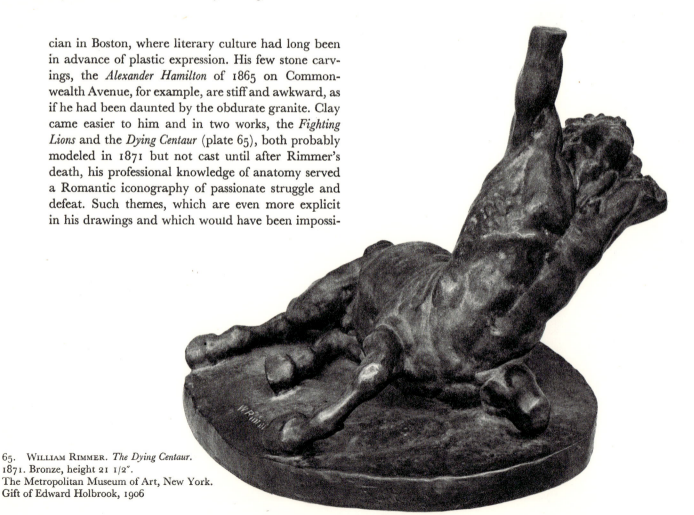

65. WILLIAM RIMMER. *The Dying Centaur*.
1871. Bronze, height 21 1/2″.
The Metropolitan Museum of Art, New York.
Gift of Edward Holbrook, 1906

ble to communicate in the impersonal abstractions of Neoclassic marbles, required the kind of restless realism that was Rimmer's strongest asset.

A carefully realistic technique had often been an important element in the concept of Romantic painting, but from the first it was perhaps the most conspicuous aspect of the work of the English Pre-Raphaelite Brotherhood, one of the last demonstrations of Romantic purpose. The movement itself was limited to six painters and a sculptor and lasted only for a few years following the exhibition of Dante Gabriel Rossetti's *Girlhood of Mary Virgin* and *Ecce Ancilla Domini* (both in the Tate Gallery, London) in London in 1849 and 1850. The abundance of detail in these paintings and in John Everett Millais' *Lorenzo and Isabella* (1848–1849; plate 66) irritated an English public accustomed to more conventional and more idealized treatments of religious and literary subjects. Rossetti (1828–1882), with his friends Millais

(1829–1896) and William Holman Hunt (1827–1910), the two ablest of the group, was determined to discredit the vapid themes and insipid treatment of academic painting by returning to the conscientious craftsmanship and seriousness of purpose they attributed to the late medieval and Renaissance masters; hence their choice of the term *Pre-Raphaelite*. They were also influenced by the example of the Nazarenes, although paradoxically they looked more to northern masters, such as Dürer, than to Perugino. They also deeply admired the work of a slightly older British painter, Ford Madox Brown (1821–1893), whose *The Last of England* (1852–1855; plate 67) exemplifies the Pre-Raphaelite virtues of impeccable craftsmanship and seriousness of theme and interpretation in a subject inspired by the emigration of the Pre-Raphaelite sculptor Thomas Woolner to Australia. The innumerable details and the differentiation of textures, especially in the several textiles,

66. SIR JOHN EVERETT MILLAIS. *Lorenzo and Isabella.* 1848–49. Oil on canvas, 40 × 57″. Walker Art Gallery, Liverpool

are evidence of Brown's remarkable visual perceptions; yet they are controlled by a masterly design of circles and curved forms contained within the larger oval of the frame. The colors, cold and hard in the Pre-Raphaelite taste, contribute to the unhappy and apprehensive mood.

Such expressive intensity, based upon visual and technical acuity and on a decision to interpret the realities, rather than the sentimentalities, of nineteenth-century life, did not, perhaps could not, last long. Millais was soon lured from the strict Pre-Raphaelite standards by the promise of success with melodramatic historical subjects and portraiture. Rossetti, never really proficient in oils but a poet of the first rank, turned to watercolors for scenes of medieval romance and, after the death in 1862 of his wife Elizabeth Siddall, interpreted his lost love after the style of Dante's longing for Beatrice. His later paintings of single female figures symbolizing varieties of erotic experience—Astarte, Venus, or the Bride of the Song of Solomon—are frequently coarse in both design and execution. But one of the last pictures he touched, the *Pia de' Tolomei* from Dante's *Purgatorio* (plate 68), begun in 1868 but not completed until 1881, is imbued with the luxuriant yet somehow morbid character of his art. The woman closely resembles Jane Burden, the wife of William Morris, to whose somewhat massive charms the painter was not immune. William Morris was himself enthralled by the Middle Ages, but his political philosophy led him to look to the past as much for remedies for the condition of the laboring classes as for the designs he incorporated in his vigorous tapestries, wallpapers, textiles, and printed books. Sir Edward Burne-Jones (1833–1898), a younger friend of Morris', continued the Pre-Raphaelite tradition to the point where it coincided with the development of Symbolist painting in France (see below, p. 133).

67. FORD MADOX BROWN. *The Last of England*. 1852–55.
Oil on panel, 32 1/2 × 29 1/2″. City Museum and Art Gallery, Birmingham, England

68. DANTE GABRIEL ROSSETTI. *La Pia de' Tolomei.* 1868–81.
Oil on canvas, 41 1/2 × 47″.
University of Kansas Museum of Art, Lawrence

From Romantic Realism to Naturalism and Impressionism

So climactic a Romantic event as Delacroix' *Death of Sardanapalus* of 1827 (colorplate 7) preceded by only three years the fall of the restored Bourbons and the coming to power of Louis-Philippe, the first and last King of the French (reigned 1830–1848). He was committed to the economic interests of the middle classes, and during the eighteen years of the "Bourgeois Monarchy" immense progress occurred in trade, industry, and technology. The first railroads were constructed to carry manufactured goods which were being mass-produced under new conditions of labor in new factories created by new combinations of capital. These developments were not peculiar to France. In England, Germany, and the United States during this second third of the century, the old order was giving way to a new era characterized by the concentration of the population in ever larger cities. In this society, which became the source and pattern for our own today, individual gestures of Romantic impulse came to have less and less pertinence to the problems at hand. In a culture dominated by material objects and materialist values, a work of art became an object to be traded and exchanged, and to be prized when it most resembled other objects considered desirable in this world—in other words, when it was most "realistic."

A realistic technique was not, of course, an inven-tion of the nineteenth century, for there had been other periods which also valued the literal description of the world around us. Greek and Roman paint-ing, if we can trust the ancient commentators, was so illusionistic as actually to deceive the spectator; late medieval painting in Flanders and Holland has never been surpassed as a record of what can be seen and touched; and the seventeenth-century Dutch and Spanish painters were masters of visual truth. But in each period such realistic methods were used for the projection of conceptual statements, about the gods or God, or about the splendors and miseries of human life. To name Jan van Eyck and Rembrandt is not only to point to the vast difference between two kinds of pictorial realism, but also to indicate aspects of their work which transcend mere statements of fact. In the nineteenth century, however, in an age which was learning to take a more statistical view of expe-rience, there came into being a kind of painting which depended more and more upon the facts of visual experience. In the schools—the academies, whence the usually derogatory term *academic*—where a realistic technique was basic to the curriculum, visual truths were often used for the interpretation of scenes from mythology and history, scenes inaccessible to any but the imaginative vision. In so typical an academic painting as the *Slave Market* of about 1867 (plate 69),

9. JEAN-LÉON GÉRÔME. *The Slave Market.* c. 1867. Oil on canvas,
33 × 25″. Sterling and Francine Clark Art Institute,
Williamstown, Mass.

Jean-Léon Gérôme (1824–1904), a gifted but pe-
dantic teacher, projected a convincing illusion of flesh
and textiles in a strangely airless space, but the
subject and its expressive interpretation could scarcely
be considered "realistic." When, however, paintings
lost such conventional and emotional connotations
and came to depend for their aesthetic effect solely on
natural facts, stated without comment, they could be
described as Naturalist rather than Realist, because
the latter term carries implications of expressive
content. The word *naturalism* was originally used to
describe literary developments after 1860, most prom-
inent in the novels of Émile Zola (.1840–1902), which
presented, in the familiar French phrase, "La Nature
telle qu'elle est" ("Nature, or life, just as it is"); but
it is also appropriate for the attitude of many artists
toward pictorial situations, including those treated by
the painters who were to be known as the Impres-
sionists. In this chapter we shall trace the emergence
of pictorial Naturalism from the Realist elements in
Romanticism to its fullest expression in the developed
Impressionist aesthetic of the 1870s.

A less individualistic and hence less Romantic
attitude can be traced in the figural and landscape
paintings of the masters of the so-called school of
Barbizon as early as 1850. Chief amongst them was
Jean-François Millet (1814–1875), who had left Paris
the year after the Revolution of 1848, which overthrew
the July Monarchy of Louis-Philippe, to settle in the
small village of Barbizon on the edge of the Forest of
Fontainebleau. The popular conception of Millet as
an untutored man of the people who painted senti-
mental versions of peasant life is not entirely accurate.
It is true that he was of Norman peasant stock, but
he was intelligent and well-read, and his presentation
of peasant life was neither so sentimental nor so ex-
aggeratedly heroic as it appeared to generations of
urban critics who had forgotten or had never known
peasant life at first hand. Millet admired the great
Classic examples of literature and art—the Bible,
Homer, Vergil, Raphael, and Michelangelo—and if he
interpreted peasant occupations in the mood of the
Georgics, or with Michelangelesque postures, as in his
first success, *The Gleaners* (1857; Louvre), he was
trying to secure a new dignity for such subjects by
raising them from the level of genre scenes to a place
within the European figural tradition. In the several
versions of what was once his best-known work, *The
Sower*, the most common and recurrent of peasant
gestures was treated with the breadth and power of
the prophets on the Sistine Ceiling, so that it became
an act symbolical of the life-giving relation between
man and the soil. In other images, notably in *Man
with a Hoe* (1859–1862; plate 70), Millet called atten-
tion to the grinding physical effort and spiritual barren-

70. JEAN-FRANÇOIS MILLET. *Man with a Hoe.* 1859–62. Oil on canvas,
32 × 39 1/2″. Collection of the Estate of Mr. and Mrs. William
H. Crocker, San Francisco, Calif.

71. THEODORE ROUSSEAU. *Le Givre—Winter Solitude*. 1844–45. Oil on canvas, 25 × 38 5/8″. The Walters Art Gallery, Baltimore

ness of farm labor. The ugly details of such scenes dismayed conservative critics quite as much as his apparent demand for social justice for the depressed rural classes pleased the humanitarians. Both groups overlooked the fact that this picture, however much it may contain of emotional and hence, we might say, of Romantic protest and appeal, is a truthful and thus realistic account of a typical moment in the life of the nineteenth-century farm laborer.

Millet's paintings have been so long neglected, and their heavily varnished surfaces grown so dark and opaque, that his color and the finesse of his brush-stroke come as a surprise when his pictures are cleaned. This feeling for color which was locally true to the objects depicted, but also clear and delicate, he shared with his companions, the landscape painters of Barbizon. Théodore Rousseau (1812–1867), the most distinguished of the group, had settled in Barbizon for most of each year. His early work was based compositionally on Dutch painting, and he

never entirely abandoned the solemn grandeur which can be created by disposing a few broad masses of trees beside a winding stream. Through his prolonged study of natural motifs his work acquired a profound sense of visual reality—even when it contained traces of a Romantic disposition to regard nature as fundamentally a revelation of a divine moral purpose. His interest in exceptional rather than typical aspects of nature can be seen in *Le Givre* (1844–1845; plate 71), a painting of winter frost upon an upland pasture. The symmetrical composition with its entering diagonal marked by a solitary figure is conservative and traditional, but the delicately opalescent effect of light upon frost is so direct a revelation of perceptual experience as to warrant the description of proto-Impressionist. Among this generation of painters V. N. Diaz de la Peña (1807–1876), Jules Dupré (1811–1889), and Charles Daubigny (1817–1878) created many fresh and revealing landscapes, al-though they lacked Rousseau's gravity and firm com-

positional structure (plate 72). In his figure compositions of gypsies and nymphs masquerading in the depths of the forest, Diaz revived the Rococo spirit of the eighteenth century.

Jean-Baptiste-Camille Corot (1796–1875) was well acquainted with the masters of Barbizon (he often painted there, especially in the summer), but his vision of landscape was more varied, more comprehensive, and structurally more complex and more flexible than theirs. He went three times to Italy—in 1825 (to 1828), 1834, and 1843—where, in many studies painted directly from the motif in the clarity of the southern light and landscape, he laid the foundations for his eminently formal and harmonious art (plate 73). In contrast to the Barbizon painters, who sometimes saw a tree as a multitude of leaves, Corot saw nature in terms of masses of light and dark. Even when he was most beguiled by small branches, tendrils, and leaves, as in the screen of foliage separating the foreground from the farther bank of the river in the painting of a woman gathering faggots at Ville d'Avray (color-plate 10), one of his favorite sites on the outskirts of Paris, Corot never lost sight of the underlying order of his design. In this painting, executed possibly as late as 1871–1874, the mixture of ingredients we have noted in earlier Romantic art has been brought down to date with a change of emphasis—the whole design has a Classic serenity without any ostensibly Classic elements. The tone of Romantic absorption in a natural environment whose mood is one of serene accommodation to man's task is less insistently Romantic with Corot than with his Barbizon friends, while the natural detail, especially in the drawing of the spindly trees, appears so true to the facts as

73. CAMILLE COROT. *Lake Geneva.* c. 1840–45. Oil on canvas, 10 1/4 × 13 7/8″. John G. Johnson Collection, Philadelphia

almost to evoke the description of "photographic."

Like most nineteenth-century painters, Corot was deeply interested in photography, and the muted tonality of much of his later work, based on a restricted color scheme of dull greens, browns, and an exquisite variety of grays, may have been due to his study of monochromatic photographs. After 1855 he enjoyed popular success with views of woodland glades at dawn or twilight, their contours veiled by mists rising from still waters, the silence scarcely disturbed by a few figures in vaguely Classic dress. Twentieth-century taste has preferred his earlier, fresher notations of nature, but these evocations of imaginative experience should be understood as sincere if belated attempts to restate, somewhat in the manner of Claude, the values of landscape seen and felt as comparable to idyllic poetry.

The more than four thousand lithographic caricatures which Honoré Daumier (1808–1879) contributed to various Parisian journals during a working life of some forty years compose an unforgettable index to human contrariness and eccentricity, and they have rightly been compared with Balzac's encyclopedic view of human nature in the many novels of his *La Comédie humaine.* But it is not quite true that Daumier took as his subject all sorts and conditions of men. He was a city-dweller, living and working in the very center of Paris, and his view reached only to the outer suburbs of the city in ludicrous depictions of the discomforts felt by the city-dweller when he ventures, of a Sunday, into the perilous countryside. His subjects came predominantly from the middle classes, whose social pretensions, intellectual limitations, awkward

72. CHARLES-FRANÇOIS DAUBIGNY. *Landscape.* 1863. Oil on panel, 12 1/2 × 19 1/2″. Sterling and Francine Clark Art Institute, Williamstown, Mass.

74. HONORÉ DAUMIER. *Six Months of Marriage.* 1839.
Lithograph, 9 1/4 × 8 1/4". From the series *Moeurs
Conjugales.* Wesleyan University Print Collection,
Davison Art Center, Middletown, Conn.

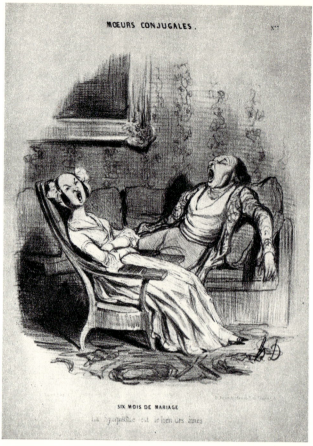

75. HONORÉ DAUMIER. *The Third-Class Carriage.* c. 1860–62.
Oil on canvas, 25 3/4 × 35 1/2". The Metropolitan Museum of Art,
New York. Bequest of Mrs. H. O. Havemeyer, 1929.
The H. O. Havemeyer Collection

affections, and infidelities he described with a line unequaled for economy of definition and variety of expression (plate 74). Of the truly poor as of the really rich Daumier had little to say. This limitation of content and restriction of subject can be traced to the circumstances of his employment. From the first years of the July Monarchy he had savagely attacked the corruption of the government and the person of the king in lithographs published in *La Caricature*. In 1832 he was arrested and sentenced to six months in prison. From his release until the end of the Second Empire thirty-eight years later he was prevented by censorship from treating political subjects. How much was lost by this policy can be seen in his last series of prints of 1870–1873, trenchant comments on the fall of the Empire, the Commune, and the birth of the Third Republic, executed in a few broad strokes of the crayon when his eyesight had seriously failed.

The range of Daumier's sympathies can be better examined in his paintings and watercolors. They were little known and rarely seen in his lifetime, but since the first large retrospective exhibition held in 1878 a few months before his death, they have established him as one of the great nineteenth-century painters. He was scarcely a colorist, his palette usually confined to a narrow range of earth colors dominated by grays and browns, but his heavy modeling, imposed upon vigorous linear underpainting, has a Michelangelesque character like Millet's, whose works his own may have affected. His powerful draftsmanship and the massive construction of his figures can be seen in the unfinished version of his *Third-Class Carriage* (plate 75), probably painted in the early 1860s. In subject and content it is typical of Daumier's unequivocal acceptance of the physical and emotional conditions of modern life and may be considered an urban counterpart of Millet's contemporary depictions of rural poverty. Here is that new but common means of transportation, the railway carriage (Daumier made many watercolors and lithographs of railway travelers), in which the passengers, although brought physically together in one place, endure the discomforts of their transit in time largely alone. In the three figures in the foreground—the old woman and the mother with a child numbed by fatigue—who can be read as images symbolizing modern spiritual alienation, there is no trace of the caricaturist's irony. In works such as this, and in his drawings and infrequent sculptures of emigrants and refugees, Daumier joined Rembrandt and Goya as one of the great interpreters of the human condition.

Daumier's compassion and humor added a spiritual dimension to the humblest fact. A more narrowly programmatic Realism attended the work and reputation of Gustave Courbet (1819-1877), the son of a well-to-do farmer in the Franche-Comté. His artistic education was sporadic, and in developing his powerful technique he owed more to his own instinct for succulent paint than to the advice of others. Although his early self-portraits, which are interesting if somewhat tardy documents of Romantic introspection, were remarked for the candor with which he celebrated his own good looks, his work was frequently rejected by the Salon jury through the 1840s. His opportunity to demonstrate the range and depth of his talent came at the Salon of 1850–1851 where he exhibited his large *Burial at Ornans* (plate 76), a canvas almost twenty feet long depicting his grandfather's funeral, which he had painted the previous winter in his native village with friends and relatives as models. In a country where funerals are conducted with as much ceremony as the family of the deceased can afford, this portrayal of the indifference, even the callousness displayed by all but the mourners of the immediate family, seemed little short of blasphemous. So shocked was the public when the picture was seen at the Salon, so dismayed were the good people of Ornans when they learned of the unfavorable reception given their group portrait, that there were few to note Courbet's achievement in uniting form and content in so wide and so unwieldy a design. At first one sees only a confusion of heads and bodies moving at contrary and cross purposes to each other, as people do on such occasions. Gradually the slow rhythms of the mass appear, revealed in the undulating line of heads and bound to the more gradual swelling of the distant hills and their fainter reflection in the sky. Upon this simple but impressive structure Courbet projected details of village life with such accuracy that the painting could almost be read as a sociological treatise; indeed, it was so interpreted by the radical social philosopher Pierre-Joseph Proudhon (1809-1865), whose discussion of Courbet's peasant pictures in his *Du Principe de l'art et de sa destination sociale* (a collection of essays published posthumously in 1865) is one of the earliest definitions of Social Realism.

When two of the nine paintings Courbet submitted to the jury for the International Exposition of 1855 were rejected, he withdrew all his entries and arranged a retrospective exhibition of his work of the past fifteen years in a building constructed at his own expense. This Pavilion of Realism, as he called it, and the manifesto published in the catalogue made his reputation as the leading Realist painter of Europe. His arguments placed him squarely on the side of those who believed that the purpose of art was to depict nature

"just as it is." His aim, he declared, was "to represent the customs, the ideas, the appearance of my own times according to my own valuation . . . in short, to create a living art."[1] His intention was clear in the large painting *L'Atelier*, subtitled "A Real Allegory of Seven Years of My Artistic Life" (plate 77). An allegory cannot, by definition, be real, but in this vast canvas, where the artist's friends from Ornans and Paris appear to the left and right of the painter seated before his easel, there seem to be symbolical references to the differing significance of rural and urban life as sources of pictorial inspiration and, in the figure of the nude woman standing beside the easel, reference to nature as the source of all artistic experience. A few years later Courbet sharpened his definition of art when, in a letter to a group of students who had asked him to teach them, he wrote that "especially in painting, art exists only in the representation of objects visible and tangible to the artist."[2]

Courbet's mastery of physical objects is most apparent when his work is least pretentious. In the portrait of *Mère Grégoire* (colorplate 11), the cashier of a restaurant he patronized in Paris, the density and texture of material substances—flesh, marble, wood, and glass—are rendered with persuasive visual and tactile effect. The silver and copper coins on the marble counter tempt us to touch them. The only false note is the genteel gesture of the hand which occasionally recurs in Courbet's work and which may be considered an unresolved aspect of his earlier Romanticism or as a slight but persistent trace of a fundamental lack of "taste." That the latter assumption may be true is apparent in his nudes, many of which are not lacking in vulgarity and some of which were painted deliberately to attract public favor. Courbet's reputation as a master of things visually seen and physically felt rests, rather, on his landscapes and hunting scenes. A mighty huntsman himself, he followed his quarry into the depths of the forest and returned with paintings irreproachable in the truth of their natural detail, yet imbued with his love for living and growing things.

Courbet's statement that he could not paint an angel because he had never seen one implies that modern painting, as it was understood by those who were opposed to the outworn attributes of idealist and academic art, should deal exclusively with "the appear-

76. GUSTAVE COURBET. *Burial at Ornans.* 1849–50. Oil on canvas, 9' 15 3/8" × 21' 9 3/8". The Louvre, Paris

77. GUSTAVE COURBET. *L'Atelier: A Real Allegory of Seven Years o My Artistic Life.* 1855. Oil on canvas, 11' 10" × 19' 7 3/4". The Louvre, Paris

ance of one's own times." This had been Courbet's purpose, but in execution he had often, by emphasis or exaggeration, attributed to his figures and animals postures which, like his own extravagant conduct, were somehow larger than life. The creation of an attitude toward contemporary life, one which would express its specific modernity, and of a style and technique capable of communicating such an attitude was the work of Edouard Manet (1832–1883). Born, like Delacroix, into the upper middle class (his father was a member of the court of appeals in Paris), well-bred, discriminating, and aloof, Manet looked upon painting as a profession rather than a way of life. And as a professional he sought the honors usually obtained in academic circles—the medals of the Salon, the ribbons of the Legion of Honor, perhaps even that election to the Institute which for so long eluded Delacroix. It is a paradox of Manet's career that although his pursuit of such distinctions puzzled and even alienated his companions, he never compromised his standards, even

when to do so might have made recognition of his gifts all the easier. After a small success at the Salon of 1861 with a *Spanish Guitarist* (New York, Metropolitan Museum of Art) he precipitated a *succés de scandale* at the Salon des Refusés of 1863, an exhibition held in conjunction with the usual Salon to accommodate the large number of paintings which had been, or so it was believed at the time, unfairly rejected by the jury. His *Déjeuner sur l'herbe* (plate 78), perhaps the most notorious painting of the nineteenth century, portrays an *al fresco* luncheon attended by two fully clothed men and by two women, one of whom is completely nude. Because the costumes, or lack of them, were entirely contemporary it was easy for the public to read the picture as evidence of the scandalous conduct of contemporary youth. The offense was all the worse because the principal characters were recognizable—the men were Manet's brother Eugene and Ferdinand Leenhoff, a Dutch sculptor and the brother of a young pianist who was shortly to become the

78. ÉDOUARD MANET. *Le Déjeuner sur l'herbe*. 1863. Oil on canvas, 7′ × 8′10″. Musée de l'Impressionnisme, Paris

painter's wife; the woman was Victorine Meurend, a prominent model who often posed for Manet.[3] What was not known, and it would scarcely have calmed the public had it been common knowledge, was that Manet had taken his composition from a group of reclining river-gods in a sixteenth-century engraving after a drawing by Raphael, and that not far away in the Louvre hung Giorgione's *Fête champêtre* portraying two young Venetian noblemen enjoying an afternoon in the country in the company of two lightly clad companions. The terms of Manet's art-historical conundrum can be stated, but it is not easily solved. Did he think, as had many artists before him, especially the portraitists of the eighteenth century, that contemporary life gains dignity by a formal resemblance to the art of the past? Or, on the contrary,

was he in some perverse way condemning the past by showing its irrelevance in a contemporary context? The first might seem the proper answer, given the occasions throughout the 1860s when he used the compositional formulas of older masters, were it not that in his *Olympia* (Louvre), painted in 1863 but not exhibited until 1865, the depiction of a fashionable young courtesan of contemporary Paris became a cruel travesty of Titian's *Venus of Urbino*.

The ambiguity and uncertainty of Manet's program could not, however, conceal the brilliance of his craftsmanship and the originality of his vision. To an exquisite sense of color, particularly for the play of pale blue, rose, lemon, and lavender, he added a capacity for reducing visual appearances to a narrow range of values between the poles of black and white,

Colorplate 11. GUSTAVE COURBET. *Mère Grégoire*. 1855. Oil on canvas, 50 3/4 × 38 1/4″ The Art Institute of Chicago

Colorplate 12. ÉDOUARD MANET. *A Bar at the Folies-Bergère*. 1882. Oil on canvas, 37 1/2 × 51″. Courtauld Institute of Art, London. Home House Collection

Colorplate 13. EDGAR DEGAS. *Woman Wiping Her Left Hip.* After 1896. Bronze, height 19 1/4″. The Metropolitan Museum of Art, New York. Bequest of Mrs. H. O. Havemeyer, 1929. The H. O. Havemeyer Collection

Colorplate 14. AUGUSTE RENOIR. *At the Concert*. 1880. Oil on canvas, 38 3/4 × 32″. Sterling and Francine Clark Art Institute, Williamstown, Mass.

which he used as colors. In the *Déjeuner sur l'herbe*, as well as in his other important paintings of the 1860s, the areas of color seemed sharply separated and the modeling simplified, until all intermediate tones were banished to the edges of the forms so that the whole looked surprisingly flat. Courbet dismissed *Olympia* as a "Queen of Spades," and he was right insofar as Manet's reductive system created a new kind of space, more two- than three-dimensional and thus truer, as we now know, to instantaneous vision uncomplicated by notions of perspective derived from touch and muscular extension.

To the degree that he depended upon what he saw of his subject, independently of what he might or could have known or felt about it, Manet was working toward Impressionism. He was painting, in the literal sense of the word, impressions of what he saw. His younger colleagues who were to become the Impressionists proper had, by 1870, made visual notations in their landscape paintings which were quite as accurate as his, and had gone further in studying the physical qualities of light as color and its reconstitution with opaque pigments on the canvas. Manet knew these younger men and profited by their theories and experiments; but although he worked for a time with them and even painted pure landscapes of his own, he remained attached to tradition, seeking official favor with large figural compositions. Yet by 1870 even he had outgrown his dependence on past masters and took his subjects, often suggested by those of his Impressionist colleagues, from the life around him. Of his later works, *Boating* (1874; plate 79) shows his ability to invest a casual moment in a summer's day with something of the monumental grandeur of earlier art. The close-up view was new, inspired by contemporary photography and by the Japanese print, which he had known since the early 1860s and which accounts here for the invisible horizon line high above the upper margin of the frame. With only two dominant colors, the blue of the water and the white of the holiday clothes, and using accents of his favorite black, Manet irradiated the picture space with sunlight reflected from the moving water. In the woman's posture, too, we can sense that inimitable chic, that infallible sensitivity to the charms of fashionable women which played so large a part in Manet's life.

In the last large picture completed before his premature death, Manet turned to the *Bar at the Folies-Bergère* (colorplate 12) to portray a barmaid waiting on a customer. Once again, a subject inherently of no consequence received magisterial treatment, as Manet's brush evoked the gaslit

79. EDOUARD MANET. *Boating*. 1874. Oil on canvas, 38 1/4 × 51 1/4″. The Metropolitan Museum of Art, New York. Bequest of Mrs. H. O. Havemeyer, 1929. The H. O. Havemeyer Collection

atmosphere of a pleasure hall filled with figures seen as shifting points of light reflected from the mirror in the background. The bottles, fruit, and flowers on the counter are a dazzling culmination to his interest in still life, which had begun with the discarded clothing and forgotten picnic lunch in the lower left corner of the *Déjeuner sur l'herbe*. Scenes from Parisian night life were to be the stock in trade of Degas and Toulouse-Lautrec, but neither artist, however superior his accomplishments, surpassed this last of Manet's scenes of contemporary manners.

The distinction between Manet and the younger Impressionists, which has prevailed since the first histories of the movement were written, was based less on differences in age, for they were all born within eleven years of each other, than on the tactics they used to make their work known to the public. Despite continual rebuffs, Manet never abandoned hope of recognition at the Salon. The others realized that success there would be long in coming, and by 1873 they had made their own arrangements for exhibiting work by themselves and by artists in sympathy with their aims. Edgar Degas (1834–1917) was the leading spirit behind the group, which held its first exhibition in Paris in April, 1874, under the noncommittal title of "Société anonyme des artistes, peintres, graveurs, sculpteurs." Because Degas demanded that the exhibitors pledge themselves not to submit their works to the Salon, Manet declined to join and remained apart from the group's activities. To this first exhibition Claude Monet (1840–1926) sent several

landscapes with the general title of *Impressions*. One in particular, *Impression: Sunrise* (possibly the painting now in the Musée Marmottan in Paris), attracted the attention of a journalist writing in *La Caricature*, the humorous weekly which had published Daumier's cartoons. He headed his account with the words, "Messieurs les Impressionnistes," and the joke stuck. The painters themselves disclaimed any intention of creating a program, but in 1877 they reluctantly accepted the term for their third exhibition. There were eight exhibitions in all, held at irregular intervals between 1874 and 1886. Camille Pissarro (1830–1903), the oldest of the group and one of the most desperately poor, participated in every one of the exhibitions, for they were among the few opportunities he had to bring his work before the public. Degas took part in seven of them and was always one of the prime movers. Of the other leading Impressionists, Paul Cézanne appeared only in the first and third, Monet in the first four, and Auguste Renoir (1841–1919) in the first three and the seventh. The last exhibition included works by Seurat, Signac, and Gauguin (see chap. 4) which were so different in character and technique that the end of Impressionism was clearly in sight.

The term *impression* is particularly suited to landscape painting in those situations where the artist recorded what his eye beheld in a moment of time, but it is less appropriate for the figural painters, whose compositions necessarily required contemplation and planning. The point was well taken by Degas, who once remarked that no art was "ever less spontaneous" than his.[4] He was wellborn, well educated, and well traveled, and his visual memory was stocked with images from the past, especially of the great Italian masters. To these he added the most sensitive appreciation of any of his generation for the unexpected and elliptical perspectives in Japanese prints and for the casual, offhand effects of photography. The combination of these ingredients can be seen about 1868 in his portrait of the popular French genre painter James Tissot (plate 80). The consummately discreet brushstroke perpetuates Degas' admiration for such Italian Mannerists as Bronzino and Parmigianino, while his interest in oriental art and the early German masters, then considered "primitive," is proved by the screen and the small portrait by Cranach on the wall just above the sitter's head. But the whole is more than a collection of historical tags; the disparate influences have been combined in a new and crisp arrangement, in which exact geometry is subtly altered by the juxtaposition of the Cranach portrait (which is in the center of the canvas) with the sitter's

80. EDGAR DEGAS. *James Tissot.* c. 1868. Oil on canvas, 59 5/8 × 44″. The Metropolitan Museum of Art, New York. Rogers Fund, 1939

head. The disposition of every element, in fact, witnesses to Degas' concern for the relation of each object to every other, so that even a space as shallow as the narrow area between the picture's surface and the wall behind it is charged with interest.

Degas' principal subjects, in addition to many portraits of his family and friends, were drawn from contemporary life—from the race course, from the ballet (both in rehearsal and in performance), from women working as milliners and laundresses, and from women at their toilet. In each category he was so little interested in episode or event—we never learn which horse won its race or what ballet was being rehearsed—that it can be said that he destroyed the earlier concept of genre painting as the depiction of scenes having some familiar or dramatic interest. What concerned him was the nature of movement, both as a condition of muscular activity, as in the horse or the dancer, and as a revelation of personality, as in an individual's gestures. In a later painting of the rehearsal room (plate 81) with eight dancers

resting or practicing extensions at the bar, executed when his eyesight had already so far failed that the meticulous craftsmanship of the Tissot portrait was an impossibility, the attitudes of the dancers, bound each to each by contrasting and complementary positions, illuminate the nature of the classical dance in terms of the physical stresses created within the body. Simultaneously, through implications of movement, he charged the expanse of empty floor, disposed as in a Japanese print along a diagonal entering from the lower right, with the tensions of movements yet to come. How unspontaneous such compositions were is clear when we examine others of the series to which it belongs (including some in which the center pole is missing) and the many studies of individual dancers which he brought together, with the subtlest adjustments, to form the friezelike groups in foreground and distance.

In his many studies of women at their toilet, of which the most important was a series of pastel paintings exhibited at the last Impressionist exhibition of 1886, Degas offered a solution for the depiction of the nude in modern life (plate 82). Where Manet's *Déjeuner sur l'herbe* and *Olympia* had seemed implausibly naked, Degas' women were glimpsed in the boudoir, unobserved by any but their servants, in situations where the nude would normally be found in modern life. Degas expressed the essential and logical privacy of these views when he remarked that his was a "keyhole vision" and that he represented woman in the simplicity of her animal nature, washing herself like a cat.

As he grew blinder Degas turned to sculpture in an attempt to settle, through his sense of touch, problems of anatomical construction he could no longer

82. EDGAR DEGAS. *Woman Having Her Hair Brushed (La Toilette)*. c. 1885. Pastel, 29 1/8 × 23 7/8″. The Metropolitan Museum of Art, New York. Bequest of Mrs. H. O. Havemeyer, 1929. The H. O. Havemeyer Collection

solve with his eyes. All but one of his sculptures were private experiments executed in clay or plasticene and soon discarded to lie crumbling in the studio. After his death, such as were at all intact were cast in bronze in a limited edition. The exception was the

81. EDGAR DEGAS. *Ballet Rehearsal*. c. 1891. Oil on canvas, 15 1/8 × 34 1/2″. Yale University Art Gallery, New Haven, Conn. Gift of Duncan Phillips

familiar *Fourteen-Year-Old Dancer*, which seemed at the time of the sixth Impressionist exhibition of 1881 a startling and quite exceptional exercise in sculptural Realism. The little painted wax figure wore a canvas bodice, a tulle skirt, a satin hair ribbon, and real hair. Less disconcerting are the smaller bronzes of horses, ballet dancers, and bathing nudes. Unpretentious and never intended for the public eye, the least of them contains Degas' mastery of form in movement or, as in the *Woman Wiping Her Left Hip* (colorplate 13), a combination of the most sensitive handling of material with an uncompromising attitude toward natural truth. In such terms they entitle Degas to rank among the few eminent sculptors of the nineteenth century.

Except for Manet, Degas, and Cézanne, whose father was a prosperous if miserly banker in Provence, the other Impressionists came from humble circumstances and for many years were miserably poor. It is then all the more remarkable that, despite suffering and deprivation which would have driven lesser spirits to forsake their principles for bread and paint, these men never deviated from their decision to depict the life of their times as they knew it, in ways which offered the most opportunities for presenting the visual truths of nature. Auguste Renoir, like Degas, was predominantly a figure painter, but where Degas was secretive and mistrustful, reserving his affection and his wry humor for his closest friends, Renoir was always interested in other people. The difference in their characters shows clearly in their work. Where Degas' portraits present the sitter as astute, intellectual, yet fundamentally wary and reserved, Renoir's figures invite us to share the beauty and joy which the world, in this instance the world of upper-class Parisian society, affords. In *At the Concert* (colorplate 14), with its deep but rich color pervaded by Renoir's favorite red, all is youth, grace, and ease (although one may wonder how the painter, often too poor to buy pigments and canvas, understood so well the opulent luxury of a theater box). This momentary glimpse of the pleasures

83. AUGUSTE RENOIR. *Luncheon of the Boating Party.* 1881. Oil on canvas, 51 × 68″. The Phillips Collection Washington, D.C.

of social life is a form, as it were, of psychological Impressionism common to his major works of these years—to the *Ball at the Moulin de la Galette* (1876; Louvre) and to his crowning masterpiece of holiday pleasures, the *Luncheon of the Boating Party* (1881; plate 83).

By 1881 Renoir had become dissatisfied with an art whose content and technique permitted only the depiction of what was visually as well as psychologically transient. He felt that he had come, as he said, to the end of Impressionism and decided to restudy the art of the past. While abroad in 1881 and 1882 he went to school in those greatest of all academies, the museums and churches of Italy, where he admired Carpaccio, Raphael, and the sculpture and frescoes of Pompeii. From 1884 to 1887 he worked in Paris on a large composition of bathing nudes which incorporated his new and stricter control of pictorial design. Among his many studies for this composition, one in pastel and wash (plate 84) shows him searching for the purest and simplest linear expression of the nude; its modeling is sensitive and reticent, and the contours as supple and as firm as any by Ingres. Yet the large *Bathers* (plate 85) was not altogether a success. The poses of the figures are awkward, the surface pallid and dry, as if he had at last succeeded, as he wrote a friend, in painting a "fresco in oil."[5] It is, however, a formidable moment of the anti-Impressionist reaction of the mid-1880s, and even if Renoir himself soon recovered his brilliant iridescent palette and his serene joy in the beauty of unaffected human beings, the discipline he gained by this exercise was an inestimable benefit, the more so in that by then he had suffered the first attacks of the arthritis which eventually crippled him completely.

In spite of this cruel handicap he never faltered. With brushes taped to his wrists he continued to paint until the day of his death. Inevitably, in the later work there are clumsy passages, but on the whole the compositions, often on such Classical themes as the Judgment of Paris, were as spaciously conceived as ever, and the color schemes, with vibrant reds predominating, just as joyous.

Encouraged by his dealer, Ambroise Vollard, Renoir turned in his last years to sculpture, supervising with a long wand the preparation of clay models by young assistants. Although his hands never actually touched them, such figures as the *Small Standing Venus* of 1913 (plate 86) or the larger monumental version, the *Venus Victrix* (1915–1916) are unmistakably products of Renoir's aesthetic and important instances of the reappearance of Classic subjects in twentieth-century art.

84. AUGUSTE RENOIR. *Bather*. c. 1885. Pastel and wash, 39 × 25″. The Art Institute of Chicago. Bequest of Kate L. Brewster

Of the landscape painters, Claude Monet possessed the most vigorous talent, the most adventurous imagination, and the greatest capacity to expand the expressive aspects of his art, all within the restrictions of the Impressionist aesthetic. At its purest this aesthetic was based on the novel assumption that visual perception can be the exclusive subject of pictorial vision. Courbet could not paint an angel because he had never seen one; the purely Impressionist painter could entrust to his canvas no more than what fell within the field of his vision, as that could be perceived from the particular spot where he happened to be. The spatial and temporal references of painting which in other times had embraced experiences of the past and future as well as the present, and those of the mind and imagination as well as the visual sense, had, so to speak, been reduced to whatever, and only whatever, could be seen from one place at one moment in time. When the metaphysical implications of Impressionism are

85. AUGUSTE RENOIR. *Bathers* (*Les Grandes Baigneuses*). 1884–87. Oil on canvas, 45 1/2 × 67″. Philadelphia Museum of Art. Tyson Collection

thus defined, it becomes apparent that it can be understood as a late and last manifestation in art of the Positivist philosophy dominant during the middle years of the century after its formulation and publication (1830–1842) by Auguste Comte (1798–1857). Comte had insisted that there is nothing outside ourselves but the interaction of cause and effect, and that the causes, like the effects, lie forever beyond our powers to change or to improve them. Similarly, an Impressionist picture from the early years when the character of the new painting was first defined will present the spectator with a given set of facts, observed under the particular conditions prevailing at the time of its execution, but with no inferences or interpretation provided by the artist, as in Claude Monet's early view of a wintry country road (plate 87). A few

years later, when technique had caught up with intention, as in Pissarro's view of the Crystal Palace after it had been re-erected in the London suburb of Sydenham (plate 88), there are enough precise observations for us to determine exactly where and when—at what time of the year, hour of the day, and condition of the climate—the artist observed these facts, but of his attitude or reaction toward them there is no indication whatever. The painting represents the objective visual truth of perceptual experience, of "nature just as it is," nothing less but nothing more. Of the impressive bulk of the Crystal Palace itself, one of the largest structures erected in the nineteenth century, or of the pleasures of an unusually fine Sunday afternoon of a late English winter, Pissarro says nothing.

87. CLAUDE MONET. *Route de la Ferme Saint-Siméon, Honfleur.* c. 1867. Oil on canvas, 21 1/2 × 31 1/4″. Fogg Art Museum, Harvard University, Cambridge, Mass. Bequest of Grenville L. Winthrop

86. AUGUSTE RENOIR. *Small Standing Venus.* 1913. Bronze, height 33 1/2″. The Joseph H. Hirshhorn Collection

88. CAMILLE PISSARRO. *The Crystal Palace, Sydenham.* 1871. Oil on canvas, 19 × 29″. Heirs of Henry J. Fisher, Greenwich, Conn.

The *Crystal Palace* was painted early in 1871 when Pissarro and Monet were living in England, having left France to avoid the German occupation following the disastrous end of the Franco-Prussian War. Pissarro later confessed that while in London he and Monet had been much interested in English landscape painting, especially the atmospheric effects of Turner. Monet would later deny that Turner had influenced him in any way, and it is true that the expressive and even the technical range of his and Pissarro's painting in the 1870s was very different from Turner's. But it is impossible not to feel that the extensive study of climate, which led the Impressionists, including Alfred Sisley (1839–1899), who was of English birth, to paint not merely the seasons and the principal times of day but all the modulations in between, from early autumn frosts to the last wet snows of winter (plate 89) and at all hours from dawn to twilight, had not been affected by earlier examinations of climatic conditions by Constable and Turner.

The compositional format, like the brushwork, of Pissarro's *Crystal Palace* is still tentative. The perspective space is as inexorably enclosed within converging parallel lines as in an early Renaissance work, and the brush still describes objects by following their forms, as in the lampposts, the wall, and the trees, rather than by registering the light reflected *from* the forms. But in all essential respects the Impressionist formula was already operative. When Pissarro and Monet returned to Paris in the summer of 1871, bringing with them paintings of this character and quality, the way was opened for the first exhibition of 1874.

Twenty years later the Impressionists were no longer a group of friends working together, and the

character of their art had changed both individually and in relation to the Impressionist aesthetic. Sisley remained closest to the early ideals of the movement, and until the end of his life, which was one of unremitting struggle and lack of recognition, he continued to produce well-made landscapes in the manner of the earlier years. Pissarro around 1886 had briefly tried to give his work more weight by adopting the Divisionist technique of the Neoimpressionists, but he soon tired of the painstaking effort required and by 1890 had reverted to his own earlier manner in which he produced some of his finest paintings—the views of the Seine, the Louvre, and the Tuileries Gardens—at the very end of his life (plate 90). The most disruptive element was perhaps the success which came to Monet. He was the first of the Impressionists to grow rich by his own efforts, and in 1889 his work was accorded signal recognition when a Paris dealer held a joint retrospective exhibition of his painting and Auguste Rodin's sculpture on the occasion of the International Exposition of 1889. Such success could not but discourage his friends whose luck had not yet turned, and his indifference to their difficulties did little to mitigate their disappointment. Meanwhile his own work had changed greatly. Alternating with the placid serenity of his landscapes of the Seineside villages below Paris were periods when his pictures became more rugged in design, harsher in drawing, more violent in color (plate 91). Certain landscapes of 1885 from Bordighera on the Riviera were admired by Vincent van Gogh when he first came to Paris. And by the end of the 1880s he had found a new concept of Impressionism in his serial paintings, or views of the same or similar subject presented in series. As long ago as 1877 at the third Impressionist exhibition, he had shown fifteen views of a railway station in Paris, the Gare St. Lazare, and often his views of the Seine villages comprised a group, but in each instance the painter s point of view had shifted from scene to scene. The point of view also moves from place to place in the first of the true series, the *Haystacks*, of which fifteen were exhibited in 1891, and in the *Poplars*, another series of which six were seen the following year. In a typical but splendid example of the *Haystacks* (colorplate 15) Monet has moved so close to his subject that the stack itself, one of the most commonplace objects on any French farm, acquires monumental scale. Simultaneously, the perspective plan has become much simpler; the middle ground, the distant hills beyond the river, and the sky are laid out as flat bands parallel to the picture surface. The result is a discreet but perceptible decorative effect,

89. ALFRED SISLEY. *Landscape, Snow Effect.* 1891. Oil on canvas, 23 3/8 × 32″. Sterling and Francine Clark Art Institute, Williamstown, Mass.

Colorplate 15. CLAUDE MONET. *Haystack at Sunset near Giverny*. 1891. Oil on canvas, 29 1/2 × 37". Museum of Fine Arts, Boston. Juliana Cheney Edwards Collection

Colorplate 16. WINSLOW HOMER. *The Fog Warning*. 1885. Oil on canvas, 30 × 48″. Museum of Fine Arts, Boston

Colorplate 17. THOMAS EAKINS. *Taking the Count*. 1898. Oil on canvas, 8′ 3″ × 7′ 3″. Yale University Art Gallery, New Haven, Conn. The Whitney Collection of Sporting Art. Gift of Francis B. Garvan

NEXT PAGE: Colorplate 18. JAMES McNEILL WHISTLER. *Nocturne—Blue and Gold—Old Battersea Bridge*. 1872–75. Oil on canvas, 29 3/4 × 21″. Tate Gallery, London

an adjustment of the conventions of perspective vision in the interest of a new pictorial harmony. Even more important was his exhaustive research into the nature of color and light. Objects were presented only through the light reflected from them, and the surface of Monet's picture became, as it were, a screen upon which he registered the arrival of the wave lengths of light reaching it from the objects within the picture space.

At this point one could argue, as many critics have, that Monet and other Impressionists destroyed the traditional structure of painting by dissolving form in light so that all that was left was a shapeless mass of colored vapor. To a degree this was true, but in place of the traditional concept of shape as the representation of solid objects so solidly that they invite the sense of touch, Monet created a new kind of pictorial form—the form, so to speak, of perception, rendered so subtle and sensitive that, in the *Hay-*

90. Camille Pissarro. *The Louvre from the Pont Neuf.* 1902. Oil on canvas, 23 5/8 × 36 1/4". Sterling and Francine Clark Art Institute, Williamstown, Mass.

91. Claude Monet. *The Cliff at Étretat.* 1883. Oil on canvas, 25 3/4 × 32". The Metropolitan Museum of Art, New York. Bequest of William Church Osborn, 1951

92. CLAUDE MONET. *Wisteria*. 1918–20. Oil on canvas, 59 1/8 × 78 7/8″. Allen Memorial Art Museum, Oberlin College, Oberlin, Ohio

stack, at the point in his canvas where the rays of the setting sun reach the left side of the haystack, the shock of visual sensitivity is indescribably acute. With paintings such as this, and with his renowned series of views of Rouen Cathedral, painted from 1892 and exhibited in Paris in 1895, Monet revolutionized the concept and practice of Impressionism. By scrutinizing the object painstakingly and for considerable lengths of time, he reversed its fundamental terms. The objective examination of the external world became the record of the infinite variations of subjective experience.

After 1900 Monet continued his exploration of nature in views of his water-lily garden at Giverny, on the Seine near Rouen. Obsessed with the constant movement of wind and water, and with the exchange of reflections between the clouds above and the plants growing beneath the surface of the pools, he came to conceive of painting as endlessly and rhythmically continuous. The principal masterpieces of this last phase of his life are eight horizontal canvases, arranged in two rooms especially constructed at the Orangerie in Paris. Standing within these rooms the spectator can feel himself enclosed by Monet's vision of a nature which absorbs all sounds, all sights, all color and light into itself. The many studies for these works, interrupted by his failing eyesight and an operation for cataracts in 1923, but which were continued until his death in 1926, were forgotten when interest in Impressionism declined in the 1920s and 1930s. Re-examined now, such canvases as the study of *Wisteria* (plate 92) show us a Monet whose conception of increasing size and freely flowing brushwork entitles him to a place as a forerunner, if not a pioneer, of Abstract Expressionism.

By 1875 many American painters were aware of the new developments in France, but if there are analogies between their works and those of the masters abroad, the differences are so conspicuous as to enable us to identify a kind of painting peculiar to the

conditions of American life. Both Winslow Homer (1836–1910) and Thomas Eakins (1844–1916) had been to France, Homer briefly in 1866–1867 when his painting of *The Confederate Spy* (New York, Metropolitan Museum) was exhibited at the Exposition Universelle of 1867, and Eakins in 1866–1870 when he studied with Jean-Léon Gérôme (1824–1904), a master of painstaking detail. Upon their return they, like Courbet and Manet, painted contemporary life as they saw and experienced it, or, as we might say, America just as it was. Homer, born in Boston and trained as an illustrator, worked for *Harper's Weekly* during the Civil War, sending from the battle fronts to the New York office quick sketches which were then engraved on wood by professional craftsmen. He was not interested in the horrors of war, but usually drew aspects of life in camp or the monotony of duty just behind the lines. After the war he settled in New York as an illustrator for *Harper's* and made many of the finest illustrations ever published as wood engravings in this country. In his representation of two boys fishing (plate 93) he perpetuated memories of his own New England childhood, and of the "long, long thoughts" of boyhood with unequaled mastery of dark against light and of details subsumed by larger masses. A scrupulous observer of American life, Homer rendered the local truths of woodland and meadow, of mountain and seacoast, and the varieties of the American climate with the fidelity of the committed Naturalist. A decade later Homer had passed from illustration and small genre scenes, usually of children or young people at play or on a holiday (plate 94), to simply but powerfully composed paintings of life at sea. In *The Fog Warning* (1885; colorplate 16) the

dramatic contrast between the sudden appearance of danger in the sky and the fisherman's apprehension at the distance separating him from the schooner is conveyed by the rocking rhythms of the ovoid boat against the waves, counterbalanced by the fish and repeated, as if in a minor key, by the angle of the oars against the waves and the horizon. So discreet an interpretation of the hard life of men against the sea

94. WINSLOW HOMER. *Snap the Whip*. 1872. Oil on canvas, 22 × 36″. The Butler Institute of American Art, Youngstown, Ohio

was not easily understood by Homer's contemporaries, who wanted more excitement in painting of actions such as this; as a result Homer was for many years misunderstood and overlooked. By 1890 he had almost withdrawn from the world, passing months of the year at Prout's Neck near Portland, Maine. Here he painted the large seascapes of waves breaking on the rocky New England coast, in which he interpreted the endless conflict of the natural elements with massive power (plate 95).

Homer was a contemporary of the French Impressionists, and it is tempting to see in his earlier genre scenes of the 1860s and 1870s something of the same study of light as the basis of color for the creation of form. But Homer pursued these researches no further, preferring to work with the local colors of objects, so that his paintings were never properly Impressionist. Nonetheless he disclosed, especially in his watercolors ranging from sullen, rain-swept Adirondack trout streams to the dazzling sun of the Bahamas, the specific quality of the American landscape seen in different American lights.

Thomas Eakins never withdrew, as did Homer, from the company of men, but his interpretation of human

93. WINSLOW HOMER. *Waiting for a Bite*. 1874. Wood engraving after a drawing by Homer, 9 × 13 3/4″. Sterling and Francine Clark Art Institute, Williamstown, Mass.

95. WINSLOW HOMER. *Early Morning after a Storm at Sea*. 1902. Oil on canvas, 30 1/4 × 50″. Cleveland Museum of Art. Gift of J. H. Wade

experience, whether in his portraits or in his landscapes with figures, was just as grave. He had studied in Paris in the late 1860s with Gérôme, and although he admired his teacher's literal method, he rejected the academic preference for exotic subject matter. In his first monumental painting, *The Gross Clinic* (1875; plate 96), only the figure of the patient's mother to the left introduces a note of unexpected horror. All else is matter-of-fact, even to the blood on the surgeon's hands, and the whole is a serious study of contemporary medical practice.

An even soberer colorist than Homer, and a more painstaking draftsman, Eakins was deeply interested in photography and participated with Eadweard Muybridge (1830–1904) in experiments with multiple cameras tripped in sequence, which produced the first accurate photographs of human and animal movements. This photographic quality of his painting can be seen by comparing Homer's *Fog Warning* with Eakins' *The Biglen Brothers Turning the Stake* (1873; plate 97), an incident in the sculling races on the Schuylkill River in Philadelphia which he treated several times. Preliminary drawings for such paintings prove that Eakins investigated the laws of linear perspective as conscientiously as any Renaissance master, but he avoided the trap of boxlike space and retained the accidentals of ordinary vision, as in the intentionally awkward juxtaposition of the head of the rower to the right with the boat behind him. That he was a masterly designer can be seen in the position of the stake in the foreground. Like the pole in Degas' rehearsal room (plate 81), it organizes the space behind it, so that were it removed, the all-important visual focus of the action would disappear.

Eakins was a Philadelphian and lived there all his life in spite of constant misunderstandings about his artistic intentions, especially his insistence that his students should study the model completely nude, as he had learned to do in France. The place of the nude in modern painting is, as we have seen, precarious, but through his interest in sports Eakins found a solution for at least the male nude in circumstances such as *Taking the Count* (1898; colorplate 17), one of his largest and most impressive works. Devoid of dramatic tension, it projects a moment of inner confrontation among the protagonists and imparts to the boxing ring the dignity with which Eakins portrayed the persons and events which he knew best.

96. THOMAS EAKINS. *The Gross Clinic*. 1875. Oil on canvas, 96 × 78″. The Jefferson Medical College of Philadelphia

Of his portraits of his contemporaries, many of them men and women distinguished in the arts as well as in public service, none is more moving or more powerful than the life-size image of *Mrs. Frishmuth* (plate 98), a noted collector of musical instruments. To portray so profound a dedication to music without the aid of obvious allegorical symbols was not easy. Eakins' solution was to show her seated among the choicest objects of her collection, whose unfamiliar and exotic shapes, arranged across the foreground of the canvas, suggest the esoteric character of her knowledge. Then he makes one note reverberate imaginatively throughout the picture when Mrs. Frishmuth, deep in thought, depresses one key, and only one, of the spinet. In contrast to the portraits of Degas or Renoir, this may seem too formal and far too dark. But Eakins was unsparing of the truth, and this was a period of unusually gloomy and cumbersome interior decoration. From the truths of such visual circumstances he created a statement unlike any other in its evocation of the range and depth of American culture at the turn of the century.

Eakins and Homer remain our greatest exemplars of a Naturalist point of view which like Courbet's, and Manet's through the 1860s, presented images of contemporary life with something of the solemnity of traditional art. Three American painters who were closer technically, if not always aesthetically, to the French Impressionists were those who chose, like Henry James, to pass the major part of their lives abroad. The portrait painter John Singer Sargent (1856–1925) was born in Florence of Bostonian parents and studied in Paris under the gifted but superficial Carolus-Duran. Sargent had a gift for presenting his sitters in their most characteristic attitudes, but too often his interest in psychology was compromised by the inevitable artificiality of society portraiture. Consequently his reputation has suffered, but how good he might have been, and indeed on rare occasions was, can be seen in the *Young Lady in White—Miss Elsie Palmer* (1890; plate 99). The draperies may be conventional and hastily handled (the shoe lacks a foot inside it), but the rigid frontal posture accentuated by the geometrical divisions of

97. THOMAS EAKINS. *The Biglen Brothers Turning the Stake.* 1873. Oil on canvas, 40 1/4 × 60 1/4". Cleveland Museum of Art. Hinman B. Hurlbut Collection

98. THOMAS EAKINS. *Mrs. William D. Frishmuth*. 1900. Oil on canvas, 96 × 72″. Philadelphia Museum of Art

the paneling underlines the disturbing tensions expressed in the wide, staring eyes and repressed by the tight lips. Miss Palmer's fate may not have been so dire as some of Henry James's heroines', but one cannot help feeling that she would have understood the implications of such a tale as *The Turn of the Screw*. Such painting, however, is technically more academic than Impressionist. For Sargent's understanding and experience of sunlight one must turn to the watercolors he painted whenever he had a chance to work informally out of doors.

Our most renowned expatriate artist was James McNeill Whistler (1834–1903). He had been born in Lowell, Massachusetts, and brought up in Russia where his father was working as a military engineer. After a few months at West Point, from which he was expelled for failing chemistry, he worked as an illustrative engraver before reaching Paris in 1855. He never returned to the United States but divided his time between France and England. He was in Paris in the 1860s, where he knew the leaders of the new Naturalism—Fantin-Latour, Manet, and the poet Charles Baudelaire—with whom he appears in Fantin's *Homage to Delacroix* of 1864, and Courbet, with whom he painted on the Channel coast. But he preferred to live in England where his fantastic manners and outrageous wit made him both the favorite and the whipping-boy of London society. Whistler's training had been meager and his craftsmanship was always uncertain. Critics complained of his inability to draw, but if the hands and feet in his portraits are often fudged, he drew well enough for his purpose. He was less a draftsman than a colorist, and less interested in color than in tone. Above all, he had an exquisitely eclectic taste which enabled him to combine dissimilar elements in a new and personal synthesis. In so early a portrait as *Harmony in Grey and Green: Miss Cicely Alexander* (1872–1874; plate 100), painted when he still troubled to take pains, the Spanish pose and faintly Spanish dress, like those of an infanta by Velázquez, are combined with the carefully proportioned verticals and horizontals of Japanese design, suggested also by the spray of flowers at the right and the matting on the floor. Whistler's understanding of Japanese art was as secure as his enthusiasm for it, and his appreciation of oriental understatement pervades this portrait, the tenderest of all his depictions of childhood. It is only equaled, although not surpassed, by two similar adjustments of personality to the most delicate balance of line and shape, his portraits of his mother (1871) and of Thomas Carlyle (1873), to which he gave the impersonal titles of *Arrangement in Grey and Black, No. 1* and *No. 2* to call attention to the abstract harmony of the pictorial elements.

Whistler understood French Impressionism but preferred to exploit his own intensely subjective reaction to, or impression of, a landscape. He preferred twilight to noon, and the misty reaches of the Thames at Chelsea with the farther factories dimmed by smoke at sunset to the sparkling reach of a French river on a sunny day. In his painting of fireworks bursting in the night sky behind the old wooden Battersea Bridge (colorplate 18), the faults of drawing (the figure on the boat is only a jumble of brushstrokes) are of no consequence beside his discovery of the poetry of the modern urban scene. A similar *Nocturne*—the musical titles in his works are evidence of his desire to awaken in the spectator tonal rather than formal sensations—*The Falling Rocket* of about 1874 (Detroit Institute of Arts), was bitterly attacked by the critic John Ruskin, who stated that he

99. JOHN SINGER SARGENT. *Young Lady in White—Miss Elsie Palmer*. 1890. Oil on canvas, 75 1/8 × 45 1/8". Colorado Springs Fine Arts Center

Colorplate 19. PAUL CÉZANNE. *The Basket of Apples*. c. 1890–94. Oil on canvas, 25 3/4 × 32″. The Art Institute of Chicago. The Helen Birch Bartlett Memorial Collection

Colorplate 20. GEORGES SEURAT. *The Channel at Gravelines—Petit Fort Philippe.* 1890. Oil on canvas, 29 × 36 3/4″.
Art Association of Indianapolis, Herron Museum of Art

100. JAMES MCNEILL WHISTLER. *Miss Cicely Alexandar:
Harmony in Grey and Green*. 1872–74. Oil on canvas,
74 3/4 × 38 1/2". The Tate Gallery, London

had "never expected to hear a coxscomb ask a hundred guineas for flinging a pot of paint in the public's face." Whistler sued for libel and technically won his case, but the jury's award of a farthing's damages was a moral justification for Ruskin and forced Whistler into bankruptcy. The case was notable for Whistler's wit under cross-questioning, but the more fundamental issues of the artist's right to paint as he chooses and to ignore or even avoid literal resemblances, which has been construed as a step toward abstraction, went unobserved at the time.[6]

Mary Cassatt of Philadelphia (1845–1926) lived and worked for many years in France and enjoyed the rare privilege of Degas' friendship. In her color and in her devotion to contemporary incidents she is one with the French Impressionists, even if the expressive range in her paintings, including her deft pastels of mothers with babies and small children, is much narrower. In 1891 she exhibited a set of twelve colored etchings, strongly influenced by Japanese prints, which are among her strongest works (plate 101).

During the last two decades of the nineteenth century the theory and practice of Impressionism spread throughout the Western world. In many countries it was too quickly accommodated to conventional systems of representation, especially in portraiture and figure painting. The Swedish artist Anders Zorn (1860–1920) and the Spanish painter Joaquín Sorolla y Bastida (1863–1923) resemble Sargent in their use of a flashing technique which is at least by definition Impressionist in the intensity with which it captures the appearance of forms dissolved by light in portraits and genre scenes that would not have been very different had they been painted some other way. In Germany, Max Liebermann (1847–1935) is counted as an Impressionist, but although he adopted the Impressionist brushstroke and studied the effects of light on objects, his palette was never so clear, and he painted figure subjects, including many peasant scenes, more often than pure landscapes. More orthodox examples of Impressionism can be found in the early work of the English painter Philip Wilson Steer (1860–1942) and of the Americans Childe Hassam (1859–1935) and J. Alden

Romantic Realism to Naturalism and Impressionism / 117

Weir (1852–1919), whose view of the ungainly out-
skirts of a small New England factory town under a
hot summer sky (plate 102) shows that objectivity in
facing facts which marked the development of
American Realism in the paintings of The Eight early
in the new century (see below, pp. 277–83).

101. MARY CASSATT. *The Bath*. 1891. Drypoint, soft-ground,
and aquatint in color, 12 1/4 × 9 3/4″. The Metropolitan Museum
of Art, New York. Gift of Paul J. Sachs, 1916

102. J. Alden Weir. *Willimantic Thread Factory*. 1893. Oil on canvas,
24 1/8 × 33 3/4″. The Brooklyn Museum, New York

Postimpressionism and Symbolism

The word *Postimpressionism* has been used since 1910 to indicate various developments in painting after the middle 1880s which had brought a sharp and irreconcilable distinction between the orthodox Impressionism of the late 1860s and 1870s and the work of four men in particular—Cézanne, Seurat, Gauguin, and Van Gogh.[1] Without the experience of Impressionism each would never have become the artist he did, but each modified its basic tenets to such an extent that the art of the future, whether Expressionist, Cubist, abstract, or nonobjective, can be traced to their revisions. Such, of course, cannot be said for the changing but continuous Impressionism of Monet, Renoir, and Degas. The new term, although indicating only a chronological demarcation, has proved useful.

The break between earlier Impressionism and the new tendencies was clearly perceptible by 1886. The last Impressionist exhibition that year was dominated by such younger artists, friends of Pissarro's, as Georges Seurat and his gifted disciple Paul Signac, and Paul Gauguin. Odilon Redon, an older painter already recognized by the younger men as an important guide, was also present. Taken together, their works showed that for them Impressionism had proved inadequate because it failed to impose a strong discipline of design and was unable to account

for the multiplicity of states of mind. The first objection had already been raised by Renoir, and Monet's investigation of the slightest alterations in climatic conditions could be considered evidence of his desire to enlarge his perceptual experience, but neither artist thought of abandoning the appearance of things. For the new generation art was to be a means for recovering the totality of consciousness as central to human experience.

The artistic crisis of the 1880s also occurred in the world of letters, with the frequent repercussions between painting and poetry which have been more conspicuous in French than in English or American cultural history. The 1880s also saw the appearance in book form of Rimbaud's *Les Illuminations* (1886) and of Mallarmé's collected *Poésies* (1887), and the publication in 1886 of Jean Moréas' manifesto of literary Symbolism, which gave a name to the new movement. In 1891 a young critic, Albert Aurier, in an essay on "Le Symbolisme en peinture" published in the influential *Mercure de France*, adopted the term for the painting of Gauguin and Van Gogh. Common to all these manifestations was a belief that facts were useless in and of themselves and acquired significance only when they were converted into, or understood as, symbols of experiences otherwise incapable of expression or communication.

Of the Postimpressionist masters Paul Cézanne (1839–1906) was most closely tied to Impressionism through his long friendship with Pissarro, Degas, Monet, and Renoir, whom he met while studying in Paris in the early 1860s. He attracted attention at the first Impressionist exhibition with a clumsy but powerful landscape, *The House of the Hanged Man at Auvers* (Louvre), which despite its dramatic title was a village street scene much like Pissarro's of that period. Cézanne worked closely, one might even say studied, with Pissarro during the 1870s, but a decade later he had mastered his own technique and found his personal color scheme, in which red and yellow were accents for delicate greens and blues placed on the canvas with short, square strokes. He exhibited twice again with the Impressionists, but from 1877, when the first of his *Bathers* was seen, until 1895, when Ambroise Vollard held the first retrospective exhibition, his paintings were unknown to the public and could be seen only at his paintseller's in Paris. Whether Cézanne lost or gained by remaining for almost twenty years out of touch with the public and the critics is debatable, but when he did reappear, his works shocked and excited a new generation of younger artists with consequences decisive for twentieth-century painting.

Cézanne was always convinced that an artist must base his practice on the close scrutiny of nature, but his own observations were so prolonged as to attract comment. For long periods of time he gazed at his motif, whether landscape, still life, or the figure, until after much hesitation he put one stroke upon the canvas. His practice was thus very different from the orthodox Impressionist's, whose pictures could be conceived and executed on the spot within a space of time governed by the prevailing atmospheric and climatic conditions. Cézanne's late landscapes were painted near his home at Aix-en-Provence in southern

103. PAUL CÉZANNE. *Mont Ste-Victoire with Viaduct.* 1885–87. Oil on canvas, 25 5/8 × 31 7/8". The Metropolitan Museum of Art, New York. Bequest of Mrs. H. O. Havemeyer, 1929. The H. O. Havemeyer Collection

France, where a succession of cloudless days can occur in all seasons. He could return day after day to the same spot, bringing his picture slowly toward the end he so rarely achieved to his own satisfaction. But the difference between these two modes of work is more than technical. Upon it depends the more powerful composition of his canvases, their greater solemnity of expression, more subtle coloration, and more complex perceptual structure.[2]

The evidence supplied by photographs of sites painted by Cézanne and little changed since his day is not needed to prove that in such a landscape as the *Mont Ste-Victoire with Viaduct* (plate 103) there is more than would have met the eye of a casual spectator. As he returned again and again to his easel, he could not help but see the principal elements—trees, small cubical houses, the distant viaduct, and the mountains closing the horizon—with eyes enriched by the perceptions of the day before and of the day before that. He constantly spoke of his difficulty in "realizing his sensations," by which he must have meant that his perceptions of nature, gathered through prolonged observation, revealed to him much more of the character of objects as they exist in space and are seen through time than could ever have been captured or understood in a single instant. It is for this reason that Cézanne's perspectives are so disconcerting, conforming as they must to his repeated observations taken from ever-so-slightly shifting positions, rather than to an instantaneous view forever caught and held in a moment of time.

Like Degas', this art was anything but spontaneous. In the construction of each picture Cézanne's hand mediated between his eye and his memory until the final work, unlike the typical Impressionist landscape, had an artistic reality more powerful, more convincing, one might say, than the actual site depicted. In Pissarro's *Crystal Palace* (plate 88) we may feel that the view, for all its charm, is no different, no less and no more persuasive, than what we would have seen had we been there ourselves. In *Mont Ste-Victoire*, on the contrary, the actual landscape is insignificant by comparison with the strength and purpose of the painting, its trees braced against the sky and the far slopes, the middle ground unfolding in directions which expand and enrich our own visual sensations as we probe the distances.

Cézanne's conception of space as dependent upon the interrelations of the objects contained within it can be studied in his still lifes, of which *The Basket of Apples* (colorplate 19), painted probably early in the 1890s, is unique among his later works in being signed. Since the later Middle Ages the still life,

emerging as an independent form of painting from the accumulation of symbolic objects in religious pictures, has in its own way come to symbolize degrees of secular satisfaction, whether of the well-laden dinner table in seventeenth-century Dutch painting, or in the more modest joys of domestic life, suggested by the kitchen utensils so lovingly arranged by Chardin. Cézanne's, on the contrary, contain no references to specific situations. Some fruit, a plate of cakes, a bottle, and a cloth were near at hand and were brought together, not as objects of interest in themselves, but as components in a structure where their purpose is to define the character of the space they inhabit. The disparity between their indifferent existences and the monumental parts they play in this supremely coherent composition is matched by Cézanne's daring in pushing toward absolute and hence abstract design by depriving objects of their accustomed meanings even as he persuades us that these things are as they are seen to be.

Cézanne's multiple and broken perspectives were one of the principal stumbling blocks for those who first saw his work in public exhibitions, and it has long been customary to explain away his apparently illogical distortions by insisting that the formal pressures established within the composition obliged him to alter natural appearances. Thus in *The Basket of Apples* the silhouette of the bottle seems to have been affected by the presence of the tilted basket beside it; were the bottle symmetrical it could not simultaneously participate in the construction of the objects to the left and right of it. More serious is the state of the table. Neither the front nor the back edges are continuous, and if the cloth were removed the table would appear broken down the middle. On the other hand, the composition as a whole would lack tension among its several parts, an element of dynamic instability, were the table entirely whole. What Cézanne must have known, his senses sharpened by perceptions more acute than those of his critics, is that objects are actually not always seen as continuous when they lie one behind another, and that if such truths of partial vision are omitted, the whole will lack the vitality and hence the reality of life.

As a figure painter Cézanne worked so slowly (he is said to have required more than one hundred sittings for his portrait of Ambroise Vollard) that it might be thought he would have extracted all life from his subjects; but the portrait of an unknown man (plate 104), painted probably about 1898, proves that he could catch, if not a likeness, which we have no way of judging, at least the feel of a personality

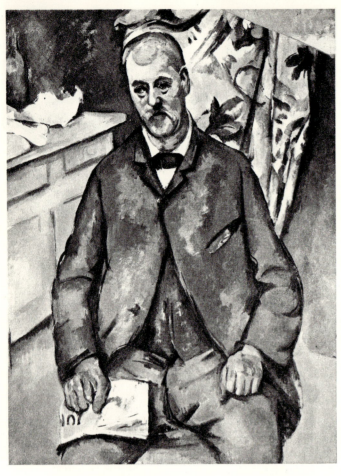

painfully been seeking, these last large paintings contain many uneasy compromises between fact and convention, but they also possess a grandeur of conception, a nobility of purpose, and a breadth of form unique in the history of nineteenth-century paintings of the nude. Beside them, even Manet's epochal *Déjeuner sur l'herbe* looks frivolous.

Cézanne's ceaseless study of his perceptions of the position of objects in space as they are revealed by light and color had been basically intuitive. To the same research his younger contemporary Georges Seurat (1859–1891) brought a supremely disciplined mind. Whereas Cézanne in his youth had been drawn to the masters of Baroque drama, to Rubens, and to the seventeenth-century French sculptor Pierre Puget, Seurat preferred such masters of Classically controlled form as Piero della Francesca and Ingres. His teacher at the École des Beaux-Arts had been a pupil of Ingres, and it is with Ingres' line alone that Seurat's drawings in soft black pencil on rough-laid paper can be compared. Ingres was a master of contour; Seurat saw forms enveloped in the penumbra of shadows as a result of his exhaustive examination of the nature of light. From scientific treatises he learned of the interactions of colors upon each other, and by reducing the number of colors on his palette and applying pigments in very small spots he controlled their interactions with the greatest precision. The Impressionists have often been charged with using "broken color," but a patch of green in an Impressionist painting is almost always of green paint, not strokes of blue and yellow laid side by side in the hope that they will fuse in the spectator's eye. Seurat, however, did construct purple from small spots of blue and red, and with his system he could also indicate how a strong red, near an orange, for instance, will induce in the adjacent color a reflection of its own complementary, green.

Seurat called his technique Divisionism because he had divided his colors into their physical constituents, but his theory and practice, together with those of his followers, were soon described as Neoimpressionist, to indicate their relation to the earlier work of the Impressionists proper and his new point of departure.[3] Like the Impressionists, Seurat and his followers were committed to the depiction of contemporary life, so that landscapes and figure scenes constitute the bulk of their work, but they impose upon the indiscriminate casualness of everyday experience a hieratic order and Classic calm. Given such painstaking technique their subjects, whether human beings or trees, were obliged

defined as much by clothes and posture as by the face. And Cézanne has told as much about middle age and the middle class as he has about the individual. The composition, although unfinished in the upper right corner and down that side, is a remarkable example of Cézanne's desire to create, through two- and three-dimensional relations, a coherent whole. Through the thrust of the figure toward the left, balanced by the chest of drawers turning deep into space, and the interlocking of the drapery with the coat, whose right side continues the unseen triangle of the drapery to its downward apex in the man's left hand, Cézanne bound one thing with another to hold firmly in place a design whose potentials for expression might otherwise have torn it apart.

In a series of paintings of bathing nudes (plate 105), upon which he worked during the last years of his life, Cézanne attempted a final interpretation of nature in terms of the European tradition of figure painting which he so much admired, as we know from his many drawings after the masters of Baroque painting and sculpture. Because he was unwilling to suppress the truths of vision which he had for so long and so

to stand stock-still. The result, in the first and greatest of all Neoimpressionist paintings, Seurat's *Sunday Afternoon on the Island of the Grande Jatte*, a favorite resort near Paris (plate 106), surprised and dismayed the spectators at the last Impressionist exhibition by its vast dimensions and the weird gestures of its many figures seemingly frozen motionless on a warm sunny day. Seurat himself said that he wanted to interpret modern life with the processional feeling of the Parthenon frieze, and that is what he did. Today we can admire the skill with which he created elegant figures from the ungainly costumes of the day and placed them in a deep space whose perspective, receding along a steeply rising diagonal, recalls those of Tintoretto. This space, including the area of river to the left, is organized through repetitions and recalls of similar figures singly or in groups of twos and threes. The subject was still Impressionist—ordinary people seen in the light of common day—but the presentation of the theme in the manner of the noblest Classic art was new. By imposing his hieratic vision upon his own times, Seurat became one of the architects of the structural vision of the twentieth century.[4]

In his short working life he painted only some seven large pictures in his studio during the winter months, among them *La Parade* (*The Sideshow*) (New York, Metropolitan Museum of Art) and *The Models* (Merion, Pa., Barnes Foundation). In the summer he painted landscapes along the Channel coast. In the reproduction of *The Channel at Gravelines* (1890; colorplate 20), the overall pattern of his spots can be seen, as well as the subtle gradations from light to shade and the sharp demarcations of shadow, the whole shimmering tissue of color supported by the firm arc of the roadway and the repeated shapes of the stanchions, the lighthouse, and the sailboats. The absence of human figures fills the silence with a strange suspense, remarked a critic at the time, a silent poetry which distinguishes Seurat's "new" Impressionism from the clatter of many earlier seaside scenes.

The fundamental principles of Impressionism had been deflected by Cézanne and Seurat from the instantaneous recording of seemingly chance perceptions to a new concern for the stability and continuity of perceptual experience and of structural design, but its energies were not yet exhausted. Through the 1890s and far into the twentieth century a modified form of Impressionism was practiced by Édouard Vuillard

105. PAUL CÉZANNE. *Bathers*. 1900–1905. Oil on canvas, 51 × 76 5/8". National Gallery, London

106. GEORGES SEURAT. *Sunday Afternoon on the Island of the Grande Jatte.* 1884–86. Oil on canvas, 6′ 9″ × 10′. The Art Institute of Chicago. The Helen Birch Bartlett Memorial Collection

(1868–1940) and Pierre Bonnard (1867–1947). They have become known as "Intimists" because of their exceptionally private interpretation of the life around them. Vuillard excelled in small paintings of interior scenes in which the play of lamplight over the furniture, the textiles, and the flowers, as much as the postures of the figures themselves, characterized their personalities (colorplate 21). Bonnard worked on a larger, often a very large, decorative scale, but in interior scenes, where the human figures were often banished to the edges, the inanimate objects—the fruit upon the table or a vase of flowers—became the active protagonists. The diffused but brilliant colors in his landscapes of the south of France, controlled by his extreme sensitivity to the nuance of hue, were the last radiant diffusion of Impressionist practice (plate 107).

In the early 1890s Vuillard and Bonnard were members of a group of young painters calling themselves the Nabis, after the Hebrew word for prophet. Their elaborate secret ritual, which included mystical passwords and monthly dinners, recalls the pseudo-mystical practices of the Rosicrucian movement which flourished in Paris just then, but their serious artistic ideas came from one of their number, Paul Sérusier (1863/4–1927), an indifferent painter but an enthusiastic disciple of Paul Gauguin. For a few years they explored the decorative possibilities of flat, two-dimensional design with broad areas of unmodulated color in the manner of Japanese prints. The spokesman for the group was Maurice Denis (1870–1943), who proclaimed in 1890 that "a picture, before being a war horse, a nude woman, or some sort of anecdote,

107. PIERRE BONNARD. *In a Southern Garden.* 1913. Oil on canv[as]
33 1/8 × 44 1/2″. Kunstmuseum, Bern, Switzerla[nd]

8. MAURICE DENIS. *April*. 1892. Oil on canvas, 14 3/4 × 24″. Rijksmuseum Kröller-Müller, Otterlo, The Netherlands

is essentially a surface covered with colors arranged in a certain order."[5] Denis was certainly not thinking of a totally abstract art, but what he meant can be seen in his *April* (plate 108), which is indeed more interesting for its arrangement of colors and lines than for its attenuated and vapid subject matter. The repetition of the figures along the diagonal (entering from the right in the manner of Japan) recalls Seurat, but the rhythmical contours and the continuous interlaces in the lower left corner were to stimulate the development of the outstanding decorative achievement of the 1890s, the style known as Art Nouveau (see below, pp. 177–79). After 1900 the Nabi movement disintegrated when the members ceased to exhibit together and Vuillard and Bonnard found their personal styles. But from the death of Van Gogh in 1890 and Gauguin's departure for Tahiti the following year until the emergence of the Fauves in 1905, the Nabis, with the Neoimpressionists, were recognized throughout Europe as the principal progressive painters among the younger generation.

The 1890s witnessed the revival and expansion of several aspects of the graphic arts. Ambroise Vollard's portfolios of colored lithographs, the two *Albums des peintres-graveurs* of 1896–1897 and the unpublished collection of 1898, raised to the level of a fine-art medium a technical process which had heretofore been used principally for commercial purposes (plate 109). The relatively new medium of advertising also contributed to a new graphic expression, the poster. The first posters to be put in public places throughout a city were

110. JULES CHÉRET. *The Dance.* 1891. Color lithograph, 46 3/4 × 32 1/4″. Sterling and Francine Clark Art Institute, Williamstown, Mass.

comparatively small and at first restricted to one or two colors. The versatile designer Jules Chéret (1836–1933) produced a notable series of commercial designs from 1866, of which some for the circus were used by Seurat for his own circus painting now in the Louvre (plate 110). In 1889 Bonnard created a commercial poster for *France-Champagne*, the first of the distinctly new type based on the flat patterns of Japanese prints which reached a climax in the posters of Toulouse-Lautrec.

The physical misfortunes of Henri de Toulouse-Lautrec Monfa (1864–1901), who suffered from a bone disease which prevented his legs from growing, made him a figure of pathos and ridicule. But, an aristocrat by birth and temperament, he ignored his handicaps in the pursuit of his art. Disdaining the social position of his family, he settled in Montmartre, which had become the center of Parisian night life, and chose his companions from among those who also lived on the fringes of society. Had Lautrec not been so greatly gifted, his work might have constituted only footnotes to the theatrical and cabaret history of the day. But he was much more than the chronicler of

109. ÉDOUARD VUILLARD. *The Avenue.* 1899. Color lithograph, 12 1/4 × 16 1/4″. From the series *Paysages et Intérieurs.* Sterling and Francine Clark Art Institute, Williamstown, Mass.

squalor. A devoted disciple of Degas and, like the older master, aware of the aesthetic principles of oriental art, he created from Degas' oblique and caustic vision and from Japanese line and perspective his own inimitable style (plate 111). He was primarily a draftsman, and his best paintings were often only slightly sketched with the brush and washed with traces of color. Of his many representations of entertainers, those of Yvette Guilbert are the most memorable (plate 112). Photographs of the enchanting singer indicate that she was prettier than Lautrec made her out to be, but if she is remembered now as a supremely comic *diseuse*, it is because of Lautrec's exaggeration of her snub nose, wide mouth, and pert expression, with the black gloves which have become almost as much his symbol as hers.

in 1896 one of the most elaborate and certainly the most beautiful of nineteenth-century English books, the folio edition of the works of Chaucer, but the text and illustrations (by Burne-Jones) were cast in so medieval a style that it represented rather an end to Pre-Raphaelitism than a new beginning. Yet from Pre-Raphaelitism came one of the most precocious and daring of the designers of the 1890s, Aubrey Beardsley (1872–1898). His first book, Malory's *Morte d'Arthur* (1892), was deeply indebted to Rossetti and its illustrations were as medieval as its contents required. The next year he abruptly announced his personal manner in a series of pen-and-ink drawings for Oscar Wilde's tragedy of *Salome*, published in 1894 (plate 113). To the lingering traces of Pre-Raphaelitism, particularly in the faces, he added his knowledge of the linear precision of Greek vase painting, the patterns of Japanese prints, and a reference to Whistler

111. HENRI DE TOULOUSE-LAUTREC. *At the Moulin de la Galette.* 1889.
Oil on canvas, 35 × 39 7/8".
The Art Institute of Chicago

The themes of Lautrec's art are not many, for he rarely strayed far from the cabarets, the circuses, and the *maisons closes* of Montmartre. Its true range is found in his sensitivity to personality, his generosity toward others' faults, his discovery of kindness beneath irony—in sum, a tolerance of human error which was strangely lacking in the work of Degas.

Comparable to the development of the modern poster in France was the attention given to the design and illustration of fine printed books in England. At his Kelmscott Press William Morris (1834–1896) created

112. HENRI DE TOULOUSE-LAUTREC. *Yvette Guilbert Taking a Curtain Call.* 1894. Gouache on paper, 16 3/8 × 9". Museum of Art, Rhode Island School of Design, Providence

113. AUBREY BEARDSLEY. *John and Salome*. 1893. Pen and ink on paper, 9 1/8 × 6 1/2". Fogg Art Museum, Harvard University, Cambridge, Mass. Bequest of Grenville L. Winthrop

(the butterflies and crescents on Salome's robe resemble Whistler's signature and his peacock designs). The public was shocked by the erogenous character of Beardsley's work, some of it frankly pornographic, but its stylistic originality could not be denied. His line, alternately brittle and insinuating, his brilliant decorative play of line and shape, and his feeling for the "color" of black and white have never been excelled. Quite apart from the morbid content of his work, they were important ingredients in the formation of the English and Scottish versions of Art Nouveau.

The unhappy and unfortunate lives of Paul Gauguin (1848–1903) and Vincent van Gogh (1853–1890) crossed only once, briefly and tragically at Arles in the late autumn of 1888, but together they have come to stand as archetypes of the isolation of the modern artist from society and his alienation from the dominant cultural values of his day. However much conditions have changed in the twentieth century, that isolation was real enough for them, a miserable handicap which dogged their days until one died by his own hand and the other almost of despair. Their courage in following their chosen artistic directions

can be measured by the fact that Van Gogh sold but one picture during his lifetime, and Gauguin but a handful. Yet to interpret their art, as has so often been done, solely as the visible expression of their biographies would obscure the originality and integrity of their work, which took the form it did in spite of, rather than because of, their sufferings.

Gauguin was a successful partner in a Parisian brokerage firm, a collector of works of art, and an amateur painter of considerable promise before he began working, when time afforded, with Pissarro. By 1883, having mastered the elements of Impressionism, he resigned from business to become an artist. His decision, which led to a permanent and bitter separation from his wife and his five children whom he deeply loved, called into question the nineteenth century's whole scale of material values. The price society exacted for his artistic freedom was eventually total poverty and, in his decision to seek a simpler existence in the remote Pacific, expulsion from its midst.

The paintings Gauguin exhibited at the last Impressionist exhibition were respectably but unspectacularly Impressionist. At Pont-Aven in Brittany in the summer of 1888 he encountered a much younger artist, Émile Bernard (1868–1941), who was already working with two-dimensional patterns and colored areas enclosed by heavy black lines like the *cloisons* in medieval enamels (hence the name he gave his method, *cloissonisme*). Bernard was also interested in medieval art, Japanese prints, and the arts of other non-European cultures, which were then considered "primitive." Gauguin enthusiastically embraced the new manner and in it executed in 1888 his *Vision after the Sermon—Jacob Wrestling with the Angel* (Edinburgh, National Gallery of Scotland), in which he combined the heads of peasants leaving the church with the image in their minds of the text of the sermon they had just heard. In *The Yellow Christ* (colorplate 22) of the next year he used as his model a painted wooden crucifix hanging in a nearby village church.

The flat, unnaturalistic colors of the yellow crucifix and vivid orange trees, and the arrangement of the landscape as a series of superimposed zones, were then as technically "primitive" as the folk sculpture and the peasant costumes. To this may be added Gauguin's interest in "primitive" emotional situations, the peasants' piety in contrast to the sophisticated religion of the cities.

When poverty and his disgust with the Parisian art world, aggravated by his failure to sell his works, led him to leave Europe for the French colony of Tahiti, his style was already formed. In place of the shifting

tonalities and complex nuances of Impressionist color, he was using deeply saturated hues, often confronting primary reds and yellows with their complementary greens and purples. Color spread in broad areas and with simplified contours marking the divisions between them were his means of escaping the shackles of probability which he felt had hampered the Impressionists. The world was no longer a set of facts inexorably governed by cause and effect, but an illusive realm in which ordinary objects might have mysterious meanings.

Gauguin's transformations of Tahitian life were actually less drastic than they appeared when he exhibited them upon his return to Paris in 1893. Such familiar paintings as *Hina Te Fatou—The Moon and the Earth* (New York, Museum of Modern Art) or *Te aa no Areois—Queen of the Areois* (New York, coll. Mr. and Mrs. William S. Paley) would have been inconceivable without the precedents of Ingres and Egyptian sculpture, photographs of which Gauguin carried in his luggage. A group of woodcuts, printed during his two-year sojourn in Paris, were more audacious. Using simple tools and fibrous tropical wood of poor quality, he cut and gouged the planks with no concern for a felicitously turned line (plate 114). The results, printed by hand in colors differing with each impression and with the marks of the instruments and grain of the wood preserved, revolutionized the techniques of European print making.

After his return to Tahiti in 1895 and his removal to the farther islands of the Marquesas in 1901 his methods became still more "primitive." In *Te Rerioa —The Dream* (1897; plate 115), which may represent the interior of his native hut with his own carved frieze, the strained perspective and postures of the figures, the discrepancies in scale between the adults and the sleeping children, and the tendency of the contours of the principal figure to become straight lines are constant elements in his decorative aesthetic. The meanings conveyed by the Tahitian titles, which he insisted should be used in exhibiting his works, are often inscrutable, hinting at overtones of feeling, at the use of signs as symbols of states of mind. The largest and most mysterious of all his canvases, the *Where Have We Come From? What Are We? Where Are We Going?* (1897; Boston, Museum of Fine Arts), presents his ideas of the passage from birth to death in terms of Tahitian figures wandering in a majestic tropical landscape.

During his lifetime Gauguin's works were largely ignored by public and critics alike. Attention was first called to them by a memorial exhibition in Paris after his death in 1903, when his incomparable color and

114. PAUL GAUGUIN. *Auti Te Pape—Women at the River.* 1891–93. Woodcut on endgrain boxwood, printed in color with stencils, 8 1/8 × 14". The Museum of Modern Art, New York. Gift of John D. Rockefeller, Jr.

mastery of decorative design, quite as much as his discovery of the significance of primitive arts and primitive states of feeling for contemporary expression, entered European art with their endorsement by the Fauves (see below, p. 184).

The Dutch painter Vincent van Gogh was the son of a country clergyman whose three brothers were art dealers in Amsterdam and The Hague. Until he was twenty-four Vincent, as he called himself after he went to live in France, floundered between the two careers until in 1880, having failed as a theological student and lay missionary, he decided to become a painter. His conception of painting as expression, and fundamentally self-expression at that, appears again and again in the hundreds of letters he wrote his younger brother Theo, who supported him during the last five years of his life. What Van Gogh wanted to express was his compassion for humanity, especially for the humble, the poor, and the dispossessed. Such themes were incompatible with Impressionism, which admitted no sentimental inferences, but Van Gogh, although wracked by sentiment himself and a great admirer of the academic subject paintings reproduced in popular illustrated papers, was too technically inexperienced to master traditional modes of representation. His early peasant scenes executed in Holland at his father's house are powerful but clumsy, crudely drawn, and darkly colored. But that his innate sensibility was stifled only by a lack of experience can be seen in certain still lifes of common garden flowers and vegetables (plate 116), in which the choice of each form and of its position in relation to every other foretells the supreme harmonies he was to

115. PAUL GAUGUIN. *Te Rerioa—The Dream.* 1897.
Oil on canvas, 37 1/2 × 51 1/4″. Courtauld Institute
Galleries, University of London

116. RIGHT TOP:
VINCENT VAN GOGH. *Still Life with Apples and Two Pumpkins.* 1885.
Oil on canvas, 23 1/2 × 33 1/4″. Rijksmuseum Kröller-Müller,
Otterlo, The Netherlands

117. RIGHT BOTTOM:
VINCENT VAN GOGH. *Fishing Boats at Saintes-Maries-de-la-Mer.* 1888.
Oil on canvas, 25 3/4 × 31 1/2″. Stedelijk Museum, Amsterdam

achieve in the flower pieces painted a few years later in the south of France.

A few months at the academy in Antwerp in the winter of 1885–1886 opened his eyes to Japanese prints and to French Impressionism, which he came to know in its full splendor when he reached Paris in February, 1886. He stayed there two years, studying the Impressionists and meeting such younger artists as Seurat, Bernard, and Toulouse-Lautrec. But the competitive life of Paris strained his health—he suffered from an epileptoid condition aggravated by starvation and overindulgence in tobacco and alcohol—so that two years later he went south to the small town of Arles, in Provence, hoping to recover his health in a gentler climate and a kindlier society. He found neither. Provence was either too hot or too cold, the mistral blew his canvas from the easel, and the townspeople were suspicious of his odd behavior. In his loneliness he pled with Paul Gauguin to share his life; together they might bring about his dream of an ideal community of artists engaged in common tasks.

In the interval between his arrival in Arles and the coming of Gauguin in October, Vincent painted some of his finest and least turbulent pictures. The *Fishing Boats at Saintes-Maries* (plate 117) shows him in complete control of his subject and of his means of expression. The water toward the right may not be entirely convincing, but the crisp drawing and taut design of the boats on the shore show his faculty for grasping the formal character of an object and setting it down with the fewest possible lines and colors. He had found his linear patterns in Japanese prints, but his brilliant colors, principally yellow, red, and green, were his own intensification of the Impressionist palette, especially as he found it in Monet's dramatic Riviera canvases of the mid-1880s. The regular pattern of brushstrokes in the sky, radiating like a halo from the point of most intense illumination, can be traced to his study of Seurat's Divisionism, although he lengthened the Neoimpressionist's tiny dot to a sweeping stroke.

Gauguin's presence alleviated Vincent's loneliness but increased his excitability. Where he was passionate and naïve, Gauguin was sophisticated and shrewd. Their conversations, as Vincent wrote his brother, became so "electric" that on Christmas Eve he lost his self-control, attacked Gauguin with a knife, and mutilated his own left ear. When he recovered, he understood that further treatment was required and voluntarily entered the asylum of Saint-Rémy near Arles, where he remained almost continuously until May, 1890, painting whenever his condition permitted. It is important to note, however, that

Vincent never painted except when his mind was lucid. His works are not the productions of a madman, for in his madness he could not paint.

During the months in the asylum he took stock of himself, returning to the masters he revered to make copies of their works from engravings and other reproductions. In his version of a *Pietà* by Delacroix (plate 118), the older painter's Baroque and broken line becomes an ecstatic expression of the terrible event. Unaware of Delacroix' somber red and green color scheme, Vincent created his own high-pitched

118. VINCENT VAN GOGH. *Pietà*, after Delacroix. 1889. Oil on canvas, 28 5/8 × 23 1/2". Stedelijk Museum, Amsterdam

discords of strong yellow and sharp blue. Most revealing of his emotional state is the substitution of his own features and bright red hair for the face of Delacroix' Christ.

When Vincent left the asylum he went north to the village of Auvers, thinking that his health had been restored and that the presence of Theo and his family nearby in Paris would calm his torment. But he had come too late. When his illness returned he understood that there was no possibility of recovery, and on July

27, 1890, he shot himself while at work in the country-side and died two days later. One of his last paintings, *Crows Flying over a Cornfield* (colorplate 23), demonstrates his command of his materials even at the desperate end of his life. The design is as firm as ever, the brushstroke agitated but precise, the few colors, the blue and yellow of corn and sky, adequate to their tragic burden. In the most ordinary of rural land-scapes, a cornfield with a flock of crows, he found symbols to express his doom.

Van Gogh's discovery of the expressive values of color and line, like Gauguin's interest in decorative harmonies and Cézanne's and Seurat's exploration of the structure of space, so enlarged the content of Impressionism that the term *Symbolism* can describe their work collectively. Their researches took them further from literal representations of subject matter toward an abstract art, analogous to music in its dependence upon pictorial elements almost divorced from thematic content. Simultaneously, another group of artists were working with traditional symbols or finding untraditional ways of using them in Sym-bolist propositions. More conservative in their insis-tence on maintaining the highest standards of crafts-manship, they rejected the banality of academic themes and by their personal interpretations of al-legorical, mythological, and historical subjects earned the respect of more adventurous painters toward the end of the century. Themes like *Oedipus and the Sphinx* (plate 119) had been used by Classicists such as Ingres often enough, but in this confrontation of man and monster by Gustave Moreau (1826–1896) we can see as early as 1864 how difficult it was to reconcile "the impossible with the real." Not the least puzzling element in the painting is the reversal of reality and myth; the nude is as unconvincing as a man as the sphinx is too "real" as a monster. The details show the same disequilibrium; the spear is too slight to support the figure, the urn too richly chased to have been found in so uncivilized a situation. But silly as such a picture seemed at the time, one can recognize Moreau's command of design, of that decorative ele-gance in the complex and swinging rhythms which was not lost on the later Symbolists. Insofar as they knew Moreau's work, they must have agreed that "the evocation of thought by line, arabesque, and plastic values" was indeed the purpose of his art.[6]

Moreau's indefatigable pursuit of the reality of the unreal recalls the Pre-Raphaelites' insistence on precise, accurate, and infinite detail. One of the younger Pre-Raphaelites, by 1890 grown full of years and honors, was Sir Edward Burne-Jones (1833–1898), who seemed at this time an original interpreter of

119. GUSTAVE MOREAU. *Oedipus and the Sphinx*. 1864. Oil on canvas, 81 1/4 × 41 1/4". The Metropolitan Museum of Art, New York. Bequest of William H. Herriman, 1921

mythical subjects. Encouraged by his friend William Morris, he had treated medieval subjects in his earlier work and had attracted the attention of French critics when his masterpiece, *King Cophetua and the Beggar Maid* (London, Tate Gallery) was seen at the Exposition Universelle of 1889. Through the 1890s he exhibited frequently in Paris, where his weird and wistful treatment of the nude in such paintings as *The Depths of the Sea* (plate 120) aroused a certain enthusiasm. Although both Gauguin and the young Picasso recognized the inherent formal weaknesses of his art, they nevertheless respected Burne-Jones for his refusal to compromise with academic realism.

In contrast to Moreau's and Burne-Jones's often niggling detail and morbid subjectivity, the work of Pierre Puvis de Chavannes (1824–1898) was unexceptionably limpid and serene. To many it seemed, and still seems, too bland, although to his conservative contemporaries his extremely simplified line and delicate color were too primitive. Had Puvis dealt only with such allegorical commonplaces as War and Peace, he might not now be so well remembered, but when for his subjects there were no textbook precedents and he had to invent his own iconography, as in his two series of murals on the life of St. Genevieve for the Panthéon in Paris, his imaginative synthesis of form and content was remarkable. In *St. Genevieve in Prayer* (1877; plate 121) from the first series, *The Childhood of St. Genevieve*, of 1874–1878, the discrepancy in scale between the parents and the little saint emphasizes the difference between their world and hers, between their parental anxiety and her spiritual detachment. Such distinctions would have been impossible in the landscapes of Corot, for instance. The tangle of naturalistic foliage in his *Ville d'Avray* (colorplate 10) may be compared with Puvis de Chavanne's selective disposition of stout trunks and slender saplings in a rhythmical order of light and dark, of thick and thin, across the top of the panel. Both Van Gogh and Gauguin respected Puvis' work. When he passed through Paris on his way to Auvers in 1890, Vincent sketched a study for Puvis' Rouen mural then on exhibition in the Salon, and the influence of Puvis' flattened, simplified drawing can be seen throughout Gauguin's Tahitian period. The latter did not have to go to Polynesia to find stocky figures like the father in the St. Genevieve mural. Picasso also adopted Puvis' drawing and the bluish tonality of the last of the St. Genevieve series for the works of his Blue and Circus Periods. Puvis' last murals were painted for the Boston Public Library, where their restrained elegance harmonizes with the architecture of McKim, Mead, and White (see p. 155).

120. SIR EDWARD BURNE-JONES. *The Depths of the Sea.* 1887. Watercolor on panel, 77 × 30″. Fogg Art Museum, Harvard University, Cambridge, Mass. Bequest of Grenville L. Winthrop

121. PIERRE PUVIS DE CHAVANNES.
Saint Genevieve in Prayer.
1877. Mural.
The Panthéon, Paris

Moreau, Burne-Jones, and Puvis de Chavannes found their imagery in Classic and Christian tradition, in the common language of the educated classes. Odilon Redon (1840–1916) looked for his in remote and private sources, in such earlier masters of an inscrutable personal mythology as the Dürer of *Melencolia I*, or among the microscopic organisms revealed by modern biology; but above all, he looked for it in dreams, especially those which rising from deep within the personal unconscious are inaccessible to any other than purely visual understanding. In the 1880s and 1890s the symbolic imagery of his charcoal drawings (whose luminous blacks were equaled only by Seurat's) and of his lithographs commemorating the poetry of Poe and the fantasy of Flaubert provided visual counterparts to the Symbolist dramas of Maeterlinck and the music of Debussy. The power and decision of Redon's imaginative symbols can be seen in a plate from his portfolio of lithographs dedicated to Flaubert's *Temptation of St. Anthony*, where the image of death as a reptilian female figure whose head is a skull looms out of the darkening chaos (plate 122). Redon's prints were issued in small editions, but they were treasured by those who found in Impressionism no answers to the mysterious questions life asks.

122. ODILON REDON. *Death: "Mine Irony Surpasseth All Others."* 1889 Lithograph, 11 1/4 × 9 1/8". The Art Institute of Chicago. The Stickney Fund

Toward 1900 Redon turned from his dark charcoals to pastels and oils. In brilliant colors he wove his iridescent fantasies, more serene, perhaps, but no less serious proofs of his determination to put "the logic of the visible at the service of the invisible."[7] His search for invisible truths led him past recognizable forms to the threshold of abstract design, and perhaps even beyond (plate 123).

The transition from a Naturalist to a Symbolist aesthetic was more conspicuous in France, more marked by startling conversions and, it must be said, by greater talents than in other countries, where Impressionism had arrived more recently or had been less warmly endorsed by younger artists. Elsewhere, it was also more difficult for a man working alone to prevail against the academic-naturalist standards supported by the Academy, by the public, and by the press. There were, however, certain artists whose solitary achievements were important contributions to Symbolist art. The earliest work of the Belgian painter James Ensor (1860–1949) and of the Norwegian artist Edvard Munch (1863–1944) were landscapes and interior scenes conventional in subject and technique, yet already touched by sufficient introspection to suggest that their authors were reaching beyond the world of appearance to one of subjective feeling. By 1885 Ensor had passed beyond Naturalism to a realm of his own invention inhabited by the dolls, the toy skeletons, and the trinkets which his mother sold in the souvenir shop where they lived at Ostend. But these holiday playthings were animated by a savagely ironic view of life. In 1888 an enormous canvas, *The Entry of Christ into Brussels*, was rejected by the liberal exhibiting society of *Les XX*, of which Ensor had been one of the twenty founders. His portrayal of Palm Sunday as a socialist holiday in modern Belgium, with the Redeemer lost in a raucous crowd of merrymakers, was too satirical for them, just as his intentionally awkward, even childish, drawing and crude colors proved embarrassing at a time when Impressionism still seemed daring. *The Entry of Christ* must be ranked, however, among the small group of unorthodox religious works, like the paintings of Georges Rouault, which presented the obverse side of the religious revival of the 1890s. Ensor's masterpiece was his *Intrigue* (1890; colorplate 24), in which the monstrous masks seem to reveal quite as much as they dissemble the personalities of the wild revelers. Perhaps behind them there are no faces at all, only the skulls which Ensor so often used to mock human pretensions. Although his father was English, Ensor was wholly a Flemish painter, Flemish not only in his realism and wit, but also in the rich and radiant color

which saturates his still lifes of vegetables and shellfish. And it is the color which sustained interest in his work after 1900, when his satirical invention and his primitivistic drawing had become conventions.

Edvard Munch won a government scholarship to Paris in 1889, where he remained until 1892, so that he was familiar with the new developments in French painting. His reputation, however, was made in Germany, where his work created an unexpected scandal in Berlin in 1892 when the conservative German artists of the capital protested and his exhibition had to be closed. Munch continued to live in Germany, where he became an important influence on nascent German Expressionism. There are perhaps traces of Gauguin and of the Nabis in his work of the 1890s, especially in the flat color patterns and fluid contours, but Munch was far more concerned than they with the psychological predicament of the individual in the modern world. His *Evening in Karl Johan Street* (1892; colorplate 25) may be the first painting since Daumier's to portray the isolation and despair lurking beneath the surface of modern society, but it probes further below that surface than ever Daumier did. Munch's crowd, approaching along the principal avenue of Christiania (now Oslo), consists of single figures, each alone and in its way terrified by nameless apprehension, each face drained of expression until it resembles Ensor's skulls. Above them the night sky is eerily illuminated by the late light of the North. In 1902 Munch conquered the German art world when eighteen canvases from his *Frieze of Life* were exhibited in Berlin. This was a series of paintings dissimilar in size and treatment but grouped by such subtitles as "Love's Blossoming and Fading," "Life's Anguish," and "Death" to indicate his interpretation of life as a constant effort to conquer anxiety, fear, and sexual tension.

His *Death of Marat* (plate 124), a large canvas begun in 1905 but worked over for more than twenty years, is a startling summary of Munch's lifelong psychic struggle with the demons within and without. The ironic reference in the title to David's steely interpretation of the historical event (plate 12) underlines the fact that this could be any modern man and woman destroying each other by less political passions. In this instance Expressionist technique and subject matter are perfectly matched. Only with such tattered brushstrokes and furious colors could Munch have evoked the horror of madness and sordid death.

Munch's own nerves were unequal to the strain, and in 1908 he withdrew to a sanitarium in Copenhagen. The next year he returned to Norway, where he lived for the remainder of his long life. His later works were

124. EDVARD MUNCH. *Death of Marat*. 1905–27. Oil on canvas,
59 × 78 3/4″. Munch-Museet, Oslo

more vividly colored and more vehemently brushed than ever. Among them are many fine portraits, landscapes, and figure studies, but except for his haunting self-portraits, which he continued to paint until he was old and ailing, the psychic content of his work had evaporated, leaving him in command of a splendid technique with which he had less and less to say.

The nineteenth century was not the happiest of times for sculpture, and the reason may be sought in the aesthetic paradox that realistic modes of repre-sentation are more convincing in the pictorial media, which are in themselves abstract, than when presented in the actual substances of sculpture, whether wood, stone, metal, clay, or wax. Thus through the central decades of the nineteenth century the sculptor was at a disadvantage, because he found it difficult, if not impossible, to pursue the search for "nature just as it is," as Courbet, Manet, and the Impressionists were doing. He was limited by the nature of his materials to the portrayal of human and animal forms, and debarred from the treatment of landscape, in which

126. AUGUSTE RODIN. *The Age of Bronze*. 1876–77. Bronze, height 71 1/4″. Cleveland Museum of Art. Gift of Mr. and Mrs. Ralph King

the triumphs of later Naturalism and Impressionism occurred. Most nineteenth-century sculpture is therefore on the whole conservative, looking back to the Classic past, the Middle Ages, and the Renaissance, as we have seen in the work of the Neoclassic and Romantic sculptors, or, after 1850, to the seventeenth century. Certainly there was no dearth of opportunities, for in the expanding cities of Europe and America there were innumerable commissions for monuments, fountains, and the decoration of important buildings. Much of this work was so routine that it has scarcely been looked at since the day it was dedicated, but occasionally a spark of talent would lift it above the ordinary. Jean-Baptiste Carpeaux (1827–1875) had a gift for lively movement and portrait characterization which makes his work more memorable than that of his contemporaries. His group of dancing nymphs of 1869 on the façade of the Paris Opera (plate 138) gathers the ponderous rhythms of Charles Garnier's Neobaroque structure into one joyous moment. A few years before, the Parisian public had been dismayed by his huge marble group of *Ugolino and His Sons* (plate 125). This formidable display of anatomical knowledge, snarled in a dense but quite conventional composition, embodied an expressive power in the projection of a disagreeable Dantesque theme which had not been seen in French sculpture since François Rude's Romantic rhetoric (plate 52).

But good as Carpeaux was, he was excelled by Auguste Rodin (1840–1917), not only the greatest sculptor of the century, but one who can be compared only with Bernini among those who have worked since Michelangelo. Like Bernini's, his world-wide fame during his lifetime was based on a prodigious amount of work in a variety of themes and media— portraits, monuments, imaginary subjects in bronze, stone, ink, and wash.

Too poor to enter the Ecole des Beaux-Arts, Rodin studied at a small school of decorative art, where he learned to model the swags and masks which were the obligatory ornaments of contemporary architecture. But the poverty which prevented him from receiving academic instruction in modeling and drawing the nude may have been a blessing in disguise. When he turned from decorative work to the human figure, he had to find out everything for himself, taking as his mentors the arts of the past he most admired—the Greeks, the portal sculptures of the great French cathedrals, Michelangelo, and, above all, nature itself. His first important figure, *The Age of Bronze* (plate 126), was so carefully studied from life that when it was first exhibited in Paris in 1877 the sculp-

Colorplate 21. ÉDOUARD VUILLARD. *Entrance to the Garden*. 1903. Oil on canvas, 23 × 30 1/2″. Collection Mr. and Mrs. Henry Ittleson, Jr., New York

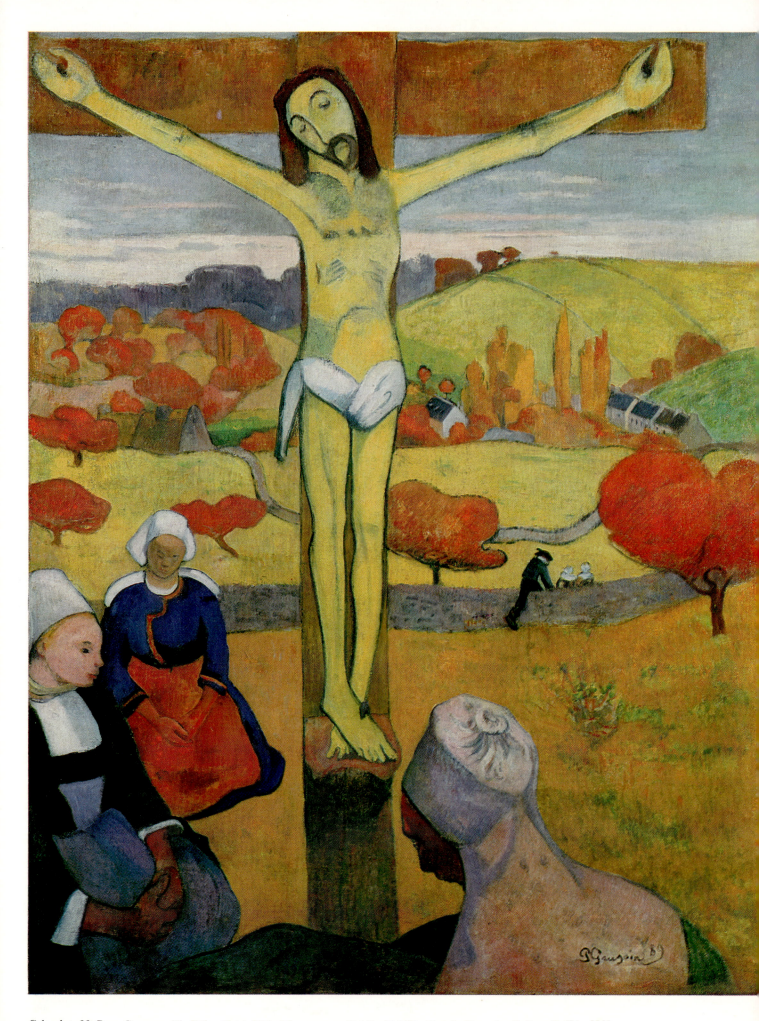

Colorplate 22. PAUL GAUGUIN. *The Yellow Christ*. 1889. Oil on canvas, 36 1/4 × 28 7/8″. Albright-Knox Art Gallery, Buffalo, N.Y.

Colorplate 23. VINCENT VAN GOGH. *Crows Flying over a Cornfield*. 1890. Oil on canvas, 19 3/4 × 40 1/4". Stedelijk Museum, Amsterdam

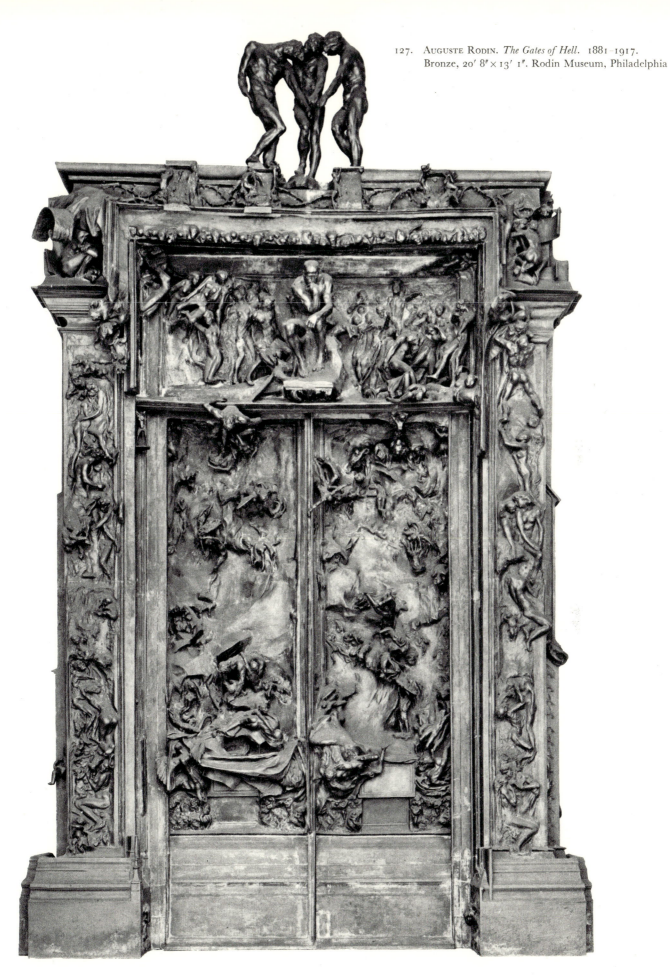

127. AUGUSTE RODIN. *The Gates of Hell*. 1881–1917.
Bronze, 20′ 8″ × 13′ 1″. Rodin Museum, Philadelphia

TOP: Colorplate 24. JAMES ENSOR. *Intrigue*. 1890. Oil on canvas, 35 3/8 × 59″. Musée Royal des Beaux-Arts, Antwerp

BOTTOM: Colorplate 25. EDVARD MUNCH. *Evening in Karl Johan Street*. 1892. Oil on canvas, 33 1/4 × 47 5/8″. Collection Rasmus Meyer, Bergen, Norway

tor was accused of having taken a cast from the living model. Yet Rodin never sacrificed expression for facts. His nudes, the most natural as they are the most Classic of subjects, never attain truly Classic serenity. Their poise is always shattered by the psychological tensions present in medieval art and in Michelangelo, so that the result is an entirely modern feeling for the pathos of human beings torn between spiritual aspiration and the constraints of the flesh. In this Rodin resembled Munch, except that his themes were more generalized, more conventional, and more symbolically accessible.

Rodin was primarily a modeler (his marbles were cut for him by professional craftsmen) whose ceaselessly manipulated surfaces catch and return the light in a way that has been described as Impressionist. But he was not an Impressionist sculptor, because he spurned the trivialities of ordinary existence. For his first important commission, a pair of bronze doors for a projected museum of decorative arts, he chose his theme from the *Divine Comedy* (plate 127). *The Gates of Hell*, as they came to be known and upon which he worked from 1881 until his death, were never finished, but they eventually contained more than 180 figures typifying the torments to which the mind and body are driven in an inferno that was not so much Dante's as that of modern psychic life. Into the *Gates* Rodin put many figures which had been conceived independently, even as from the mass of bodies swarming up and down his portals he drew inspiration for other figures to be enlarged and exhibited separately. An example of the former method is *She Who Was Once the Helmet-Maker's Beautiful Wife* (plate 128), originally an illustration for François Villon's poem. As a statement of the physical degradation of old age, she found her place with the damned upon the *Gates*. No more repulsive nude is remembered from the nineteenth century, yet there is no more moving presentation of the havoc time wreaks upon us. Here we touch, if we cannot solve, the secret of Rodin's genius. His technique could encompass any facts demanded in a materialistic era, but his poetic imagination transformed them into other and spiritual truths.

The great *Gates*, of which the final model is to be seen at the Rodin Museum in Paris (another cast at the Rodin Museum, Philadelphia), may have remained unfinished because of the sculptor's inability to see beyond the parts to the architectural character of the whole. The arrangement of the free-standing figures in his *Burghers of Calais* (1884–1886; plate 129), commemorating the physical and spiritual anguish of the six civic leaders who surrendered the fortress to the English king in 1347, was reached only after

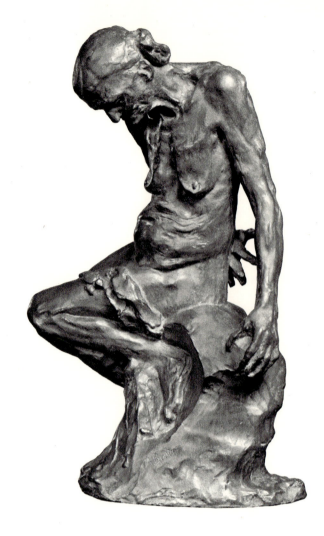

interminable effort, and in the end lacks the inevitability a more architecturally minded sculptor might have foreseen from the first. Rodin's feeling for the part rather than the whole led him to exhibit incomplete or apparently unfinished figures lacking heads, arms, or legs. The public was loath to recognize the expressive character of the sculptural fragment, but what was once exceptional and seen only in deliberate imitations of the antique has become, in the form of the torso, a familiar sculptural convention.[8]

Rodin's finest monuments were usually the simplest. In the *Victor Hugo* (1890; Paris, Palais Royal) he gradually eliminated the allegorical figures until only one was left. In the *Balzac* (plate 130), the tilted, towering body swathed in a heavy dressing gown is surmounted by the massive head, its features deeply and ruggedly undercut to hold the light which slides off the rest of the figure. This, the "ugliest" and the

128. Auguste Rodin. *She Who Was Once the Helmet-Maker's Beautiful Wife*. 1885. Bronze, height 20″. The Metropolitan Museum of Art, New York. Gift of Thomas F. Ryan, 1910

129. Auguste Rodin. *The Burghers of Calais*. 1884–88. Bronze, 85 × 98 × 78″. The Joseph H. Hirshhorn Collection

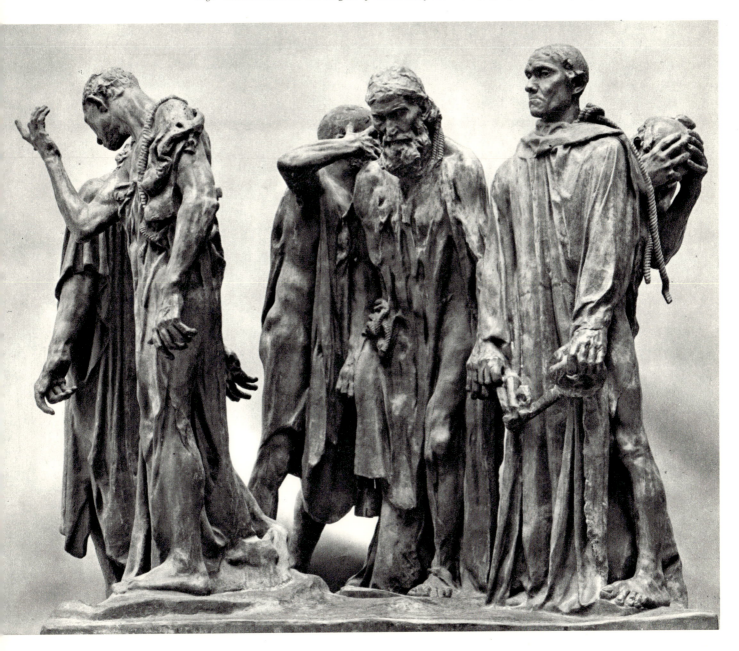

130. AUGUSTE RODIN. *Balzac.* 1897. Bronze, height 9′ 3″. The Museum of Modern Art, New York. Presented in memory of Curt Valentin by his friends

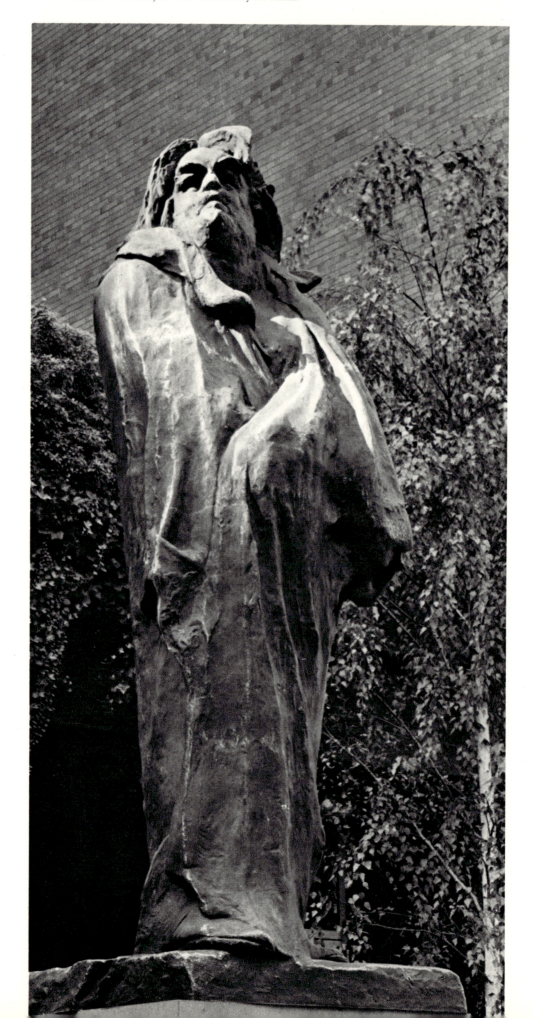

most "modern" of nineteenth-century sculptures, caused an uproar at the Salon of 1897. The literary society which had given Rodin the commission rejected it as unworthy of the writer, and the critics complained, as they had of Monet, that Rodin had surrendered all sense of form. Others, more sympathetic to Rodin's attempt to suggest Balzac's overwhelming creative energy rather than his merely physical appearance, likened it to a monolith, a menhir, even to Egyptian sculpture in its colossal and crushing power.

After 1900 Rodin confined himself to portrait sculpture and drawings. Among his busts are many penetrating characterizations of celebrated contemporaries. In countless ink and wash drawings, which were not studies for future sculpture but works of art in their own right, he studied the nature of human movement from models constantly moving about the studio. The informality of their poses is sometimes extraordinarily daring, because Rodin never flinched before the natural truth, before even the most ungainly continuities of form in motion.

A more narrowly Impressionist position was taken by the Italian sculptor Medardo Rosso (1858–1928), who chose light as his point of departure. He, rather than Rodin, did dissolve material substances by modeling only the play of light reflected from their surfaces, until, as in his *Conversation in the Garden* (1893; plate 131), we seem to see the figures only as interruptions of the light. Rosso was in Paris in the 1880s where he knew Rodin, who admired his work. Rumors later circulated that the great *Balzac* owed much to his influence. It may have, to some extent, but Rodin's vision had a grandeur Rosso never approached in his modest, small-scaled figures and groups.

In the United States a comparable if less inclusive reaction to the pragmatic vision of the Impressionists had appeared by the end of the 1880s in the paintings of Albert Pinkham Ryder (1847–1917) and the sculpture of Augustus Saint-Gaudens (1848–1907), exact contemporaries, it may be worth noting, of Gauguin and only a few years younger than Rodin. Ryder, like Homer, was something of a recluse, although he preferred an untidy two-room apartment on New York's West 15th Street to the rigors of the Maine coast, but, again like Homer, he was neither so unsocial nor so humorless as the legends have it. He was largely self-taught and perhaps for that reason wholly independent, indifferent both to contemporary and to older art. As a landscape and figure painter he ignored the world around him with its parade of harsh, insistent facts, a world revealed by the powerful but literal Realism of Homer and Eakins, and found his inspiration in the heroic literature of the past. But he was in no sense a literary painter bent on illustrating a given text. Great poetry served him—as it had Delacroix—as a stimulus for introspection, as a means for discovering images drifting just beyond the waking eye, images he painted as dark simplified shapes often dimly sensed against a fitfully moonlit sky (plate 132).

Ryder's paintings are usually small and endlessly reworked, often to their detriment. His knowledge of techniques, like Whistler's, was so faulty that many have been ruined by the unequal contraction and separation of the multiple glazes, and even those that are reasonably intact are sadly obscured. Yet despite their condition, Ryder's works are proof that through the clamorous decades of the later nineteenth century he never abandoned his desire to communicate

131. MEDARDO ROSSO. *Conversation in the Garden*. 1893. Plaster, 12 5/8 × 25 1/4". Galleria Nazionale d'Arte Contemporanea, Rome

132. ALBERT PINKHAM RYDER. *Siegfried and the Rhine Maidens.*
Before 1891. Oil on canvas, 19 7/8 × 20 1/2".
National Gallery of Art, Washington, D.C. Mellon Collection

through his paintings not facts but symbols of the poetry of life.

Saint-Gaudens, whose French and Irish parents brought him to New York as a small child, was also French by training. He studied and worked in Paris from 1867 to 1875 and returned again in 1881 for two years to create his first important commission, the statue of Farragut in Madison Square, New York City. He knew Rodin's work but distrusted its aggressive expression, and for his own purposes developed a more attenuated modeling which allowed him

133. AUGUSTUS SAINT-GAUDENS. *The Robert Gould Shaw Memorial.*
1884–97. Bronze, height c. 10'. The Common, Boston

to combine, in a restless but subtle relationship, facts from the actual world with symbolic abstractions. The meeting of such extremes occurs in works of such monumental dignity as the Shaw Memorial (Boston Common), where the Angel of Death strews poppies over the doomed Civil War leader and his Negro troops (plate 133), who are modeled with anthropological accuracy, or in the Sherman monument (New York, Fifth Ave. at 59th St.), where the general on his lithe horse follows a striding figure of heroic Victory. The standing *Lincoln* (Chicago, Lincoln Park) is a more convincing synthesis of fact and symbol. Saint-Gaudens took extraordinary pains to re-create the historical truths of Lincoln's appearance, but the commonplace details of nineteeth-century dress are spatially and visually enfolded in the severe abstractions of the Classical curule chair from which Lincoln has just risen.

Saint-Gaudens' increasingly skillful ability to subordinate the realism in which he and his generation had been trained—and which was the source of Eakins' strength—accounts for the serene grandeur of his masterpiece, the Adams memorial (plate 134), commissioned by the writer Henry Adams for the grave of his wife. Adams' religious scepticism precluded any conventional symbolism, so that the sculptor had to conceive a figure which, in Adams' words, would have "no name that the public could turn into a limitation of its meaning." Passionless and inexplicable, swathed in the massive folds of a textureless garment, the seated bronze figure remains the noblest symbolic image in American art of the later nineteenth century.

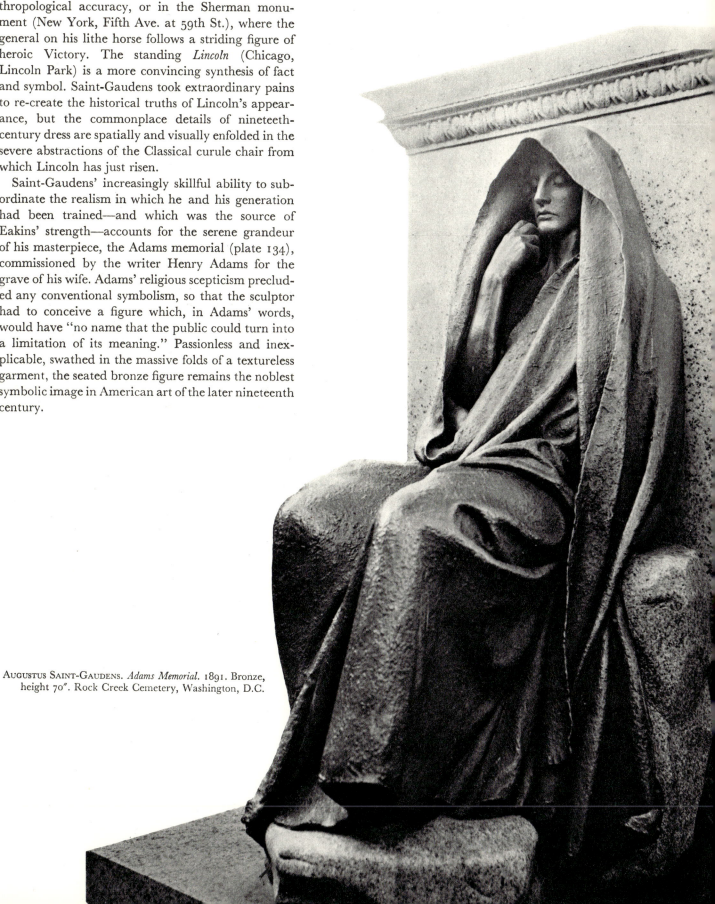

134. Augustus Saint-Gaudens. *Adams Memorial.* 1891. Bronze, height 70". Rock Creek Cemetery, Washington, D.C.

Architecture in Europe and the United States: 1850–1910

By the middle of the nineteenth century the adaptation of past architectural styles had become customary for important monumental and public commissions. Yet Eclecticism, as the use of historic styles is called, may be neither good nor bad in itself, as we know from the work of the architects of the Italian Renaissance who wanted to revive the Roman past. Hence, to condemn all mid-nineteenth-century architecture as Eclectic is to call attention to certain unfortunate lapses of taste or of imagination while ignoring the indisputable merits of a number of handsome and successful buildings.

The waning but still sporadic use of Classic forms, as in the Grecian temple erected for the Austrian Parliament in Vienna in 1873, was occasionally matched by buildings in the Gothic style, sometimes large and richly decorated like the Vienna Rathaus (Town Hall) of 1872–1883, not far from the parliament building. But to these styles were added many variations of Italian and French Renaissance architecture, among the earliest examples of which were the Travellers' Club (1830–1832) and the Reform Club (1837–1840; plate 135) in London by Sir Charles Barry (1795–1860), who was to design the neo-medieval Houses of Parliament (plate 39) immediately afterwards. Of the two the Reform Club, a discreet but recognizable modification of the Farnese Palace

in Rome, was the more influential, the first in a long succession of such institutions in London and New York, designed in emulation of Florentine and Roman palaces of the Early and High Renaissance.

Meanwhile, as the wealth acquired by nineteenth-century clients enabled them to achieve more extravagant effects than could be found in the Renaissance, they turned so often to the Baroque that the term *Neobaroque* applies as well as any to much of the public architecture of the middle years of the century. One impetus for this development came from Napoleon III's decision to enlarge and complete the palace of the Louvre by joining it to the Tuileries Palace (destroyed in 1871) to the west. The large wings extending into what is now the outer courtyard, providing space for government offices as well as for the expanding art collections in the old Louvre, were designed by L.-T.-J. Visconti (1791–1853) and H.-M. Lefuel (1810–1880) to harmonize with the seventeenth-century block by Lemercier closing the inner courtyard, but in a much richer, more three-dimensional manner (plate 136). The massive pavilions, with the center one on each side topped by a convex mansard roof, the columns projecting in front of the wall plane, and the exuberant sculptural ornament caught the eye of every visitor, of whom there were many, from the Americas as well as Europe, in the years when the

Paris of the Second Empire (1852–1870) was the gayest and most fashionable city in the world. The consequences were that the so-called Second Empire style spread throughout the Western world, although, paradoxically, its principal characteristics of the high mansard roof, central and end pavilions, and lavish ornament were little admired by most French architects. Their rigorous architectural training at the government's École des Beaux-Arts seems to have enforced a preference for the drier, less three-dimensional designs still to be seen in the dignified but unassertive blocks of apartments lining the older streets of Paris. After the Louvre only the Opera House by Charles Garnier (1825–1898), begun in 1861 but not completed until 1875 after the fall of Napoleon, was authentically in the Second Empire taste (plates 137, 138). When the Hôtel de Ville was rebuilt after having been burned in May, 1871, during the Commune, it was reconstructed according to the sixteenth-century original, but the proportions were heavier and the decoration much richer.

By enlarging the Louvre, Napoleon III hoped to confirm his right of succession to his royal and imperial predecessors; by rebuilding the center of Paris he accomplished the most important urban redevelopment of the entire century. Under the direction of Baron G. E. Haussmann (1809–1891), two

135. SIR CHARLES BARRY. Reform Club, London. 1837–40

136. L.-T.-J. VISCONTI and H.-M. LEFUEL. The New Louvre, Paris. 1852–57

concentric lines of fortifications were razed to create the ring of outer and inner boulevards which were joined by new avenues cut through a maze of medieval alleys to connect the outlying districts with the new center of the city. Haussmann's activities were bitterly contested by his contemporaries, both because he destroyed much of medieval Paris, which was romantically treasured by the readers of Victor Hugo's *Notre Dame de Paris* (1831), and because of the real estate speculation that enriched those who bought up the properties just before their condemnation. Criticism aside, the result created the image of Paris as the *ville lumière*, the city of light, its broad, tree-lined avenues sparkling at night with thousands of lamps. The center of the city is now choked with traffic, but at the time, the combination of radial and circumferential arteries brought an ease of circulation no other city knew and established Paris as the model modern capital.

In the United States the Second Empire style flourished for municipal and federal buildings in the years just after the Civil War. Characteristic examples are the State, War, and Navy Building in Washington (1871–1888; plate 140), now the Executive Office Building, and the city halls of Boston (1862–1865) and Philadelphia (1874–1898), the latter enjoying a notable site at the junction of Broad and Market

137. CHARLES GARNIER. *Plan of Opera House, Paris*

138. CHARLES GARNIER. Opera House, Paris. 1861–75

139. JOHN McARTHUR, JR. City Hall, Philadelphia. 1874–98

Streets and crowned with a tall tower rising from the interior courtyard (plate 139).

In the hands of a gifted architect, a Garnier, for instance, the older styles could still be used with taste and some degree of logic, but often the past was ransacked without regard for the appropriate union of a given style with different functions, structural methods, or materials (as in the reproduction of carved Gothic and Renaissance ornament in cast iron). To resolve this anarchical situation two solutions were possible: a radical rethinking of the relation of material and structure to function, without regard for stylistic precedent, or a more sober and consistent use of a past style. The latter course was followed in the United States by several architects, among them the firm of McKim, Mead, and White, whose principal designer, Stanford White (1853–1906), had a remarkable ability to integrate the styles of the past with the functions of the present.

Their Boston Public Library (1887–1892; plate 141) is a notably dignified and coherent restatement of Renaissance themes, as were the Villard Houses on Madison Avenue at 50th Street (1883–1885), which subsequently became the headquarters of Random House and of the Roman Catholic Archdiocese of New York (plate 142), and the University Club (1899–1900) at Fifth Avenue and 54th Street.

140. A. B. MULLET. State, War, and Navy Building, Washington, D.C. 1871–88

142. McKim, Mead, and White. Villard Houses, New York. 1883–85

141. McKim, Mead, and White. Public Library, Boston. 1887–92

McKim, Mead, and White also contributed importantly to the revival of this country's eighteenth-century Colonial architecture, which had been studied with increasing appreciation since attention had been called to our Colonial heritage by the Philadelphia Centennial Exposition of 1876. An unusually gracious example of the revival in residential architecture is Stanford White's Hill-Stead (1899; colorplate 26), the country home of Mr. Alfred Pope in Farmington, Connecticut, now preserved as a museum with its contents, which include a collection of French Impressionist paintings. White's handling of the informal masses, executed in wood, the traditional structural material of the New England countryside, has a distinction quite apart from any considerations of historical authenticity.

Another gifted designer was Richard Morris Hunt (1827–1895), the first American to study architecture at the École des Beaux-Arts in Paris, whose residence of 1892–1895 for Cornelius Vanderbilt at Newport, Rhode Island (colorplate 27), where many mansions in various historic styles are still to be seen, is in the manner of a princely Genoese palace of the sixteenth century. Hunt's eye for the relation of detail to mass is more apparent on the exterior than within, where his patron's wealth demanded a surfeit of luxurious appointments.

The most spectacular instance of such consistent Eclecticism occurred in 1893 at the World's Columbian Exposition in Chicago, commonly known as the Chicago World's Fair. The committee in charge of the plan required the architects of the principal buildings to adopt a Neoclassic design, generically Roman, and a uniform sixty-foot cornice height. The result, executed in temporary materials painted a dazzling white (unlike Rome itself), surpassed in unity, dignity, and majestic scale anything yet seen in America (plate 143). But the architect Louis Sullivan (1856–1924), whose Transportation Building with its huge semicircular gilded portal was a conspicuous exception to the Roman rule of the "White City," thought otherwise. For him the Fair was "snobbish and alien," an "appalling calamity" which would cripple American architecture for fifty years to come. So it seemed, when through the rest of the decade and well into the new century Classical columns, entablatures, and pediments became ubiquitous symbols of prudence and permanence for banks and colleges, libraries, courthouses, and post offices. A more temperate opinion holds that the Fair was a splendidly unified architectural ensemble and that its influence was not entirely baneful. Many of the later columned porticoes were sensitively designed and have become

143. Manufacturers and Liberal Arts Buildings. World's Columbian Exposition, Chicago. 1893

valued civic monuments, providing continuity as well as dignity in our changing urban environments. Such would have been true of McKim, Mead, and White's vast Pennsylvania Station in New York (1906–1910; plate 144), demolished in 1964–1965 to make way for a sports arena and office building. Fortunately their Low Library of 1893–1897 still crowns the heights at Columbia University with severely simple Roman majesty.

The new search for formal order, even when based on the authority of the past, was not always narrowly academic or too archaeologically correct. A not exceptionable example is the New York Public Library by Carrère and Hastings (1902–1909; plate 145). Its general aspect may be more European than American, and consequently less compelling to those in search of an unquestionably American style, but its spacious proportions and the fine detailing of the white Vermont marble, not to mention the clear expression of the utilitarian book stacks at the rear, still put to shame the urban confusion and banality that surround it. Yet in the end Sullivan was right. In the hands of unimaginative architects the results could be deplorable, as in the endless dull blocks, punctuated at regular intervals with porticoes and colonnades, that filled the Federal Triangle in Washington in the 1930s (plate 146).

The development of a new architectural rationale, based on the integration of function, plan, material, and structure and leading to a new formal synthesis, can be seen from an early date in domestic architecture, where the requirements of public display were

144. McKim, Mead, and White. Pennsylvania Station New York. 1906–10. Before demolition

145. Carrère and Hastings. New York Public Library. 1902–9

146. Federal Triangle, Washington, D.C. c. 1930

less exigent. It may be traced to the residential work of the English architects Philip Webb (1831–1915) and Richard Norman Shaw (1831–1912). The former's Red House of 1859 at Bexley Heath, near London, for William Morris, was very simple despite a vaguely medieval flavor, and remarkably independent in plan and massing (plate 147). In the 1870s and early 1880s, Webb's and Shaw's respect for local materials —brick, tile, and wood—and for regional traditions of design in relation to plans, controlled by the logic of function and use rather than by arbitrary symmetry, became known to architects elsewhere, especially through the publication of Shaw's drawings.

One of the first important residences by the American architect Henry Hobson Richardson (1838–1886), the William Watts Sherman House (1874–1876; plate 149) at Newport, in its informal massing, varied materials, and freedom from specific style, is like Shaw's contemporary English work, at that time oddly described as "Queen Anne." Richardson's first important public building, Trinity Church in Boston (1873–1877; plate 148), was more immediately medieval in its appearance, although the term *Richardsonian Romanesque*, which was soon invented to describe his work, overemphasizes the secondary decorative elements at the expense of the splendid massing and the highly abstract treatment of individual shapes and different materials. This can now best be seen from the rear, a triple portal in a truly derivative Romanesque manner having been added to the west façade after Richardson's death. But from the east, where the church sits proudly on its own city block, the broad pink granite mass, so wide within that the nave, transepts, and chancel compose a single space, rises through the strongly projecting

apse and baptistery, linked to the separate parish house by a colonnaded cloister, to a square tower topped by an octagonal roof. In profile and detail this tower recalls the lantern of the Old Cathedral at Salamanca and is the most deliberately Romanesque element of the church. Probably designed and possibly suggested by Stanford White, then Richardson's gifted young assistant, it foretells the stricter copying of European precedent that became characteristic of White's later work. But when the existing church is compared with Richardson's preliminary drawings, one can see how right the scale and proportions of the tower are, and how it exemplifies Richardson's instinct for the play of masses one against another.

147. PHILIP WEBB. Red House, Bexley Heath, Kent, England. 1859

148. Henry Hobson Richardson. Trinity Church, Boston. 1873–77

However medieval Trinity Church may have appeared to the architect's contemporaries, Richardson himself was never bound to any one historical style. His genius for discovering an original solution for a given problem can be seen in his houses of the early 1880s. When he used wood, as in the Stoughton House in Cambridge, Massachusetts, of 1882–1883, he covered the framing with a continuous sheath of shingles. The material shows his awareness of seventeenth-century New England buildings, but his house is entirely without stylistic detail, and the massing of the wings and stair tower owe nothing to New England precedent. This Shingle style, as it has been called, was handled brilliantly in a few instances by McKim, Mead, and White, but by the early 1890s they were turning away from Richardson's strenuously individual revision of traditional forms to a more scholarly examination of such sources, especially the surviving eighteenth-century houses in New England. In 1885–1886 with their H. A. C. Taylor house at Newport (now demolished) they, as much as anyone else, inaugurated the academic revival of Colonial architecture. By contrast, Richardson, in his F. L. Ames Gate Lodge at North Easton, Massachusetts (1880–1881; plate 150), had taken the granite boulders from the dry walls surrounding so many New England fields and heaped them in masses without reference to the past. The continuous roofs, lying low over the walls, and the bands of windows grouped according to the need for light inside, are hallmarks of his mature manner. They are notable in his libraries for towns near Boston, of which those at Quincy of 1880–1883 and Malden of 1883–1885 are among the best, and in his small stations for the Boston and Albany Railroad.

In his masonry buildings Richardson treated stone, especially quarry-faced granite laid as random ashlar, with a feeling for the play of shape and pattern that was in the highest degree abstract. His understanding of masonry was never finer than in his last large compositions, the gray granite County Courthouse and Jail in Pittsburgh (1884–1887) and the red granite and sandstone Marshall Field Wholesale Store in Chicago (1885–1887; demolished 1931). Libraries and railroad stations were, to be sure, building types new to the nineteenth century, and other architects had already created larger and more influential examples; but in the Marshall Field Wholesale Store (plate 151) Richardson found a new and unexpected dignity for a type of commercial building which at best had been treated respectably, as in the earlier stone warehouses in London, Liverpool, and Boston, and at worst, slighted. His sources

149. HENRY HOBSON RICHARDSON. William Watts Sherman House, Newport, Rhode Island. 1874–76

150. HENRY HOBSON RICHARDSON. Ames Gate Lodge, North Easton, Massachusetts. 1880–81

151. HENRY HOBSON RICHARDSON. Marshall Field Wholesale Store, Chicago. 1885–87

may have been the Florentine palaces of the Quattrocento, but he transcended them in his explicit statement of the commercial character of the building through spacious windows rhythmically grouped by pairs and by stories to articulate the immense façade both vertically and horizontally. The floors were supported by metal columns and beams, but the external walls were load-bearing and very thick. Their function was made clear by the broadened corners and the massive base. This harmonious and dignified design, in which Richardson's predilection for Romanesque mass was controlled by an acceptance of utilitarian function, inspired a host of imitations in commercial architecture through the 1890s, but it was never surpassed, nor even equaled.

When Richardson died in 1886, the exterior design of the Marshall Field Store may have exceeded in originality and refinement all other commercial buildings, but in its structural system it was already out of date. By then the application of engineering principles to iron and steel construction had made possible a new architectural type, the tall office building, or skyscraper, as it was soon to be called. The history of building in iron and steel which, with concrete and glass, were the materials that changed the character of later nineteenth-century architecture, begins toward the end of the eighteenth century, when cast-iron columns were first used as supports for floor beams in certain English churches and factories. In St. Anne's Church, Liverpool, the galleries rested on such columns as early as 1770–1772, and they were similarly used in several textile mills in the Midlands in the 1790s. By 1800 the internal supporting structure, including the beams, was a complete metal skeleton in at least two mills. Very slim tall columns, which the tensile strength of the material allowed,

153. JOHN A. ROEBLING and WASHINGTON A. ROEBLING. Brooklyn Bridge, New York. 1869–83

were soon used for decorative as well as structural purposes. In 1818–1821 John Nash put columns jointed like bamboo stalks, with copper palm leaves spreading from their tops, in the kitchens and other rooms of the Royal Pavilion at Brighton. Just before that, Thomas Hopper had added a Gothic conservatory to Nash's Neoclassic Carlton House in London, complete with fan vaulting and tracery in cast iron. From the start the structural and decorative properties of the new material were not clearly distinguished, and for many years the reproduction in one material of the visual effects proper to another hampered the understanding of the innate aesthetic character of structural metal. As late as 1855–1859, in the University Museum at Oxford (intended for the display of scientific collections), the interior court of a masonry building, in whose medieval design John Ruskin himself had had a hand, was covered with a light roof of iron and glass on metal arches steeply Gothic in profile and continued to the ground on columns cast as Gothic clustered piers with crisp metal foliage (plate 152). The most revolutionary structural parts

of the building were the most retrograde in appearance.

A more sensitive understanding of the nature of the new material appeared in buildings less affected by traditional architectural concepts than were churches and museums. In the new bridges, required by the increased traffic on roads, railways, and canals, from the first of all at Coalbrookdale in Shropshire of 1777–1779, with its arch thrown high over the Severn, to such famous examples as the Menai Straits Bridge of 1819–1824 by Thomas Telford (1757–1834) which spanned the water between England and Wales, the character of metal worked as thin lattices or as long wire cables was boldly expressed. Only the masonry supports were traditional, and as late as 1869 the stone towers between which John A. Roebling (1806–1869) and his son spun the Brooklyn Bridge, completed in 1883 and long the most celebrated of America's large suspension bridges, were Gothic (plate 153).

The most rapid progress occurred when iron, whether cast or in the stronger form of wrought or rolled iron, was used in conjunction with glass. In

152. BENJAMIN WOODWARD. University Museum, Oxford, England. 1855–59

154. GIUSEPPE MENGONI. Galleria Vittorio Emmanuele, Milan, Italy. 1865–77

many cities arcaded shopping galleries were a familiar sight. In Paris there was one as early as 1829–1831, the Galerie d'Orléans designed by the Neoclassic architect P. F. L. Fontaine. The most magnificent of all was the colossal Galleria Vittorio Emmanuele in Milan (1865–1877; plate 154) by Giuseppe Mengoni (1829–1877). Here four passages, as wide as streets and lined with three stories of shops and offices behind stone façades, High Renaissance in style to harmonize with the older architecture of the adjacent squares, were covered with a glass and metal roof rising to a glass dome over their octagonal intersection.

By the middle of the century the larger railway stations usually showed the same discrepancy between the Eclectic stylism of a masonry shell and the frankly functional, often unadorned, treatment of the metal and glass train shed. In 1839, at Euston Station in London, one of the first monumental termini, the traveler, as already noted, passed through a huge Greek portal before reaching the shed, which was

unostentatiously covered with a metal roof supported on plain cast-iron columns. In Paris, the waiting room and offices of the Gare de l'Est of 1847–1852 were dissembled as two Italian Renaissance palaces joined by an arcade, with the shed looming behind a rose window with metal tracery in a masonry arch. Hittorff's second Gare du Nord (1861–1865) was more restrained than Napoleon III's new Louvre, but the shed was hidden behind a triple central arch with flanking pavilions, whose colossal Ionic pilasters were more reminiscent of Rome than of the cities for which the travelers were departing. In London a decade before, Lewis Cubitt (1799–?) had found a more coherent expression for the mass and size of the shed. In his King's Cross Station (1851–1852; plate 155) the double shed was expressed externally as two large round arches, each surmounting three lower arched entrances for the passengers. The severely plain masonry of ordinary stock brick enhanced the unexpected monumentality of the whole scheme (now masked by subsidiary structures).

Cubitt's courageous decision to eschew historical detail may have been prompted by the greatest and most influential of all glass and metal sheds of the century, the one constructed for the Great Exhibition of All Nations, the first truly international exposition, inspired by Prince Albert, Queen Victoria's consort, and held in Hyde Park, London, in 1851. This was essentially a mammoth greenhouse. Its designer, Sir Joseph Paxton (1801–1865), formerly gardener at Chatsworth, had built there for the Duke of Devonshire in 1836–1840 a greenhouse 277 by 123 feet, covered by an arched glass roof on an iron frame, and in 1850 he was working on a smaller one with a flat ridge-and-furrow roof of his own invention. When the Commission for the Exhibition could produce no

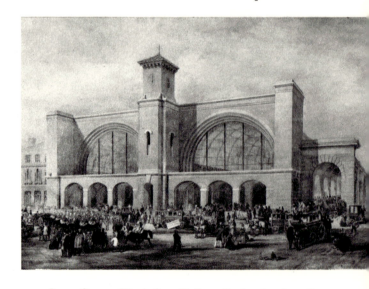

155. LEWIS CUBITT. King's Cross Railway Station, London. 1851–52

164

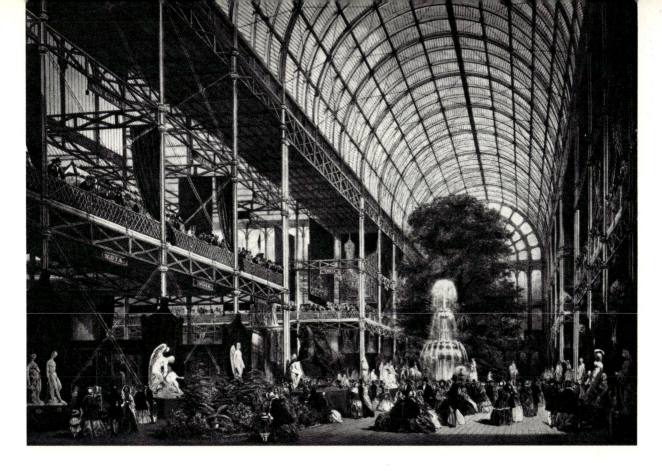

156. SIR JOSEPH PAXTON. Crystal Palace, London. Transept looking north. 1850–51

satisfactory design, Paxton's suggestion of a glass and iron structure was quickly accepted, and work began only nine months before opening day. The precision and clarity of the Crystal Palace, as it was immediately called, with its seemingly endless rectangular interior crossed by a tall transept and sheathed in sparkling glass, the whole so daring in construction yet so simple in design, enraptured the public as no permanent structure could have done (plate 156). So great was the affection for the Crystal Palace that it was taken down and re-erected in 1852–1854 in an enlarged and altered form at Sydenham, south of London, where it served variously as a museum and concert hall until its destruction by fire in 1936. As important, however, as the public's acceptance of this first large example of a totally nonstylistic architecture, in which the forms, their proportions, and their details were inseparable from the undisguised materials and techniques of construction, was Paxton's use of mass-produced, interchangeable metal parts which could be assembled and bolted into place on the site. The glass, 900,000 square feet of it, was cut to predetermined sizes at the factories before being placed on the iron frame.

The repetition of many identical elements lightly and precisely fitted together undoubtedly contributed to the experience of an overwhelmingly vast but unified space, an essential condition given the heterogeneous character of the exhibits within it. Unity was also achieved by color, for the ironwork was painted according to a scheme devised by Owen Jones (1809–1869). The principal members were pale blue, the underside of the girders strong red, and the diagonal faces of the columns and other details were yellow. Some observers thought the colors more appropriate for wood, but it is worth reflecting that there is no reason why ironwork must necessarily be painted black. The Eiffel Tower, designed for the Paris Exposition of 1889 by Gustave Eiffel (1832–1923), still standing and still the most conspicuous example of exposed metal construction, was originally painted in iridescent hues. At the same exposition the Galerie des Machines (plate 157), afterwards demolished, proved that an enormous space could be spanned by metal arches springing directly from the ground and devoid of ornament, even of the sort of simplified floral and geometrical designs that Eiffel had applied to his tower.

The principle of prefabrication, implicit in the

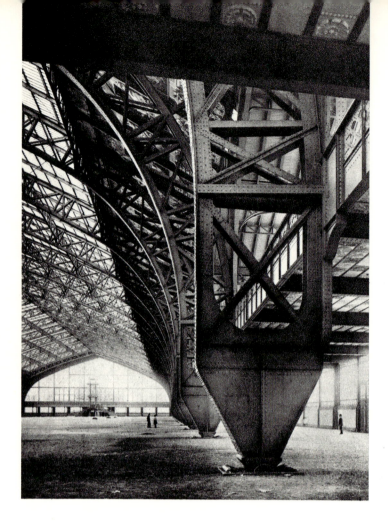

157. FERDINAND DUTERT. Galerie des Machines, Exposition Universelle, Paris. 1889. Demolished

construction of the Crystal Palace, was not indeed new with Paxton. For ten years or more, houses, lighthouses, and even churches had been serially produced in English foundries for export to under-developed areas in Africa, Australia, the British West Indies, and even to California, where during the Gold Rush of 1848–1849 housing was in short supply. In the United States James Bogardus (1800–1874) had been experimenting with cast iron for walls as well as for the internal supports of buildings. In 1848, the bearing walls of his own four-story factory in New York consisted solely of cast-iron piers and lintels, the spaces between being filled with glass or brick. His patented system was soon widely imitated in many American cities. It had the virtue of permitting the walls to be reduced to a skeletal grid of metal and the windows made correspondingly larger (plate 158). The disadvantages appeared when the metal was indiscriminately smothered with coarse, stylistic ornament. Nor was exposed cast iron, unprotected by masonry, sufficiently fireproof, because it melted at high temperatures.

The structures we have just considered were de-signed and built by men who were primarily engineers rather than architects. Consequently, the decisions which affected the design of their buildings were prompted more often by functional than by aesthetic considerations. When such structures had perceptible architectural qualities, and we have seen that some-times they did, they were the result of the engineers' expression of a logical relation between material and function. The role of the associated architect was

158. JAMES BOGARDUS. Edgar Laing Stores, New York. First cast-iron building in New York. 1848

frequently subsidiary, if not irrelevant. From these circumstances arose the unfortunate distinction between architecture as an art of design and engineering as the science of structure. One of the greatest accomplishments of American architecture in the last two decades of the nineteenth century was the obliteration of this distinction in a series of buildings novel in design as well as in structure, in which architect and engineer, mutually responsive to the other's role, created the conditions for an entirely new architectural aesthetic.

That this development occurred in Chicago can be partially explained by the need for new office space as the city prospered in the years after the disastrous fire of 1871. Similarly, the tendency to build upward was a response to rising real estate values in the few blocks where financial and mercantile institutions were clustered beside Lake Michigan. But the qualities of invention and design in the tall office buildings of the so-called Chicago school, erected between 1885 and 1900, were in the end the contribution of a few men of immense talent and imagination.

The structural technology for a tall building was in existence once Bogardus had patented his system of skeletal metal construction, which, being itself load-bearing, removed the weight of the upper stories from the outer masonry walls, and once Elisha Graves Otis (1811–1861) had installed the first passenger elevator in a New York department store in 1857. In addition, by 1865 Henry Bessemer (1813–1898) had perfected the inexpensive production of steel, which was stronger and more fire-resistant than iron. In 1879 William Le Baron Jenney (1832–1907) erected in Chicago the first Leiter Building (now the 208 West Monroe Building), a five-story structure with timber floor beams carried on cast-iron columns encased in brick piers for fireproofing. Jenney had served in the Corps of Engineers during the Civil War and, although well-read in architectural history and engineering, was not, strictly speaking, an architect. The exterior of his epochal Home Insurance Building (1883–1885; demolished 1931) presented a forthright but unsubtle attempt to organize the inherently monotonous surface of a ten-story structure, the tallest at that date, by grouping the windows in pairs and dividing the stories at intervals of two and three by means of wide moldings resting on carved capitals. The rusticated granite base, embracing the first two stories, and the high parapet reinforced the thought that Jenney had taken the archetypal elevation of a Florentine palace as his source. The walls, however, were carried on extensions of the steel floor beams and so were entirely non-bearing. Although of brick,

159 WILLIAM LE BARON JENNEY. Second Leiter Building (now Sears, Roebuck, and Co.), Chicago. 1889–90

Jenney's curtain wall, as it is now known, could have been executed in any other material, such as glass or tile, at any height. All that remained was to find for the exterior a more harmonious expression of the new internal structural system.

In his second Leiter Building (1889–1891; now the Sears, Roebuck store), in which he was assisted by his later partner William Bryce Mundie (1863–1939), Jenney expressed the internal structure fully and successfully (plate 159). The principal elevations are divided by continuous vertical piers and unbroken horizontal spandrels into large rectangular panels, where the groups of windows, separated by narrow iron mullions, recapitulate the general ordonnance of the façade. The wall plane, reduced to the thinnest of supports for the expanse of glass and articulated equally in both directions, was a straightforward statement of the structural system.

In spite of the stumbling character of the Home Insurance Building only four years before, Jenney's and Mundie's resolution of the twin problems of structure and design was not precocious, but is to be seen in relation to other and taller buildings erected in Chicago in these years. In the design and structure of the thirteen-story Tacoma Building (1886–1889; demolished 1929; plate 160), William Holabird (1854–1923) and Martin Roche (1855–1927) created one of the outstanding examples of the Chicago school. The skeleton of cast and wrought iron and Bessemer steel

160. HOLABIRD and ROCHE. Tacoma Building, Chicago. 1886–89

Building. Although its structural system was already retarded, the simplicity and clarity of the Monadnock Building made it for many the most satisfying of the Chicago skyscrapers. There was less agreement about the Reliance Building (1890–1895; plate (161), nominally by the firm of D. H. Burnham and Company, but actually by Charles B. Atwood (1849–1895), who, in quite another mood, had designed the academically domed and colonnaded Fine Arts Building, the only permanent structure at the World's Fair of 1893. Here the weightless wall was entirely in glass and tile, the latter material being used for the first time in a building of this size. Visually, the horizontal structure and function of the building as a vertical pile of floor slabs supported by slender piers were expressed by the continuous spandrels stretched across the walls and the projecting bay windows. The combination of so large an amount of glass with the light tile created an effect of delicate, yet controlled, strength.

was the first riveted frame, a process that increased the speed and efficiency of construction. Just as novel were the tiers of bay windows admitting air and light from three directions. In addition to their functional value, they increased the three-dimensional plasticity of the building by breaking up the boxlike cube of the usual office block. Similar tiers of bay windows were used by Daniel H. Burnham (1846–1912) and John W. Root (1850–1891) in the Monadnock Building, which was the last large masonry building, sixteen stories tall, to be constructed in Chicago. Burnham expressed the weight and pressure of the load-bearing walls by a slight outward flare of the ground story, matched by a similar curved projection of the parapet. Between the top and bottom the brick walls were severely plain, their surfaces broken only by the knife-sharp window openings and modulated by the tiers of bay windows in the manner of the Tacoma

161. CHARLES B. ATWOOD, and D. H. BURNHAM AND COMPANY. Reliance Building, Chicago. 1890–95

Colorplate 26. STANFORD WHITE. Hill-Stead, Farmington, Connecticut. 1899

Colorplate 27. RICHARD MORRIS HUNT. The Breakers, Newport, Rhode Island. 1892–95

162. Louis Sullivan. Transportation Building, World's Columbian Exposition, Chicago. 1893

In the detail of the Reliance Building, especially in the thin, flat roof hovering at the corners, may be seen the influence of Louis Sullivan, the most gifted of all the architects working in Chicago during those years. He had been associated with Dankmar Adler (1844–1900), like Jenney primarily an engineer, in the Auditorium (1887–1889; plate 163), now Roosevelt College, a large and complex building on Michigan Avenue which incorporated a theater seating 4,200, a hotel, and an office block. It was most remarkable for its interiors, especially the auditorium and the restaurants, on which Sullivan expended his inexhaustible decorative imagination. The impressive exterior, in cut stone above a rusticated granite base, owed much to Richardson's Marshall Field Store, but the fenestration of the tower was unmistakably Sullivan's. In his residential architecture and in his banks for several small Middle Western towns, executed after 1900 when his practice had declined, Sullivan continued to develop Richardson's idea of a central arched portal, so conspicuous a feature of his own Transportation Building of 1893 (plate 162), while adding the original decoration which was one of the most significant American contributions to the international style of Art Nouveau (see below, pp. 179–82).

Sullivan's last three large buildings, however, were not only his most original creations; they established as well an artistic standard for the American office building that has never been sur-

passed. Yet they were ignored during the many years when economic prosperity encouraged the erection of taller and taller buildings, whose exteriors were adorned with a selection of stylistic details totally inappropriate to their height and function. For example, the Woolworth Building in New York

163. Louis Sullivan and Dankmar Adler. Auditorium Building (now Roosevelt college), Chicago. 1887–89

164. CASS GILBERT. Woolworth Building, New York. 1913

the wall plane and from the shop windows, so that they emerge as free-standing columnar supports for the metal cage above. The ductile nature of terra cotta is also indicated by the cast ornament sheathing the piers and spandrels.

In the last of his important large works, which was also in a way the last great building of the Chicago school, the Carson Pirie Scott store (originally the Schlesinger & Mayer store; 1899–1904; plate 166), Sullivan stressed the horizontal floors by unbroken spandrels wider than the piers which pass but do not interrupt them. The unusually wide, so-called Chicago windows consist of a central fixed pane between narrower, double-hung sashes. At the corner Sullivan joined the three bays on the side street to the seven of the principal façade (extended by five more in 1906 by Burnham) by a cylindrical pavilion, where the horizontal rhythms of the other elevations are varied by unbroken circular piers rising in front of the curved spandrels. On the first two stories Sullivan lavished his ornamental cast-bronze reliefs of inextricably intertwined foliate elements. Today such luxuriant decoration seems unnecessary for that or any other building; but although Sullivan acknowledged that buildings might be "well formed and comely in the nude," he also insisted that "a decorated

(1913; plate 164) is dressed with Gothic ornament to make it look like a monstrous village church. In Sullivan's buildings, on the contrary, the ornament, freshly conceived for the occasion by the architect himself, was an integral part of the expression of structure. In the ten-story Wainwright Building of 1890–1891 in St. Louis, the upper seven stories are enclosed within a square formed by the two-story base, the powerful corner piers, and the story-high cornice with its flat projection. Within this, the vertical height and horizontal function of the building are interwoven by having the decorated metal floor spandrels pass behind the continuous, vertical brick piers between the windows. Ornament is concentrated on the nonsupporting surfaces around the ground-floor entrances, on the spandrels, and on the cornice which conceals the machinery on the roof. The formula is similar in the Guaranty Building in Buffalo (now the Prudential Building; 1894–1895; plate 165), but the shaft of the building is more independent, the corner piers being narrow and the cornice reduced in height and in its relative projection. And in the relation of the continuous piers to the spandrels behind them, Sullivan found a still more logical and precise expression of the taut but directionally neutral steel skeleton, an effect further emphdasized at the groun story by the isolation of the bearing piers, both from

165. LOUIS SULLIVAN. Guaranty Building (now Prudential Building), Buffalo, New York. 1894–95

166. LOUIS SULLIVAN. Carson Pirie Scott and Company Department Store, Chicago. 1899–1904

structure, harmoniously conceived, well considered, cannot be stripped of its system of ornament without destroying its individuality."[1]

Sullivan's search for truly contemporary solutions to the architectural problems of his day led him to two principal ideas, that of an organic architecture in which, as in living beings, the style would be "the response of the organism to the surroundings," and one in which each form, of the part as well as of the whole, would "clearly correspond with its function." Sullivan drew his analogies from nature, from the tree and the tendril, and his intention clearly was to suggest an architecture responsive to human needs. Unfortunately, those who objected to his architecture interpreted his famous statement that "form ever follows function" in strictly materialistic and mechanical terms, forgetting that he insisted not on the letter of his law but on its spirit. To him it was the "pervading law of all things organic and inorganic . . . of all true manifestations of the head, of the heart, of the soul."[2]

Sullivan spoke only of an architecture that was to

167. FRANK LLOYD WRIGHT. James Charnley House, Chicago. 1891

be organic. His younger friend, disciple, and erstwhile partner, Frank Lloyd Wright (1869–1959), made the term "organic architecture" his own in the course of the longest and most distinguished career in American architectural history. Wright's complex relation to Sullivan, whom he always addressed as "Master," was apparent as early as 1891 in the Charnley House in Chicago (plate 167), ostensibly by Adler and Sullivan but undoubtedly by Wright, who was then their principal designer for residences. The cramped dimensions of a corner lot required an urban composition, which Wright supplied with incomparable elegance, piercing the flat walls of thin, yellow brick with a few emphatically square windows and emphasizing the entrance by carrying the smooth stone base around its flanking windows and up to a projecting balcony with typically Sullivanian ornament. At first glance the composition appears entirely foursquare, until one sees that the recession of the wall plane behind the balcony creates an inward-outward movement of volume against void which has implicitly more action than Sullivan's symmetrical and so more static manner would have permitted.

Wright's ability brought him so many clients of his own that Sullivan dismissed him in 1893. In the following fifteen years he created in the Middle West an entirely new domestic architecture, nonstylistic because Sullivan had taught him to despise such tactics, but one in which the relations between function, materials, and the resulting design were so closely reasoned and expressed, so analogous to a natural form whose organic growth has been deter-

mined by the interaction of its purpose with its environment, that the consequence was a unique style. It is entirely Wright's but also more than personal, American even, and when its originality was understood in Europe, a style that has been a principal component of modern architecture ever since.

Wright rejected the conventionally symmetrical plan of rooms arranged along either side of a hall for one in which the principal rooms were placed on cross-axes extending from a central space, with a large living hall usually dominated by a cavernous fireplace. As the doorways were enlarged between the rooms, the walls became short projections indicating the major spatial divisions without interrupting the continuous flow of interior space. The windows were grouped horizontally, sometimes even turning the corners, so that the direction and movement of light would emphasize the free disposition of space and draw the eye to the far, flat horizons of the Middle Western landscape. For these houses were intentionally broad, low, and horizontal in order to symbolize the identity, in Wright's philosophy as in Sullivan's, of man and his environment.

In some of the first of the so-called Prairie houses the intersecting gabled roofs, like folded screens, and the banding of the stucco walls with stained wooden trim to indicate the structural members within, were reminiscent of Japanese architecture (plate 169). Wright is known to have admired the Hōō-Den, the Japanese pavilion at the World's Fair of 1893, and Japanese prints and oriental sculpture and ceramics were the only works of art he would tolerate in his own home. Therefore, Japanese influence in these early houses is not surprising, however much he might deny it. Especially was this so in the interiors, where whatever was left of the walls was treated almost like the sliding screens of Japan, and where the continuity of space was stressed by the cornice carried as a flat band of wood or stucco through all the rooms (plate 168). Wright's insistence on exploring and exposing the nature of his materials seems to have owed as much to his almost oriental sensitivity to natural substances as it did to William Morris and the Arts and Crafts Movement.

168. FRANK LLOYD WRIGHT. Interior of the Avery Coonley House, Riverside, Illinois. 1908

170. FRANK LLOYD WRIGHT. *Ground and First-Floor Plans of Robie House, Chicago*

171. FRANK LLOYD WRIGHT. Frederick D. Robie House, Chicago. 1909

The culmination of the Prairie style occurred before 1914 in a series of large and well-known residences which included the Martin House of 1904 (Buffalo), the Coonley House of 1908 and its Playhouse of 1912 (Riverside, Ill.), the Roberts House of 1908 (River Forest, Ill.), and the climactic examples, the Robie House of 1909 (now the property of the University of Chicago; plates 170, 171) and Wright's own home, Taliesin East of 1911 (Spring Green, Wis.; largely destroyed by fire in 1914, but afterward continuously rebuilt and enlarged throughout Wright's lifetime). In all of these the hipped roofs were so flattened that they floated as continuous broad planes projecting over the terraces which extended the living space to the outdoors, seeming, when required, to pass as unbroken planes through vertical elements like the chimneys. The continuous expanse of transparent glass in the windows clustered just below the roofs and spanning the whole wall between its terminal structural piers increased the weightlessness of the roofs. Never since the Middle Ages had the expression of supporting and enclosing elements—the walls, windows, and roofs—been so carefully articulated in order to reveal the integration of the interior volume with the exterior mass. And always Wright expended the most meticulous attention on the proportions, textures, details, and on the planting of the landscaped terraces.

In addition, Wright found original solutions for problems other than those of residential architecture. The project of 1902 for the Yahara Boat Club in Madison, Wisconsin, was never executed, but the published design ranks as one of the most influential sources for the later development of European architecture after 1920. He extended the abstract and geometrical symmetry of the Charnley residence by a broad, low wall topped by a ribbon of windows and a flat roof which stretched between the piers at either end and over the adjacent terraces. The more formal, Sullivanian symmetry of the Boat Club reappeared soon after in two of his most influential structures, the Larkin Company Administration Building in Buffalo (1904; now demolished) and Unity Church in Oak Park (1906). In the latter the interior space is interpenetrated by balconies suspended between four piers standing freely within the walls, with staircases winding behind them. On the exterior, the rich complexity within is suggested only by the distinction between the austere concrete walls, crowned by groups of windows, and the lower square corner piers reinforcing the cubical mass of the upper part of the auditorium which rises above. Wright had found a modest but monumental expression for a church which owed no allegiance to any historical style. Even more monumental was his treatment of the Larkin Building (plate 172), whose function had scarcely any history at all. From the street the massive square piers, which were not solely decorative, since they contained the stairs and other services, stated the new, aggressive power of modern industrial management. On the sides and between the piers at each end, the utilitarian character of the structure was expressed by rows of windows separated horizontally by broad spandrels and joined vertically by continuous pilasters. It was a simpler scheme than any Sullivan would have wanted, but one in which the form did not merely mechanically follow the function, but gave that function a new and powerful expression. Within the building, where the office floors surrounded a court, the interplay of vertical and horizontal elements repeated the articulation of the outside walls. Once again, Wright had created an organic architecture where the distinction between exterior and interior was suppressed so that the whole might be integral and indivisible.

The Larkin Building was, until the Johnson Administration Building of 1936–1939 in Racine, Wisconsin, Wright's largest industrial commission. The loss which American commercial architecture suffered through the neglect of his talents can be sensed in his projects for the Press Building of 1912 for San Francisco, in descent again from Sullivan, but with a more active grid of windows stressing their greater verticality, and in the project for a smaller, glass-sheathed apartment building in New York, the St. Mark's Tower of 1929. By 1914, however, his reputation had been compromised by personal difficulties, which are perhaps reflected in the ex-

172. FRANK LLOYD WRIGHT. Larkin Administration Building, Buffalo, New York. 1904

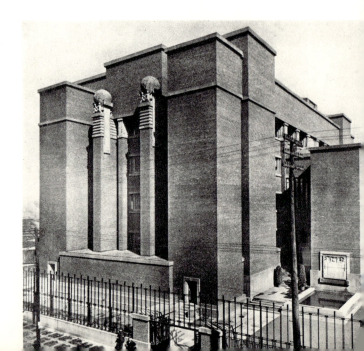

uberant but tense decoration of his Midway Gardens in Chicago of that year and in the fantastic ornament and heavy spatial complexities of the Imperial Hotel in Tokyo of 1916–1922. Wright was still a master of structure, as the world learned when the hotel rode out the disastrous earthquake of 1923, but by then he was better understood in Europe, where the publication of his work after 1910 affected the generation of German and Dutch architects who were to create the so-called International Style in the 1920s (see chapter 12).

The prominence of ornament in Sullivan's and Wright's buildings, whether naturalistic in the former's or increasingly geometrical in the latter's, sets their work apart from the more austere and stripped styles of the twentieth century. Such decoration for some time has seemed faintly old-fashioned, but it has a more than strictly American relevance and is best considered in the wider context of the international style generally known as Art Nouveau, from the shop in Paris where the new decorative designs were first shown to the French public in 1895. Art Nouveau was neither an essentially architectural nor even pictorial phenomenon, but rather the result of certain concepts of decorative design related to the reform of the whole artistic environment. If Art Nouveau failed to achieve that much, and indeed, after its brief flowering in the 1890s, it disappeared almost entirely after 1910, the reason can be found in its fundamentally decorative, rather than structural, character. But for a few years the artists and architects who used the forms of Art Nouveau demonstrated that modern designers were capable of working in entirely nonhistorical terms.

Among the many sources of Art Nouveau must be counted the denunciation by Ruskin, Morris, and their followers of the misuse of the historical styles and their belief that the decorative arts could be reinvigorated by the careful study of natural, organic forms. The most distinctive element of the mature Art Nouveau products of the 1890s was a sinuous swelling and recurving line (the famous "whiplash" curve) like the stems of water lilies and other undulant aquatic plants. The opponents of Art Nouveau sometimes called it the "noodle" or "tapeworm" style, and there was unquestionably something silly, if not tired, dank, and neurotic, about its extreme manifestations. Such lines, however, had their historical precedents in the reversed S–curves of eighteenth-century Rococo art.

Another important characteristic was a conscious, at times willful, asymmetry, probably derived from Japanese woodcuts, which were more admired in the 1890s than at any time since their first appearance in

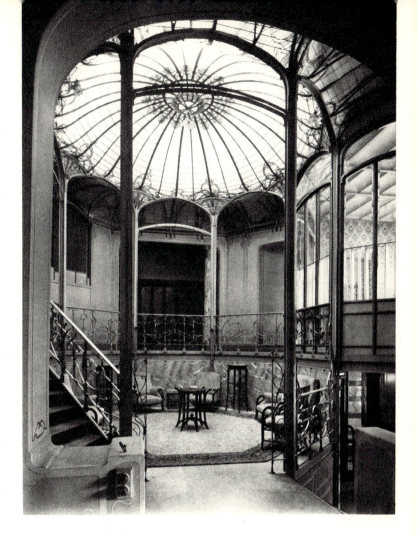

173. VICTOR HORTA. Van Eetvelde House, Brussels. 1895

Europe some thirty years before. Sinuous lines and asymmetrical emphasis can also be found after 1885 in the work of such progressive painters as Van Gogh, Gauguin, Toulouse-Lautrec, Munch, and Beardsley (plates 112, 113, 114, 118; colorplate 25), although none would have wished to be, nor indeed should be, classed as a decorative artist. It is of some interest, however, that such lines and asymmetry served to increase the subjective emotional expression of their work.

The architectural and three-dimensional treatment of these decorative elements was inaugurated suddenly and in a mature form in Brussels by the Belgian architect Victor Horta (1861–1947). In his Tassel House of 1893 he revealed the structural metal beams and columns and from them developed curvilinear bands of ironwork for the stair rail, echoing the twining patterns in the mural decorations and mosaic floors. Two years later, in the Van Eetvelde House (plate 173), he covered the hall with a glass dome supported on an exposed metal frame. The lighting

fixtures were metal tubes bent and curved to resemble water lilies. This frank expression of metal and glass recalls earlier nineteenth-century greenhouses and even the Crystal Palace, but Horta treated his material with a consistently decorative and antihistorical intent.

In Paris the most conspicuous monuments were the new entrances to the subway, or Métro, by Hector Guimard (1867–1942). The metal railings and lampposts were actually of iron cast in series, but they seem like a new species of plant life freely modeled by a sculptor. Guimard's furniture is among the finest of the period, fundamentally Rococo in its rhythms, but freely planned and with seminaturalistic carvings (plate 175).

The principal American designer was Louis Comfort Tiffany (1848–1933), whose Favrile glass (the term was his own) enjoyed international esteem (plate 174). He had perfected a way to reproduce the opalescent sheen found on ancient glass after it has been buried a long time, but the iridescence also had naturalistic connotations in its resemblance to peacocks' feathers, one of the favorite decorative motifs of the period.

The most extravagant use of curvilinear forms is to be found in Barcelona in the work of the Catalan architect Antoni Gaudí (1852–1926). As early as 1885–1889, in his Palau Güell, he had found his way past historical ornament to the invention of astonishingly original forms, not only on the surface but in the structure as well, as in his parabolic arches and vaults. His unfinished Sagrada Familia, the Cathedral of the Holy Family, begun in 1883, is the most personal and possibly the most important religious edifice of the nineteenth century. On the façade of the east transept,

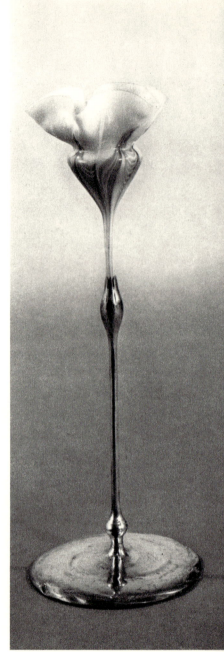

174.
LOUIS COMFORT TIFFANY.
Vase. c. 1900.
Bronze and
Favrile glass,
height 15 7/8".
The Museum of Modern
Art, New York.
Phyllis B. Lambert Fund

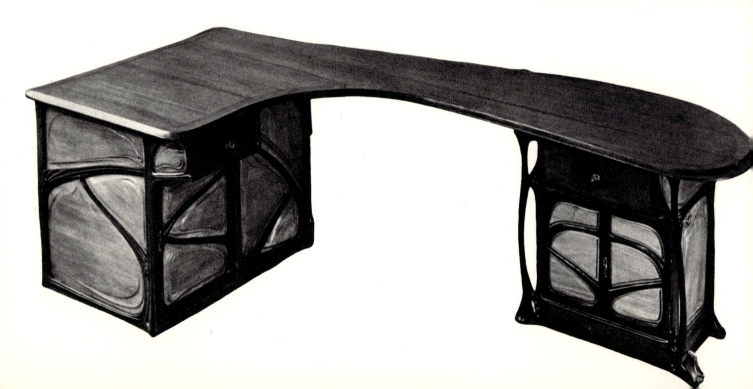

the stone seems to flow over the towers and portals as freely as sand dribbled in sea water. Gaudí's finest work may be the Casa Milá, an apartment block in Barcelona (plates 176, 177). Although it was designed and built only in 1905–1910, almost beyond the chronological limits of Art Nouveau, in no other building were the plan, structure, and decorative effects so completely controlled by undulating and organic curves. Many walls are curved, no two rooms are of the same shape or size, and the plans of the apartments differ from one floor to another. The façades, not cast in concrete as one might have expected, but of fine, cut stone carefully weather-worn by hand, sway and sag as if the material were in a state of flux. The feeling of water, of waves washing on a shore, is borne out by the marinelike growths of the intricate wrought-iron balconies and grilles.

The Casa Milá was Gaudí's triumph, but so personal an approach hastened the collapse of Art Nouveau. When its designs were vulgarized by mechanical and commercial reproduction, it proved impossible to sustain such extremes of individuality. Horta himself abandoned the style soon after 1900, and his later work is in a conventional and simplified Neoclassicism. Yet even in the 1890s there were signs of a reaction against the curve, or, to put it another way, a countercurrent of rectilinear design. This, too, can be traced to Britain, but this time to Glasgow, where the Scottish architect Charles Rennie Mackintosh (1868–1928) was producing designs for furniture and interiors dominated by slim, straight lines and light colors, often pink and ivory. His principal

building was the Glasgow School of Art of 1897–1899, where the library in the new wing, added in 1907–1908, is entirely rectilinear in plan, structure, and detail (plate 178). In the jointed wooden members supporting the balcony, which interpenetrate and articulate the space, he demonstrated the decorative possibilities of the straight line. Mackintosh's work was well known abroad through exhibitions of the decorative arts, and it was particularly influential in Germany and Austria, where the new style was known as *Jugendstil*, after the Munich illustrated periodical *Jugend* (*Youth*), or as the Secession style, from the Vienna Sezession, an organization of artists opposed to the dominance of academic art, whose exhibitions in the late 1890s introduced to the Central European public the work of the most prominent contemporary artists and designers. The building erected for these exhibitions, designed in 1898–1899 by Josef Maria Olbrich (1867–1908), was a rectangular cluster of massive pylons topped by an openwork metal dome of gilded laurel leaves (plate 179). Straight lines, alternating with slight structural curves, are found in the buildings of other Viennese architects, notably in the Post Office Savings Bank in Vienna by Otto Wagner (1841–1918), built in 1904–1906 and one of the first structures in which the exposed metal parts were of aluminum. A more ornate, but still severely rectangular, building was the marble Stoclet residence in Brussels of 1905–1911 by Josef Hoffmann (1870–1956). The sumptuous interiors included mosaics by Gustav Klimt (1862–1918), one of the leading painters of the Vienna Sezession.

175. HECTOR GUIMARD. *Desk*. 1905. African and olive ash, 28 3/4″ × 8′ 5″.

Chair. 1900. Walnut and leather, height 32 1/4″

The Museum of Modern Art, New York. Gift of Mme Hector Guimard

176. ANTONI GAUDÍ. Casa Milá, Barcelona. 1905-10

177. ANTONI GAUDÍ. *Plan of Typical Floor, Casa Milá,
Barcelona*

178. CHARLES RENNIE MACKINTOSH. Interior of the Library,
School of Art, Glasgow. 1907–8

By 1910 this countercurrent had become a true reaction against the curvilinear aesthetic of Art Nouveau. Since 1894 Otto Wagner, although of the older generation and the master of Olbrich and Hoffmann, had been preaching and practicing a coherently rationalistic architecture based on the expressive integration of structure, materials, and function, with decorative details reduced to a minimum. The next step was taken by another of his pupils, Adolf Loos (1870–1933), who had been in the United States in 1893–1896 where he saw the work of Sullivan and Wright. Possibly taking his cue from Sullivan's plea to consider the structure of a building apart from its ornament, he devoted himself, upon his return to Vienna, to a series of polemical attacks, going so far as to declare in 1908 that "ornament is a crime." Not unexpectedly, his own work, such as the Steiner House in Vienna (1910; plate 180), was extremely severe, not only devoid of ornament inside and out, but uncompromisingly expressive of its material, which, for the first time in a residence of this size, was reinforced concrete. Although Loos had learned something of the new planning from Wright and connected his principal rooms by larger openings, his interior was not so completely or continuously integrated as Wright's were by this time. On the exterior, the rigidly symmetrical distribution of the masses and windows belied the functional differentiation of the spaces within. Nonetheless, and ungracious as much of Loos's architecture was, it offered to a still younger generation the suggestions for a coherent and rational twentieth-century style with no traces of the Romantic nature sensibility that had finally vitiated the earlier promise of Art Nouveau.

180. ADOLF LOOS. Steiner House, Vienna. 1910. Garden façade

Fauvism and Expressionism

The word *Expressionist* as a definition of modern painting was first used by German critics about 1910 to call attention to certain French artists whose bold colors and emphatic drawing set them apart from the Impressionists.[1] Within a few years the term was applied to many varieties of modern art, some of which are now more familiar as Cubism or Futurism, while Expressionism customarily means certain developments in German art between 1905 and 1930. There are distinctions to be made between German and French Expressionist painting, but the similarities are greater than the differences. Expressionist artists of whatever nationality placed a premium on their own and the spectator's response to the elements of pictorial design—color, line, and shape—which may be emphasized, exaggerated, or distorted to any desired degree in response to the artist's emotional commitment to his subject and in order to provoke a similar response in the spectator. The subject, and this is more true of French than of German art, may of itself have little ostensible emotional content, so that the artist's attention can be held by certain aspects of the aesthetic situation. Many subjects in French painting are no different from those treated by the Impressionists; only the treatment counts. The Germans, on the other hand, were more interested in the expressive character of the subject itself and made explicit its dramatic or emotional character. The difference

between these two attitudes toward subject and content can be seen by comparing Matisse's *Blue Nude* with Schmidt-Rottluff's *Nude Before a Mirror* (colorplate 28; plate 191). In each work the female figure has been subjected to strenuous linear distortion, but Matisse's is largely a linear arabesque, whereas Schmidt-Rottluff's says something about human nakedness. Behind the *Blue Nude* lie the decorative harmonies of Gauguin's tropical visions. The German artist knew something of Gauguin, too, for certainly he had seen the Tahitian woodcuts, but his concern with the human condition places him in descent from Van Gogh.

Expressionism emerged as a perceptible direction in modern painting in both France and Germany in 1905. By then the work of Gauguin and Van Gogh had been seen in some quantity by the younger painters on several occasions, for the French especially at the memorial exhibitions following Gauguin's death in 1903, which were held in Paris at the Salon d'Automne. This Salon had been founded in 1903 as a liberal forum for new tendencies, including those in the decorative arts, which were ignored by the official Salons, and its exhibitions were held in the fall to avoid competition with others which occurred in the spring. The first Salons d'Automne in 1903 and 1904 were chiefly remarkable for well-selected retrospective exhibitions honoring Gauguin, Redon, Rouault, and

Renoir, but the third was a more exciting occasion. Critics and public were startled by the presence, in one small room, of work by Matisse, Derain, Marquet, Vlaminck, and Dufy which seemed violently distorted and outrageously colored. Ever since the critic Louis Vauxcelles wrote that a small and rather conservative sculpture in this room looked like "a Donatello in a cage of wild beasts (*fauves*),"[2] these painters have been known as Fauves. If the name was ever apt, it was so only at the first when their work looked alarmingly violent, in contrast to the subtle harmonies and intimate subject matter of the late Impressionist and Nabi painters, and while the artists themselves were still working with a common purpose. But Fauve painting proper was very short-lived. After a few years each painter developed his own style, so that by 1910 the concept of a group of artists working together no longer held true.

Of the group who exhibited in 1905 Henri Matisse (1869–1954) and the landscape painter Albert Marquet (1875–1947) had already been exploring the properties of color and simplified design for some years. Raoul Dufy (1877–1953) and Othon Friesz (1879–1949) were friends from Le Havre and had been searching together for a way past Impressionism. André Derain (1880–1954) and Maurice de Vlaminck (1876–1958) had met while painting along the Seine at Chatou. Vlaminck, as impetuous a person as he was a painter, had been led to his radical revision of Impressionism by his first sight of Van Gogh's painting in 1901. Derain, better educated and more reserved, found his new formulas in the Italian "primitives" in the Louvre. The Dutch artist Kees van Dongen (1877–1968) had used brighter colors and stronger linear simplifications before he left Holland for Paris in 1897. There were others who were drawn to the group, but these were the principal Fauve masters in 1905, and of them all Matisse had the major and most varied talent. He had come late to painting from the law, and his art, however wild and disorderly it appeared to those who saw it for the first time, was based on reasoned principles of artistic order which he set forth in his "Notes of a Painter," published in 1908.[3]

For all the clarity of his thinking, Matisse based his aesthetic upon instinctual aesthetic feeling. We may admire his orderly argument about the power of colors to alter proportional and spatial relations as they are successively juxtaposed on a white canvas, but for his choice of colors Matisse had only his instinct to guide him, that infallible instinct which made him the greatest colorist of his day. He also explained that the source of aesthetic experience was not contingent upon pictorial elements, but inseparable from them.

As early as 1905-1906 Matisse put his theories into practice, in a large canvas now known as *The Joy of Life* (Merion, Pa., Barnes Foundation). In this bacchanalian revel the dancers and musicians are little more than swinging outlines in blue, red, violet, and green. In places the brushstrokes recall the mosaic-like pattern of the later Neoimpressionists, especially Signac, whose rainbow palette influenced many young painters in the first years of the century. In the works exhibited in 1905 Matisse showed a denser paint structure, although still bright, and a firmer control of his composition. By 1907, when he finished *The Blue Nude—Souvenir of Biskra* (colorplate 28), he was his own master. Color and line are indivisible, for Matisse was drawing with color. Furthermore, the exaggerations in the figure and the abbreviated indications of landscape are consistent with his intensely expressive reaction to his theme; he was not painting the nude as it is seen in life, but rather his feelings about it as an object of aesthetic interest.

With such paintings Matisse won the title of "King of the Fauves," as well as an international reputation far more extensive than any he had at home. The American writer Gertrude Stein (1874–1946) and her brothers Leo and Michael, who were then living in Paris, were among his first patrons, and their enthusiasm brought others, including two wealthy Russian merchants, Ivan Morosov and Sergei Shchukin, whose collections of modern French painting, formed before 1914, were outstanding at the time and are now among the principal treasures of the Soviet state museums. For his Moscow residence Shchukin in 1909 commissioned two large murals, *Dance* and *Music*, which were installed in 1911 and 1912 (now in the Hermitage, Leningrad). The former is well known through the large study for it now in the Museum of Modern Art in New York (plate 181).

Matisse's sculptures, of which he executed some seventy pieces between 1894 and 1950, are often closely related to his paintings. A bronze *Nude* of 1907 reclines in the same posture as the *Blue Nude*, and other sculptures reappear in his paintings of the Fauve years. In two groups—the five versions of a portrait of *Jeannette* (1910–1913) and the four examples of *The Back*, of 1909, c. 1914, 1916–1917, and c. 1929 (plate 291)—one can follow the progressively radical eliminations whereby he removed all adventitious detail. In each group he began with a naturalistic image, strongly but sensitively modeled in the manner of Rodin. By the time he reached the final versions, as in the last *Jeannette* (plate 182), only the bust and base remain from the Rodinesque earlier states. The

182. HENRI MATISSE. *Jeannette V.* 1910–11. Bronze, height 23″.
The Art Gallery of Ontario, Toronto

181. HENRI MATISSE. *The Dance—Study.* 1909. Oil on canvas,
8′ 6 5/8″ × 12′ 9 5/8″. The Museum of Modern Art, New York. Gift of
Governor Nelson A. Rockefeller in honor of Alfred H. Barr, Jr.

head itself has been sliced almost in half, and the face deeply gouged into planes and furrows comparable to, but not identical with, similar displacements of mass and volume in Picasso's and Braque's painting at that time. What was left of the model was the essential form, impersonal as subject matter but not abstractly geometrical, infused as it is with Matisse's inimitable feeling for life.

Toward 1912 Matisse was drawn to Cubism and for a time his work was unusually spare and colorless, but in the early 1920s he recovered the luminous serenity which he retained until the end of his long career at the age of almost eighty-five. He lived much of the time on the Riviera, where he painted numerous odalisques, still lifes of tropical flowers and fruit, and interiors saturated with a sense of luxurious leisure and irradiated by the rich colors and strong sun of the South (plate 183). This was not an art of serious social concern, and when Europe darkened in the 1930s it frequently seemed trivial; but as long ago as

183. HENRI MATISSE. *Still Life in the Studio, Interior at Nice.* 1923. Oil on canvas, 39 3/4 × 32″. Collection Mrs. Albert D. Lasker, New York

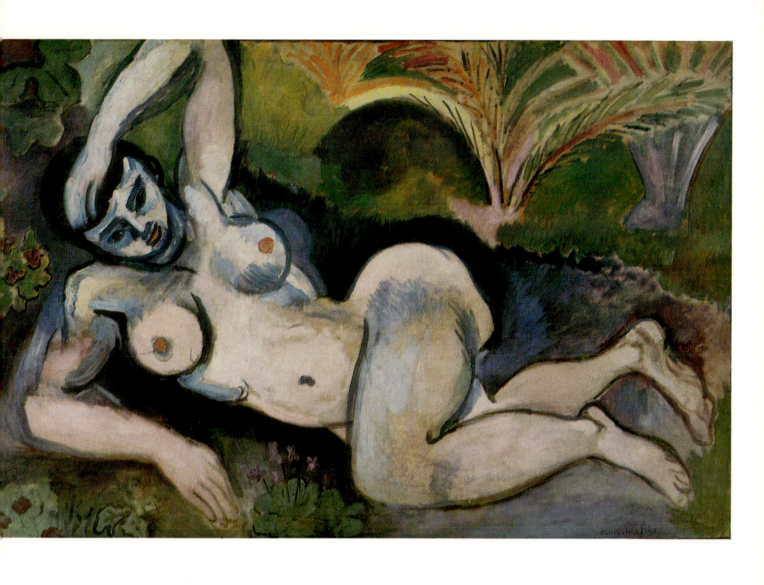

Colorplate 28. HENRI MATISSE. *The Blue Nude—Souvenir of Biskra*. 1907. Oil on canvas, 36 1/4 × 55 1/8″.
The Baltimore Museum of Art. The Cone Collection

Colorplate 29. GEORGES ROUAULT. *Clown*. c. 1907–8. Oil on paper, 23 5/8 × 18 1/2″. The Dumbarton Oaks Collection, Washington, D.C.

184. ANDRÉ DERAIN. *The Pool of London.* 1906. Oil on canvas, 25 7/8 × 39". Tate Gallery, London

1908 Matisse had declared that he was only interested in painting pictures that would unravel the tensions of modern existence, and his art had always done just that. In his old age he made the joyous designs for the Chapel of the Rosary at Vence (plate 345), consecrated in 1951, not as an exercise in religious art, for he was not a believer, but to express what he had once described as "the nearly religious feeling I have for life." While bedridden in his last years, he cut and pinned large sheets of paper, prepainted to his specifications with his inimitable colors, in designs whose extreme and witty economy never wholly concealed his joy in nature and in the beauty of human beings.

For the few years between 1905 and 1908 the paintings of André Derain rivaled Matisse's in their emphatic designs, brilliant color, and dramatically synthetic draftsmanship. The subjects were still in the tradition of Impressionist landscape, as in the views of London of 1906 (plate 184), when Derain was consciously emulating Monet, who had painted at some of the same sites only a few years before, but his attack was incomparably bolder. Derain was briefly the most daring of the Fauves, and he was never a better painter than when he was a Fauve. A year or so later he was attracted to Cubism, but he pursued that arduous research no further than in certain modifications of Cézanne's landscape forms as simplified planes. He then turned to the museums, consulting the masters of the seventeenth century

185. KEES VAN DONGEN. *Modjesko, Soprano Singer.* 1908. Oil on canvas, 39 3/8 × 32". The Museum of Modern Art, New Yo
Gift of Mr. and Mrs. Peter A. Rübel

when his interest in the earlier Italians waned. Derain was always a vigorous artist, and for a while, in the early 1930s, his accommodations to the past only increased his international reputation as a leading member of the School of Paris. Lately they have seemed fundamentally less original than his slighter designs for Diaghilev's and other ballets. His rehabilitation will depend upon critical reaction to the renewed study of his later work which is now under way.[4]

The other Fauve painters followed less adventurous paths. By 1914 each had found the best way to utilize his own talent, and thenceforward exploited it with skill, if not without monotony. Vlaminck's Fauve landscapes were his strongest, his brush suddenly presenting individual forms in a burst of yellow, red, and blue, a combination of colors harsher than any he found in his revered Van Gogh. The somber palette of his landscapes after 1920, often views of small villages in northern France under lowering winter skies, became a formula, but his brush could still create the most Expressionist flurries of pigment in France. On the other hand, the Fauve work of Raoul Dufy was less interesting and less varied than his later paintings, despite repetitious themes and treatment. Dufy was a specialist in the delights of life—of the racecourse, of the Riviera of a leisurely summer afternoon in the park—and for such subjects developed a combination of gaily syncopated drawing for figures and details and a background of flat washes of color for architecture and landscape. The result was supremely decorative, rarely without a touch of humor, and wholly pleasant. Kees van Dongen retained more of the original Fauve energy in his portraits, which sometimes had a wildly caricatural quality (plate 185). Perhaps his restricted subject matter proved less accessible to the international public, for Van Dongen has almost disappeared from the history of modern painting. But his place in the School of Paris is secure and will eventually be better understood.

Georges Rouault (1871–1958) was never actually a Fauve, but his name became joined with theirs through his appearances at the Salon d'Automne from 1903 with paintings which seemed equally violent. In content they were actually more so, because Rouault was always concerned with man's plight, torn between hope of heaven and the torments of the flesh. He was not only a devoted Catholic and a profoundly religious artist, but also the greatest modern French religious painter, even if the spiritual character of his works went unregarded by the Church until late in his life. He was deeply influenced by the social writings of Léon Bloy (1846–1917), and among

186. GEORGES ROUAULT. *This will be the last time, little father!* 1927. Aquatint, drypoint, and roulette over heliogravure, 23 3/8 × 17″. Plate 36 from the series *Miserere et Guerre.* The Museum of Modern Art, New York. Gift of the Artist

the first pictures he exhibited at the Salon d'Automne were figures of prostitutes and clowns, archetypes of those who have had to sell their bodies or their souls for others' pleasure (colorplate 29). In paintings of soldiers, lawyers, and judges, among which the best-known is *The Old King* (Pittsburgh, Pa., Carnegie Institute Museum of Art), he created awesome images of authority, sometimes close to caricature but always condemnations of the kind of power that abuses the rights of the innocent and weak. The drooping figures of his wounded and humiliated clowns recall his images of the rejected Christ. The wide, melancholy eyes of both figures are also those of the painter himself, for Rouault's artist, like Christ and the clown, is truly Everyman.

Rouault had been apprenticed to glass painters, and from them and his study of medieval glass may have come the strong black outlines which enclose his figures like leads in ancient windows. From Gustave Moreau, his teacher at the École des Beaux-Arts, he

learned the power of color to communicate overtones of feeling. His darkly iridescent surfaces were the result of patient overpainting until the colors smoldered beneath layers of translucent glazes. He was also a printmaker, working over his plates with the same indefatigable curiosity until they defy exact graphic description. The series of fifty-seven prints of *Miserere et Guerre* (1916–1918, 1920–1927) is doubly monumental, as the climax of his technical invention and as his most sustained and poignant treatment of man's suffering in this mortal life (plate 186).

Rouault was the most Expressionist of the French painters; the content of his work, unlike that of his French contemporaries, was always meaningful, and his technique was a means with which to express it, rather than an expressive end in itself, as might be said to have been true of Matisse. In Germany, emphatically expressive content has been conspicuous since the Middle Ages, and it cannot be ignored as a factor, perhaps the most important one, in German painting of the twentieth century. By 1900 the comparatively detached point of view toward their subjects of Liebermann and the German Impressionists had been superseded by more subjective considerations. Lovis Corinth (1858–1925) was a gifted Realist whose early work was ponderously descriptive, ex-

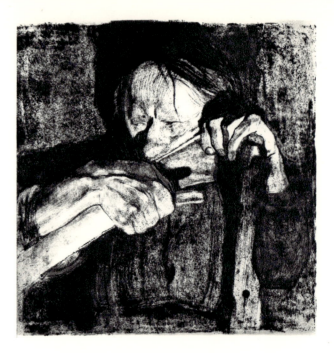

188. Käthe Kollwitz. *Sharpening the Scythe.* 1905. Etching, 11 3/4 × 11 3/4". From the series *Bauernkrieg* (*The Peasants' War*), published 1908. Busch-Reisinger Museum, Harvard University, Cambridge, Mass.

187. Lovis Corinth. *Eduard, Count Keyserling.* 1900. Oil on canvas, 39 1/8 × 29 3/4". Bayerische Staatsgemäldegalerie, Munich

ecuted in a palette of dulled local colors. In middle age his religious paintings and portraits became more sensitive, like the portrait of Count Keyserling (plate 187), a brilliant characterization of an aristocratic presence touched by intimations of psychological deterioration. In later life, after suffering a stroke which impaired his muscular control of his hands, Corinth executed slashing views of the blue-black Walchensee, a lake in the Bavarian Alps, which are among the best of Expressionist landscape paintings.

At the other end of the social scale in subject matter were the early etchings of Käthe Kollwitz (1867–1945), who introduced attitudes of social protest in the guise of historical events. Although technically conservative, her expressive point of view was thought radical at the time, and her etchings of the sixteenth-century Peasants' War encountered official disapproval. In the plate of a peasant woman sharpening her scythe (plate 188), the deliberate ugliness accords with the subject and contributes to the intensity of the whole. Kollwitz is best known for many lithographs portraying the conditions of the working class before the rise of National Socialism. No one has excelled her portrayal, with a few broad and fluent lines, of the agonies caused by war, inflation, disease, and economic chaos, but her work, however estimable for its humanitarian purpose, lay

189. ERNST LUDWIG KIRCHNER. *Street Scene.* 1911. Oil on canvas, 49 1/4 × 35 3/4″. Staatsgalerie, Stuttgart

slightly outside the formal developments of strictly modern art.

On the contrary, Paula Modersohn-Becker (1876–1907) accepted aspects of French Postimpressionism to express a more personal content. She was a resident of Worpswede, an artists' colony near Bremen somewhat like a latter-day Barbizon. But her companions' moody landscapes of the north German moors were less interesting to her than the new ideas she encountered on visits to Paris early in the century. After she had seen the work of Cézanne and Gauguin, her color grew brighter and her drawing more synoptic and forceful as she successfully combined her German passion for introspection with a broader, more French understanding of abstract form. Unfortunately her early death deprived Germany of a talent which might have been an important link between two vital modern traditions.

A more consistent and programmatic attack upon the problems of contemporary artistic expression occurred in 1905, when a group of young painters in Dresden formed the organization called *Die Brücke* (The Bridge) and issued a manifesto calling upon all like-minded artists to join them in creating "a bridge" whereby they might pass from academic conventions to a new world of artistic progress based upon the acceptance and interpretation of modern life. The members of The Bridge lived and worked together, and from the first their art was intentionally directed toward the criticism of contemporary society. Its tone, however, was very different from the art of the Fauves, whose paintings, as we have seen, were essentially investigations of purely pictorial problems, even if, in their first exhibition held in Dresden in 1905, much of their work, particularly their landscapes, derived from Later Impressionism and Neoimpressionism. The leader of The Bridge was Ernst Ludwig Kirchner (1880–1938), painter, sculptor, printmaker, and critic, whose harshly colored and emphatic drawing expressed his disenchanted view of life. The sources of Kirchner's rejection of Naturalism and Impressionism were medieval woodcuts, where he found his abrupt angular lines, and primitive artifacts, especially those from Polynesia, whose artistic quality he was among the first to appreciate when he discovered them in the ethnographic museum in Dresden. His understanding of the aesthetic quality of such exotic traditions and his adaptation of certain conventions were contemporary with, but independent of, Picasso's and Matisse's discovery of African sculpture in Paris, but the influence of primitive art upon his own work, even on his painted wood sculptures, was more a matter of emphasis—of heightening the emotive impact of color, line, and plane—than of imitating primitive forms. In *Street Scene* (plate 189), one of several painted in Berlin after he moved there in 1911, the influence of early German woodcuts accounts for the jagged lines, just as the repetition of the same simplified form for the men in the background is a convention in much primitive art. But the tone of the whole is entirely European and contemporary, life at night on the boulevards of the great cities, in this instance along the Kurfürstendamm where sexual appetites were notoriously intensified by the tensions of the modern metropolis.

Kirchner's own nervous system could not withstand the strains of the First World War. In 1916 he was invalided out and settled in Switzerland, where he remained for the rest of his life. After 1920 his work, like that of the other members of The Bridge, did not maintain the high level of introspective and mordant social criticism so marked before the war, although there was no loss, and even an enlargement, of technical refinement and experimentation, especially in his prints.

Erich Heckel (1883–1970) had been an architectural student before he joined Kirchner in The Bridge. His training as a draftsman possibly accounts for his relatively dry and meager handling of paint, certainly so in comparison with Kirchner's robust surfaces, but Heckel excelled as a printmaker. In his *Portrait of a Man* (plate 190) the vigorous cutting of the wood block is not without a certain linear elegance that is almost Japanese, but the deeply introspective attitude is profoundly German. Heckel and Kirchner, like Gauguin, whose example was before them, did their own printing and varied the colors in successive proofs.

The first of the Bridge artists to attract a wide, even an international, reputation, was Max Pechstein (1881–1955), who for a while was considered by critics and the public as the outstanding German Expressionist. His popularity is understandable, for his sources were less German—principally Van Gogh and Matisse—and his subject matter less an attack upon social conventions. The work of Karl Schmidt-Rottluff (born 1884), on the contrary, was extremely aggressive, in technique if not in content. Although he usually treated neutral subjects, such as figure studies, the nude, landscapes, and still life, he exploited clashes of intense color and strong linear distortions, often based on primitive art, as in the woodcut *Nude Before a Mirror* (plate 191), where the face and figure are unmistakably from African masks and figures.

The discrepancy between form and content noticeable in Schmidt-Rottluff's work—between radical technical innovations and innocuous, even traditional

190. ERICH HECKEL. *Portrait of a Man*. 1919. Woodcut, 11 7/8 × 9 1/2″.
Collection Mr. and Mrs. Walter Bareiss, Greenwich, Conn.

191. KARL SCHMIDT-ROTTLUFF. *Nude Before a Mirror*.
1914. Woodcut, 19 5/8 × 15 3/4″.
Collection Mr. and Mrs. Walter Bareiss,
Greenwich, Conn.

192. EMIL NOLDE. *Legend of St. Mary of Egypt: The Conversion*. 1912. Oil on canvas, 41 3/8 × 47 1/4″. Kunsthalle, Hamburg

subjects—weakens much Expressionist painting in every country. A commitment to psychologically expressive content, to the revelation of the meaning of the theme rather than its merely formal manipulations, is essential if an Expressionist work of art is to survive repeated contemplation. Such a commitment informs the work of Emil Nolde (1867–1956). He was a member of The Bridge for a few months, but resigned to go his own way, not caring for his younger colleagues' ideal of work in common and of common criticism. For many years he spent his summers on the lonely islands off the North Sea coast of Schleswig-Holstein, near his birthplace. There he encountered

nature in its most elemental moods and painted landscapes which are unequaled as expressions of its power and variety. His colors were few but strong, usually reds, yellows, greens, and purples, against the black which is so prevalent in modern German painting. In his concentration on nature's moods, he often approached a kind of automatic painting as he momentarily lost awareness of his immediate surroundings and painted as if in a trance. He also studied primitive artifacts, and even before a long voyage to Oceania in 1913–1914 had incorporated their extreme simplicities of form and gesture in his religious paintings, notably in a twelve-part *Passion* (Seebüll, Ger-

Colorplate 30. FRANZ MARC. *Stables*. 1913–14. Oil on canvas, 29 1/8 × 62 1/4″. The Solomon R. Guggenheim Museum, New York

Colorplate 31. MAX BECKMANN. *Blindman's Buff*. 1945. Oil on canvas, center panel 80 7/8 × 90 3/4″; side panels, each 75 1/2 × 43 1/2″. The Minneapolis Institute of Arts. Gift of Mr. and Mrs. Donald Winston

Colorplate 32. GEORGES BRAQUE. *Man with a Guitar*. 1911. Oil on canvas, 45 3/4 × 31 7/8″.
The Museum of Modern Art, New York. Acquired through the Lillie P. Bliss Bequest

193. EMIL NOLDE. *Irises and Poppies*. 1930–35.
Watercolor, 13 3/4 × 18 3/4″. Nolde Museum,
Seebüll, Germany

194. FRANZ MARC. *Animal Destinies*. 1913. Oil on canvas, 6′ 5 1/4″ × 8′ 8 3/4″. Kunstmuseum, Basel

many, Nolde Foundation) which offended many religious sensibilities in 1912. The climax of his primitivism is seen in his triptych of the life of St. Mary of Egypt (plate 192), where the Expressionist distortions present the almost unbearable pitch of religious ecstasy. On quite another plane, Nolde was one of the greatest of modern flower painters, capturing, whether in oil or watercolor, not only the formal structure, but what it might not be too extravagant to call the psychology of flowers, especially those with heavy or erotic blossoms—the amaryllis, the iris, and the sunflower (plate 193).

Although the expressive purpose of these painters was frequently the criticism of specific social conditions, by 1914 many younger German artists were aware of more exclusively formal developments elsewhere in Europe. In Munich the exhibitions in 1911 and 1912 of the group known as *Der blaue Reiter* (The Blue Rider) brought together work by contemporary French and Russian artists, Cubist as well as Expressionist. Of the principal Blue Rider painters, the Russian Vasily Kandinsky (see below, pp. 232–33) by his

195. GEORGE GROSZ. Illustration from Wieland Herzfelde's
Tragigrotesken der Nacht, Berlin. 1920.
Ink and wash, 9 1/8 × 6 1/8"

own testimony had discovered only the year before the possibility of a totally abstract art. His colleague Franz Marc (1880–1916) was in Paris in 1912 where he visited the Cubist painter Robert Delaunay (see below, p. 221) and learned how a more consistently formal design could clarify his studies of animal life. As Marc wrote, in words reminiscent of the widespread contemporary interest in psychoanalysis, he wanted "to get back . . . to the mysterious and abstract images of inner life." In his paintings he grew less interested in describing the outward appearance of animals (colorplate 30) than in exploring the mysteries of nonhuman psychology, so that he might present the world as it appears to animals in all its oppressive and fearful immediacy. This is best seen in his large and somber *Animal Destinies* (1913; plate 194), where in the dark forest the simplified animal forms are threatened by the splintered light. For this concept of all existence as "flaming suffering" (as Marc wrote on the back of the canvas), he enriched the angular patterns of German Expressionism by his awareness of Cubist planes and Futurist rhythms (see chapter 7).

The increasingly international range of the modern movement could also be seen in Berlin, where as early as 1914 George Grosz (1893–1959) used Cubist and Futurist mannerisms in the satirical drawings with which he denounced Germany's feverish enthusiasm for the First World War. As the war progressed and Grosz experienced both the indignities of military service and the increasingly difficult conditions of civilian life in Berlin, his drawings became cruel and scathing attacks on the war. With a deliberately childish line he intensified the calculated indifference of the upper classes and the military caste to the people's sufferings (plate 195).

The paintings of Max Beckmann (1884–1950) were slow to attract attention; one might even think that his reputation, now so secure, was made only after he emigrated to the United States three years before his death. The reasons may be sought in his unpleasant subjects and, contrariwise, in his aesthetic detachment from them. Beckmann never forgot the horrors he had seen as a medical corpsman in the First World War, but he succeeded in transmuting his revulsion against physical cruelty and suffering into symbols of man's agonizing psychological frustrations. Even when his figures are not tortured or mutilated, their bodies are forced into a shallow space which seems to intensify their anguish. Like other Expressionists, Beckmann was impressed by the spiritual character of late Gothic art, so often conveyed by linear distortions and abrupt changes of scale and perspective. The

196. MAX BECKMANN. *Christ and the Woman Taken in Adultery.* 1917. Oil on canvas, 58 3/4 × 49 7/8″. City Art Museum,
St. Louis, Mo. Bequest of Curt Valentin

197. GUSTAV KLIMT. *Death and Life* (*Death and Love*). c. 1908. Oil on canvas, 70 1/4 × 78".
Collection Marietta Preleuthner, Vienna

198. EGON SCHIELE. *Mother with Two Children.* 1917. Oil on canvas,
59 × 62 1/2". Österreichische Galerie, Vienna

influence of the medieval masterpieces of the Rhineland is most apparent in works painted near the close of the war, especially in his *Christ and the Woman Taken in Adultery* (plate 196) and the *Descent from the Cross* (New York, Museum of Modern Art). Beckmann's criticism of the spiritual emptiness of modern life, for him a wasteland of pride, arrogance, and heartless indifference, is the content of seven large triptychs painted at the height of his powers. The best-known is *Departure* (1932–1933; New York, Museum of Modern Art), which may perhaps be interpreted al-

legorically as the departure of truth and justice, personified by the king and his companions, from contemporary Germany, indicated by symbols of ruthless barbarism in the side panels. *Blindman's Buff* (1945; colorplate 31) is a savage portrayal of social life, of that frenetic "jazz age" which supplied Beckmann, as it had Berthold Brecht and Kurt Weill, with satirical subject matter.

Austrian Expressionism was at first characterized by the morbid tendencies of Jugendstil design, as the Austro-German version of Art Nouveau was known.

This is best seen in the figure and portrait studies of Gustav Klimt (1862–1918), who combined extreme realism in details like the face and hands with intricate decorative patterns for the clothing (plate 197), and Egon Schiele (1890–1918), who exaggerated Klimt's linear mannerisms for more profound psychological characterizations (plate 198). Oskar Kokoschka (born 1886) was similarly touched by Jugendstil influences but soon rejected them for such violence of technique, subject, and content that he was obliged to leave Vienna after his works had offended the public at the annual Kunstschau (art exhibition) of 1908. Then began a life of ceaseless wandering which took him to all the major European countries. He has been one of the greatest of modern portraitists, from his dark-toned early works, in which he exposed the spiritual deterioration underlying the cultural refinement of pre-World War I Vienna, to such later high-keyed portraits as the formidable image of the mayor of Hamburg, Max Braun (Hamburg, Kunsthalle). In figure subjects, often highly fanciful, like *The Tempest*, or *The Wind-Bride* (1914; plate 199), he expressed the tormented course of his own emotional life with colors low in key but with forms of Baroque complexity and power. In contrast to the objectivity of the Impressionists, intent only on recording what the eye can observe, Kokoschka in his many landscapes of famous cities throughout Europe depicted his own experience of scenes where the earth, the waters, and the works of man seem caught up into the sky in one vast, cosmic rapture.

Kokoschka's intransigent *Self-Portrait as a Degenerate Artist* (1937; private collection, Scotland), a brilliant example of his mastery of color, is a reminder of the terrible fate which overtook the modern artists of Germany, especially the Expressionists, when the Nazis came to power. Their works were condemned as *entartete* (degenerate), and after a vast exhibition in 1937 of such supposedly degenerate art, composed of works purchased by German museums from state funds under the Weimar Republic (1918–1933), many were forbidden to exhibit, and eventually even to paint. The German artists discussed in this chapter were among those publicly humiliated. Since the war their honors have been restored, and the German museums have, as best they could, replaced the works which were sequestered, sold abroad, and even in some instances destroyed.

199. OSKAR KOKOSCHKA. *The Tempest (The Wind-Bride)*. 1914. Oil on canvas, 71 1/4 × 86 1/8". Kunstmuseum, Base[l]

Cubism and Futurism

Fauvism and Expressionism were the first indisputably modern modes of twentieth-century painting, but they were not for that reason entirely unrelated to the arts of the past. The somber content of German Expressionism can be traced to such late medieval masters as Grünewald, whose Isenheim Altar at Colmar inspired many artists. The two-dimensional surfaces and flat areas of color of the Fauves were new to European painting, but they can be related to Byzantine enamels and Persian miniatures which were seen in large exhibitions in Paris (1903) and Munich (1910, which Matisse had seen). A quite different development occurred in the few years between 1909 and 1912 when Pablo Picasso (born 1881) and Georges Braque (1882–1963) created a new kind of pictorial space to which the misleading term *Cubism* was applied before its character and implications were fully understood. Cubist space differs from Expressionist space in the sense that it cannot be analyzed or described in terms of either two-dimensional pattern or three-dimensional perspective. Braque put the matter succinctly when he stated that he and Picasso had been trying to paint "not objects but the space they engender."[1] Heretofore the object and the space it occupied could be thought of as separate situations, the space complete in itself without the object, the object detachable from the space in which it was seen. The first hint of this new kind of space occurred in Cézanne's late paintings. In the *Portrait of a Man* (plate 104) we can see how the area around the figure has become an extension of it, so that if the figure were removed the objects which define the space—furniture, walls, and drapery—would collapse.

This new concept of pictorial space is easier to describe than it was to discover. Neither Picasso nor Braque deliberately started out to be a Cubist. What at their hands became the new kind of painting was the result of their experimentation with various kinds of form description. Although as individuals and as painters they were remarkably unlike and came to Cubism from different directions, for a few months in the winter of 1910–1911 their research brought them together in a community of effort and identity of style so similar that the paintings of their high Cubist moment are almost indistinguishable.

The son of a professor at the academy in Barcelona, Picasso grew up in a city which in the 1890s was a center for Art Nouveau. At thirteen he surpassed his talented but conventional father, and his first youthful caricatures of his companions testify to his visual acuity. His first important paintings, executed in Barcelona and during visits to Paris between 1900 and 1904, when he settled there permanently, were

drenched with *fin de siècle* frustration and nostalgia. These Blue Period pictures, as they are called from their prevailing color, portray beggars, café habitués, and people from the poorest classes, sunk in lethargy, melancholy, and despair (plate 200). Despite the morbid subjects, their elegant mannerisms brought Picasso some attention. By 1905 his palette had brightened and his subjects were less lugubrious—acrobats and other performers of the one-ring indoor circuses popular in Europe. In the paintings and drawings of this Pink, or Circus, Period Picasso exchanged the somber Spanish detachment of El Greco for something of the wry pathos of Toulouse-Lautrec.

200. PABLO PICASSO. *Boy with Pipe*. 1905. Oil on canvas, 39 5/8 × 32" Collection Mr. and Mrs. John Hay Whitney, New York

At this time, presumably in 1905, Picasso became interested in prehistoric and primitive art. The bulging eyes and angular planes of the Iberian (pre-Roman) stone heads he had seen in the Louvre appear in the late Pink Period work of 1906. More critical was his discovery of African Negro sculpture, to which he is said to have been introduced by Matisse. He and other Fauve and Expressionist artists appreciated its expressive power; Picasso was more interested in its formal properties, especially in the exaggeration of certain features of the head, face, and body at the expense of others. During the winter of 1906–1907 he worked on a large canvas of female nudes in an interior, ostensibly a tribute to Cézanne in the manner of Cézanne's late *Bathers*, but any lingering traces of Classic theme or content were obliterated as the figures became angular, their proportions drastically distorted, the color limited to blue, pink, and terra cotta, and the expression aggressively harsh. In *Les Demoiselles d'Avignon* (plate 201) his changing conception of figure painting can be followed step by step. The figures to the left, although much simplified and in their postures resembling Egyptian sculpture, are reasonably naturalistic. Those to the right are violently transformed, their bodies like flat wooden arcs, the planes of their faces hollowed out like those in African masks.

Picasso's treatment of a convex plane as concave, or of a solid plane as a transparent void, was an important discovery for him, as well as for Braque, who saw *Les Demoiselles d'Avignon* while Picasso was working on it. Braque's previous painting, including his first contributions to the Salon d'Automne in 1907, had been brightly colored landscapes in the Fauve spirit. Now he followed Picasso's example and turned to problems of space construction. In landscapes executed in Provence in 1908 he reduced his houses, roads, and trees to geometrical shapes, like those in Cézanne's late paintings which he and Picasso had admired at the Salon d'Automne's memorial exhibition the year before. When some of these landscapes were rejected by the jury for the Salon of 1908, Braque withdrew all his entries and showed them at the gallery of Daniel-Henry Kahnweiler, who became the friend and principal dealer for the Cubists. It was at Kahnweiler's in this autumn of 1908 that the critic Louis Vauxcelles described Braque's paintings as "cubist." Matisse is also said to have remarked that they seemed made of "little cubes." However that may be, the term stuck, with the result that the public and the critics for years have looked into Braque's and Picasso's pictures for what was never there. Instead of opaque, cubical shapes the artists were creating a new kind of space

201. Pablo Picasso. *Les Demoiselles d'Avignon*. 1906–7. Oil on canvas, 96 × 92″.
The Museum of Modern Art, New York. Acquired through the Lillie P. Bliss Bequest

of blue and rose to a sober scale of ochre, green, brown, and gray. The hues, which for the Impressionists had revealed the world as a system of dazzling reflections of light, proved distracting to Braque and Picasso in their search for the visual properties of form. With their almost monochromatic colors they could more effectively examine objects in relation to the space they occupy and the space which they create. From this study came their construction of the typically shallow Cubist space, sometimes seeming to extend a few inches beyond the picture's surface so that the spectator has the illusion that the nearest planes reach outwards into his own space. Statements so simple scarcely account for the complexity of the first completely Cubist paintings, those which have sometimes been called "Analytical" because one can find evidence of the artists' having taken objects apart, of having analyzed them into their component elements, only to rearrange them on the canvas in a new and exclusively pictorial order.[2] Because the

202. GEORGES BRAQUE. *Landscape at l'Estaque.* 1908. Oil on canvas, 28 3/4 × 23 5/8″. Kunstmuseum, Basel

which was only visible when solid forms became transparent and lost their rigid cubical contours. In Braque's *Landscape at L'Estaque* (1908; plate 202), from a site where Cézanne had often painted, the cubical houses are like those in Cézanne's *Mont Ste-Victoire* (plate 103), but they are more abstract, less like actual houses, just as the trees and hills seem less observed than conceived as essential components of the picture space. Because the walls of the houses are illuminated from different directions, they lose solidity and become transparent. This process, which can be followed step by step in the two artists' work through the summer of 1909, led to the still lifes and figure studies executed when they were living near each other on Montmartre the following winter.

By then both painters had reduced the range of their palettes from the full brilliance of Braque's Fauve color and from Picasso's delicate harmonies

203. PABLO PICASSO. *Aficionado (Bullfight Fan).* 1912. Oil on canvas, 53 1/4 × 32 1/2″. Kunstmuseum, Basel

results were often difficult to comprehend, such paintings have been described as "hermetic" to indicate what was thought to be the too private character of such research. In so typical a work as Picasso's *Bullfight Fan* (1912; plate 203) the practiced eye can glimpse the major outlines and principal directions of an *aficionado* of the bull ring seated in a café, but he is seen only when the eye accepts the intricate pattern of interpenetrating planes as the means of presentation rather than as an obstacle to visual understanding. But to pursue the original object further would reduce Cubism to a puzzle whose solution would obviate further contemplative pleasure. The delights of Cubism are found in the very portions of the compositions which remain unsolved, in the spatially inexplicable situations where planes dissolve and interpenetrate, or come together in configurations which Guillaume Apollinaire, one of the earliest critics of Cubism, described as "new structures [painted from] elements borrowed not from visual reality, but from the reality of intellectual knowledge."[3]

Cubist subjects may have been difficult to decipher, but they were usually such familiar and even commonplace objects of ordinary life as musicians, persons seated at café tables, or still lifes of cups, bottles, and musical instruments. Picasso once protested that he never painted an abstract picture, by which he meant one constructed from purely invented, rather than from observed, elements. Braque inserted a *trompe-l'oeil* nail and its shadow in his *Violin and Palette* (1910; New York, Guggenheim Museum) in which other solid objects dissolved into planes, and a year later he added stenciled letters to *The Portuguese* (Basel, Kunstmuseum). In *Man With a Guitar* (colorplate 32) the emphatically literal cord and tassel in the upper left are, as it were, the last hints of the actuality which served as the starting point for the new pictorial reality. The contrast between the nail, the letters, or the cord and tassel and the many fragmented planes, whose reference to a musical instrument or human figure was intelligible only to those who could attend to the relationships between shapes rather than to the shapes themselves, added to the ambiguity of the Cubist image. What, the artist might have asked, is more real, an object there in outer life, or my pictorial metaphor? The answer had to be that pictorial reality had become something other than the reality of actual things. The laws of art were no longer subject to the laws of life, and the artist was his own legislator once he had determined which laws he would obey.

In 1912 Braque and Picasso incorporated papers and other materials in their drawings and paintings. In his first construction in *papiers collés*, or pasted papers, Braque added cuttings of imitation wood-grained wallpaper to a charcoal drawing. The result, aided by the letters *B A R* and *A L E*, was a still life of fruit and a beer bottle in a paneled barroom (*The Fruit Dish;* private collection, France). Picasso compounded the problem when he glued a piece of oilcloth lithographically printed in imitation of wickerwork to a still-life collage (from *coller*, to paste or glue, meaning the addition of nonpictorial materials to a painted support; plate 204). The question now was where the bit of oilcloth belonged. Was it merely oilcloth misplaced upon a painting, or did it, through its illusionistic appearance, become a wicker chair seat within the larger pictorial illusion of the whole canvas? Then what of the other objects, the pipe and glass, whose forms were more than one degree abstracted from their originals in life? For these questions there were no final answers. This unceasing visual and conceptual exchange between actual substances and their pictorial counterparts, between things remembered from life and the same things reconstructed in inappropriate or ironical materials, was the fundamental principle of Cubism. These were not cubes as such, but the world of things reduced to their constituent elements and put together again, or, as in Picasso's and Braque's pictures of

204. PABLO PICASSO. *Still Life with Chair Caning.* 1912.
Oil and pasted oilcloth on canvas, 10 5/8 × 13 3/4".
Collection the Artist

205. GEORGES BRAQUE. *Musical Forms (Guitar and Clarinet)*. 1918. Pasted paper, corrugated cardboard,
charcoal, and gouache on cardboard, 30 3/8 × 37 3/8″.
Philadelphia Museum of Art. The Louise and Walter Arensberg Collection

1912–1914, a world of new objects originating in the pictorial process itself. The new direction can be seen in a later collage by Braque, *Musical Forms* (1918; plate 205). The materials are nothing more than plain and corrugated papers, the colors are those of the papers themselves—white, grays, and tans—and the tools only scissors and paste. But the artist's eye has become so skilled in seizing the essential form of each object that he need present only its outline for us to accept his cutout shapes as metaphors of actual things.

This shift in emphasis and in practice led to what

has been called "Synthetic" Cubism to distinguish it from the earlier Analytical phase of 1909–1911. The terms were first used by the Spanish painter Juan Gris (1887–1927), who explained their significance epigrammatically when he insisted that "Cézanne turns a bottle into a cylinder, but I begin with a cylinder . . . and make a bottle—a particular bottle—out of a cylinder."[4] Gris encountered Picasso and Braque only after 1910, so that he was less an inventor of Cubism than its theorist, reducing what for its elders had been an intuitive development to a logical process. In his works we can often see how

206. JUAN GRIS. *The Sideboard.* 1917. Oil on plywood, 45 3/4 × 28 3/4".
Private collection, New York

were treated as opaque geometrical forms. More characteristically Cubist transparencies soon appeared in compositions based on urban themes, in which portions of figures and architecture were woven through drifts of smoke from factory chimneys. The modern city and all the attributes of metropolitan life were Léger's chief inspiration. In the trenches of the First World War he had been struck by the beauty of a modern gun barrel, and he was always fascinated by machinery, by clear, hard, machine-produced forms, the rhythms of mass production, and the strong colors and emphatic shapes of modern advertising, particularly on billboards and illuminated signs. By 1918 he had painted a number of compositions based on the rhythms of machine shapes—cogs, gears, propellers, levers, and the like. In these industrial landscapes man almost disappeared (plate 207). As the operator of machinery he became a mechanical element himself, his figure simplified, his features almost obliterated as if by the repetition and anonymity of his task. In paintings like the large *City* (1919; Philadelphia Museum of Art) man is a shadow slipping between the brilliant planes of the abstracted architecture and advertisements. In the monumental *Three Women* (*Le Grand Déjeuner*) (1921; colorplate 33) it is women who seem made of interchangeable parts; even their hair looks as if it had been cut from rippling sheet metal.

207. FERNAND LÉGER. *Acrobats.* 1918. Oil on canvas, 38 1/8 × 42".
Kunstmuseum, Basel

apparently abstract configurations of colored planes could grow, like the cylinder changing into a bottle, into familiar still-life objects by the addition of defining lines, contours, and colors (plate 206). From such preconceived elements Gris created his "synthetic" compositions. The method had its dangers, and he did not entirely avoid a certain rigor and dryness. But at his best his sensitivity was only little less than Braque's and Picasso's.

The third major Cubist, Fernand Léger (1881–1955), was less interested in purely aesthetic solutions to pictorial problems. In his first large work, *Nudes in the Forest* (1909–1910; Otterlo, The Netherlands, Rijksmuseum Kröller-Müller), the figures and trees

Léger's attitude toward human beings was less antihumanistic than architectural. In the spare red, black, and white color scheme of the *Three Women* and in the passage from realistic forms to abstract patterns toward the edges, one detects the influence of the Dutch De Stijl movement, which was a contemporary attempt to unify all aspects of modern artistic expression by geometrical principles (see below, pp. 239–40). Léger also painted pure abstractions assembled from flat, precise, architectural elements (plate 208). Often imposing in size as well as in scale, their architectural character was recognized by Le Corbusier when he hung Léger's paintings in his epochal Pavillon de l'Esprit Nouveau at the decorative arts exposition in Paris in 1925. The year before, in collaboration with the American painter Dudley Murphy (born 1888), Léger produced the short film *Ballet mécanique*, in which actual human movements were equated with the obsessive monotony of identical mechanical rhythms. His paintings and film were landmarks in the enthusiasm during the 1920s for a machine aesthetic. In 1918 Le Corbusier himself and the painter Amédée Ozenfant (1886–1966) had announced their own version of Cubism, which they called Purism. Their pictures, principally still lifes, were composed of ordinary kitchen utensils and tableware presented in clean isometric profiles like those in mechanical drawings. In later life Léger created several very large figure paintings celebrating the work and pleasures of the modern city-dweller. The *Constructors* (1950; Biot, France, Musée Léger), showing riggers high on steel scaffolding, was an explicit tribute to labor. The title and design of a composition of Sunday bicyclists posed as if for an itinerant photographer, *Homage to Louis David* (1948–1949; plate 209), expressed his devotion to a style of maximum formal clarity for themes of social purpose.

These four masters—Picasso, Braque, Gris, and Léger—would most likely have painted as they did with or without the emergence of a Cubist movement. The movement was the work of numerous artists, frequently of considerable gifts, who adopted the stylistic devices of the major painters instead of inventing systems of their own. Although Braque and Picasso never exhibited in the annual Salons and their work could be seen only at Kahnweiler's, by 1910 they had become the dominant personalities in Paris. At the Salon des Independants that year Cubism was conspicuous, and in 1911 there were so many Cubist artists that a room was set aside for them. They included Albert Gleizes (1881–1953) and Jean Metzinger (1883–1956), who published the first treatise on Cubist aesthetics in 1912. Their at-

208. FERNAND LEGER. *Composition No. 7.* 1925. Oil on canvas, 51 1/2 × 35 1/4". Yale University Art Gallery, New Haven, Conn. Collection Société Anonyme

titude was more rational and doctrinaire than Apollinaire's, whose collected "aesthetic meditations" on contemporary art appeared early in 1913. Apollinaire was interested in the poetic quality of the new painting. Gleizes and Metzinger interpreted it as a conceptual process, based on a Neo-Kantian attitude toward spatial intuition, and they first described the typical Cubist device of juxtaposing and superimposing successive views of a single object so that the pictorial image can be said to embody perceptions of time as well as of space. In their best work, executed between 1910 and 1920, they industriously demonstrated their own Cubist definitions (plate 210).[5]

Gleizes and Metzinger participated with other artists, among them Léger and Gris, in the Cubist demonstration at the Salon de la Section d'Or in

209. FERNAND LÉGER. *Homage to Louis David.* 1948–49. Oil on canvas, 60 1/2 × 72 3/4″. Musée National d'Art Moderne, Paris

Colorplate 33. FERNAND LÉGER. *Three Women (Le Grand Déjeuner)*. 1921. Oil on canvas, 72 1/4 × 99″. The Museum of Modern Art, New York. Mrs. Simon Guggenheim Fund

Colorplate 34. UMBERTO BOCCIONI. *Dynamism of a Cyclist*. 1913. Oil on canvas, 27 1/2 × 37 3/8″. Collection Dr. Gianni Mattioli, Milan

Colorplate 35. GEORGES BRAQUE. *The Blue Mandolin*. 1930. Oil and sand on canvas, 45 5/8 × 34
City Art Museum, St. Louis, Mo.

October, 1912. Gris himself occasionally used the mathematical formula of the Golden Section, but giving the title to the group exhibition indicated the exhibitors' desire to establish Cubism upon a rational and less intuitive basis. Of the Golden Section artists Jacques Villon (1875–1963) was a painter of rare distinction whose canvases after 1945, executed in transparent planes of delicate color, were late but elegant contributions to the movement. The important Cubist sculpture by his brother Raymond Duchamp-Villon (1876–1918) will be considered farther on (see below, p. 329).

Somewhat apart from these artists were Robert Delaunay (1885–1941) and his wife Sonia. Delaunay was little tempted by Braque's and Picasso's renunciation of color. For him form could only be perceived in light; but because light could only be apprehended as color, color became the only means for creating forms in space. In a series of paintings of the Eiffel Tower (1910–1911) his reorganization of familiar objects was more violent than Braque's or Picasso's and he retained, as they had not, a feeling for the expressive character of the subject itself. He presented the tower as a soaring symbol of modern technology, tottering as if under the stresses generated by the dynamic tensions of its steel structure (plate 211). As Delaunay proceeded with his studies of the spatial properties of color, identifiable objects faded and finally disappeared, until in 1912 he produced what may have been the first purely abstract painting created by a French artist (see below, pp. 238–39). Before 1914 Delaunay's work was known beyond France. Franz Marc and Paul Klee visited him in 1912, and through exhibitions in Germany his art was seen by Kandinsky in Munich, so that for a brief period he was an important influence in Central European painting. Sonia Delaunay-Terk (born 1885), a decorative artist in her own right, applied the principles of her husband's color divisions to a wide variety of ornamental and useful objects.

Each of these artists, in one way or another, contributed to the realization of Cubist vision in works of great beauty and originality. In addition to those who remained more or less Cubist, there were others for whom the Cubist discipline was a passing but important phase in their artistic development. Their Cubist works, however unlikely they now appear in relation to their mature styles, can rank with all but the masterpieces of the movement. The Cubist collages of the Russian artist Kasimir Malevich (1878–1935), and the early paintings of the Mexican Diego Rivera (1886–1957) and of the Americans Marsden Hartley (1877–1943) and Max Weber (1881–1961) are au-

210. ALBERT GLEIZES. *Women Sewing*. 1913. Oil on canvas, 73 × 49 1/2".
Rijksmuseum Kröller-Müller, Otterlo, The Netherlands

211. ROBERT DELAUNAY. *Champs de Mars, The Red Tower*. 1911.
Oil on canvas, 64 × 51 1/2". The Art Institute of Chicago.
The Joseph Winterbotham Collection

thentic Cubist inventions (plate 268). Unhappily, there were a host of others who, with more or less skill, applied the obvious stylistic attributes of Cubism—the broken, transparent, and interpenetrating planes, the angular compositions, and the depthless space—to entirely conventional subjects. Their modish adaptations familiarized the public with the appearance, if not the significance, of Cubism, leading on the one hand to its acceptance as a modern style often condemned as merely "modernistic" and on the other to its vulgarization for commercial purposes.

The conjunction of Cubism and Italian Futurism was a brief but spectacular episode in the spread of Cubist theory and practice. In 1909 the Italian poet Filippo Tommaso Marinetti (1876–1944) published in Paris the first Futurist manifesto. This was a violent denunciation of contemporary culture for its attachment to outworn traditions, and a demand for a new visual and literary art which would more convincingly and forcefully express the dynamic quality of modern life. His mechanistic bias was clear in his declaration that "a roaring automobile is more beautiful than the *Victory of Samothrace.*"[6] Much of his excitable proclamation can be traced to the disappointment many Italians felt in their country's failure, after the stirring days of the Risorgimento and the unification of Italy, to become a truly modern nation. Except for the large industrial centers of Milan and Turin, the cities of Italy—Florence, Venice, and Rome—seemed content to exist as museums of a past which for Marinetti was irretrievably dead. The following year the first of several manifestoes of Futurist painting was issued by five young artists who endorsed Marinetti's position. These documents were full of ringing phrases promising an art that would express the potentials of Italian culture for the future as well as for the present in terms of the dynamic and mechanistic energies of modern society, but as yet the artists themselves had nothing more than a program. In their early work Giacomo Balla (1871–1958) and Gino Severini (1883–1966) used a Neoimpressionist technique, as did Umberto Boccioni (1882–1916) in his first major composition, *The City Rises* (1910; plate 212). But the Divisionist technique, with its time-consuming application of small spots of color, was inappropriate for the expression of strenuous motion, and Boccioni's rearing workhorses, symbolizing the physical effort required for the construction of a new world, are not in accord with the delicate Pointillism of the rest of his large canvas. Balla and Severini also painted Neoimpressionist pictures which are technically admirable but unexciting. Then in 1911 Boccioni and Carlo

Carrà (1881–1966) visited Marinetti and Severini, who were living in Paris, and saw for the first time the new Cubist productions. Carrà accepted the technique in its entirety and painted still lifes and collages which are equal to all but the best Paris work. Upon their return to Italy the others variously adopted Cubist techniques for subjects closer to the Futurist program. The flailing limbs and weapons in Carrà's *Funeral of the Anarchist Galli* (1910–1911; New York, Museum of Modern Art) and the repeated angles in *The Revolt* (1911), by Luigi Russolo (1885–1947), now in The Hague, are variations of the Futurist "lines of force" intended to express the changing relationship between moving objects and the space they occupy, and, in these instances, the dynamism of radical political action. Balla's best-known work is the amusing *Dynamism of a Dog on a Leash* (1912), which is a study of objects in motion, including the pebbles seen by the dog's owner as she passes down the road, recorded as if on a stationary plane during a time exposure. Balla went on to study more abstract problems. In various paintings of the flight of birds or of a speeding automobile (plate 213) he found pictorial and pseudo-mathematical formulas for the dynamism of animate and mechanical motion. In his *Mercury Passing Before the Sun As Seen Through a Telescope* (1914; Milan, coll. Dr. Gianni Mattioli), he traced the intricacies of interplanetary movements and hinted at the cosmic consequences of Futurism.

In his obsession with modern technology Marinetti had apostrophized war as the sublime experience of modern life, and the Futurists endorsed Italy's entrance into the First World War in 1915. They painted a few interesting propaganda pictures, like Severini's *Armored Train* (plate 214). But the conflict actually ruined their movement, and the decline of quality in their later work did them as much discredit as their protofascist political enthusiasms. Far more serious was Boccioni's death, as a war casualty, in 1916. He was indisputably the most imaginative and technically the most gifted of the group. At the first exhibition of Futurist painting, held in Paris in February, 1912, and subsequently in London and other European capitals, his three large *States of Mind* (New York, coll. the Hon. Nelson A. Rockefeller), subtitled "The Farewells, "Those Who Go," and "Those Who Stay," had given Futurism a psychological dimension even while its technique was still tentatively Cubist. Such paintings as *The Noise of the Street Penetrates the House* (Hanover, Landesgalerie) and the iridescent and almost totally abstract *Dynamism of a Cyclist* (colorplate 34) demonstrated his

212. UMBERTO BOCCIONI. *The City Rises.* 1910. Oil on canvas, 6' 6 1/2" × 9' 10 1/2". The Museum of Modern Art, New York. Mrs. Simon Guggenheim Fund

213. GIACOMO BALLA. *Swifts: Paths of Movement + Dynamic Sequences.* 1913. Oil on canvas, 38 1/8 × 47 1/4". The Museum of Modern Art, New York

214. GINO SEVERINI. *The Armored Train.* 1915. Oil on canvas, 46 × 34 1/2".
Collection Mr. Richard S. Zeisler, New York

belief that the sights, sounds, scents, and objects of contemporary existence constantly impinge upon each other and interpenetrate the observer's experience. Cubism was a valid means for portraying such exchanges of objective and subjective feeling, but Boccioni went further and tried to portray such situations in the three physical dimensions.

Much of his sculpture has been destroyed, and so it is difficult to judge from inferior photographs whether or not the interpenetration of an actual wooden window frame with a plaster head in *Fusion of a Head and a Window* would have been sculpturally convincing. His finest work, *Unique Forms of Continuity in Space* (1913; plate 215), was the last of several studies of the human figure in movement. Paradoxically, and for all its technical originality, this representation of a striding figure partially penetrated by the resistance of the space through which it moves is reminiscent of that very *Victory of Samothrace* that Marinetti had derided. Boccioni's ideas were often as provocative as his executed work. By insisting that the modern sculptor eschew "the traditional sublimity of the subject" as well as the precious materials of former times—marbles and bronze—for everyday substances like glass, wood, cardboard, iron, cement, horsehair, leather, cloth, mirrors, and electric lights, he laid the foundations for much that was to be realized in Dada and by certain Constructivist and Pop artists of the present day.[7]

Futurist art, erupting on the European scene in 1912, was a nine month's wonder soon extinguished by the First World War, but its importance in the development of modern aesthetics has been greater than all but a few of its actual productions. By calling attention to the specific character of modern life, it forced the public to accept the artist as an interpreter of that life, even in its most raw and immediate actualities. And although the course of modern art had led us far from their first enthusiasms for modern technology, the Futurists' acceptance of modern experience as valid on its own terms helped to win the public's acceptance of modern architecture.

Between the Armistice of 1918 and the end of the 1930s, the development of modern art in Europe may in large part be described as a dialectical exchange between abstract design and the Surrealist image.

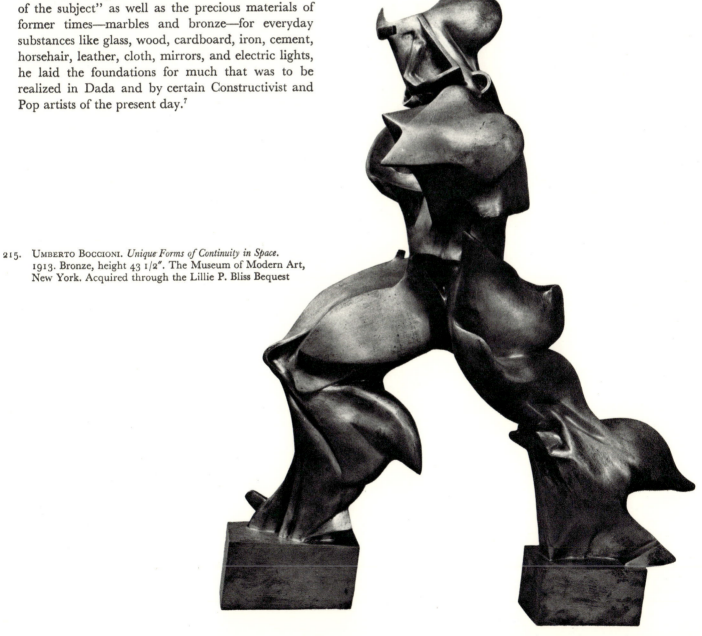

215. UMBERTO BOCCIONI. *Unique Forms of Continuity in Space.* 1913. Bronze, height 43 1/2". The Museum of Modern Art, New York. Acquired through the Lillie P. Bliss Bequest

216. GEORGES BRAQUE. *The Studio II*. 1949. Oil on canvas, 51 5/8 × 64″. Kunstsammlung Nordrhein-Westfalen, Düsseldorf

Between such poles there was little place for the subtleties of Cubism, constantly approaching the object only to withdraw into its own conceptual space. For this reason the later work of Braque and Picasso, who never abandoned the Cubist idiom, was carried on apart from the movements which compose the convenient historical sequence. Like Matisse and Léger, they had found themselves before the First World War, and their subsequent work primarily strengthened the positions they had already gained. Braque never ventured far from the strictest Cubism,

although he enriched it with very personal inventions. When he started painting again after his return from the war, in which he had been severely wounded, he created a long series of still lifes, at first dark in tone and highly "synthetic" in their elliptical condensed shapes, but changing in the 1930s to lighter colors and a spacious, easy draftsmanship, their surfaces often tactilely enriched with sand or sawdust (colorplate 35). Their mood of Classic serenity had appeared more explicitly in the 1920s in his *Canéphores*, a group of decorative seminude figures bearing baskets of fruit

and flowers. Braque was always the most "French" of the Cubists, and his splendidly harmonious compositions would have done no violence to the most stately seventeenth-century interior.

His interest from the late 1930s in how things seen in the studio alter under different and changing lights led to the nine large paintings in the *Atelier* series (1949–1956; plate 216). The formal premises of these mysterious pictures of indifferent objects, dominated by a hovering, disembodied bird, had been created fifty years before, but his wealth of invention proved that for Braque, as for Picasso, Cubism was not a manner but a style, that is to say, a mode of vision which embraced his view of life.

Picasso's later history has been very different. He has worked in a multitude of expressive modes—Neoclassic, Romantic, Surrealist, Realist—so various that many critics have felt that his art has lacked consistency or a continuous direction. But like Braque, he has always been a Cubist, and the secret of his sorcery may lie in his constant use of the fundamental ambiguities of Cubist painting, in the head seen simultaneously full-face and in profile, in the one shape that must do the work of two.

PABLO PICASSO. *Bather*. 1922. Oil on panel, 7 7/8 × 5". Wadsworth Atheneum, Hartford, Conn.

218. PABLO PICASSO. *Weeping Woman with Handkerchief*. 1937. Oil on canvas, 21 × 17 1/2". Study for *Guernica*. Los Angeles County Museum of Art. Gift of Thomas Mitchell

In his ballet designs during the First World War for Sergei Diaghilev's Ballets Russes and in his paintings of the early 1920s, he turned to Hellenistic and Roman sculpture for nudes in a Neoclassic vein, whose ponderous bodies are sometimes belied by the miniature size of the painting (plate 217). By 1924 he had returned to his own restless varieties of Cubism in which he painted, often at dazzling speed, the monumentally complex figures and still lifes which are among his finest single works (colorplate 36). *Guernica*, a mural painted in six weeks in 1937 for the Spanish Pavilion at the Paris Exposition (New York, lent by the artist to The Museum of Modern Art), was a courageous and generous statement of his antipathy to fascism. The very free Cubist execution of *Guernica* and of a number of works related to it (plate 218) proved that the idiom could embody, as it never had before, a range and intensity of feeling equal, at least if they were Picasso's, to the finest Expressionist painting. And in the worst years of the

Cubism and Futurism / 227

Second World War, which Picasso endured in Paris, he plumbed below the level of the conscious mind, hunting for the awesome and appalling shapes which are the visual manifestations of the most profound and secret human instincts (plate 219). The ceaseless variety and endless formal surprises in his innumerable paintings, sculptures, prints, and ceramics suggest that a strictly formal analysis of Picasso's work may prove inadequate and that for its fuller understanding we must wait for a criticism based upon the psychology of form.

219. PABLO PICASSO. *Woman Bathing Her Right Foot*. 1944.
Pencil on paper, 19 7/8 × 15 1/8".
The Art Institute of Chicago

Colorplate 37. VASILY KANDINSKY. *Painting with White Form, No. 166*. 1913. Oil on canvas, 47 3/8 × 55 1/8". The Solomon R. Guggenheim Museum, New York

Abstract Art

The most radical and, as it now appears, the most characteristic development in twentieth-century art is that which under many forms and in many places is known generically as *abstract* as well as, more precisely, but awkwardly, *nonrepresentational* or *nonobjective* art. As the terms indicate such art—often sculptural but first and fundamentally pictorial—contains at the most no more than glancing references to natural objects or situations and, in its strictest phase, is entirely without reference to anything in the external phenomenal world. Expressionist and Cubist painters approached abstraction when, in stressing the dramatic or structural qualities of subject matter, they suppressed, even if they never entirely eliminated, its visual aspects. The totally abstract, or nonobjective, work contains no references to nature, nor can such references be read into it except through the spectator's caprice or intentional misinterpretation. In its origin and essential structure it is composed of formal elements regarded as having expressive properties in their own right.

The premises for such works antedated their actual execution. The awareness that formal principles could be thought of as existing apart from subject matter and as ultimately determining the essentially artistic character of works of art had been present in much aesthetic theory since the eighteenth century.

In 1780 Sir Joshua Reynolds advised the students of the Royal Academy in London that "the beauty of form alone, without the assistance of any other quality, makes of itself a great work," and he further described the artistic quality of the *Belvedere Torso* (in which the expressive character of the human figure is minimized by its mutilated condition) as "the science of abstract form."[1] A later and more explicit statement of these qualities was pronounced in 1877 by the English essayist Walter Pater in his paper on "The School of Giorgione" where he wrote that "in its primary aspect, a great picture has no more definite message for us than an accidental play of sunlight and shadow for a few moments on the wall or floor: is itself, in truth, a space of such fallen light, caught as the colors are in an Eastern carpet, but refined upon and dealt with more subtly and exquisitely than by nature itself."[2]

Toward the end of the century Van Gogh's belief that "color expresses something in itself" and Gauguin's conviction that if one sees a blue in nature one should paint it as blue as possible encouraged their younger followers, the Symbolist and Nabi painters of the 1890s, to stress the expressive properties of color, shape, and line rather than the anecdotal character of their subjects, which more often than not were simple, unexciting scenes of ordinary life.[3]

Colorplate 38. EL LISSITZKY. *Proun 99*. c. 1924. Oil on wood, 50 3/4 × 39*.
Yale University Art Gallery, New Haven, Conn. Collection Société Anonyme

Their position was unequivocally stated as early as 1890 when Maurice Denis, as already noted, declared that "a picture, before being a war horse, a nude woman, or some sort of anecdote, is essentially a surface covered with colors arranged in a certain order."

The arrangement of colors in an order determined by an expressive purpose rather than by the requirements of naturalistic representation, however highly schematic, has always been characteristic of the decorative arts, and it is in certain decorative developments of the later nineteenth century, particularly in Art Nouveau, that the significance of abstract design became more apparent. From Gauguin's elastic and expanding contours to the looped tendrils of much Art Nouveau decoration, and from his "musically" chromatic palette to the glinting iridescence of Tiffany's Favrile glass, were short steps. The next was accomplished when line, color, and shape were considered sufficient not only for the structure but for the expressive content of the independent work of art, a work in which composition was in no wise thought of as pattern, or a repetitive pattern at that, in any strictly decorative sense.

The demarcation between decorative design and independent works of art is not easy to establish, nor can the place and time when the first totally abstract work of art was created, one without any purely decorative considerations, be exactly determined. But certainly in the two years before the outbreak of the First World War in 1914 a number of artists independently succeeded in creating color compositions which had no recognizable subjects. Among them were Adolf Hölzel (1853–1934) in Stuttgart, Augusto Giacometti (1877–1947), a Swiss whose boldly patterned paintings, worked in a thick impasto, were ultimately derived from floral designs, and Frank Kupka, a Czech painter living in Paris, whose work will be considered presently. None, however, pursued his researches so thoroughly or with such relentless technical and aesthetic exposition as did the Russian painter Vasily Kandinsky (1866–1944). His is also, by his own testimony, the most fully documented account of the discovery of this new kind of painting. He believed it had happened in Munich in 1910 when, returning one evening to his studio, he failed to recognize one of his own works when he came upon it in the darkened room, lying on its side. He had then, he said, the instantaneous revelation of the power of color and design when released or separated from identifiable subject matter. And to the year 1910 he dated what was long considered the first totally abstract watercolor (Neuilly,

coll. Mme Nina Kandinsky), but which more probably was an early study for his *Composition No. VII* of 1913.[4] In 1910, in his treatise *Concerning the Spiritual in Art* (published in 1912), Kandinsky analyzed the expressive character of color taken by itself, but he was still reluctant to eliminate subject matter entirely lest he fall into decorative error. By 1913 at the latest he had overcome his reservations and had produced what were among the first, if not the very first, paintings in which any references to objects in nature or in other works of art were so tenuous as to be unrecognizable.

Kandinsky divided his abstract paintings into two series, *Improvisations* and *Compositions*. The latter, as the term indicates, were carefully planned in advance, the artist elaborating and extending a design from one stage to another. The former were quite literally improvised, the painter obeying whenever he could the promptings of intuition in the choice, distribution, and application of his pigments. One may, of course, question the extent to which any painter can surrender his conscious control over the artistic process when working on a canvas several square feet in size, but Kandinsky's assertion that he did so constituted a significant advance in the development of modern art and aesthetics. The solicitation of instinctive, "automatic" inspiration would later become an important aspect of Surrealist art. The recognition that factors of unconscious experience may be, probably must be, present in any artistic situation, whether in creation or in the spectator's re-experience of that act, added psychological dimensions to contemporary aesthetics and criticism.

The improvisatory character of Kandinsky's first mature abstractions can be studied in his *Painting with White Form* (1913; colorplate 37). His peculiar genius for the invention of a new kind of space can be seen in the unfolding and retracting colored shapes which surge into and beyond one another in dimensions which are neither those of conventional perspective nor of the most imaginative mathematics. They are reducible to no rational system, whether of experience or of the mind. Kandinsky described his art as an attempt to realize, visually, the spirit's "inner necessity," and however imprecise his terms may have been, anyone who takes the time to experience his work of the prewar period—where the forms are not so much in as of the space they inhabit and create—will feel that he has seen one of the first and one of the most convincing presentations of the space of dreams, which is, as we now know, so often the arena for the conflict and resolution of our own inner necessities.

When Kandinsky returned to Moscow in 1915 he found that his message and his works had preceded him. His paintings had been exhibited in Russia since 1904, and parts of his treatise had been translated and published. More than that, certain Russian artists had already gone as far, if not further than he, in exploring the expressive character of abstract forms and conferring upon them transcendental meanings. Possibly as early as 1911 Mikhail Larionov (1881–1964) had proclaimed the doctrine of Rayonism and with his close friend, later his wife, Natalia Goncharova (1881–1962) had produced compositions in which objects were splintered into rays of light, somewhat in the manner of the Italian Futurists, by whose example they had been much impressed (plate 220). By 1912 their canvases consisted entirely of short lines whose angular intersections created visual fields of force. But Rayonism did not survive the war, and in 1915 Larionov and Goncharova settled in Paris, where they became known for their stage designs for the Ballets Russes.

A movement of considerably more speculative and artistic significance was Suprematism, revealed by

221. KASIMIR MALEVICH. *Suprematist Composition: White on White*. c. 1918. Oil on canvas, 31 1/4 × 31 1/4″. The Museum of Modern Art, New York

MIKHAIL LARIONOV. *Glasses*. 1909. Oil on canvas, 41 × 38 1/4″. The Solomon R. Guggenheim Museum, New York

Kasimir Malevich (1878–1935) in 1915 when he exhibited in St. Petersburg a number of paintings containing flat polygonal and trapezoidal shapes in red and black against white grounds. Among them was his *Black Square on a White Ground*, which he insisted had been painted two years before. Three years later, in 1918, he exhibited in Moscow his famous Suprematist series, *White on White* (plate 221), in which a tilted white square can be distinguished from the white ground only by slight differences in the painted texture. For Malevich such paintings were not just exercises in simplifying and reducing the rules of design until one was left with the least common denominators. They were part of his search for the basic pictorial elements that would communicate the most profound expressive reality. He believed that after all references to ordinary objective life have been left behind, nothing real would remain "except feeling . . . the feeling of nonobjectivity."[5]

Malevich thought, and history has proved him right, that his could be a new art for the twentieth century, and he hoped that he had found the expressive forms for the new society that was to arise in the Soviet Union. Unfortunately, that society of soldiers, workers, and peasants, of whom almost none had

222. VLADIMIR TATLIN. Project for *Monument to the Third International*. 1919–20. Wood, iron, and glass.
Re-created in 1968 for the Tatlin Exhibition at the Moderna Museet, Stockholm

had any experience of contemporary art, had no use for objects that were unintelligible to the masses. Malevich was also worsted in a dialectical dispute with Vladimir Tatlin (1885–1953), who believed that art, as the product of society, must directly express the social needs of any given time. Tatlin himself had been in Paris before the war, where he saw Picasso's Cubist relief sculptures, the immediate source for his own entirely abstract compositions of 1914 of bits of wood, iron, and glass. From them he turned to the study of materials and their structural principles and of mass production techniques in modern industry. This emphasis upon the structural aspect of the work of art led to the concept of a constructed art, by 1920 known as Constructivism, which, like Malevich's, was intended as the artistic expression of the new Soviet society. What would have been the most impressive example of Constructivist art, had it ever been executed at full scale, was Tatlin's project for a Monument to the Third International, conceived as an open spiral metal tower some 1300 feet high on a slanting axis, with three chambers for legislative and scientific purposes revolving at different speeds. Tatlin himself described his large model (plate 222) as a "union of purely artistic forms (painting, sculpture, and architecture) for a utilitarian purpose."

Tatlin's work differed from Malevich's less in its artistic justification than in its outward appearance—both men were interested in architectural design, which Malevich treated as unadorned cubical masses, Tatlin as openwork metallic volumes—but he was at first more fortunate in his appeal to the masses. By 1922, when the country had been wracked for eight years by war, revolution, and social upheaval, public indifference and dismay hardened into official disapproval. After Lenin's death in 1924 the government officially preferred realistic representations of the emergent Soviet society, and the Constructivist movement withered away although its influence could still be seen as late as the 1940s in typography and posters. Malevich visited Germany in 1927 when his paintings were exhibited in Berlin. His lectures at the Bauhaus, published in revised form as *Die gegenstandslose Welt* (*The Non-Objective World*), constitute one of the primary documents for the aesthetics of abstract art. But in Russia both he and Tatlin, with other Constructivists like Alexander Rodchenko (1891–1956), were effectively silenced by the accusation that their work constituted a "leftist deviation" from the doctrines of socialist realism (see below, p. 345).

The history of Constructivism in Western Europe and America has been quite different. In the early 1920s Constructivist ideas were disseminated throughout Germany by El (Eliezer) Lissitzky (1890–1941), who had known Malevich and Tatlin. In 1919 he exhibited in Moscow his first *Proun*, the title he gave his large abstract paintings and which apparently meant "For the New Art." His program was less metaphysical than Malevich's, but also less utilitarian and materialistic than Tatlin's, and consequently more accessible as purely artistic expression to the Western European public. His typographic designs appealed both to the Dutch De Stijl group and to the Dadaist Kurt Schwitters, and his free disposition of different type faces is still an influential aspect of modern commercial design. In his own painting (colorplate 38) he incorporated the geometrical elements of Malevich within the three-dimensional visual structures of Tatlin. In the example illustrated, geometry has been stretched beyond the limits of conventional perspective until an irrational, or non-Euclidean, space seems to unfold.

Just as the word *Constructivist* has lost, for the West, its original connotations of design specifically directed toward the expression of a new socialist society, so, in such phrases as "socialist realism" the word *realism* has lost the implications of philosophical and formal abstraction given it by Antoine Pevsner (1886–1962) and Naum Gabo (born 1890; now lives in the United States), two of the original Russian contemporaries of Malevich and Tatlin. The attitude which soon became known as Constructivist they defined in a proclamation of 1920 as Realist, by which they meant that their works, fundamentally conceptual and owing nothing whatever to the perceptual experience of phenomenal appearances, were "real" and stood in no relation whatever to anything else. The novel and specifically twentieth-century character of their work was announced in their arbitrary challenge: "Space and time are the only forms on which life is built and hence art must be constructed."[6] The elder brother, Pevsner, had first studied painting and became a sculptor only after returning to Russia in 1915. He had been in Paris from 1911 and in his *Abstract Forms* (plate 223), customarily dated 1913 but probably painted a few years later, the source of his abstract style in French Cubism can be seen in the transparent and interpenetrating planes. But the whole design is more compact, more abstract, and more subdued in color than anything by a French Cubist. The complex coordinates of gray-brown and black planes define a spatial structure entirely new, in the sense that it has not been derived from any pre-existing structure and is, by his own definition, real.

223. ANTOINE PEVSNER. *Abstract Forms.* c. 1913. Encaustic on wood, 17 1/4 × 13 1/2". The Museum of Modern Art, New York. Gift of the Artist

Gabo from the first worked in three dimensions. One of his earliest sculptures, the *Head of a Woman* (1917–1920; plate 224), was made of small pieces of cardboard placed at angles to the surfaces of the natural object. Thus the mass was suggested by empty volumes rather than represented by an opaque surface. Also, from 1916 he used celluloid and then the newer translucent and transparent plastic materials to create virtual, rather than actual, volumes, abandoning all vestiges of phenomenal appearances for structures architectural in scale, like his unexecuted designs for a radio tower and for a monument for an observatory, in which the technological functions as well as the philosophical idealism of twentieth-century society might be expressed.

When it became impossible for him to work in Russia, Gabo went first to Berlin (1922) and ten years later joined Pevsner in Paris. Although their work was little regarded in the years between the two world wars, it was an important contribution to the

224. NAUM GABO. *Head of a Woman.* 1917–20, after a work of 1916. Celluloid and metal, 24 1/2 × 19 1/4". The Museum of Modern Art, New York

225. ANTOINE PEVSNER. *Developable Column of Victory (The Flight of the Bird)*. 1946. Bronze, height 16′, including base. General Motors Technical Research Center, Warren, Mich.

international abstract movement, which by 1930 had become centered in the French capital. By then Pevsner had found his own way as a sculptor, preferring on the whole opaque to transparent materials and achieving toward the end of his life such a monumental expression in cast bronze as the *Developable Column of Victory*, also known as *The Flight of the Bird* (plate 225).

Gabo has continued to explore the character of virtual volumes created by spatial voids in plastic and metallic sculptures of unequaled delicacy and precision, those "mentally constructed images" which he insists are "the very essence of the reality of the world which we are searching for." Since settling in Connecticut in 1947 he has also worked in bronze and steel, the materials of his huge abstract form, ninety feet in height, commissioned by the Bijenkorf Department Store in Rotterdam and erected beside it in 1955–1957. This, the largest example of Constructivist sculpture ever created, is a signal and still infrequent instance of the monumentality that abstract design can confer on large civic projects. On a small, but no less formidable, scale his *Linear Construction in Space, No. 4* (1958; plate 226), of slender steel springs stretched over a plastic core, exemplifies his ability

227. NAUM GABO. *Blue Construction in Space—Kinetic Painting.* 1945–53. Oil on wood panel, diameter 36″. Wadsworth Atheneum, Hartford, Con

226. NAUM GABO. *Linear Construction in Space, No. 4.* 1958. Transparent plastic and stainless steel springs, 40 × 21 1/2″. Whitney Museum of American Art, New York

to create new structures, in Guillaume Apollinaire's words, "from the reality of intellectual knowledge" Gabo's insights into the character and structure of imagined space have carried him toward the frontiers of a more than three-dimensional world.

Gabo's rare paintings are less familiar than his sculptures, but one deserves particular comment. As his circular *Blue Construction in Space—Kinetic Painting* (plate 227) slowly revolves by means of a concealed mechanism, the opalescent and translucent forms seem mysteriously to expand and shrink as they exchange positions in their imaginary space (an effect the reader can partially duplicate by slowly revolving the illustration in this book).

The origins of abstract art in France were associated with the diffusion of Cubism. The study of color, even when only partially released from its subservience to subject matter, persuaded Robert Delaunay (1885 –1941) that space could be apprehended entirely through light and that light could be represented on his canvases by color. His studies of the spatial properties of color led in 1912 to *Disk* (Meriden,

Conn., coll. Mr. and Mrs. Burton G. Tremaine), a series of concentric colored circles, based on a color wheel divided into quarters, which may well be the first nonrepresentational painting by a French artist. More interesting were the numerous "simultaneous" compositions of disks and circles which followed (colorplate 39). In these Delaunay explored the space-creating effects of color—in works often of considerable size and complexity—in which the wheeling movements of the colored circles seem to extend deep into the imaginary space of the painting. Apollinaire created for Delaunay's painting the category of Orphic Cubism, and the title has become associated with such abstract works. Delaunay's influence was in some respects more significant than his actual production. Paul Klee and Franz Marc visited him in Paris in 1912 and, when they returned to Munich, told Kandinsky what they had seen. The French artist's colored circles then began to appear in Kandinsky's work and can be found as late as the 1920s.

The Czech painter Frank (František) Kupka (1871–1957), who had been living in Paris since 1894, was another pioneer in abstraction. His *Amorpha—Fugue in Two Colors* (Prague, National Gallery), exhibited at the Salon d'Automne in 1912, may have been begun, or studies for it undertaken, as early as 1911. But the later date still testifies to Kupka's originality in working, so early, with colors having no objective connotations. Another painting of 1912, his *Disks of Newton* (colorplate 40), is a further investigation of the physical qualities of color. The composition of interpenetrating circles divided into spectral hues suggests that he was aware of Delaunay's contemporary researches. But Kupka was unable to sustain his powers of invention; his later work, although completely abstract, offered no further discoveries for others to build on.

The specifically spiritual and ultimately ethical values which the principal members of this first generation of abstract artists placed upon their works, which they saw less as manifestations of their own subjective individualities than as statements having positive, even practical, value for the general common good, were equally consequential factors in the work of a group of Dutch artists who called their movement *De Stijl* (Style). The laconic title indicated their belief that they could discover an inclusive, anonymous, and fundamental principle of design which, when applied to every aspect of contemporary life, from furniture to town planning, would enable men to transcend individual, subjective experience with all its distracting aspects of pain and frustration.

Piet Mondrian (1872–1944), the most gifted painter in the group, had been in Paris before the First World War, where he had seen Picasso's and Braque's Cubism but felt that it "did not accept the logical consequences of its own discoveries; [that] it was not developing abstraction toward its own goal, the expression of pure plastics." Even before he left France, just before the outbreak of hostilities in 1914, his own painting was more rigorously abstract than anything the Cubists, with the exception of Delaunay, had done (plate 228). By using straight lines and a palette restricted to a few neutral tones, he kept his planes close to the two-dimensional surface of the canvas. During the war years in Holland Mondrian was in contact with other young artists and architects who also were searching for new forms expressive of

228. PIET MONDRIAN. *Composition (Tableau I)*. 1912–13. Oil on canvas, 37 3/4 × 25 1/4". Rijksmuseum Kröller-Müller, Otterlo, The Netherlands

contemporary life. The most aggressive among them was Theo van Doesburg (C. E. M. Küpper; 1883–1931), a man of inexhaustible energy, curiosity, and talent. With Mondrian and the architect J. J. P. Oud (1890–1963) he arrived at the concept of a universal style based on what Mondrian believed were the fundamental principles of life as well as of art—straight lines and the right angle. For Mondrian, whose ideas owed much to his conversations with a contemporary Dutch philosopher, M. H. J. Schoenmaekers, a vertical line signified the active vitalistic principle of life, a horizontal line tranquillity, rest, and eventually death. Hence their conjunction in the right angle expressed the highest possible vital tension between positive and negative forces.

Mondrian returned to Paris in 1920, leaving the propagation of De Stijl principles and the editing of the journal of the same title to Van Doesburg. His own task was to perfect his painting as an expression of what he somewhat clumsily described as Neoplasticism (the English translation of his French equivalent for the Dutch phrase *de nieuwe beelding*, which might better be rendered as "the new structuring, or forming"). To that end he had, by 1920, reduced his means to the straight line, right angle, square, and rectangle, and to the three so-called primary colors—red, blue, and yellow—with black and white. With these he believed he could create "the equivalence of reality." By maintaining his pictorial elements in a state of dynamic visual tension, he could, if successful, "through the rhythms and relations of color and size, make the absolute appear in the relativity of time and space" (colorplate 41).[8]

Whether so philosophical and spiritual an intention could ever be completely realized within the space of the small canvases upon which he usually worked may be questioned, but there is no denying the variety of pictorial intensity which he achieved with his ascetically restricted program. His constant problem was to maintain all the elements of his painting—the lines and colored rectangles—in a state of equilibrium. Thus there was no single focus, no center, to his compositions, which Van Doesburg characterized as "peripheral." Each square inch of the surface counts for as much as any other, and all are held as tightly to the plane of the canvas as the vagaries of perceptual experience permit. The most important consequence for modern art was that the fundamental two-dimensionality of the painted surface was emphasized as it had not been since the discovery of perspective in the fifteenth century. And with the elimination of any feeling of mass, of three-dimensional objects existing in a represented space which was not identical with the actual flat space upon which they were seen, Mondrian revealed a new kind of space, the thinnest possible, which has become that of much abstract and nonobjective art.

Mondrian's paintings—one cannot call them pictures, for if they are pictures of anything they are only of themselves—were square or rectangular and normally placed with the bottom edge parallel with the ground. Occasionally he turned a square at a forty-five degree angle, so that it stood on its diagonal and the straight lines within it met the edges at acute or obtuse angles. The unexpectedly more dynamic visual tensions so produced may have warned Mondrian to avoid color in such works, but although they are usually in black and white the mastery of space is unexcelled. Nor are the edges of the painting merely the boundaries of the canvas. The apparently interrupted lines may be thought of as intersecting at other invisible points in a space which embraces the spectator and all the world besides (plate 229). In the paintings from his later years in London (1938–1940) and New York (1940–1944), the more closely intersecting lines were broken into short strips of intense color. The titles of his last large works—*Trafalgar Square* (1939–1943) and *Broadway Boogie-Woogie* (1942–1943)—convey Mondrian's delight in jazz music and in the visual syncopation of modern city life.

Mondrian's work was often considered cold and unfeeling in his lifetime. One could have answered that his paintings, unlike those of the Expressionists, were not descriptions of feeling but diagrams of projected emotions, those emotions of clarity, order, and peace which are so inaccessible to troubled humanity. All things considered, it is not so very remarkable that Mondrian's limited formula—straight lines, squares, and five hues—has been taken over for many commercial purposes, so that the public encounters it in innumerable disguises, from linoleum to yard goods. Mondrian wanted to create "an environment, not merely utilitarian or rational, but also pure and complete in its beauty." If his dreams have not yet come true, the pervasive influence of his work in industrial design may be a step toward ending what he considered the deplorable separation of art "from our surrounding environment which is the actual plastic reality."

Before his death in 1931 Van Doesburg's talents had been somewhat obscured by Mondrian's and dispersed by his own ceaseless activities, but he was an artist of taste and distinction whose paintings deserve to be better known. His early work, before 1920, would be almost indistinguishable from

229. PIET MONDRIAN. *Composition with Two Lines.* 1931. Oil on canvas, diagonal 44 7/8″. Stedelijk Museum, Amsterdam

230. THEO VAN DOESBURG. *Simultaneous Composition.* 1929. Oil on canvas, 19 5/8 × 19 3/4″. Yale University Art Gallery, New Haven, Conn. Collection Société Anonyme

Mondrian's were it not for a lighter palette—he retained gray and green long after Mondrian rejected them—and a less drastic attempt to confine his planes to the surface of the canvas. Often the lines crisscross the colored squares with the effect of overlapping planes (plate 230). He also parted company with Mondrian in 1924 when he painted his *Contra-Compositions*, in which he shifted the axes of his rectangles and lines by forty-five degrees. The bolder decorative effects which Van Doesburg achieved, even if the cost was a lessening of the intensity inseparable from Mondrian's restrictions, were splendidly shown in his mural designs for the Café l'Aubette in Strasbourg (1928; now destroyed; plate 231), executed in collaboration with Jean Arp and his wife Sophie Taeuber-Arp.

In 1930 Van Doesburg published a manifesto calling for an *art concret*, but he died the next year before the movement could be organized. The word *concrete*, however, has taken its place in modern criticism and in the aesthetics of abstract art. Like Gabo's and Pevsner's term *real*, it signifies the essentially positive character of abstract works of art, a character somewhat compromised, linguistically at least, by the negative term *nonobjective*.

232. GEORGES VANTONGERLOO. *Volume Relations Projected by the Menton Cone.* 1927. Plaster, 12 5/8 × 10 5/8 × 10 5/8". Collection the Artist

231. THEO VAN DOESBURG. Mural painting in the Café l'Aubette, Strasbourg. 1928. Destroyed 1940

233. LYONEL FEININGER. *Church at Gelmeroda.*
c. 1936. Oil on canvas, 39 1/2 × 31 5/8".
The Metropolitan Museum of Art, New York.
George A. Hearn Fund, 1942

A more influential movement was Abstraction-Création, *art nonfiguratif*, founded in 1931 for the promotion of "nonfigural" art by a number of artists, including the Belgian sculptor Georges Vantongerloo (1886–1965), who had been one of the first members of the De Stijl group. In his earlier abstract sculptures (plate 232) the lines and right angles of Mondrian's paintings were extended into the three actual dimensions, much like the architectural projects of Van Doesburg and Rietveld. For five years their exhibitions and annual publications of the same title brought together a large number of abstract painters and sculptors from many different countries. Although French painters were in the minority—the point of view of the so-called School of Paris, dominated during these years by Matisse and Picasso, being fundamentally figural—the activities of the abstract group made Paris for the decade before the Second World War the international center of the movement. After 1945 the emergence of Abstract Expressionism in New York inaugurated a new aspect of the abstract movement. In the two decades since then, abstract art in the form of Abstract Expressionism became a dominant form of painting, not only in America, but also in Europe, with the exception of the Soviet Union and some of its satellite countries, but in the last five years its pre-eminence has been challenged by new aspects of figural imagery (see below, pp. 390, 393).

The development of abstract art in Germany was closely related to the program of design at the Bauhaus in Weimar and Dessau directed by the German architect Walter Gropius (see below, pp. 352–55).

234. VASILY KANDINSKY. *Composition 8, No. 260*. 1923. Oil on canvas, 55 1/2 × 79 1/8". The Solomon R. Guggenheim Museum, New York

Like the Constructivists in Russia and the members of De Stijl in Holland, Gropius believed that new forms were necessary for the expression of the social forces of the new society which had to be built on the ruins of the old regime. To that end he called to his school those who he believed to be the most progressive contemporary painters and sculptors. Some, like Oskar Schlemmer (1888–1943) and the American-born painter Lyonel Feininger (1871–1956), worked in an abstractly figural style (plate 233). Others, like Paul Klee (see below, pp. 262, 264), were equally at home in abstraction and in various representational modes, although among Klee's masterpieces are his figural paintings. The most consistently abstract artists working at the Bauhaus were Kandinsky, who

came directly to Weimar when he left Russia late in 1920, the Hungarian artist László Moholy-Nagy (1895-1946), and Josef Albers (born 1888). Kandinsky's work during his second residence in Germany (1920-1933) was more restrained, more precise, and more geometrical than it had been in Munich during the Blaue Reiter years (plate 234). In Moscow during the war he had undoubtedly seen Malevich's geometrical paintings, and he must also have been impressed by Klee's methodical analysis of pictorial composition. His own treatise, *Point and Line to Plane* (published 1926), has much in common with Klee's *Pedagogical Sketchbook* (published 1925). In 1933, when the Nazis forcibly closed the Bauhaus, Kandinsky left Germany for Paris. During the last eleven

years of his life he continued to work in a style still largely geometrical, but enlivened by a fanciful play of line and color owing much to his contact with the Spanish painter Joan Miró. In the very late *Circle and Square* (1943; plate 235), painted the year before he died, the brownish totemlike vertical elements against the flat pink ground recall Miró's more biomorphic configurations, but the references to irrational and intuitive vision are abruptly checked by the jagged construction of triangles in the center flanked by the monitory red square and green circle, reminiscent of the precise geometry of his Bauhaus paintings.

Moholy-Nagy was an early convert to Constructivism, which he encountered in the work of Lissitzky, but to the Russian's projection of non-Euclidean forms he added his own concern with forms in movement in actual space. The clearest demonstra-tions of his definition of Constructivism as "the activation of space by means of a dynamic-constructive system of forces actually at tension in physical space"[9] are his Space-Modulators, in which revolving planes of transparent plastic create virtual structures of moving light and shade, thereby exemplifying his belief that a new artistic reality would emerge from "the sovereign organization of relationships of volume, of material, of mass, of shape, direction, position, and light."

Moholy-Nagy was also active in Berlin as a stage designer, typographer, and photographer. In 1937 he came to Chicago to organize a School of Design, where he put into practice many of the educational principles developed at the Bauhaus. These may be studied in his books, *The New Vision* (1936) and *Vision in Motion* (1947). Josef Albers, one of the first graduates of the Bauhaus, remained as a member of

235. VASILY KANDINSKY. *Circle and Square*, No. 716. 1943. Tempera and oil on cardboard, 16 1/2 × 22 7/8".
Collection Mme Nina Kandinsky, Neuilly-sur-Seine, France

the faculty and developed with Moholy-Nagy the famous introductory course. Since 1933 he has lived in the United States, where his abstract compositions have contributed to the development of the new American geometrical painting.

The geometrically abstract work of the De Stijl artists, of the Russian Suprematists and Constructivists, and of the Bauhaus painters accounts for a large part of abstract art between 1910 and the present, but it was not the only significant tendency. Kandinsky's early explorations of intuitive suggestions and his success in devising methods for their visualization were just as important as the analysis of forms rationally selected by the logical consciousness. The techniques devised for spontaneous and intuitive selection have, however, so often led to the production of biomorphic forms with overtones of psychological expression that such works may more appropriately be examined in other contexts than the specifically abstract.

Colorplate 39. ROBERT DELAUNAY. *Sun Disks (Composition simultanée: les disques soleils)*. 1912–13. Oil on canvas, diameter 53″. The Museum of Modern Art, New York. Mrs. Simon Guggenheim Fund

Colorplate 40. FRANK KUPKA. *Disks of Newton (Study for Fugue in Two Colors)*. 1912. Oil on canvas, 39 3/8 × 29'.
Philadelphia Museum of Art. The Louise and Walter Arensberg Collection

Colorplate 41. PIET MONDRIAN. *Opposition of Lines: Red and Yellow.* 1937. Oil on canvas, 17 × 13″. Philadelphia Museum of Art. A. E. Gallatin Collection

Dada and Surrealism

The almost simultaneous production of totally abstract works of art in Germany, Russia, Holland, and even in America, in the years just before 1914, was almost at once matched by a new attitude toward figural images which was to have important consequences, not only for the immediate future but even half a century later. The outbreak of the First World War in 1914, after a century of peace in Europe, and the stalemate that ensued during four years of trench warfare on the Western Front, came as a devastating disillusionment to a generation of young people whose lives were jeopardized by the senseless holocaust. In certain neutral capitals in the years 1915–1916 a number of artists, fortuitously come together, expressed their disgust and contempt for the degradation of that European culture which the aggressor states professed to be defending even while the conduct of the war hastened its collapse. As a conscious protest, therefore, not so much against civilization itself as against the uses to which art had been put in their societies, the groups in New York and Zurich staged their calculated revolt. Although the first stirrings of the new spirit can be traced to the activities of Marcel Duchamp, Francis Picabia, and Man Ray in New York in 1915, the fact that the movement first found its name through the more organized manifestations of the Dada group in Zurich makes it

appropriate to discuss the events in Switzerland first.

In February, 1916, Hugo Ball (1886–1927), a German writer and theatrical director, arrived in Zurich where he established a small cabaret, the Café Voltaire, as a center for creative activity "to remind the world that there are independent men, beyond war and nationalism, who live for other ideals."[1] The invitation committed the company to no particular artistic direction, and, indeed, Ball's tastes were more conservative than otherwise. The tone was soon set by more aggressive young men. Among them were two Rumanians, the poet Tristan Tzara (1896–1963) and Marcel Janco (born 1895; lives in Israel), who had been an architectural student; two Germans recently released from the army, Richard Huelsenbeck (born 1892; lives in New York City), a poet and student of psychiatry, and Hans Richter (born 1888; lives in Switzerland and the United States), then a painter but soon to become a pioneer of the abstract film; and the Alsatian artist Jean (Hans) Arp (1887–1966). Tzara was the *agent provocateur* who diverted the evening's entertainment from performances of Tchaikovsky's piano music to a belligerently subversive attack on contemporary culture. To a degree, abstract art was one of the weapons Tzara and his companions used to destroy the bourgeois values they held responsible for the calamity,

Colorplate 42. KURT SCHWITTERS. *Merz 163, with Woman, Sweating (Mz 163 mit Frau, Schwitzend)*. 1920. Pasted paper, 11 3/4 × 8 5/8″. The Solomon R. Guggenheim Museum, New York. Bequest of Katherine S. Dreier

but other means were equally up to date, like the cacophonous jazz music against which Tzara and Ball, dressed in fantastic costumes, shouted nonsense verse composed of vowel and consonant sounds or put together from words drawn at random from a sack. For these activities, at first apparently spontaneous but soon planned to occur on appointed occasions, a name was needed. When, where, and how the word *Dada* was chosen is still disputed, but it is enough to know that the original Dadas, as they called themselves, accepted it as nonsense syllables, like the first sounds spoken by a baby, and that it first appeared in an announcement of the events at the Café Voltaire published by Ball on May 15, 1916.

At that time there was no specifically Dada art. The most adventurous items in the exhibitions arranged by Arp at the cabaret were Cubist collages by Picasso and his own abstract drawings. But a detectably Dada point of view began to appear in the experiments of Arp and his friend, the designer Sophie Taeuber, whom he married in 1922. Arp's collages, entitled *Squares Arranged According to the Laws of Chance*, were a deliberate attempt to substitute for the traditional values of handicraft the random effects achieved by chance. They were composed of bits of paper haphazardly torn to pieces or cut with scissors, thus avoiding personal intervention as far as possible, and then let fall as they would upon a horizontal surface. So infallible, however, was Arp's taste that even willed accidents could not entirely eliminate all traces of his personality. In his woodcuts for *Dada*, Ball's journal, the apparent effect of unmotivated play with materials could not disguise the innate sensitivity that determined the result (plate 236).

The artistic production of the Zurich Dadas was inconsiderable in comparison with their propaganda. Tzara's seven Dada manifestoes, each more incomprehensible to the public than the one before, gained the Dadas a reputation for malicious iconoclasm which was not mitigated by Arp's collages, prints, and poetry, or by Janco's constructions of odds and ends of junk, precocious for the time but now unfortunately destroyed.

After the Armistice of 1918 the political and social tensions in Zurich relaxed, and there was less sympathy, even less interest, in Dada antics. In 1919 Tzara departed for Paris, while Arp took word of the events in Switzerland to his friend Max Ernst (born 1891), a German artist living in Cologne. Before that Huelsenbeck had returned to wartime Berlin, where he organized his disaffected friends in a Dada movement that was inherently political, rather than artistic, and sympathetic to the radical left. Their activities

236. JEAN ARP. Cover of special edition of *Dada 4–5*, Zurich. 1919. Newspaper collage with woodcut

culminated in a large Dada exhibition in June, 1920, in which the most artistically significant objects were the collages, incorporating fragments of photographs, by George Grosz (1893–1959), John Heartfield (1891–1968) and Raoul Hausmann (born 1886; lives in France). Soon after, with the restoration of political stability under the Weimar Republic, the Dada movement in Berlin expired.

Elsewhere in Germany Dada fared better, with consequences still influential for contemporary art. In Cologne, Max Ernst, who had studied philosophy and psychiatry at the University of Bonn, had already found in the lithographs of the Italian painter Giorgio de Chirico (see below, pp. 261–62) the haunted perspectives and strange poetry suggested by the inexplicable juxtaposition of unrelated objects. Arp joined him in making collages from the most disparate elements clipped from advertisements, out-of-date scientific catalogues, and nineteenth-century illustrated novels. His extraordinarily sensitive feeling for the character of objects whose conventional meanings had been repudiated or distorted by the irrational circumstances in which they were found is present in the large painting *Woman, Old Man, and Flower* (1923–1924; plate 237). Although by that date Ernst was living in Paris and the last vestiges of the Dada movement were about to be absorbed by the Surrealists, the harsh, mechanical effect of the painting is typical of his Dada manner. Dada, too, is the prevailing atmosphere of meaningless malevolence. Peculiar also to Ernst, and to Dada, is his disregard of ordinary canons of design. But Ernst has always cared more for the value of his subjects as signs and symbols than as counters in an exclusively artistic maneuver. Even when they defy precise explication his paintings exist to be read quite as much as seen.

In Hanover Kurt Schwitters (1887–1948), one of the most genial of men, embraced Dada as a total way of life. In 1919, while putting together one of his collages, he noticed the syllable "merz" in the

237. MAX ERNST. *Woman, Old Man, and Flower.* 1923–24. Oil on canvas, 38 × 51 1/4″. The Museum of Modern Art, New York

letterhead of a commercial (*kommerzial*) bank. This he then used to characterize all his activities, artistic or otherwise. The materials of his Merz collages were the lowliest odds and ends, retrieved from the wastebasket and the gutter, but in his hands the colors and textures of discarded chocolate wrappers, matchboxes, and tram tickets became elements of an abstract and beautiful artistic order, often humanized by witty visual and verbal puns (colorplate 42). Schwitters, like Arp, could turn the rubbish he touched to artistic gold, and now that the iconoclastic irritability of the original Dada movement has subsided into history, Schwitters' collages remain unimpeachable artistic documents, redeemed by the very taste the Dadas so much despised.

238. KURT SCHWITTERS. *Merzbau*, Hanover. c. 1924–33. Architectural construction within Schwitters' residence. Destroyed

Schwitters was also a poet, whose *Anna Blume* verses parodying sentimental German love poetry have a small place in the history of the modern German lyric. His Merz poems were more daring, composed of letters of the alphabet, of numbers, or, in his unfinished *Ur-sonate* (original, or primal, sonata), which he often recited in public, of unintelligible sounds. There was also a Merz architecture (plate 238). In his house in Hanover Schwitters put together bits and pieces of discarded lumber until they rose through the floors into the attic. The structure was destroyed in the bombings of 1945, but by then Schwitters had fled to Norway, where he began another *Merzbau* (later accidentally destroyed by fire), and then to England, where he was working on a third at the time of his death.

Schwitters' activities were those of a greatly gifted artist to whom the twentieth century paradoxically offered the challenge of innumerable technical inventions and the predicament of finding expressive themes in a world where all traditional values had been discredited by the war. In one sense his work had no subject; in another, its indubitable poetic expression arose from the humor and humility with which he solved artistic problems of the greatest complexity with materials of no value at all. His example became paramount many years later in the re-emergence of certain Dada attitudes in the 1960s.

Even before the term *Dada* had been coined in Zurich, the activities in New York of a group of refugees from war-wracked Europe had reached a degree of erratic high spirits and radical artistic invention which can only be defined as proto-Dada. At the Armory Show in 1913 the painting that provoked the most intense public reaction was Marcel Duchamp's *Nude Descending a Staircase* (plate 239). Duchamp (1887–1968), the brother of Jacques Villon and of the sculptor Raymond Duchamp-Villon, had participated in the theoretical discussions about Cubism which led to the exhibition of the Salon de la Section d'Or, but his Cubist concepts were already less orthodox than his elder brothers'. His provocative and mechanistic treatment of the traditional theme of the female nude had so annoyed his colleagues that he withdrew it from exhibition in the spring of 1912. When it was seen at the Armory Show the next year it was considered offensive as well as incomprehensible, the usual fate of Duchamp's major works. But when the artist himself arrived in New York in 1915, he was received as an international celebrity, in contrast to the discourtesy he had endured in wartime Paris, where a heart condition debarred him from military service. He was

239. MARCEL DUCHAMP. *Nude Descending a Staircase, No. 2.* 1912. Oil on canvas, 58 × 35″. Philadelphia Museum of Art. The Louise and Walter Arensberg Collection

240. MARCEL DUCHAMP. *The Bride*. 1912. Oil on canvas, 35 1/8 × 21 3/4″. Philadelphia Museum of Art. The Louise and Walter Arensberg Collection

anatomy resemble parts of an internal combustion engine made more mysterious by the pinkish flesh tones and succulent texture of the paint. How far behind him Duchamp had left the aesthetic attitude of the Cubists can be seen by comparing the structural articulation of the *Bride* with the more abstract configuration of a Cubist personage (plate 203), whose shadowy existence within the network of Cubist planes committed neither artist nor spectator to a specific view of life. Duchamp's *Bride* is quite otherwise, for if his vision is true, then man and woman are no more than machines, and passion is only the fuel that sets the machinery in motion.

This mechanistic interpretation of human biology, so bleak in comparison with Léger's optimistic equation of men with, rather than as, machines, appears in Picabia's insouciant works executed during his sojourn in New York in 1915 and again in 1917. His cynical estimate of American culture as one dominated by materialistic and technological values was stated in drawings and collages like the *Portrait of a Young American Girl in a State of Nudity*, which was a mechanical drawing of a spark plug labeled "For-Ever," or *The American Girl*, an electric-light bulb reflecting the words "Flirt" and "Divorcée." A more elaborate statement of this mechanical vision can be seen in his *Child Carburetor* (c. 1917; plate 241), a large painting whose title recalls the "headlight child" in one of Duchamp's early annotations for the *Bride*. The *Child Carburetor* similarly evokes the possibility of the psychological experiences of inanimate things. The child's body is composed of mechanical elements and instruments, seemingly unrelated one to another, but the hand-lettered observations ("Destroy the Future," "Migraine Sphere," etc.) suggest some sort of animate existence. Nor should one overlook, in this conjunction of impersonal objects with quite personal problems—headaches, for example—the contrast between the elegant precision of the draftsmanship and the irregular patterns of the bare wood panel, between the artificial and the natural, so to speak.

That contrast, within a similar but even more hermetic manipulation of invented forms, is an essential aspect of Duchamp's mysterious masterpiece, the painting on glass entitled *The Bride Stripped Bare by Her Bachelors, Even*, also known as the *Large Glass*

soon joined in New York by Francis Picabia (1879–1953), a Cuban citizen of French and Spanish descent as well as a wildly adventurous young man whose own painting had passed from a competent Impressionism by way of Cubism to the mechanistic treatment of the human body that had become Duchamp's preoccupation. The latter's *Bride* (plate 240), painted in the summer of 1912 and once owned by Picabia, is an important step in the series of drawings and paintings with which Duchamp transformed the act and art of love from a physiological situation encumbered with psychological and philosophical connotations into a spare mechanistic diagram of the contradictory relations between male and female forces. The details of the Bride's internal

241. FRANCIS PICABIA. *Child Carburetor*. c. 1917. Mixed media on wood, 49 3/4 × 39 7/8″. The Solomon R. Guggenheim Museum, New York

242. MARCEL DUCHAMP. *The Bride Stripped Bare by Her Bachelors, Even* (*The Large Glass*). 1915–23.
Oil and lead wire on glass, 9′ 1 1/4″ × 5′ 9 1/8″.
Philadelphia Museum of Art. The Louise and Walter Arensberg Collection

(plate 242). It was begun in New York in 1915 and, after many interruptions, was left "definitively unfinished" in 1923. Sometime later it was accidentally shattered while being returned from an exhibition. The damage was not discovered until 1931, and in 1936 Duchamp painstakingly put the countless fragments together, sealing them in a steel frame between panes of plate glass. In his opinion the complementary weblike pattern of the fractures enhances the work, contributing the contrast of accident to what otherwise is a relentlessly logical image. Its logic, however, is that of the ultimately illogical, a *reductio ad absurdum* of human affairs. For example, the Bride's suitors, the Bachelors, appear at the left of the lower panel in the Cemetery of Uniforms and Liveries as nine Malic Molds, somewhat like dressmakers' dummies, suggesting the ridiculous pretensions of the male who hides his nakedness behind the masks of the masculine professions. The mechanical repetitiousness of sexuality is stated unequivocally in the nearby machines, the Watermill and Glider, and the Chocolate Grinder, which frustrate quite as much as further the Bachelors' pursuit of the Bride. The Bride herself is seen at the left of the upper panel, alternately tempting and repulsing her admirers, in the form of a Hanging Female Thing (*Pendu femelle*), a kind of vestigial reminiscence of the *Bride* of 1912.

So brief a synopsis of the *Large Glass* can neither fully explain it nor justify, aesthetically, the discrepancy between Duchamp's rejection of traditional materials in the execution of so commanding a work and the exquisite precision with which he "drew" his forms in lead wire and tin foil on the reverse of the glass itself. For a fuller understanding of this work, which has been interpreted as one of the most profoundly intellectual of modern works of art, one should consult Duchamp's notes which he published as ninety-three facsimile documents in the so-called *Green Box* of 1934. They are not easy reading, even in translation, but one may gain more respect

for the quality of the ideas within *The Bride Stripped Bare* when one learns that the *Pendu femelle* is the form "in ordinary *perspective* of a Pendu femelle for which one could perhaps try to discover the true form." Duchamp means that because "any form is the perspective of another form according to a certain vanishing point," and the *Pendu femelle* in the *Glass* is a two-dimensional rendering of a three-dimensional

243. MARCEL DUCHAMP.
In Advance of the Broken Arm.
1945, from the original of 1915.
Snow shovel, length 47 3/4".
Yale University Art Gallery,
New Haven, Conn.
Collection Société Anonyme

object, then a three-dimensional object may be "the perspective of another form" existing in more than three dimensions.[2]

Duchamp's preoccupation with the character and authenticity of objects, even the most ordinary, led to the discovery of his "ready-mades," things already present in the world around us but promoted to a new existence within the context of artistic speculation by the artist's decision.[3] Such were the first among them, the *Bottle Rack* of 1914, a device common enough in French restaurants for stacking bottles to dry, but strangely menacing to American eyes, and the snow shovel of 1915 which he teasingly entitled *In Advance of the Broken Arm* (plate 243). Another was more disturbing, the porcelain urinal called *Fountain* and signed "R. Mutt," which he submitted to the first exhibition of the Society of Independent Artists in New York in 1917. Some, including the first of all, had been "assisted." The *Bicycle Wheel* (1913) was inserted upside down on an ordinary white-painted kitchen stool. Still others were cunningly fabricated, like *Why Not Sneeze?* (1921; plate 244), an everyday bird cage containing a cuttlebone, a thermometer, and lumps of sugar which turn out, when one tries to lift the cage, to be made of white marble.

Such objects have never ceased to tantalize or infuriate public and scholars alike, for the questions they raise, as Duchamp knew, are unanswerable.

244. MARCEL DUCHAMP. *Why Not Sneeze Rose Sélavy?* Ready-Made, 1921. Marble blocks, thermometer, wood, and cuttlebone in birdcage, 4 1/2 × 8 5/8 × 6 3/8". Philadelphia Museum of Art. The Louise and Walter Arensberg Collection

Have they really become works of art, even though they contradict the primary qualification of all past works of art in that they have not been made by hand? And if they are works of art, then what of all the vaunted techniques whereby art objects have been made heretofore; for if one mass-produced thing can be a work of art, then cannot all be? The beleaguered critic may take comfort in thinking that in his ready-mades Duchamp has called our attention to a still more primary fact, that before works of art can be made by hand they must be conceived in the mind, that every work of art is thus a mental event, a "brain fact," as he called it.[4] And Duchamp himself has said, with reference to such works as the *Bride*, that he was "interested in ideas—not merely in visual products. I wanted to put painting again at the service of the mind." That may be, but lately the issue has again been joined by his having authorized the production of replicas of the original ready-mades, some of which have been lost. Can, then, the original conception still be found in an object which has apparently been mass-produced and selected more or less at random, and which appears in the likeness of its old self, but which has actually been painstakingly fabricated as a "work of art" from the first?

A final and fundamental point of contact between Duchamp and the Dadas abroad was his exploitation of chance and accident. He found a "new measure of length" when he let a thread one meter long fall from a height of one meter, "twisting as it pleases." He suspended a geometry textbook from the corner of an open porch and let the wind and weather work their will. He fired three matches dipped in paint at a preliminary drawing of *The Bride Stripped Bare* to determine the position of three "shots," surely a chancy way of organizing one's composition. But here again such accidents were always willed; hazard was enlisted on the artist's side. The decision to accept such assistance may have seemed capricious at the time, but one can now see, especially in the light of what immediately followed, that it constituted an inexhaustible enlargement of artistic experience and creativity.

When Duchamp and Picabia returned to Paris in 1919, the Dada movement had been brought to France by Tzara, but after the exciting discoveries in Zurich and New York, and the work of Ernst and Schwitters in Germany, the events in Paris were anticlimactic. The uproarious confusion with which the Dada meetings, convoked in the most respectable places, invariably ended disturbed not only the public but also certain artists and men of letters. Among

them was the poet André Breton (1896–1966), a student of psychiatry who had served in the medical corps in the recent war. He was first entertained and then annoyed by what he considered irresponsible behavior. His serious, if misguided, call for a world congress of Dadas to decide the direction the modern movement should take was rejected by Tzara, who rightly felt that such a conception was utterly alien to the Dada spirit. The controversy between these two brilliant theoreticians of modern art ended in 1923 when a demonstration by Breton's supporters at a performance of a play by Tzara ended in scenes of "indescribable" disorder.

Before that Breton, in collaboration with the poet Philippe Soupault (born 1897), had begun to explore the imaginative dimensions of psychic experience through automatic writing. In their first publication, *Les Champs magnétiques* of 1920, the continuous flow of verbal metaphors induced by the suppression of conscious control included images of such striking visual potentials that it was not long before artists as well as writers were deeply interested in the revelation of the "real process of thought," as Breton defined his purpose in the first Surrealist manifesto, published late in 1924. He himself acknowledged the importance of Surrealist art only in 1928, in an important essay on "Surrealism and Painting,"[5] but in a footnote to the manifesto he called attention to those artists of the present who could be associated with literary Surrealism. Several were Fauves or Cubists (Matisse, Derain, Braque, and Picasso) whose work scarcely fitted his definition of Surrealism as "pure psychic automatism." Among them, however, was the Italian painter Giorgio de Chirico (born 1888), the founder and principal master of the short-lived *Scuola Metafisica* (Metaphysical School), the name he and the Futurist painter Carlo Carrà gave to their work produced in Ferrara in 1917. De Chirico had lived in Paris from 1911 to 1915, and his paintings had been admired by Guillaume Apollinaire, who in 1918 subtitled his own play, *Les Mamelles de Tirésias*, a "surrealist drama." It seems appropriate that the French poet, who thus used the word for the first time and who was himself a master of verbal and psychological novelty, should have recognized De Chirico's talent, for in those early works De Chirico shattered the conventional visual logic of painting quite as much as had the Cubists whom Apollinaire had championed, and with even more expressively disturbing results.

De Chirico's world is deceptively orderly at first glance, so neat are his edges, so clear his colors, so bland the light that illuminates his forms. Then one discovers that this is a world where space, and probably time, have escaped from the tidy boundaries they had heretofore obeyed. The illogical juxtaposition of several perspective points of view in the buildings, the table top, and the objects in *The Evil Genius of a King* (1914–1915; colorplate 43) can induce psychic as well as visual discomfort. The sense of alienation and loss, of separation from all other human beings, and of uncertainty about one's surroundings and hence about one's identity, is intense. How can one know where one is or what the objects are in the foreground? Even if we knew what they were, we still would not know by whom or for what purpose they have been brought together. The title is another disturbing element; it explains nothing, yet raises expectations that are not fulfilled. Other titles, like *The Enigma of an Autumn Afternoon* or *The Anguish of Departure*, communicate overtones of the haunted spaces that appealed to Breton because of the likeness of their proportions and perspectives to our dreams. Here, as never before in the history of painting, was a world based on what Breton defined as "the superior reality of certain forms of association neglected heretofore, in the omnipotence of dream, in the disinterested play of thought."[6] For Breton the truly Surrealist element in painting, that superior or super-reality he sought, could be produced by the juxtaposition of unrelated objects, as in the metaphor the Surrealists so prized from the Comte de Lautréamont's *Les Chants de Maldoror* (1868): ". . . as beautiful . . . as the fortuitous encounter on a dissecting table of a sewing machine and an umbrella." Such fortuitous encounters in actual life, which we otherwise know as coincidences, Breton defined as "objective hazard."

In 1915 De Chirico began his paintings of automatons, hollow figures seemingly made of rolled and folded buckram, like dressmakers' dummies with egg-shaped, featureless heads, propped upright on rickety wooden slats. Whether presented as *Hector and Andromache* (plate 245) or a *Troubadour*, they are only simulacra of passion. Having no faces and no internal anatomy, they can neither move nor love. Contemporaries of Duchamp's mechanized Bride and Bachelors, they, too, enlarge this bleak iconography of mechanical desire.

By 1924, when Breton made his public pronouncement that Surrealism was a means of discovering, through automatic association, the fundamental reality of psychic life, De Chirico had turned away from the magical stillnesses of his early work and was trying to recover, as did Derain at the same time, the impersonal monumentality of High Renaissance

style. The attempt was disastrous, for De Chirico has since floundered among various outmoded traditions of technique and subject matter.

Aside from De Chirico, none of the artists who participated in the first Surrealist exhibition in Paris in June, 1925, as yet commanded what could be called a coherently Surrealist style. Picasso and Arp were already mature. Masson and Miró were moving from representation to a more abstract treatment of form, and Paul Klee, then at the Bauhaus, could never have been considered a strict Surrealist. In the work of each, even in Picasso's, fundamentally artistic considerations determined the character of the pictorial and sculptural form. Only Max Ernst, as we have seen, had already, in his Dada productions, put a premium on expressive content, especially in

245. GIORGIO DE CHIRICO.
Hector and Andromache. 1917.
Oil on canvas, 35 5/8 × 23 5/8."
Collection Dr. Gianni Mattioli, Milan

246. MAX ERNST. *The Eye of Silence*. 1943–44. Oil on canvas, 42 1/2 × 55 1/2″. Washington University Art Collection, St. Louis, Mo.

his Fatagaga collages. After he settled in Paris in 1922, he continued to manipulate pasted elements in a series of collage "novels," in which his brief texts in the form of captions are as arcane as the illustrations. The best-known was *La Femme cent têtes* (the title contains a play on the French phonetic sounds for "headless" and "hundred"), which presumably tells of the baleful career of Germinal, its lascivious adolescent heroine, in a series of subversive psychological images composed, as Ernst himself said, "with method and violence."

Ernst did not invent collage, which in the hands of the Cubists had been a device for heightening the aesthetic reality of the picture surface, but while working with actual objects and substances, rather

than with conventional brushes and pigments, he made two discoveries of his own. The first, which he called *frottage*, was the result of an hallucinatory obsession he experienced one evening in 1925 when he saw images in the irregular grain of a well-scrubbed wooden floor. He found that he could perpetuate them in pencil rubbings, and he went on to experiment with other substances like tree bark, leaves, and string. When the forms so produced were slightly exaggerated by his own hand, he had available an immense range of new images. In 1926 he published an album of the "first fruits of *frottage*," suitably titled *Histoire naturelle*. Because the method, according to Ernst's definition, permitted him to intensify "the irritability of the imaginative faculties, by appropriate

263

technical means, [while] excluding all conscious mental transmission (of reason, taste, or morals)," he considered it "the real equivalent" of automatic writing.[7]

With his second discovery, which he shared with the Spanish Surrealist Oscar Dominguez (1906–1957), Ernst further subordinated the conscious efforts of the artist to automatic and accidental effects. This was the technique he called decalcomania. After compressing paint on the canvas while it was still wet, he found that when the pressure was removed the paint assumed mysterious forms suggesting a new range of images. When additionally strengthened and adjusted by the artist, they were particularly useful for the forest scenes which occupied him after 1927. Forests had always had frightening associations for Ernst. In their dense shadows and mysterious perspectives, man's reason was no longer sovereign. "What is summer for the forests?" he asked. It is the future: "the season when masses of shadows will be able to change themselves into words and when beings gifted with eloquence will have the nerve to seek midnight at zero o'clock."[8]

The climax of Ernst's treatment of natural scenes through *frottage* and decalcomania occurred during his residence in the United States after the fall of France. In 1943 he spent the summer in Arizona, where later he lived for several years. The endless distances of the Southwest, as well as the fantastic colored rock formations, began to appear in his paintings, but were treated with the violence and the disagreeable overtones of human feeling that had been present in the earlier imaginary scenes. In *The Eye of Silence* (1943–1944; plate 246) the dank pool and the grotesque rock walls are brilliantly recorded, but they are haunted by presences inimical to man.

Although works by the German-Swiss artist Paul Klee (1879–1940) were included in the first Surrealist exhibitions in Paris, he was never officially a member of the movement, and his art cannot easily be subsumed under any such heading as Surrealist. Klee was, to alter a familiar phrase, a Jack-of-all-contemporary-techniques and a master of most. He was in Munich before 1914, where he knew Kandinsky and Marc and contributed etchings and drawings to the second Blaue Reiter exhibition, and after the war he taught for ten years at the Bauhaus in Weimar and Dessau. Thus he knew the principles and practices of Expressionism and Constructivism at first hand, and the other movements, too, from his travels to Paris and Berlin. His classroom notes, published in English as *The Thinking Eye* (1961), prove that he conscientiously studied the basic problems of visual formulation, but he brought to his study of old and modern masters a remarkable gift for poetic insight and interpretation. No solemn Cubist device for fracturing and reassembling planes was safe from his ironic wit, which is preserved in the magical titles he gave to so many of his works (plate 247). In 1930 he left the Bauhaus to teach at Düsseldorf, but three years later he was dismissed by the Nazis. Thereafter, he lived in Switzerland until his death, where he painted pictures larger than any he had attempted before—not only larger, but alarming —in which the humorous human symbols of his earlier work became gaunt ideograms pointing toward the terrible things to come (colorplate 44).

The artist who emerged most conspicuously as a Surrealist, in his art as well as in the self-conscious irregularity of his life, was the Catalan painter Salvador Dali (born 1904). His art contains the most sharply defined formulations of the dream image, projected by a technique derived from earlier masters of European Realism, notably the seventeenth-century Dutch painter Vermeer and the Spaniards of the same period, including Velázquez. With such means

247. PAUL KLEE. *The King of All the Insects*. 1922. Pen, ink, and watercolor on paper, 13 5/8 × 11 1/4". Yale University Art Gallery, New Haven, Conn. Collection Société Anonyme

he recorded, in his own words, "images of concrete irrationality with the most imperialist fury of precision,"[9] images which he has insisted were induced by paranoia. Throughout his earlier work, which is by far his best, there is an often disturbing but compelling conflict between the plausibility of the image and the inexplicable, irrational situations in which it occurs. More than any other painter, Dali has been able to realize, through the most specific images, that "superior reality" (superior at least in the sense that it is utterly different from everyday experience) which Breton felt could be found in "certain forms of association neglected hitherto." Essential for this was his extraordinarily developed capacity to see multiple forms in a given configuration. Although not the most "paranoiac" or violent of his works, the *Apparition of a Face and Fruit Dish on a Beach* (1938; colorplate 45) is one of the most visually complex. The spectator at every moment finds himself looking past or through at least four layers of interlocking forms. Upon the beach which stretches like a tablecloth across the foreground stands the colossal fruit dish, whose bowl and stem dissolve into a woman's brow and features, her hair becoming simultaneously the fruit within the dish and the pattern of the dog's coat. The dog's body, in turn, is formed of many disparate elements, his muzzle, for example, serving also as a rocky cavern in the far distance beyond the waves and beach.

The constant exchange and instability of these images, and the peculiarity of Dali's spaces which, although supposedly remote, seem near at hand, so crystalline is the atmosphere which fails to blur them, are truly dreamlike. And indeed, he has succeeded in visualizing those spaces, sharp and incessantly in flux, that we know in dreams. But the very privacy of our dreams, unique to each dreamer, imposes between Dali and ourselves a barrier which neither his titles nor the extreme precision of the images can entirely surmount. After all, each person's paranoia is his own affair.

One need not be asleep to dream. In the broadest daylight mystery may be close at hand, to be disclosed by the dislocation of matter-of-fact experience, as the Belgian painter René Magritte (1898–1967) found. Before he encountered the art of De Chirico and Ernst, he had worked as a designer of advertisements and wallpaper, thereby acquiring the apparently artless techniques of the sign painter with which he presented his disconcerting discoveries. He also lived for three years (1927–1930) near Paris, where Breton recognized his talent for putting "the visual object on trial ... and demonstrating the subordinate character of figures of speech and thought." What Magritte had done was not only to subordinate speech and thought to the visual image; but, by establishing new equations between word and sign, to destroy the conventions of logical causality.

At first some of his devices, like the bleeding marble statues, were little more than the melodramatic claptrap of romantic imagery, but his methods soon became more refined. In 1929 he published, in the last issue of Breton's *La Révolution surréaliste*, his contention that objects, their images, and their names have no necessary or unalterable connections. The word "leaf" could be represented just as well by a picture of a cannon. Anything, in other words, might stand for something else. When Magritte thus set thought free from its habitual references to the familiar and the everyday by heeding the Surrealists' injunction to explore the mysteries lurking in the unexpected juxtaposition of everyday things, he uncovered depths of terror and delight in the most obvious situations. In *The Realm of Light* (1954) a small house stands on a suburban street at night, shrouded in shadow and illuminated by a street lamp. All seems peacefully asleep, except that high overhead the sky is flooded with the full light of noon. Because no explanation is possible, we must live with the mystery. In *Chambre d'écoute* (plate 248) the visual puzzle defies a logical solution. Is the apple too big for the room, or the room too small for the apple? Whichever is so, there is no way of knowing, and the claustrophobic sensation is acute.

Ernst, Dali, and Magritte, with other painters like the Belgian Paul Delvaux (born 1897) and the Rumanian Victor Brauner (1903–1966), have remained the masters of the "hand-painted dream," ranging in intensity and complexity of expression from Dali's "paranoiac-critical method" to Magritte's imperturbable dislocations. For them the deserted house of Mondrian's abstractions, as Joan Miró (born 1893) called it, had no attraction. But Miró himself was to move far from the sun-drenched half-Cubist, half-abstract landscapes of his first maturity to the borders of the dreamworld and beyond. When he arrived in Paris in 1919 he found Cubism already threatened by the academic and decorative tendencies which only Braque and Picasso were able to surmount, and Dada already in full cry. His debt to Dada has been immense. Its disdain for any traditions whatsoever enabled him to eliminate, almost overnight, all vestiges of conventional pictorial idioms, even the most advanced. In the *Harlequin's Carnival* (plate 249) a host of odd, unnamable creatures attend to their own activities. Something

248. RENÉ MAGRITTE. *Chambre d'écoute* (*The Listening Chamber*). 1955. Oil on canvas, 31 1/2 × 39 3/8″. Collection William N. Copley, New York

249. JOAN MIRÓ. *Harlequin's Carnival*. 1924–25. Oil on canvas, 26 × 36 5/8″. Albright-Knox Art Gallery, Buffalo, N.Y.

Colorplate 45. SALVADOR DALI. *Apparition of a Face and Fruit Dish on a Beach*. 1938. Oil on canvas, 43 1/2 × 57″. Wadsworth Atheneum, Hartford, Conn.

Colorplate 44. PAUL KLEE. *La Belle Jardinière*. 1939. Oil and tempera on canvas, 37 7/8 × 27 5/8″. Klee Foundation, Bern, Switzerland

Colorplate 46. JOAN MIRÓ. *Composition*. 1933. Oil on canvas, 50 3/4 × 76 3/4″. Washington University Art Collection, St. Louis, Mo.

of the actual world is still left; we can estimate the size of the room in relation to the corner of the table seen at the right, and we know that the rear wall is pierced by a window. But the landscape beyond the window is neither real nor abstract, consisting only of two pointed shapes, one red and one black, which must be trees, and a bicolored black-and-white star with black rays hung in a sharp blue sky. This continual reduction of natural forms to geometrical simplicities, in contrast to the biomorphic swelling and attenuation of others, even those which are hard and precise in reality, is typical of Miró's witchery. In the center of the picture an outstretched hand, plausible enough in itself, is attached to an undulating, black snakelike shape. It is as if some uncanny process were at work whereby the forms of life and of art had become impelled to exchange their natures one with another.

In 1933 Miró painted a series of large canvases in which the witty amusements of his imaginary carnival were replaced by flat black-and-white forms, occasionally punctuated by a bright red shape, rising and falling in a featureless space (colorplate 46). Is this again the space of dreams, no longer dominated, as in Dali's traumatic experiences, by the mind's ability to see one image in terms of another with the dazzling clarity of hallucination, or the deep, drowned space which lies below even irrational vision, where the psychic experiences of preconsciousness restlessly strive to discover the forms that will render them visible to the dreamer? We may think so when we notice, as one of Miró's forms hovers before us, how it seeks to become a more coherent biological organism, whether like the features of a human being or of some embryonic yet animate particle.

Miró's ability to postulate the visual conditions of preconsciousness, if indeed this be the correct interpretation of these masterly paintings, was enhanced by his acceptance of Breton's insistence that true creativity occurs when intuition is released through automatic techniques. In his cultivation of spontaneity Miró had been encouraged by the French painter André Masson (born 1896). In 1926, two years after Breton had described him in the Surrealist manifesto as being unusually "close to us," Masson created accidental images by flinging sand over canvases upon which glue had been spread in random patterns (plate 250). The images so suggested were, like those of Ernst's *frottages*, intensified by a drawn line or a spot of color. That the carefully casual results interested Miró is proved by his own use of sand and other materials in conjunction with pigment, and by the increasingly spontaneous play of

250. ANDRÉ MASSON. *Painting (Figure)*. 1927. Oil and sand on canvas, 18 × 10 1/2". Collection William S. Rubin, New York

line and form in his own work, always controlled by his comparatively limited palette of bright blue, red, and yellow, offset by black and white (Mondrian's colors, oddly enough, but used for so contrary a purpose and with such different results!).

Miró, more than most of his contemporaries, has been, by and large, politically unengaged, but as a Catalan he could not remain aloof during the Spanish Civil War. Soon after it began in July, 1936, his work took on such an embittered and aggressive tone that these years have been described as his "savage"

251. JOAN MIRÓ. *The Beautiful Bird Revealing the Unknown to a Pair of Lovers.*
1941. Gouache and oil wash on paper, 18 × 15″. The Museum of
Modern Art, New York. Acquired through the Lillie P. Bliss Bequest

period. Animate forms appeared, monstrous insects too much like human beings, and the colors became harsh and hot. Subsequently, after peace of a sort came to Spain, and although the rest of Europe became involved in a far greater war, Miró in isolation on the island of Mallorca produced his elegant *Constellations,* tiny paintings in watercolor and gouache on paper, in which a host of black or brightly colored, quasi-geometrical shapes are bound by a web of lines in which now and then a single eye appears. Titles like *The Beautiful Bird Revealing the Unknown to a Pair of Lovers* (plate 251) are verbal images in themselves, complementing rather than explaining the visual patterns, for Miró has always insisted that he does not distinguish between poetry and painting. They are both means with which he seeks "the sources of human feeling." In recent years he has found new sources, not only in his own paintings and pottery, but in primitive art of the remotest epochs and in the very forms of nature itself, in rocks and twisted roots, where he discerns the working of formal powers analogous to his.

Another painter who created images entirely his own was the French artist Yves Tanguy (1900–1955), who lived in the United States from 1939. His earlier work was dominated by De Chirico, whose deep, stretched space Tanguy extended into an infinity in which the land, if indeed it be anything so palpable as earth, becomes without perceptible transition water, and the water sky (plate 252). But the sky in turn is of some inexplicable substance upon which objects cast shadows. The indeterminate foreground of these works, otherwise uninhabited by any natural or geologic growth, is littered with bone-like structures, sometimes complexly bound together by threads or wires. Tanguy defined them with such flawless clarity that, although their function or intent is unfathomable, we can believe in them as artistic forms, even as sculptural constructions. Although their substance looks protoplasmic, more than once they seem to be the contemporaries, even the predecessors, of the stone sculptures of Henry Moore or Isamu Noguchi (colorplate 60).

The sculptural emphasis, so to speak, of Tanguy's painted forms is the more interesting because Surrealism was not in essence sculptural, nor did its program attract many sculptors, probably because the materials of sculpture, by their very nature, are resistant to the artist's hand and tool and offer less opportunity for the expression of intuitive experience through automatic techniques. Then, too, Arp's genius had already been revealed in his Dada works, and the sculptures of Ernst (plate 253), of Miró, or even of Picasso when he most closely approached Surrealism, were ancillary to their paintings. The one major sculptor whose works can properly be defined as Surrealist, and who retained even in his later figures of very different conception something of the Surrealist revelation of a psychic reality coexisting with the outer world of everyday experience, was Alberto Giacometti (1901–1966), a Swiss long resident in Paris. From 1922 to 1925 he studied with Bourdelle, but his own work from the first was a protest against his master's reminiscent Classicism. For the expression of his own "vision of reality," which he knew was "different," as he said, from what we usually see and know, Giacometti found very few forms, and those only with difficulty. One of the most violent, and at the same time most symptomatic, was the *Woman with Her Throat Cut* (1949; plate 254). What we observe in this object lying recumbent upon a flat surface are the bare bones of past despair, of an anonymous anguish surviving only in these disagreeable bronze shapes.

The Surrealist movement originated in Paris, but

252. YVES TANGUY. *The Furniture of Time (Le Temps meublé)*. 1939. Oil on canvas, 45 3/4 × 35″. Collection James Thrall Soby, New Canaan, Conn.

253. MAX ERNST. *Oedipus.* 1960, from the plaster of 1934. Bronze, height 24 3/8″. Collection Mr. and Mrs. Jerome Stern, New York

254. ALBERTO GIACOMETTI. *Woman with Her Throat Cut.* 1949, from the original of 1932. Bronze, length 34 1/2″. The Museum of Modern Art, New York

MATTA. *The Bachelors Twenty Years After.* 1943. Oil on canvas, 38 × 50″. Private collection, Williamstown, Mass.

within a decade it had spread abroad. The international exhibitions of 1937 in London and New York actually preceded one in Paris in 1938, and in each there were representatives from almost every European country and from the United States. When the Second World War drove several of the founders from Paris, they reappeared in New York, where for a few years there was a lively revival of Surrealist discussions and exhibitions whose flavor is preserved in Breton's New York periodical, *VVV* (1942–1944). Such Surrealist occasions as have occurred since the close of World War II, principally the Paris exhibition

of 1947, have seemed more retrospective than creative.

The influence of European Dada and Surrealism can occasionally be seen in American painting of the period, although less in any evocative or dislocated images than in an undercurrent of irritability which had been present in European Surrealism from the start. This emerged in the United States in the latter 1940s in the mythic references and angry pictorial gestures of Jackson Pollock's early work, and, perhaps even more specifically, in the first paintings of Matta (Roberto Matta Echaurren; born in Chile 1912). *The Bachelors Twenty Years After* (1943; plate 255) is

an obvious tribute to Duchamp's *Bride Stripped Bare* (plate 242), but Duchamp's creaking machinery had acquired an explosive force which shattered the tidy conventions of true Surrealist dream space.

The vitality of the Surrealist point of view should nevertheless not be minimized. In his most succinct statement of the Surrealist aesthetic, Breton declared that "the marvelous is always beautiful, anything that is marvelous is beautiful; indeed nothing but the marvelous is beautiful."[10] The equation is, of course, too simple, because it avoids the problems of artistic purpose, technical execution, and critical evaluation, but it does indicate that the term *Surrealist* can be correctly applied only to those objects, however dis-quieting or unpleasant they may be, that have the power to evoke sensations of psychic reality, of "another world," even though it be one, as the poet Paul Éluard noted, which is "assuredly in this one." The definition also enables us to understand that there are two aspects to artistic Surrealism, the first being the programmatic literary and artistic movement that originated in Paris in 1924; the other is the attitude of mind that discovers in objects and situations, whether of the past or present, and whether revealed by pure psychic automatism or not, that glimpse of existence in its fullest psychic dimensions which Breton described as "the real process of thought."

American Painting: 1900–1940

Until early in the twentieth century American painting, but for its subject matter, had not in any essential way been distinguishable from European. Indeed, it is usually discussed within the context of European movements from Romantic Classicism through Impressionism. Its virtues have always been difficult for Europeans to estimate; Americans have recognized them whenever, as in Cole or Homer or Eakins, techniques and modes of vision fundamentally European have been used successfully to interpret specifically American experiences. During the first half of the twentieth century this condition was gradually reversed. What in 1900 had seemed a timid and provincial form of expression by 1950 had become a new kind of painting, not only qualitatively equal to contemporary European art, but one which in recent years has influenced artistic expression throughout the world. The stages in this development can be seen as occurring when American artists and their public became more intensely and selectively aware of contemporary European modernism, and also when they found ways to equate new techniques with their continuing desire to project as well as to record what life in this country had been like.

The first event of consequence occurred in 1908, when eight painters exhibited together at the Macbeth Galleries in New York. The action of The Eight, as they were called, was partly a protest against the conservatism of the schools, especially of the still-influential National Academy of Design in New York, and partly a desire to show themselves to the public, on their own terms, as painters of what has since become known as the American Scene. The oldest, and for several of them their master, was Robert Henri (1865–1929), who in 1891 had returned after two years in Europe to Philadelphia where he became the teacher of four slightly younger men, George Luks (1867–1933), John Sloan (1871–1951), William J. Glackens (1870–1938), and Everett Shinn (1876–1953). All four had worked as illustrators for Philadelphia newspapers, and in their paintings they retained something of the journalist's amused and sentimental feeling for city life. The work of Thomas Eakins may have encouraged their pursuit of visual truth, although, following Henri's example, they rejected Eakins' painstaking description for an easier brushstroke and stronger colors, derived from Velázquez and Hals by way of Manet and the Impressionists. Soon after 1900 they left Philadelphia for New York, where Henri was teaching in the New York School of Art founded by William Merritt Chase. Henri's point of view was actually less vigorous than theirs. Except in certain dark but directly observed city scenes, his work lacked those accents of local truth in subject and expression

which became the distinguishing characteristics of The Eight. In his portraits his fluent brushwork was no more pungent than Sargent's or Chase's, and his color, although bright, was often crude. But he was a gifted teacher, and his belief that the young artist must find his own way independently of the academic tradition was cogently argued in his treatise *The Art Spirit*, published in 1923.

Of his followers John Sloan and William Glackens depicted city life more incisively, principally around Greenwich Village and in New York's parks and playgrounds. In Sloan's *Sunday, Women Drying Their Hair* (1912; plate 256) his affection for the city, even for its slums, belies the analogies that have been drawn between the Realism of The Eight (to which all eight were by no means committed) and the analyses of social conditions by such writers as Theodore Dreiser and Frank Harris or the efforts at urban reform by Lincoln Steffens and the muckrakers.

Sloan's work, however anecdotal, was based on a firm control of spatial design and figural structure. George Luks chose more aggressive subjects—wrestlers, dancers, and the like—but he had little command of design. At his best, as in the early *Hester Street* (plate 257), he was a faithful reporter of urban squalor, but more often than not his vitality was dissipated by technical weaknesses. Sloan's depiction of city life, with or without implicit criticism of social conditions, is also found in the work of Glenn O. Coleman (1887–1932) and Guy Pène du Bois (1884–1958).

Another of Henri's students, and a more significant

256. JOHN SLOAN. *Sunday, Women Drying Their Hair.* 1912. Oil on canvas, 25 1/2 × 31 1/2". Addison Gallery of American Art, Phillips Academy, Andover, Mass.

257. GEORGE LUKS. *Hester Street*. 1905. Oil on canvas, 26 × 36″. The Brooklyn Museum, New York

258. GEORGE BELLOWS. *42 Kids*. 1907. Oil on canvas, 42 3/8 × 60 1/4″. The Corcoran Gallery of Art, Washington, D.C.

259. GEORGE BELLOWS. *Elinor, Jean, and Anna.* 1920. Oil on canvas, 59 × 66″. Albright-Knox Art Gallery, Buffalo, N.Y. Colonel Charles Clifton Fund

painter although not a member of the original Eight, was George W. Bellows (1882–1925). In his choice of subjects from the prize ring, the swimming hole, or the dust-blown empty lots of upper Manhattan, he shared the contempt of The Eight for academic studio arrangements and prettified landscapes, but his execution did not always match his intentions. In an early work such as *42 Kids* (1907; plate 258) his quick, schematic brushstroke is appropriate for the subject, but how superficially the incident was observed and felt may be seen by recalling Eakins' elegiac *Swimming*

Hole (Fort Worth Art Center), where time for the mature swimmers seems to stand still. The incidents in Bellows' paintings and lithographs of prize fights, from *Stag at Sharkey's* (1909; Cleveland Museum of Art) to the *Dempsey and Firpo* (1924; New York, Whitney Museum of American Art), are exciting in themselves, but the paint often slithers over the forms rather than defines their positions in space. Bellows was also a sensitive portraitist. Sometimes, as in *Elinor, Jean, and Anna* (1920; plate 259), he described the pathos of old age, and by using costumes already old-fashioned he

unexpectedly contributed to the revival of the Victorian decorative arts in the 1920s.

In the work of other members of The Eight an awareness of contemporary European art was more apparent. Ernest Lawson (1873–1939) was a very competent Impressionist (plate 260), and Everett Shinn was at his best in his early views of Paris. Glackens had been in Paris in 1895–1896 and again in 1906, where he much admired Renoir. In his beach scenes and landscapes the brushwork at times is as delicate, the mood as hedonistic, and the color as iridescent as Renoir's had been in the 1890s. His nudes may never have been as languidly voluptuous as the French master's, but in certain figure compositions he succeeded in a vein which almost daunted Renoir himself. In the large *Family Group* (1911; plate 261) the play of light through the room may be compared with the best of later Impressionist painting, such as Bonnard's, while the tensions induced by the stiff tilted figures set against the angular pattern of the furnishings suggest that Glackens might have gone beyond French painting in the projection of psychological situations.

More aesthetically adventurous and eventually more effective for the development of modernism in America were the work and attitude of two other members of The Eight, Maurice Prendergast (1859–1924) and Arthur B. Davies (1862–1928). Prendergast was a Bostonian who had spent many years in Europe, in Italy as well as in France, where he observed the transition from Impressionism to the more powerfully constructed art of the Symbolists and Postimpressionists. He has sometimes been considered our first and only Postimpressionist, because his emphatic flat patterns and his organization of the painted surface into large spots and blocks of color, which stand for and thus symbolize rather than describe the forms, would have been impossible had he not known the work o Seurat, Gauguin, and their Neoimpressionist and Nabi followers in the 1890s. *On the Beach, No. 3* (1918; colorplate 47), is a representative example of the turn his art had taken after 1908 from a more descriptive and instinctive type of Impressionism. The feeling of remoteness, of the intervention of an emotional as well as visual distance between the observer and the artist's subjects, the usual Impressionist summertime

260. ERNEST LAWSON. *Spring Night, Harlem River*. 1913. Oil on canvas, mounted on panel, 25 × 30″. The Phillips Collection, Washington, D.C.

261. WILLIAM GLACKENS. *Family Group.* 1911. Oil on canvas, 72 × 84". Collection Mr. and Mrs. Ira Glackens, Washington, D.C. on loan to the Currier Gallery of Art, Manchester, N.H.

activities, confers upon his painting something of the monumental presence he must have admired in Puvis de Chavannes.

In the art of Arthur B. Davies, universal rather than regional values are conveyed by lyrical, idyllic subjects presented in a gentle, unaggressive technique. In 1908 his pictorial reveries were still dominated by dreamlike figures whose ancestors were the melancholy maidens of Pre-Raphaelitism (plate 262). He resembled Redon, too, in his exploration of the world of imaginative rather than objective vision, as well as Ryder in his aesthetic isolation from contemporary fashions. But he was not a recluse. A man of wide intellectual and artistic interests, he accepted the radical painting of Europe sooner than many of his contemporaries. A few years after 1908, he adopted the conventions of Synthetic and Orphic Cubism in brightly colored prismatic paintings of the nude, and he was one of the prime movers of the Armory Show of 1913, when many aspects of European modernism were first presented to the American public.

This International Exhibition of Modern Art was held in the Sixty-Ninth Regiment Armory in New York from February 17 to March 15, 1913. It had originated in the desire of many artists, including The Eight, to have a more comprehensive exhibition of contemporary American art and was to have followed the principles of the juryless Independent Artists Exhibition organized by Davies, Henri, Lawson, Sloan, Shinn, Glackens, and Walt Kuhn (1880–1949) in 1910. That exhibition had reaffirmed the earlier position of The Eight, and the Armory Show would have done so too, had not Kuhn, at Davies' suggestion, traveled to Cologne in the fall of 1912 to see the Sonderbund Exhibition, when the modern movement was first presented in force to the European public.

Kuhn and Davies, with the critic Walter Pach (1883–1958), transformed the projected exhibition into a demonstration of the principal currents of European modernism. In the late winter of 1913 the public in New York, and later in Boston and Chicago, where a reduced version was seen, encountered head on, without previous experience or preparation, such seemingly violent manifestations of contemporary art as the Cubism of Braque and Picasso, the early abstractions of Kandinsky, the sculpture of Brancusi, and the post-Cubist paintings of Duchamp and Picabia, to say nothing of representative selections of Renoir, Redon, Cézanne, Van Gogh, and Gauguin. Such art made American painting, including even the work of The Eight, look limited in technical invention, dull in color, and prosaic in subject.

The public's hostility, which was shared by the

262. ARTHUR B. DAVIES. *Dream.* 1908. Oil on canvas, 18 × 30″. The Metropolitan Museum of Art, New York. Gift of George A. Hearn, 1909

academic artists and by most of the critics, was focused on Duchamp's *Nude. Descending a Staircase* (plate 239), which became the scapegoat of the exhibition. But the significance of the Armory Show cannot be restricted to one painting. In spite of the inevitable surprise and shock, attentive observers soon saw that the brilliant color, novel forms, and strangely intense expressiveness of the European works were based on sincere and strenuous formal research. When the anger and astonishment subsided, a new situation had been created for the American artist. Whether or not the Armory Show made America safe for modernism, it showed him that he could venture as far as the Europeans had gone, and it eventually made possible a more sympathetic audience, one which could see beyond Walt Kuhn's carnival types (plate 263) to the simplified but powerful design and the weighty modeling of the forms, aspects of Kuhn's art which were not unrelated to Picasso's and Rouault's treatment of similar subjects.

From another point of view the Armory Show can be considered the inevitable result of a process already underway for more than a decade. Since the turn of the century, the artists who were to lead America away from its conservative and traditional past had, almost without exception, spent some time in Europe. Hence it is not too much to say that before 1913 there was no advanced movement in European art with which some man soon to be a major American painter was not acquainted. Nor was the Armory Show the first and only occasion on which modern art had been seen in New York. In 1905 the photographer Alfred Stieglitz (1864–1946) established his Little Galleries of the Photo-Secession on lower Fifth Avenue, more

263. WALT KUHN. *Trio*. 1937. Oil on canvas, 72 × 50″. Colorado Springs Fine Arts Center.
Gift of the El Pomar Foundation

familiarly known as "291" from its address. A distinguished artist himself in the comparatively new medium of creative photography (plate 264), Stieglitz exhibited not only photographs but also work by European painters and sculptors and by those among the younger Americans whom he considered the most promising. The list of his "firsts" is unequaled in the annals of American art history; his exhibitions of Rodin's and Matisse's drawings in 1908, of Toulouse-Lautrec's lithographs in 1909, of Rousseau le Douanier's paintings in 1910, and Cézanne's watercolors in 1911 presented those artists' works for the first time in this country. Among the Americans whom he presented for the first time were Marsden Hartley, Arthur G. Dove, Alfred Maurer, John Marin, and Georgia O'Keeffe.

Stieglitz' encouragement was just as important for these artists as the one-man exhibitions, for it came at a time when European ideas were little known and in some instances had not been entirely absorbed by the artists themselves. Stieglitz closed "291" in 1917, but from 1925 to 1929 he ran the Intimate Gallery, and from 1929 until his death An American Place, on Madison Avenue. The artists whom he exhibited remained, however, those whom he had befriended before the war, with the result that their stories have been inextricably mixed with his. Taken together, his group, for all its diversity and in contrast to The Eight, represented the first successful accommodation of European modernism to American themes and ideas.

Perhaps this was most conspicuous in the work of John Marin (1870–1953), who with Alfred Maurer had been brought to Stieglitz' attention by another distinguished American photographer, Edward Steichen (born 1879), who knew both painters when they were working in Paris. Marin had been trained as an architect and had gone abroad in 1905 as an etcher of Whistlerian themes. When he returned five years later his art was still conservative, more Impressionist than otherwise, so that he may have found at Stieglitz' gallery, rather than in Paris, the suggestions he needed to make of his own vision a truly modern way of seeing. However that may be, he found in each of the principal directions of contemporary French painting—in Fauvism and Cubism—what he needed for the presentation of the American landscape, whether on the island of Manhattan or the shores of Maine. In Fauvism he found parallels for his deeply personal identification with his themes, and in Cubism the devices of disintegrated and reconstituted planes, which enabled him to present the form and structure of his feelings with unrivaled economy. A comparison

264. ALFRED STIEGLITZ. *Equivalent.* 1926. Photograph, 4 3/4 × 5 7/8". The Museum of Modern Art, New York. Gift of Dorothy S. Norman

of his early watercolors of downtown Manhattan with the cityscapes of The Eight is instructive. Where they had remained faithful to the closely observed genre scene, much as Stieglitz did in his magnificent photographs of New York early in the century, Marin found the precise note of emotional intensity that made the experience of living in New York uniquely modern, and American. In his watercolors of the Woolworth Building, where the fragmentation of form can be compared with Delaunay's contemporary views of the Eiffel Tower, he saw not the solecisms of its details, but how the architecture overwhelmed the observer with its stupendous height and mass.

After 1914 Marin spent most of his summers in Maine, where he painted his most condensed and expressive landscapes. For his views of the sea, of the pine-clad islands off the rocky coast, and of the mountains which come down to the water he developed a kind of pictorial shorthand with which he could indicate the principal elements but reduce the surrounding environment and atmosphere to a few abstract strokes and lines framing the central motif. In his more complex paintings the view may be divided into intersecting compartments, each treated as if at a different distance from the observer or seen from a different point of view (plate 265). The method is basically Cubist but refined for Marin's purpose, which was to convey more than the structure of the landscape. In the best of his watercolors we sense the sounds and smells, as well as the sights, of Maine. He

265. JOHN MARIN. *Speed, Lake Champlain.* 1931. Watercolor, 16×21″.
Munson-Williams-Proctor Institute, Utica, N.Y.

266. ALFRED MAURER. *Two Heads with Yellow Background.* c. 1928–29.
Oil on gesso panel, 21 7/8 × 18″. University of Minnesota, Minneapolis.
Collection Ione and Hudson D. Walker, on extended loan to the
University Gallery

also painted in oil, but the medium proved less tractable to his point of view.

Alfred H. Maurer (1868–1932), an exact contemporary of Matisse and, with Marin, one of the oldest of the first generation to work in the modern idiom, was in Paris much of the time between 1897 and 1914. There he knew the American writers Gertrude and Leo Stein, who were among the earliest collectors of Matisse and Picasso. By 1909, when Stieglitz first showed his work, Maurer had taken the drastic, and eventually disastrous, step of abandoning his sensitive Whistlerian figure style for a commitment to modernism so intense and total that he became, with Max Weber, one of the first of whom it might be said that they were the American counterparts of the French Fauves. After 1920, driven by personal tensions, he painted a series of double portraits, at first recognizable as two sisters, somewhat in the manner of Derain, but gradually intensified through the enlargement of the eyes until the abstracted figures became images as powerful as any painted in this country up to that time (plate 266). But the strain proved intolerable and Maurer, who had become a recluse, took his own life in 1932.

In 1909 at "291" Marsden Hartley (1877–1943) exhibited dark landscapes in the manner of Ryder, whom he deeply admired. Three years later, with the help of Stieglitz and others, he went abroad. He spent only enough time in Paris to learn something of Cubism before going to Germany, where he exhibited in Munich and Berlin. He was again in Europe in 1914–1916, for most of the time in Germany, where he painted several enigmatic canvases, abstract designs of checkerboards and stripes with military symbols and insignia, as in *Portrait of a German Officer* (1914; plate 267). Hartley's German sympathies may account for the power as well as for the clumsiness of his painting. His work could be charted in terms of his confrontation of his sources, such as Cézanne, who was the primary influence in his landscapes of the middle 1920s, but to do so would be to miss the peculiarly personal accent which eventually became dominant. In landscapes and figure scenes of his beloved Maine, the simply drawn forms and broadly spaced colors absorb all unessential details, while the colors communicate the strong, often unharmonious contrasts of autumn foliage with the dark waters of lake and sea. His late "archaic portraits" of hunters and fishermen were painted only after the forms had been intensified and simplified by memory. In the hieratic postures of the mother and her drowned sons in *The Lost Felice* (1939; plate 268), the staring eyes testify to Hartley's study of Coptic textiles and Fayum

Colorplate 47. MAURICE PRENDERGAST. *On the Beach, No. 3*. 1918. Oil on canvas, 26 × 33 3/8″. Cleveland Museum of Art. Hinman B. Hurlbut Collection

Colorplate 48. STANTON MACDONALD-WRIGHT. *Synchromy in Green and Orange.* 1916. Oil on canvas, 34 1/2 × 30 1/2″. Walker Art Center, Minneapolis

267. MARSDEN HARTLEY. *Portrait of a German Officer.* 1914. Oil on canvas, 68 1/4 × 41 3/8".
The Metropolitan Museum of Art, New York. Alfred Stieglitz Collection, 1949

268. MARSDEN HARTLEY. *The Lost Felice*. 1939. Oil on canvas, 40 × 30″. Los Angeles County Museum of Art. The William Preston Harrison Collection

portraits. In certain late landscapes, like *The Wave* (1940; Worcester Art Museum), he can be compared only with Winslow Homer, who painted no finer drama of the darkening sea.

The origins of Max Weber (1881–1961), like his art, introduced a new strand into what was becoming the complex pattern of American modernism. Marin, Maurer, and Hartley, like The Eight before them, had been American born and bred, and their encounters with the modern movement were attempts to accommodate what they had felt since childhood in this country to the styles and techniques created by Europeans for the expression of quite other experiences. The wonder is that in their work, especially in Marin's and Hartley's, the American accents were not submerged by the new artistic languages. Weber, on the other hand, had been born in Russia, the son of a poor tailor who brought his family to this country when the boy was ten. Weber's earliest memories, which in the later years of his life were to dominate his art, were of the Hasidic community in Byelostok. Growing up in the poorer part of Brooklyn, mastering English almost too late to enter grammar school, and earning his way through Pratt Institute, Weber was typical of other immigrants whose cultural heritages have profoundly affected the character of American art in this century.

By 1905 Weber was in Paris, where he stayed until 1908, during three of the most important years in the history of French art. He saw the first Fauve exhibitions at the Salon d'Automne, the Cézanne exhibitions of 1906 and 1907, and he became a close friend of Henri Rousseau le Douanier. His first work after he returned to New York in 1909 was more Fauve than otherwise, but gradually Cubist principles acted as a support for his color, which was denser but as opulent as the Fauves' (plate 269). For the next decade he explored many aspects of color and design. Sometimes his work was abstract, at others figural with the figures dissolved by Cubist formulas, while at the same time the massive proportions and explicit definition of space reflected his interest in primitive sculpture, especially Mayan and Aztec objects he had seen at the American Museum of Natural History. His Cubist masterpiece is the well-known *Chinese Restaurant* (1915; New York, Whitney Museum of American Art), in which he conveyed the sensation of dazzling light splitting the interior into fragments as one entered from the darkness outside. Among the last of these early Cubist works were groups of figures, including *The Visit*, or *Conversation* (1919; plate 270). Critical attention has for so long been directed toward the major French Cubists that even today it is difficult to

269. MAX WEBER. *Composition with Three Figures.* 1910. Gouache on board, 47 × 23″. William Hayes Ackland Memorial Art Center, University of North Carolina, Chapel Hill

recognize the artistic authority of painters who have worked outside the immediate influence of Picasso and Braque.

After 1920 such intensity of expression somewhat abated. Through the 1930s the compositions of nude figures were massive, even ponderous, occasionally comparable to Picasso's nudes of his Classic period, but often contrived in the studio rather than freshly seen and felt. After 1940 came the Jewish themes, like the ritual dances, and the figures in an interior conversing or making music. They were executed in combinations of swiftly looping and disappearing lines which only partially enclose the sensitively colored planes.

By 1916 the results of these first contacts with European modernism could be seen in a large exhibition of contemporary American painting organized by the *Forum* magazine. In contrast to the heterogeneous display of American art at the Armory Show, this was rigorously selective. Almost two hundred paintings and drawings were on exhibition, but they had been contributed by only sixteen artists, selected from a list of fifty by a committee that included Henri, Stieglitz, and Willard Huntington Wright, the perceptive critic of the *Forum*. A little more than three years after the Armory Show, where there was nothing that could be called truly abstract by any American artist, no less than nine of the sixteen painters were working in abstract or semiabstract modes. Among the latter we have already considered Hartley, Marin, and Maurer. A more sweeping elimination of perceptible objects appeared in the work of Arthur G. Dove (1880–1946), while Stanton Macdonald-Wright (born 1890) and Morgan Russell (1886–1953) were represented by paintings which have a place in the history of European as well as of American abstraction. Dove had worked as an illustrator until 1907 when he went to Paris for eighteen months. Soon after he returned, Stieglitz showed his work in 1910 with that of other young Americans and in 1912 gave him his first one-man exhibition. Between these dates Dove had begun a series of small abstract compositions in pastel which he called *The Ten Commandments*. As slightly larger works were added, the generic title became *Nature Symbolized*, of which *No. 2* (1911–1914; plate 271) was one of sixteen with the same title in the *Forum* exhibition. Of the two terms the second is the more important, for as the perceptible aspects of nature gradually disappeared, the symbolic qualities of form and color became the essential factors in the composition. In the example illustrated, whatever may once have been suggested by natural shapes has been transmuted into abstract, quasigeometrical elements.

All that is left of nature are the ambiguous effects of space created by contrasts of value and color. For such works Dove must be considered a pioneer of international abstract art, for it is probable that by 1911 he had gone as far in that direction as had Larionov and Goncharova in Moscow, Kandinsky in Munich, and Kupka in Paris.

Dove was not always so thoroughly nonobjective. His love of nature was too profound for him to eliminate it entirely from his work, nor did he need to do so. "Works of nature," he wrote in one of his poems, "are abstract. They do not lean on other things for meaning."[1] Among the best of his later paintings are those in which concentric circles drift through veils of color to create a cosmology intensely personal while at the same time true to his and our experience of natural phenomena.

Both Morgan Russell and Stanton Macdonald-Wright, the younger brother of W. H. Wright, had been studying in Paris before 1914. Russell worked with Matisse on his sculpture, and both men learned the great constructive lessons to be found in Cézanne. But more important than these experiences were their studies of color which led them to invent, parallel to and independently of the Orphic Cubism of Delaunay and Kupka, a kind of painting in which space was created by the advancing and recessive properties of color, the resulting forms being independent of any shapes in nature. The first effective demonstration of the method occurred in their joint exhibition at the Bernheim-Jeune Gallery in Paris in 1913. By then Russell had invented the term Synchromy ("with color") to describe their method. His own painting was perhaps the more intellectual, to the degree that the clearly defined blocks of opaque color in his compositions were related to the position of forms in space previously defined by constructed models. Macdonald-Wright also studied the movement and displacement of forms in light before creating equivalents for them in dissolving veils of prismatic color, and at times a natural form can be detected within his diaphanous hues. But in his most developed paintings, like the *Synchromy in Green and Orange* (1916; colorplate 48), which is comparable to the best French Orphic Cubism, nothing is left of the original object but the sensations of disembodied movement turning and dipping in a space whose depths and boundaries are created by the direction and intersection of prismatic planes.

Other artists were briefly attracted to Synchromism, among them Joseph Stella and Patrick Henry Bruce (1881–1937), whose five *Compositions* painted before 1918 are closely related to Russell's angular and

271. ARTHUR G. DOVE. *Nature Symbolized, No. 2*.
1911–14. Pastel on paper, 18 × 21 5/8″. The Art
Institute of Chicago. Alfred Stieglitz Collection

0. · MAX WEBER. *The Visit (Conversation)*.
1919. Oil on canvas, 42 × 32″.
Collection Mr. and Mrs. Milton
Lowenthal, New York

272. PATRICK HENRY BRUCE. *Composition II.* Before 1918. Oil on canvas, 38 1/4 × 51". Yale University Art Gallery, New Haven, Conn. Collection Société Anonyme

opaque style (plate 272). The movement itself did not survive the First World War. Even by 1914 the founders had moved apart, and although they continued to paint Synchromatic compositions, their later work was less inventive.

Synchromism was the first instance of American artists' inaugurating a programmatic movement in abstract art, but because it had been worked out in Paris in close proximity to Cubism and Orphism, even if without the direct intervention of Delaunay, it could be considered almost as much a development in French as in American painting. Something of the same ambiguous relation between European and American expression occurred during the First World

War when several members of the Parisian avant-garde came to New York. Francis Picabia (see above, pp. 251, 256) had been there as early as 1913 when his paintings were shown in the Armory Show, and Stieglitz arranged his first American exhibition at "291." He returned in 1915 for almost a year, and again for six months in 1917. Marcel Duchamp, the antihero of the Armory Show, arrived in 1915 to remain for five years. Others who were there more briefly were the Cubist painter Albert Gleizes and Jean Crotti, Duchamp's brother-in-law. Picabia's and Duchamp's ironic attitude toward all conventions, social as well as artistic, and their iconoclastic productions—Picabia's irreverent collages and comic-strip

drawings and Duchamp's extravagant labors over the *Large Glass*—were admired by Man Ray (born 1890), a young American artist then working as an advertising illustrator. Through his friendship with Duchamp, Man Ray became the first and remains the most authentic American Dada. In 1916 he was represented in the *Forum* exhibition by *Invention—Dance* (New York, coll. Mr. and Mrs. William N. Copley), which resumed the theme of Duchamp's inanimate bachelors in a collagelike image of flat shapes resembling a dressmaker's patterns. Man Ray was also one of the first to paint with an airbrush, an instrument he had been using in his advertising work, for a series of abstract compositions, among them *Jazz* (plate 273), probably painted in 1916. He exploited gradations of tone, not only in his airbrush compositions, but also, after he had moved to Paris in 1920, in his photographic Rayographs (plate 274), unique prints obtained by exposing a film upon which "some odd miscellaneous objects" had been placed. It has been thought that his success abroad as a portrait photo-

274. MAN RAY. *Manikin.* 1923. Rayograph, 9 1/4 × 7". Yale University Art Gallery, New Haven, Conn. Collection Société Anonyme

. MAN RAY. *Jazz.* c. 1916. Airbrush color on paper, 27 1/4 × 21 1/4". Columbus Gallery of Fine Arts, Columbus, Ohio. Ferdinand Howald Collection

grapher interfered with his career as a painter, but he always excelled as an imaginative inventor of devices to tease and shock other people's conventional sensibilities. His *Gift* (1921), a flat iron studded with carpet tacks, survives as a startlingly original Dada object with malicious Surrealist overtones.

A brief but impressive integration of American themes with the most advanced European techniques was achieved at this time by Joseph Stella (1877–1946). He had been born in Italy but came to New York at nineteen. He was abroad again from 1909 until 1912, when he discovered Cubism and Italian Futurism. The latter is the dominant influence in his first large canvas, *Battle of Lights—Coney Island* (1914; Yale University Art Gallery, coll. Société Anonyme), with its mosaic pattern of flashing colors much like the contemporary work of Severini. Four years later in *Brooklyn Bridge* (plate 275), a typically Futurist subject, the dynamic energies of the modern industrial city, symbolized by the lights of traffic streaming across and beneath the bridge, was treated in terms of Cubist space created by transparent and interpenetrating planes. Although neither people nor vehicles are to be seen, the tensile strength of the great

275. JOSEPH STELLA. *Brooklyn Bridge.* 1917-18. Oil on bedsheeting, 84 × 76″. Yale University Art Gallery, New Haven, Conn. Collection Société Anonym

metallic structure—of the "choiring strings," as the poet Hart Crane apostrophized the bridge—is recreated in Stella's vertiginous perspectives glimpsed between the intricate pattern of the suspension cables.

In 1922 Stella painted the metropolis again in the five large panels of *New York Interpreted* (Newark Museum Association). The themes were by now familiar—the piers of the harbor, the bridge, the airport—but the treatment was drier and more mechanical. Stella's reputation as one of the first painters to present, on a majestic scale, the majestic aspects of the modern city is deserved, but it rests on only a handful of work.

The quickening pace of America's, or at least of New York's, interest in modern art could also be seen in the founding of the Society of Independent Artists in 1917. Modeled after the organization of the same name in Paris, it held an annual exhibition (until 1932) with neither jury nor prizes, which was open to anyone upon payment of a small fee. Among the founders and first officers were Glackens, Prendergast, Bellows, Marin, Stella, and Man Ray. Like the exhibitions in Paris, the New York Independents were from the first something of a hodgepodge where the gifted were swamped by the inferior and amateur, but it must be noted that among the two thousand items shown in 1917, there were paintings and sculptures by no less than nineteen prominent artists of the School of Paris.

The managing director of the first Independent exhibition was the poet and scholar Walter Conrad Arensberg (1878–1954). He and his wife Louise were among the first American patrons and collectors of modern art who made possible a wider public understanding of its history and principles. During the war years and until their departure for California in 1921, the Arensbergs' apartment on West 67th Street was a meeting place, at all times of the day and night, for the liveliest and most adventurous spirits. Their encouragement and understanding has been perpetuated in their collection, now in the Philadelphia Museum of Art, which is particularly rich in works by Duchamp and Brancusi. The Philadelphia Museum also has the smaller but choice collection of A. E. Gallatin (1882–1937) which includes Léger's masterpiece of 1919, *The City*. The largest and probably the finest collection of these years was gathered by the attorney John Quinn (1870–1924). Of Irish descent, he had first been interested in Irish and English art, at one time owning exceptional works by Augustus John and Wyndham Lewis, the latter acquired through his friendship with the American poet Ezra Pound. Quinn was the attorney for the Armory Show, to which he lent generously and where he came to understand the qualities of French painting. Between then and his premature death he acquired an immense quantity of works by French artists and others working in Paris. His collection was never exhibited in its entirety during his lifetime and was dispersed soon after his death, but insofar as it can be reconstructed from sales catalogues and by those works which were once his and are now treasured in museums here and abroad, his eye for what was good as well as for what was new was one of the best of his day.

In Washington Mr. and Mrs. Duncan Phillips established their collection as a public museum in 1918. While French painting is represented in superb examples, notably by Renoir's *Luncheon of the Boating Party*, works by American artists have been included from the first. Such discriminating connoisseurship was perhaps not so conspicuous in the two collections formed by Katherine S. Dreier (1877–1952), but her purpose was different. With Duchamp and Man Ray, whom she met at the Arensbergs' after the Armory Show, she founded in 1920 the Société Anonyme, Inc. (the pun was Man Ray's; the French words also mean "incorporated") to promote the knowledge of modern art in this country. Although she had no permanent headquarters she arranged a series of exhibitions that included the first presentations in this country of Léger, Archipenko, Kandinsky, Klee, and Villon. By 1941, when Miss Dreier and Duchamp presented the collection of the Société Anonyme to Yale University, it contained some five hundred works in various media by 169 artists. After her death her own collection, smaller but with works of equal quality, was distributed among several museums. At that time Duchamp's *Large Glass* rejoined the Arensberg Collection in Philadelphia.

The educational activities of the Société Anonyme had been carried on by one woman working with modest means. In 1929 the modern movement received massive support with the establishment in New York of the Museum of Modern Art. The first board of trustees included such notable collectors as A. Conger Goodyear, Stephen C. Clark, Duncan Phillips, Miss Lillie P. Bliss, who bequeathed her collection to the museum in 1931, and Chester Dale, who left his to the National Gallery in Washington in 1964. Guided by Alfred H. Barr, Jr., the first director, the exhibition program and the permanent collection of the museum have become models for similar institutions throughout Western Europe and America.

In 1937 Solomon R. Guggenheim established the Museum of Non-Objective Art with a large group of paintings by Kandinsky and other important abstract artists. As the Solomon R. Guggenheim Museum, it

now occupies the only structure in New York designed by Frank Lloyd Wright, where since 1960 important retrospective and loan exhibitions of all phases of the modern movement have been held (see below, p. 421, and plate 381). The promotion of American art has been the exclusive purpose of the Whitney Museum of American Art, founded in 1930 by Gertrude Vanderbilt Whitney and now housed in a new building designed by Marcel Breuer (see below, p. 431). In addition to its permanent collection and frequent loan exhibitions, the museum holds comprehensive biennial exhibitions of paintings and of sculpture and drawings. In addition to the activities in New York, the three institutions have arranged traveling exhibitions, often in cooperation with museums in other cities, which have brought every aspect of the modern movement to the public throughout the country.

By 1920 modernism was, for all but the most conservative artists, a legitimate mode of expression. Since then academic painting has become less and less prominent, although some rear guard skirmishes have been carried on by conservative sculptors, temporarily encouraged by government commissions for war memorials after 1918 and 1945. But there was never any single direction that all modern artists followed. Some, like Man Ray and Abraham Rattner (born 1895), remained abroad after the First World War and took more part in European than in American developments. Man Ray remains a prominent figure in Paris, and although Rattner returned to the United States in 1940, his strongly emotional painting is related more to the School of Paris than to recent and more Abstract Expressionist tendencies at home. Others, having been abroad before 1914, adapted European ideas to their own pictorial problems without, however, treating specifically American subject matter. Except for Marin, and Hartley in his later years, their work, like Maurer's and Weber's, could be considered without regard for their nationality. Still others have tried to define American experience within the continuing traditions of American Realism, to the extent of avoiding or even condemning European influences. The interplay of these several points of view accounted for the variety within American art in the years between the two wars, although during the Depression, beginning in the winter of 1929–1930, extra-artistic concepts—social and political as well as economic—sometimes outweighed purely artistic considerations in the continuing attempt to define the American characteristics of American art.

Among those who interpreted the appearance and experience of American life within contemporary attitudes toward form were the painters who have been described as the "Precisionists" or "Immaculates." They were never a formal group, nor had they a common program, but the terms indicate their interest in precisely defined forms and clean, smoothly brushed surfaces devoid of any emphatically personal touch. The oldest among them was Charles Demuth (1883–1935). He had been to Europe twice before 1914 and, knowing the latest Cubist developments at first hand, used separated and interpenetrating transparent planes to examine the buildings of his native Lancaster, Pennsylvania. Sometimes he contrasted contemporary squalor with the serene formality of the early nineteenth-century architecture, or the traditionally American promise of a higher standard of living with the sordid actuality. In *Modern Conveniences* (1921; plate 277) the pattern of parallel lines and arcs of circles resembles Stella's union of Cubist and Futurist formulas, but in Demuth's hands the geometrical abstractions cast melancholy light over industrial structures whose artistic potentials had been negligible until the artist saw them. Such are the grain elevators in his well-known *My Egypt* (1927; New York, Whitney Museum of American Art), whose stark cylindrical power was recognized as intrinsically beautiful at about the same time by the architect Le Corbusier (see below, pp. 347, 349).

Demuth's abstract portraits of his friends, composed of objects, letters, numbers, and symbols, were witty reflections on contemporary intellectual life. His figural illustrations, notably for Zola, Wedekind, and Henry James, in pencil and fluid watercolor washes somewhat reminiscent of Rodin, are subtle evocations of character and situation. No one has surpassed his visualizations of the perverse psychological anguish of the characters in James's *The Turn of the Screw* or *The Beast in the Jungle*. His watercolors of flowers and fruit were more delicately drawn and transparently colored, the Cubist analysis of form being less apparent than his admiration of Cézanne.

The crisp edges of Demuth's forms are conspicuous also in the paintings of Charles Sheeler (1883–1965), who had been to Europe several times before 1914 and was aware of the structural character of Cubist design. However, his first subjects were the rural architecture and folk arts of eastern Pennsylvania as well as, later on, the radically simplified forms of Shaker furniture, of which he had a notable collection. But Sheeler was never sentimentally addicted to Early Americana. As a professional photographer, specializing in architectural and industrial subjects, he became one of the principal celebrants, after Stella, of the growth of the American city and its technology. In his paintings forms were seen with the precision of a sharply focused

276. CHARLES SHEELER. *Upper Deck.* 1929.
Oil on canvas, 29 1/8 × 22 1/8″. Fogg Art Museum,
Harvard University, Cambridge, Mass.

277. CHARLES DEMUTH. *Modern Conveniences.* 1921.
Oil on canvas, 27 × 20″. Columbus Gallery
of Fine Arts, Columbus, Ohio. Ferdinand
Howald Collection

lens, their basic structures stripped of everything unessential to become the expressive content of the design, as in *Upper Deck* (1929; plate 276). The clarity of Sheeler's painting and drawing would be inconceivable without his photography, but he never confused the media. He always held, as a working principle, that "pictures realistically conceived might have an underlying abstract structure."[2] This came to mean that before starting a painting he had to have "a complete conception of the picture" in his mind, analogous to an architect's plans for a house.

Demuth and Sheeler, with others like Morton Schamberg (1881–1918), who was one of the first Americans to paint real and imagined machinery (plate 278), were responsible for creating the image of an urban environment dominated by the precise, clear forms of the new technology, overwhelmingly powerful but eerily inhuman (for there are no human figures in their scenes). This imbalance was remedied by Georgia O'Keeffe (born 1887) in her views of midtown Manhattan, especially at night, seen from the tall buildings when the darkness is punctuated by irregular patterns of light in the skyscrapers and the streets far below are bright with traffic. O'Keeffe is better known as the painter of natural, rather than man-made, forms presented in huge close-ups, the small object monumentalized and transformed by the change in scale. Through her studies at Columbia with Arthur Wesley Dow (1857–1922) she learned the principles of oriental design, including the effects of abstract rhythm. By 1916 she had produced abstract drawings which Stieglitz exhibited that year. She and Stieglitz were married in 1924, so it is proper to think that her magnified images and the impeccable clarity of her outlines and painted surfaces are related to her appreciation of his photography, although her own works could never be mistaken for colored photographs. Like Sheeler, she has always been aware of the importance of abstract design. In *Black Iris* (1926; colorplate 49) the sinuous pattern of the huge blue and blue-black petals transcends our knowledge of the natural form, while at the same time it enhances the creative vitality of the natural force within the flower. O'Keeffe has lived for many years in New Mexico, where she has created a very personal iconography from the elementary forms of adobe

278. MORTON L. SCHAMBERG. *Telephone.* 1916. Oil on canvas, 24 × 20″. Columbus Gallery of Fine Arts, Columbus, Ohio. Ferdinand Howald Collection

architecture, the fantastically colored rocks, and the bleached bones lying on the desert.

The Precisionists' treatment of natural and man-made forms as almost abstract arrangements of planes and lines in space, yet without loss of contact with the objective existence of the things themselves, was a constant factor in the work of Stuart Davis (1894–1964). He had studied with Henri and, like so many other American painters, had worked as an illustrator until at nineteen he exhibited five watercolors in the Armory Show. Soon thereafter, he abandoned literal representation and on the basis of Cubist collages and the later works of Juan Gris created his semiabstract compositions in which aspects of ordinary objects seen from different points of view were combined in flat patterns in the hard, strong colors of commercial art. One of the first of these, *Lucky Strike* (1921; plate 279), where portions of the then familiar green package were greatly enlarged and reassembled, is a legitimate predecessor of the Pop art of the 1960s. More agreeable, perhaps, were the flatly painted superimposed views of Paris and the confrontation of landscape fragments of Paris and New York, based on his visit to France in 1928–1929. From them came the abstracted American landscapes in which the syncopated rhythms of the small bright patterns correspond to titles like *Swing Landscape* (1938; Indiana University), recalling his love of jazz. But what now appear to be Davis' most historically significant canvases were painted the year before he went abroad. These are the four *Egg Beater* paintings of 1927–1928 (colorplate 50), based on a still-life arrangement of a rotary egg beater, a rubber glove, and an electric fan, which Davis nailed to a table and used as his "exclusive subject matter" for a year. The presence of such commonplace objects eliminated any nonpictorial considerations of subject matter which he had come to feel were irrelevant to his art. The true subject of his pictures, he said, was "an invented series of planes which was interesting to the artist." It led him away from naturalistic forms to a new kind of subject whose "emotional reality [was] fundamentally . . . our awareness of planes and their spatial relationships."[3]

The *Egg Beater* canvases, with a few others like *Percolator* (1927; New York, Metropolitan Museum of Art), are among the most convincing transformations of French Cubism into an unmistakably American idiom. References to Gris, to Léger, and in some instances to the loose configurations of Miró, can be recognized, but the pure brilliant colors, the uncompromising angularity, and the taut equilibrium of line and edge with plane have nothing of the suave elegance of French painting. Only with such sharp edges

279. STUART DAVIS. *Lucky Strike*. 1921. Oil on canvas, 33 1/4 × 18″. The Museum of Modern Art, New York. Gift of the American Tobacco Company, Inc.

and loud hues could Davis have so accurately distilled the noisy essence of modern American life.

Although Edward Hopper's *Freight Cars, Gloucester* (1928; plate 280) was painted within a few months of Davis' *Egg Beater*, at first glance it seems to belong to another and older America, to Winslow Homer's, where forms were seen in the same strong New Eng-

280. EDWARD HOPPER. *Freight Cars, Gloucester.* 1928. Oil on canvas, 29 × 40″. Addison Gallery of American Art, Phillips Academy, Andover, Mass. Gift of Edward W. Root

land light, or to Thomas Eakins', where there was a similar unflinching observation of contemporary ugliness. It is true that Hopper (1882–1967) in his way continued their tradition of pictorial objectivity within a generally Realist technique, and it is also true that he believed that painting, to be essentially American, should remain immune to foreign influence. But if he chose to reject the techniques of European modernism, he was not ignorant of what they were. After studying with Henri, he spent much of the years from 1906 to 1910 in Paris, where he found that a superficially Impressionist technique was inadequate for his vision of architectural forms defined in space by light. Slowly he discovered his proper and long neglected subjects: shabby houses in small towns, the

soiled edges of cities eroded by industrial decay, and the hard, flat planes of New York's streets and buildings. To portray them, to express their essential character (a process he defined as "the most exact transcription of my most intimate impressions of nature"), Hopper had to develop a broadly generalized brushstroke, more like Manet's than Eakins', and a structural design in which there is something of Cézanne and the Cubists in the articulated planes and strongly abstract patterns of verticals and horizontals. In his controlled composition Hopper was actually closer to Stuart Davis than one was at first aware, closer to abstract art than appearances would seem to warrant. But in those appearances, in the ostensible subjects of his pictures, he was entirely American.

This is truly, as Hopper himself has written, our own "chaos of ugliness . . . our native architecture with its hideous beauty."[4]

Hopper was pre-eminently a landscape painter. When figures occur in his landscapes and city views, they are seen not as individuals but as types—the waitress, the movie usherette, the middle-aged couple in the second-rate restaurant, physically together yet emotionally apart. Isolated and alone under the desolate artificial light of which Hopper was a master, they function as extensions of their dreary environment, their minds and bodies numbed by its banality, alienated even from each other by the directionless conformity around them (colorplate 51). Consequently, Hopper's America, except in certain luminous watercolors and oils of the untarnished natural scene, is tragic, closer to Theodore Dreiser's than to Carl Sandburg's, and a world away from Sheeler's with its self-assured and glittering efficiency.

In the 1920s Charles Burchfield (1893–1967) had also presented the presumably less attractive aspects of America, particularly the small Middle Western towns and villages whose intellectual and spiritual poverty had been so cruelly satirized by Sinclair Lewis in his novel *Main Street* (1924). Burchfield, however, loved the flat plains of his native Ohio, especially when rain came on toward evening and lights glowed in even the unloveliest windows. He saw America with more affection than did Hopper, and he was less tempted to portray its bleakly impersonal power. Burchfield was also at his best as a watercolorist, one of three artists, with Hopper and Marin, who painted major pictures in what has often been considered a minor medium. At the beginning and again in the later decades of his career he saw nature as alive with spirits. In the early watercolor *Church Bells Ringing, Rainy Winter Night* (1917; plate 281) the windows, roofs, and steeple are distorted by the remembered fears of childhood, fears that cannot be stilled by the lighted candle and the Christmas tree in the house to the left. Such an attitude is rare in American painting, which has more often been drawn to the polar attractions of doctrinaire abstraction and programmatic realism.

The Precisionists' pictures of an immaculate technological world, totally efficient and unsullied by human frailty, were actually more dream than truth, a part of the American vision of a supremely efficient mechanical world. But in 1929, the year Sheeler completed *Upper Deck*, the supposedly indomitable economic power of the United States began to falter. The Depression years inevitably altered certain basic presuppositions about the place of art in American life. New subjects with a new content emerged as artists and critics examined the American Scene, looking for the faults which had led to the debacle as well as for traits of character which would lead the way out. The distinction between good and evil in American life was also drawn in terms of town and country, of the degrading effects of city life—the more conspicuous when economic troubles were identified with the failure of Wall Street—in contrast to the supposedly uncorrupted rural life. The contrast had appeared from the early 1920s in less ideological terms in Hopper's cheerless townscapes and in Burchfield's watercolors of nature awakening to spring.

A stylistic contrast can also be seen in different attitudes toward the interpretation of industrialized

281. CHARLES BURCHFIELD. *Church Bells Ringing, Rainy Winter Night.* 1917. Watercolor on paper, 30 × 19″. Cleveland Museum of Art. Gift of Mrs. Louise M. Dunn, in memory of Henry G. Keller

society, between a Precisionist geometry with Surrealist overtones and the literal illustration of social facts. Surrealism was not of much consequence in American art until after 1940, when several European Surrealists spent the war years in this country, but as early as 1930–1931 Peter Blume (born 1906) had incorporated certain aspects of Surrealist psychological imagery in *South of Scranton* (New York, Metropolitan Museum of Art) and *Parade* (1930; plate 282). The central part of *Parade* might almost belong to the well-oiled world of Sheeler and the Precisionists, except that the streets seem even more deserted and the factories are ominously silent. The suit of medieval armor held by the worker, a hollow shell emptied of its original function, seems to suggest that the modern

factory in its turn may become obsolete. Blume's projection of this ambiguous content with the cool clear colors and rigid forms of technological geometry is as eloquent of the despair of those years as a photograph of a bread line. But the artistic significance of his painting consists less in its lingering Realism than in the powerfully abstract design of the industrial forms. Thirty years later *Parade* could be read as an early essay in hard-edge painting, just as the signs on the building to the left are like a preliminary exercise in Pop art. Blume himself did not pursue abstraction further, but developed an intricately realistic technique for his *Eternal City* (1934–1937; New York, Museum of Modern Art), a bitterly satirical attack on Italian fascism.

282. PETER BLUME. *Parade.* 1930. Oil on canvas, 49 1/4 × 56 3/8″. The Museum of Modern Art, New York. Gift of Abby Aldrich Rockefeller

Colorplate 49. GEORGIA O'KEEFFE. *Black Iris*. 1926. Oil on canvas, 36 × 29 7/8″. The Metropolitan Museum of Art, New York. Alfred Stieglitz Collection, 1949

Colorplate 50. STUART DAVIS. *Egg Beater, No. 1*. 1927. Oil on canvas, 27 × 38 1/4″. The Phillips Collection, Washington, D.C.

283. REGINALD MARSH. *Tattoo and Haircut.* 1932. Tempera on canvas, 46 1/2 × 47 7/8". The Art Institute of Chicago.
Gift of Mr. and Mrs. Earle Ludgin

The dominant Realism of the 1930s was used by Reginald Marsh (1898–1954) for a more specific exposure of social deterioration. A prolific illustrator, he never lost the illustrator's eye for details of dress, stance, or facial expression that reveal a personality in relation to and determined by its environment. He had studied with John Sloan and Kenneth Hayes Miller (1876–1952), whose figures were taken from the streets and shops of New York but were presented according to the canons of Renaissance design. Marsh had fewer illusions about equating the past with the present. In his studies of the city, especially along the crowded streets of lower Manhattan and the Bowery, he accepted the total visual reality before him. The lack of selectivity which has been the virtue as well as the handicap of illustrators since Hogarth was turned to advantage in his many studies of the Depression's derelicts, such as *Tattoo and Haircut* (1932; plate 283). Each face reveals not just a type but a person, while the disorder of the man-made and man-ravaged environment is presented with uncompromising and apparently unselective fidelity. Yet there is actually more artifice in this crowded composition than at first appears. The confusion of the lettered signs is weighed against the darker shifting mass of human figures to the left, while above the confusion the metal supports of the elevated railway create their own kind of order. Marsh worked in egg tempera, a drier medium suiting his preference for linear constructions, covered with thin washes of color. In his exploration of city life he was also fascinated by the theater, especially vaudeville and burlesque, and by the sprawling masses on the beach at Coney Island. Often his dexterity carried him further than his expressive content could go and the heaped-up anatomies became tiresome, but in his Bowery scenes of the 1930s he made convincing, if discouraging, statements about life in America during difficult times.

The contrasting virtues of rural life were affirmed by three painters, Thomas Hart Benton (born 1889) of Missouri, John Steuart Curry (1897–1946) of Kansas, and Grant Wood (1892–1942) of Iowa. They were all from the Middle West, they had studied for various periods at the Art Institute of Chicago, and they had been to Paris. Benton has been the most outspoken in his repudiation of foreign influences, and he has the most energetically explored themes from the western prairies, the Mississippi, and even the modern American city. But for all that, his art now seems less profoundly American than the quiet, undogmatic vision of Hopper. Perhaps his interpretation of America has been vitiated by his own knowledge. His emphatic musculatures, his abrupt changes

in focus and scale, and the contrived oppositions of still life and landscape are not only mannered but Mannerist, having more to do with sixteenth-century Florence than with the Middle West. John Steuart Curry also saw his native Kansas in terms of the old masters. There is something of the excitement of Baroque movement and perspective in *Tornado over Kansas* (1929; plate 284), but in much of his work the juxtaposition of foreign modes and native subjects now seems contrived.

Grant Wood's solution was radically different, and in his lifetime sensationally successfull. In the early German and Flemish masters—the so-called primitives—whom he studied in Munich, he found the painstakingly realistic technique and the straightforward expression of character which he used in *American Gothic* (1930; plate 285), a portrait of an elderly farm couple who were in actuality his sister Nan and his dentist. The repeated patterns of the woman's apron and of the pitchfork and overall bib, reversed in the arched window behind, hold the simply stated facts together and increase the feeling of sober lives lived close to the American soil, just as the reference in the title to an earlier century increases the nostalgic longing for a simpler, less citified America. This was Wood's finest picture, but it included elements which soon weakened his powers of expression. The smooth rounded forms became soft and doll-like, and the subjects, as well as their interpretation, self-consciously cute.

Wood's adaptation of supposedly primitive techniques may be compared with the work of the true primitive painter, the one who has never had professional training. The search for American primitives followed the revelation of the genius of Rousseau le Douanier, whose work was first shown by Stieglitz at "291" in 1910. Rousseau, however, had a peerless command of design and expression. No American primitive, not to speak of those elsewhere, ever equaled his monumental sense of form, but several have had an authentic vocation and an unmistakable sensitivity for fine painting. John Kane (1860–1934), a Scottish-born miner, carpenter, and house painter, had painted for himself since 1897, but he became known only in 1927 when one of his pictures was included in the Carnegie International Exhibition. In the remaining years of his life his works were widely exhibited, and his reputation was increased by the notoriety attending the discovery that at least one of his pictures had been painted from a photograph, a not uncommon practice among untrained artists. His best works were his views of Pittsburgh, where he had lived since 1890, with the steel mills wedged between

34. JOHN STEUART CURRY. *Tornado over Kansas*. 1929. Oil on canvas, 46 1/2 × 60 3/8″. The Hackley Art Gallery, Muskegon, Mich.

the busy rivers and the steep hills (plate 286). Kane's perspective and drawing may have been academically faulty, but his accurate, delicately brushed details were always controlled by a firm design, and his ability to suggest the atmospheric qualities of the industrial landscape shows him to have been a true, if untrained, artist. Two other well-known primitive painters were Louis Eilshemius (1864–1941), who "reverted" from an earlier academic training, and "Grandma" Moses (Anna Mary Robertson Moses; 1860–1961). The softness of Eilshemius' form and

space betrayed his less spontaneous inspiration. Although Mrs. Moses only began to paint when she was sixty-seven, she was astonishingly prolific. Much of her work is beguilingly quaint, even if her figures are merely cutouts in spaces no deeper than themselves.

Primitivism of another kind accounts for the strongly expressive early work of Ben Shahn (1898–1969). Using photographs, newspaper illustrations, and hints of the crude but emphatic drawings of children and the untrained, he created unforgettable images of social criticism, most notably in *The Passion*

285. GRANT WOOD. *American Gothic*. 1930. Oil on beaverboard, 29 3/8 × 24 7/8″. The Art Institute of Chicago. Friends of American Art Collection

286. JOHN KANE. *Prosperity's Increase*. 1933. Oil on canvas, 31 1/2 × 39 1/2". Collection Mr. and Mrs. William S. Paley, New York

of Sacco and Vanzetti of 1931–1932. Such pictures as the *Miners' Wives* (1948; plate 287) continued to prove his contention that serious art requires a serious purpose, which is to say, a socially meaningful content. More recently he seemed to disprove his own beliefs in works of great style and technical facility, but inherently decorative and devoid of protest.

As the Depression deepened after 1930, many artists suffered acutely until in 1934 the federal government took unprecedented steps to provide commissions within the competence of those who needed them. The first subsidies for mural paintings in new public buildings were administered by Edward Bruce (1879–1943), a capable landscape painter himself,

under the Public Works of Art Project of the Treasury. The following year the scope of these activities was widened to assist artists of every category under the Federal Art Project, a division of the Works Progress Administration (WPA), directed by Holger Cahill (1893–1960). The project lasted until the beginning of the Second World War and resulted not only in substantial economic assistance, but also in moral encouragement for the artists. The artistic results are difficult, and perhaps even unnecessary, to assess. Certain older, well-established painters weathered the crisis without subsidies. Others like Shahn, Philip Evergood (born 1901), and Jack Levine (born 1915) made their reputations or began their careers with works for

287. BEN SHAHN. *Miners' Wives.* 1948. Tempera on board, 48 × 36″. Philadelphia Museum of Art

the WPA. And a great many more, well-intentioned but undistinguished, have since disappeared from sight. Certain projects were more memorable than others. The Index of American Design, employing hundreds of painters to make exact watercolor copies of Early American artifacts of every kind, may have done little for contemporary expression, but it uncovered unexpected riches in the folk arts and handicrafts of the past. The more conspicuous mural projects brought color and movement to many post offices and other public buildings. But the importance of the federal intervention was less directly artistic than indirectly social, for it affirmed, at a time when it was necessary to do so, the right of the artist to earn a decent living and the essential place of art within society itself.

European and American Sculpture: 1900–1940

Throughout the nineteenth century, painting was so far the dominant art that between Canova's maturity toward 1800 and Rodin's in 1900 there were no sculptors in any country who achieved so international a reputation as theirs. The decline of sculpture was most probably due to a lack of first-rate talent, but other factors contributed to it. The invention of the camera in 1839 and the rapid spread of photography were the results quite as much as the cause of the pre-eminence of painting, for, like the camera, it could convey so much more factual data than any other art. To a period obsessed with the importance of facts—essential for the development of the sciences and of the new archaeological and historical studies—sculpture could supply little descriptive data. In good sculpture, as in good painting, facts have always been subordinated to design and expression. Rodin's supremely factual *Age of Bronze* (1876–1877; plate 126) was an early and isolated instance of extreme Naturalism; otherwise he was more concerned with the expression of psychological and symbolic values.[1] There were, of course, many sculptors whose works were annually to be seen in the Salons and other officially sponsored exhibitions, but with rare exceptions they did little more than continue the increasingly artificial conventions of an idealism basically Neoclassic even when the details were treated re-

alistically. This sculptural aesthetic can still be seen in public parks around the world where, in monuments to obscure statesmen, the closely observed details of boots and spectacles conflict with their declamatory gestures. Rodin dismissed such sculpture as "commercial," as indeed much of it was, and by his example showed that the individual sculptor would have to create his own standards of technical and expressive integrity apart from popular canons of taste and execution.

There are several reasons for the revival of sculpture in the twentieth century and the new interest in it on the part of critics and the public. Increased knowledge of other than European traditions—whether peripheral, as in folk art, or remote, as in Far Eastern, African, Polynesian, and Pre-Columbian American art—hastened the discovery of expressive elements which owed nothing to the conventionally idealistic treatment of the human body, so long the principal vehicle of sculpture in the West. Gauguin had been one of the first to recognize the artistic character of Breton carvings, usually considered late provincial variants of medieval sculpture, and he admired their "primitive" qualities even before he arrived in Tahiti. Soon after 1900 Derain and Vlaminck, and, a little later, Picasso and Matisse and the German painters Kirchner and Nolde, discovered the authentically

288. ARISTIDE MAILLOL. *Mediterranean.* c. 1901. Bronze, height 41″. The Museum of Modern Art, New York. Gift of Stephen C. Clark

artistic quality of African and Oceanic objects lying forgotten by all but the social scientists in the anthropological museums of Paris, Dresden, and Berlin. A parallel study of more familiar art led to a revision of established values. Predynastic Egyptian, archaic Greek, and early Chinese sculpture were eventually preferred to later phases of the same traditions. In each instance the revaluation was in favor of expressive power embodied in simpler, more tangible shapes having little or no associational content intelligible as such to Western eyes. This emphasis on formal values was persuasively argued by the English critic Clive Bell (1881–1964) in his treatise *Art*, published in 1914. Bell's ideas can be traced to the art-for-art's-sake theories of later nineteenth-century English aestheticism, but his hypothesis that the single quality "shared by all objects that provoke our aesthetic emotions [is] significant form" is still persuasive. His assertion that "to appreciate a work of art we need bring with us nothing but a sense of form and color and a knowledge of three-dimensional space" is not entirely true, but his insistence that "many of the most moving forms ever created are in three dimensions" called attention, after a long lapse of time, to the aesthetic response that sculpture can evoke.[2]

The new awareness of space, no longer schematic as in painting, but actually existing in three dimensions, was reinforced by developments in painting and architecture. Cézanne's search for colored equivalents of the spatial relations he perceived in landscape and still life, which led to the Cubists' subordination of representational subjects in favor of the three-dimensional implications of their forms, and the simultaneous appearance in the new architecture of continuous and interpenetrating spaces further increased the understanding of sculpture.

The consciousness that a new century had begun, with the promise of ever-new benefits for mankind based upon present and future technological developments, encouraged the search for forms truly characteristic of the age. We have seen how the Futurists believed that the dynamic qualities peculiar to modern

times could best be expressed in terms of movement, *velocità*, especially the movement of machines which in themselves are like sculptural forms. Some early twentieth-century sculpture was, indeed, mechanistic in appearance, and some of it even had the capacity to be set in motion, like Alexander Calder's Mobiles (plate 311), but the mechanical principle has the additional importance of contributing to the concept of a totally abstract, nonobjective sculpture even when the final forms, as in Brancusi's work, were organic in origin. The study of machinery and of machine tools also led to an appreciation of metals treated with the care and precision necessary for the proper functioning of machines, and to the use of new metals and alloys.

New materials, a new sensitivity toward space and toward sculptural volumes in space, and new forms found in alien and unfamiliar cultures, all these contributed to the new sculptural aesthetic perceptible at least by 1914 when the first completely abstract works of art had been created. At first the new sculpture was figural, and the first of the sculptors was one of the most traditional, his art appearing in reaction against Rodin's expressive exaggerations as a renewed synthesis of Classical and ideal elements. But the Classic factors in the sculpture of Aristide Maillol (1861–1944) are also essential aspects of modern art, analogous to the recall of Classic forms and themes and the desire to recover a kind of antique breadth and harmony that occurred in the work of Picasso, Braque, and Stravinsky, to name only a few, in the 1920s.

Maillol had come to Paris in 1887 to study painting. Discouraged by the perfunctory instruction at the École des Beaux-Arts, he turned to tapestry design after meeting Gauguin's young friends, the Nabis. His tapestries and the surviving paintings of this time might almost be taken for the work of Bernard or Denis, so flat are the patterns, so languid the contours. Only in his large, simply defined drawings of the nude can one detect Gauguin's more vigorous influence. Maillol was thirty-five in 1896 when he became a sculptor after his eyesight had been strained by weaving. His first success was the seated nude, in a pose familiar from Gauguin's Tahitian paintings, which he exhibited in plaster at the Salon d'Automne of 1905 (plate 288). When André Gide saw the figure in the context of the clamorous paintings by Matisse and the Fauves, he admired it because it "signified nothing," thus helping to define the new doctrine that form can be its own excuse for being.[3] Maillol's later title for the work, *Mediterranean*, suggests its Classical inspiration, but his Classicism was remoter than

Rodin's, more pastoral, and rarely disturbed, if at all, by psychological stress. But although it is true that Maillol's spacious figural geometry, unlike Rodin's, usually embodied no extraneous symbolic references, it was not thereby without expressive content. The *Mediterranean* was the first of many figures in which he projected on a monumental scale those concepts of repose, of fruitfulness, of purely physical satisfaction untroubled by intellectual exertion. Perhaps his constant preoccupation with the female figure seems repetitious and uneventful, and for that reason he is now considered more a conservator of traditional values than a pioneer of new ones; but between 1905 and his death in 1944 the abstract geometry of his complacent women helped to define on the one hand the dramatic exaggerations of the Expressionist sculptors and, on the other, the complete abstractions of the nonobjective artists.

A more individual treatment of similarly generalized Classic forms can be seen in the work of the German sculptor Wilhelm Lehmbruck (1881–1919). Before he left Düsseldorf for France in 1910, he had already experimented with Michelangelo's dramatic pathos in a male nude much like Rodin's *Adam* of 1880. In Paris Maillol's placid volumes soon appeared in his own female figures, especially in the *Standing Nude* (1910) and the *Torso* related to it. But Lehmbruck's figures, although motionless, are not so Classically mindless. If they seem withdrawn in reverie, it may be because their surfaces and contours are subtly blurred, and the artificial stone which he preferred for his casts preserves something of the indistinct coloration of the original clay. These qualities of texture and color are important in the more personal *Kneeling Woman* (1911) and the *Standing Youth* (1913; plate 289). Their angular distortions and extreme elongations are typical of contemporary German Expressionist painting, especially of Kirchner's jagged figures of the same years, and can be related also to the Expressionists' interest in medieval sculpture. During the First World War Lehmbruck embodied his tragic vision of humanity in slender male figures seated in dejection or prostrate in defeat. The crisper geometrical treatment of a *Female Torso* of 1917, one of his last works, suggests that had he lived he might have contributed to an Abstract Expressionist style.

The influence of medieval art, especially of wood carving, is more pronounced in the work of the principal German Expressionist sculptor, Ernst Barlach (1870–1938). Although his sculptures were often executed from plaster casts of the original clay models, their broad planes and deep concave under-

289. WILHELM LEHMBRUCK. *Standing Youth*. 1913. Bronze, height 9
Wilhelm Lehmbruck Museum, Duisburg, German

316

cuttings suggest a carver's, rather than a modeler's, approach. Barlach's generically Expressionist themes, of man's loneliness and despairing search for others and for God, were usually stated in single figures whose lumpy, all-too-human anatomies were swathed in coarse garments accentuating their timeless spiritual predicament. His several war memorials were dismantled by the Nazis, who objected to their tragic content, but the most unusual one has since been reinstalled in the church in Barlach's village of Güstrow in East Germany, and a second cast hangs in the Antoniterkirche in Cologne (plate 290). It is a massive bronze angel floating above a memorial slab. The heavy robes are motionless and the huge eyes in the still face are closed, so that one cannot tell whether it mourns in sleep or beyond death.

There is no such somber symbolism in the sculpture of Henri Matisse, which includes no less than sixty-eight separate works. That Matisse could turn from color, always the principal agent in his pictures, to colorless bronze indicates the paramount place he assigned to formal problems. The most impressive demonstrations of this are the four large reliefs of a standing female figure seen from the rear, known as *The Back*, which were executed between 1909 and 1929. Taken together they can be seen as an exercise in the progressive reduction and concentration of form—from the first, heavily Rodinesque figure twisting in space and seemingly lighted from a source outside itself, to the final version (plate 291), where space and light, almost as in a Cubist painting, are projected by a few simplified planes and hence are inseparable from them. These were the largest of Matisse's sculptures, but in many other figures he explored problems of form and line closely related to similar situations in his paintings.

The powerful simplifications of the second and later versions of *The Back* may owe something to the Negro sculpture which Matisse is known to have admired and which had already affected Picasso while he was painting *Les Demoiselles d'Avignon* (plate 201) during the winter of 1906–1907. A more direct influence of African art can be found in the sculpture of Constantin Brancusi (1876–1957). He had mastered the techniques of academic realism at the academy in Bucharest before he arrived in Paris in 1904. His first bronzes had something of Rodin's subjective pathos and fluent surfaces, but before long he rejected subtleties of modeling for direct carving in wood and stone. In *The Prodigal Son* (1913; plate 292) the oval protuberances and the angular profiles of the legs, much like those in *Les Demoiselles d'Avignon*, recall the masks and fetishes of Gabon and the Ivory Coast,

290. ERNST BARLACH. *War Memorial*. 1927. Bronze, length 84 1/4".
Antoniterkirche, Cologne

291. HENRI MATISSE. *The Back IV*. c. 1929. Bronze, 77 × 44 1/4".
Tate Gallery, London

the basic ovoid volumes of human and animal existence. Yet despite his economy of means, the effects can be visually as well as psychologically complex, as in the *Leda* (colorplate 52), where the union of god and mortal is achieved by the juncture of two irregularly ovoid masses. The search for essential forms underlying the multiplicity of actual shapes eventually took precedence over the materials of sculpture, so that sometimes there are several versions of the same subject in different stones and metals. The attenuated flight of the famous *Bird in Space*, for instance, exists in black, gray, and white marble as well as in highly polished brass. Brancusi was one of the most inventive and influential of modern sculptors, although the influence of his extraordinarily pure and polished forms has often been more conspicuous in fashionably sleek ornaments than in creative sculpture, and his aesthetic now seems constrained by the Neoclassicism of the 1920s.

Jean Arp (1887–1966), the Alsatian sculptor who spent most of his life in Paris, has already appeared in this history as one of the founders of Dada in Zurich in 1917 (see above, p. 251), and the ironic Dada play with images, irrelevant in themselves for artistic purposes until endowed with formal meaning by Arp's intuitive command of sculptural rhythms, dominated his painted wood reliefs of the 1920s (plate 294). But he soon grew beyond Dada's flirtation with anti- and non-art into one of the leading modern sculptors. He was always interested in natural forms, but unlike Brancusi Arp saw them more as process than as products, and in his sculpture he tried, as he said, "to make forms grow."[4] In his stone carvings he worked in such close sympathy with natural activities that objects like *Stone Formed by Human Hand* (1938; plate 293), poised upon what looks like an entirely natural stone, seems almost as much a work of nature as of art. He described other sculptures as "human concretions" to indicate that however abstract or nonrepresentational the forms might be, they were nevertheless absolute, actual, concrete in their own right, and as right and natural as fruit. Art, Arp once wrote, "is a fruit that grows in man like a fruit on a plant or a child in its mother's womb." His business was to keep the forms of such fruit intact, not to let "the spiritual fruit of man" degenerate into "an absurd resemblance to the aspect of something else."

African influences can also be seen in the work of Amedeo Modigliani (1884–1920) and of the Anglo-American sculptor Jacob Epstein (1880–1959). Modigliani today is better known as a painter, but when he came from Italy to Paris in 1906 he was primarily interested in carving. He may even have pointed out

yet the simplifications that prevent us from quite identifying the shapes of the father and son of the parable are not exclusively primitivistic. There is about them something hard and impersonal, as if this small but massive wooden construction were a model for some ponderous machine. So much of Brancusi's metal and stone sculpture has the smooth, precisioned surface of machine-made products that he has sometimes been considered a protagonist of an abstractly mechanistic aesthetic. On the contrary, his search for "the real sense of things" led him to study organic rather than mechanical forms and to

294. JEAN ARP.
Overturned Blue Shoe with Two Heels under a Black Vault.
1925. Painted wood, 31 × 41″.
Collection Peggy Guggenheim, Venice

293. JEAN ARP. *Stone Formed by Human Hand.* 1938. Stone, length 16 1/4″.
Kunstmuseum, Basel. Emanuel Hoffmann-Stiftung, 1944

295. AMEDEO MODIGLIANI. *Head of a Woman*. c. 1911–12. Stone, height 25 3/4".
National Gallery of Art, Washington, D.C. Chester Dale Collection

the qualities of primitive art to Brancusi, and in his own sculpture the extreme figural distortions can be traced to African work. In his female heads (plate 295) the long noses and extended planes of the cheek, and the treatment of the eyes and lips as small knobs, resemble Ivory Coast masks. Modigliani, however, ignored the symbolic expressiveness of his sources.

His own sculptures were extremely sophisticated exercises in purely formal relations, devoid of the magical suggestiveness of truly primitive art.

Jacob Epstein had been born in New York City of Russian parents, but after a brief stay in Paris he settled in England, where he became noted for his powerfully Expressionist bronze portraits and notorious for colossal stone sculptures which scandalized the British public as much by their anatomical distortions as by their nudity. But his interest in primitive art was no passing fancy. As a young man he studied examples in the Louvre and the British Museum, he had a fine collection of his own, and he adapted certain aspects of African art as early as 1917 in a large marble *Venus* (plate 296). The rigid vertical planes of the body and the unnaturalistic African features, all with no hint of conventional beauty, contradict the title with its implicit reference to Greek art. Beside Epstein's clumsy but indisputable power and Modigliani's elegance most adaptations of primitive form seem insignificant, but mention should be made of the wood carvings of the German Expressionist painters Kirchner, Schmidt-Rottluff, and Heckel. They are modest in size and closely related to painting (some are actually colored), but they also emphasize the importance of primitive art for the early twentieth century.

Although the Cubist painters were first of all concerned with representing on a flat surface the multiplicity of spatial experiences engendered by a given object, almost at once they tried to realize such experiences in three dimensions as well as in two. Braque came to sculpture only later, and then infrequently, and his small bronzes are of little consequence in comparison with his paintings; but Picasso from the first, even before he discovered Cubism, had practiced sculpture, and has always done so. His first Cubist work, the *Woman's Head* (1909; plate 297), is a dense form with the face and hair broken into angular planes which do not penetrate or open up the solid mass, as they were to do in his paintings within the next year. In 1913 and 1914 he created a number of constructions from odds and ends of wood and other materials, but the relatively slight projection and the identity of the still-life subjects with those of his paintings show that his ideas were still primarily pictorial. More truly sculptural, as well as Cubist, was the *Glass of Absinthe* (1914; plate 298), in which he merged reality with illusion by introducing an actual object (the perforated utensil holding the lump of sugar). In disclosing the interior of the glass as well as its exterior surface, he may have taken a hint from Boccioni's *Development of*

Colorplate 51. EDWARD HOPPER. *Room in New York*. 1932. Oil on canvas, 29 × 36″. University of Nebraska Art Galleries, Lincoln

Colorplate 52. CONSTANTIN BRANCUSI. *Leda*. 1920. Marble with plaster base, 26 × 19″. The Art Institute of Chicago

296. Jacob Epstein. *Venus.* 1917.
Marble, height 92 3/4".
Yale University Art Gallery,
New Haven, Conn. Gift of
Winston F. C. Guest

297. PABLO PICASSO. *Woman's Head*. 1909. Bronze,
height 16 1/4″. The Museum of Modern
Art, New York. Alfred Stieglitz Collection

298. PABLO PICASSO. *Glass of Absinthe*. 1914.
Painted bronze with silver spoon, height 8 1/2″.
The Museum of Modern Art, New York.
Gift of Mrs. Louise Smith

a *Bottle in Space* (1912; plate 299) where the curved surface of the bottle starts to uncoil into the space around it. And by coloring the bronze in the manner of the glasses in his painted still lifes, he further intensified the ambiguity of this object which exists simultaneously in three imaginative dimensions—as a painting, as a sculpture, and partially as an actual object. The implications of Picasso's unpretentious little sculpture were immense, but many of them were to be realized only later on.

Many so-called Cubist sculptures were merely Cubist drawings or paintings almost literally transposed into very low relief, but an exception must be made for the constructions of Henri Laurens (1885–1954). With such unlikely materials as cardboard, corrugated paper, and tin he made witty equivalents for the painted surfaces of the familiar Cubist bottles and guitars. After 1925 Laurens developed an abstractly figural style in which the continuous contours of his swollen forms, sometimes on a monumental scale, resemble those in Picasso's paintings of the later 1920s, an instance of the frequent exchanges of form and content between painting and sculpture in this century (plate 300).

Other attempts to find new sculptural forms through the Cubist analysis of objects in space were made at this time by the Ukrainian sculptor Alexander Archipenko (1887–1964) who arrived in Paris in 1908. He had a taste for primitivism, too, but in the *Boxers*, or *Struggle* (1914; plate 301), he treated a Futurist situation, the confrontation of two sources of physical energy, as an interlocking construction of forms abstracted from the human body. Archipenko carried his discovery that voids could intensify the spaces around and within his forms a stage further in the small bronze *Woman Combing Her Hair*, in which the figure's head and face are replaced by an opening like a twisted keyhole. He did this in 1915, a year before Jacques Lipchitz inserted a gratuitous hole in the center of his *Man with a Guitar*. In 1923 Archipenko came to the United States, where he became a successful teacher. He remained a prolific sculptor, although his works were often little more than arbitrary elaborations of his brilliant early inventions. The Russian sculptor Ossip Zadkine (1890–1967) also opened up the solid masses of his sculptures and constantly sought to incorporate Cubist qualities in figural sculpture on a monumental scale. His forms, however, are rarely compatible with their violently expressive content, although the large bronze *Des-*

299. UMBERTO BOCCIONI. *Development of a Bottle in Space.* 1912. Bronze, height 15″. The Museum of Modern Art, New York. Aristide Maillol Fund

300. HENRI LAURENS. *Night*. 1937. Bronze bas relief, 32 × 24 1/4″. Musée National d'Art Moderne, Paris

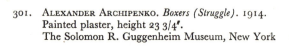

301. ALEXANDER ARCHIPENKO. *Boxers (Struggle)*. 1914. Painted plaster, height 23 3/4″. The Solomon R. Guggenheim Museum, New York

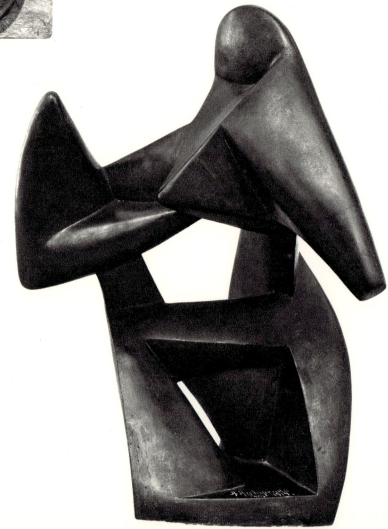

troyed City in Rotterdam communicates something of the tragedy of the bombing of the city in 1940 and its heroic reconstruction after the war.

The Cubist experience of space was worked out more radically within the context of Futurism. In his *Bottle* and in striding figures like the *Unique Forms of Continuity in Space* (plate 215) Boccioni adapted the Cubist technique of fragmented and interpenetrating planes for the typically Futurist projection of the dynamic energy of animate or inanimate objects expanding and passing through space. The Cubist concern with the concentration rather than the dispersal of energy appears in the one major work of Raymond Duchamp-Villon (1876–1918). The brother of Jacques Villon and Marcel Duchamp, he participated in the theoretical and mathematical discussions of the Section d'Or group and in his own sculpture passed from a literal and then simplified treatment of human and animal forms to a series of equestrian studies which ended in *The Horse* (1914; plate 302). Like Duchamp, whose *Nude Descending a Staircase* of 1912 had been followed immediately by the mechanistic forms and forces of the *King and Queen Surrounded by Swift Nudes* (Philadelphia Museum of Art), Duchamp-Villon equated vitality with mechanical energy, treating muscular activity (the horse seems about to clear a fence) as a combination of cranks and pistons. Duchamp-Villon may well have taken a hint from the Futurists. Boccioni's sculptures had been shown in Paris in 1913, and there are similarities between the curving planes of Duchamp-Villon's *Horse* and Boccioni's *Horse + Rider + House* (1914;

Venice, coll. Peggy Guggenheim), but the Frenchman's work is altogether more compact, more intense, and more monumental than the Italian's. His vision of vital forces transposed into mechanical terms is also more impersonal and more complete than any the Futurists ever had. It leads not only to the mechanistic world of Fernand Léger, but beyond his abstractions of human events to the nonobjective deductions of the Russian Constructivists and to the later work of Gabo and Pevsner.

For Jacques Lipchitz (born in Russia 1891) Cubism provided the visual and technical discipline that

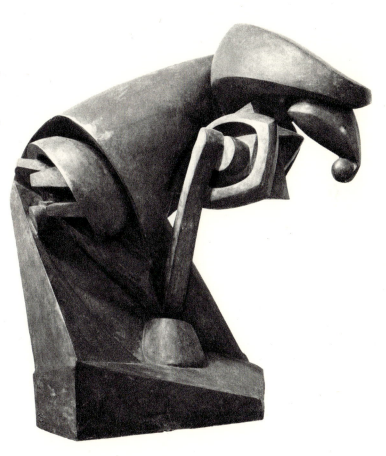

302. RAYMOND DUCHAMP-VILLON. *The Horse.* 1914. Bronze, height 40″. The Museum of Modern Art, New York. Van Gogh Purchase Fund

determined the direction of his first sculptures, as well as the imaginative character of all his later work, however different it may at first sight appear. He has said that for him "there is no difference between painting and sculpture," and there are many occasions when his sculpture has been closely related to comparable formal inventions in painting, especially in Picasso's. Lipchitz, too, was interested in primitive and archaic art, and in the bronzes done within a few years of his arrival in Paris in 1909, there are

hints of African figures fragmented and reassembled according to the Cubist technique of interpenetrating planes. After he met Juan Gris in 1916 his more opaque figures, often executed in stone although carved for him by professional craftsmen, included exchanges of simplified and interlocking planes much like those in Gris' later work (plate 303).

303. JACQUES LIPCHITZ. *Seated Man with Guitar*. 1922. Granite, height 15 7/8". Private collection, New York

In 1925 Lipchitz began his "transparents," sculptures cast from pieces of cardboard cut and bent like the flattened figures in Picasso's paintings of the early 1920s. By opening the interiors of these small bronzes, much as they had been made visible in earlier Cubist painting, he discovered that interior voids need not be empty spaces but could be vital components of the whole structure. Lipchitz learned from Surrealism, possibly more than did Picasso, to choose his subjects for their expressive character as well as for their purely sculptural possibilities. In this respect he

parted company with his great contemporaries, Maillol, Léger, Braque, and Matisse, who continued to investigate formal problems of their own devising. Only Picasso, and then only infrequently, as in the *Guernica* of 1937, undertook subjects commensurate with the troubled times. Lipchitz, on the contrary, interpreted the exalted themes of human experience, themes of conflict, sacrifice, and reconciliation, in increasingly monumental terms. His largest undertaking, the colossal plaster *Prometheus Strangling the Vulture* for the Paris Exposition of 1937, was redesigned in 1944 for the Ministry of Education in Rio de Janeiro but unfortunately was executed on too small a scale. Something of its quality, and of many others which followed to the present time, can be seen in the *Return of the Prodigal Son* (1931; plate 304), where the strained and interlocking limbs, stretched around the space between the bodies, are formal counterparts of the passionate embrace. In 1941 Lipchitz came to the United States, where he has made his reputation as one of the principal sculptors of modern times.

Just as Picasso's Cubist sculptures complement his Cubist paintings, so in the 1920s and 1930s, when he was again working in a less abstract figural style, he made ponderous plaster images of female figures and heads whose exaggerated features—the enormous noses swelling from the foreheads and the dislocated breasts—continued his pictorial researches into three dimensions. In 1930 he worked with the Catalan sculptor Julio Gonzalez (1876–1942), who had been trained in Barcelona as a metalworker and had come to Paris in 1900, at the same time as Picasso, although without so easily discovering his vocation. Under Gonzalez' guidance Picasso began working directly in metal, fashioning lean openwork structures of metal rods very like the linear figures in certain paintings of the later 1920s. Gonzalez' mastery of this technique can be seen in his *Maternity* (1933; plate 305), in which the figure is reduced to a spare construction of welded metal arcs and rods.

By 1931 Picasso had put together his first constructions from discarded scrap metal, creating abstractly organic figures often of considerable power and wit (plate 306). During and after the Second World War, when traditional materials were in short supply, he composed with anything at hand—corrugated paper, chicken wire, broken knives and forks, children's toys, and old pots. Even when his constructions were cast in metal they preserved much of the feeling of improvisation and of unexpected visual humor, the result of his ability to see one form within another (plate 307). His best-known sculpture is the *Man with a Lamb* (1944), of which a cast has been set up in

304. JACQUES LIPCHITZ. *Return of the Prodigal Son.* 1931. Bronze, 60 × 47 1/4". Marlborough Gallery, New York

305. JULIO GONZALEZ. *Maternity*. 1933. Wrought iron, height 55″.
Collection Mme Roberta Gonzalez-Hartung, Paris

306 PABLO PICASSO. *Sculpture*. 1931.
Bronze, height 33 1/8″.
Collection the Artist

307. PABLO PICASSO.
Woman with Apple. 1943.
Bronze, height 70 7/8".
Collection the Artist

his honor in the village of Vallauris, where he worked for some years. An awkward, rough-textured variant of the ritual calf bearer of antiquity, it has a place among recent attempts to recover certain mythic values in figural sculpture.

Epstein and Lipchitz, with their strongly Expressionist figures, often of religious significance, and Picasso and the English sculptor Henry Moore (born 1898), with their more narrowly formal intentions, have been the major sculptors most interested in perpetuating the theme, if not the formal tradition, of the figure. Moore's earliest sculptures, of the 1920s and early 1930s, were dominated by recollections of archaic and primitive objects he had studied in the British Museum and by suggestions from Picasso's overblown images of that period. In the so-called Chacmool figures from Mexico he found his favorite theme of the reclining woman, usually with the upper torso propped upon her elbows and forearms. She has appeared throughout his work of the past thirty years in many guises, at one time almost an abstract skeleton, like some strange insect, at others more literally representational. Enlarged beyond life, she looms as a rocky, mountainous form, like some distant landscape of sea and cliff, of rocks washed and hollowed by water and wind (plate 308). Moore does not reject such references to nature, for they imply that his sculpture is continuous with organic and inorganic life, with conscious and preconscious knowledge. So wide a field of reference saves his work from the monotony that might attend so prolonged an investigation of almost a single theme. Changes of material (wood, stone, and metal) and changes within what has become a characteristically abstract style (although sometimes there are references to his long-delayed admiration for Classic Greek sculpture) enable him constantly to vary his formal response to the same theme.

In the United States during the decades between the two wars, there was no sculpture comparable in originality to the work of the Europeans. The principal sculptors were William Zorach (1887–1966) and Gaston Lachaise (1882–1935). Zorach was a leading practitioner of direct carving, and he avoided the conventions of academic idealism through a more forthright attitude toward the physical presence of his models. But his themes were often conventional, as in his best-integrated work, the large

308. HENRY MOORE. *Recumbent Figure*. 1938. Green Hornton stone, length 55″. Tate Gallery, London

309. WILLIAM ZORACH. *Mother and Child.* 1927–30. Marble, height 65″. The Metropolitan Museum of Art, New York. Fletcher Fund, 1952

pink marble *Mother and Child* (1927–1930; plate 309). Lachaise, who came to this country from France in 1906, was as preoccupied with the female figure as Henry Moore was to be, but in a more sensual, less maternal manner. His obsession, for it seems sometimes to be that, led him to exaggerations that now seem more sculpturally inappropriate than erotic, so that it is in such temperate bronzes as the *Standing Woman* of 1912–1927, his first major work, and in her more voluptuous successor of 1932 (plate 310) that his formal preoccupations can be seen as deriving from Maillol in the immediate past.

The most notable American sculptor of the period was simultaneously the most original and the most closely related to European modernism. Alexander Calder (born 1898) had been trained as an engineer, but by 1926 he was in Paris, where he became known for his animated circus with little wire figures and for his wooden toys. He was often there between 1928 and 1933, when he knew Léger, Miró, and Mondrian. In Paris in 1932 he held the first exhibition of his Mobiles. Some were abstract constructions activated by motors; others were made of metal rods and wires terminating in metal discs and so supported or suspended that they could turn of themselves in a current of air (plate 311). Nothing looked easier to imitate and many have tried, but Calder's have been both deceptively simple and inimitable. His favorite colors for the painted discs—the primaries with black and white—were basic to Mondrian's and Miró's paintings and prove Calder's affinities with the international modern movement. The sly humor of the Mobiles may at first have concealed the revolutionary character of his discovery that sculpture can be created through movements defined in empty space by the orbits of wires and discs. The more substantial masses of his Stabiles formed of flat metal plates were at times more serious, even threatening. Calder was the first American sculptor to achieve a truly international reputation. At the Paris Exposition of 1937 his black iron fountain flowing with mercury could be seen in the Spanish Pavilion near the murals of Miró and Picasso, and his Mobiles and Stabiles, often very large, float or stand in public places throughout the world.

310. GASTON LACHAISE. *Standing Woman.* 1932. Bronze, height 88″.
The Museum of Modern Art, New York. Mrs. Simon Guggenheim Fund

311. ALEXANDER CALDER. *Horizontal Spines.* 1942. Sheet metal, wire and rods, and sheet aluminum, height 53″.
Addison Gallery of American Art, Phillips Academy, Andover, Mass.

Twentieth-Century Architecture: The International Style

Although the functions, the forms, and the structural systems of twentieth-century architecture are too various to be embraced by a single stylistic concept, certain general principles are useful for the analysis and evaluation of the important buildings constructed during the past fifty years. When the imitation of the historical past is no longer a consideration, the style of a given building, at least in the sense of its visual appearance, can be determined by the relation of its purpose or function to the materials and structural system whereby the requirements of that function are satisfactorily met, both economically and aesthetically. Because the most economical structural system may not always be the most satisfying, in terms of vision or of use, the architect is still more than an engineer. His task is to bring the logic of structure into conformity with the logics of human vision—which we might call taste—and of human use by incorporating structure and function in a coherent design.

The functionalist doctrine that the form of a building should be an unequivocal expression of its function has sometimes been forced to the extreme by a didactic insistence on function without regard for aesthetic form. But structures whose forms have been determined exclusively by functional and structural necessities—power plants, transmission towers, fuel storage tanks, and the like—are not by those very facts necessarily satisfying, except in terms of mechanical efficiency. The catch phrase "form follows function" is, as we have seen (above, p. 173), an oversimplification of Louis Sullivan's belief that the function of a building should be expressed, not literally stated, by its form. Plumbing and heating pipes, to take an obvious example, are functional necessities in most buildings, although they need not be seen to be understood. But the argument about which functions of a building must, should, or even can, be stated as well as expressed is not easily resolved. Some function in every building is symbolic, but symbolic meanings cannot always be reduced to three-dimensional statements in physical materials. Nor should one ignore the possibility of functional excellence even when the symbolic expression seems absurd. The Sterling Memorial Library at Yale University is a conspicuous example of symbolic extravagance, because its functions are stated in the forms and visual effects of a late medieval church attached to an immense, fortified keep. The expression of the library as a "cathedral of learning" is merely expensive masonry embroidery on a plan which, for its date (1930), was unusually rational, coherent, economical, and hence functional.

The fact that many functionalists stressed the hard,

precise, machine-made elements of contemporary engineering and construction—a tendency often identified with Le Corbusier's statement that a house is "a machine to be lived in"—provoked a reaction in favor of less rigorously intellectual solutions to the relation of form to function and structure, especially in residential architecture. Frank Lloyd Wright was a vigorous advocate of what he called "organic architecture," by which he meant that the building in its plan, siting, and materials—preferably brick, wood, and stone rather than concrete, steel, and glass—should evolve with the ease and purposefulness of a natural organism. In this way it would retain that quality essential for all architecture, human scale. Such considerations were of course more effective in residential than in industrial or institutional buildings, where many functions are non- and even anti-individualistic.

The refinement of older building materials and techniques and the development of new ones have profoundly modified the forms of contemporary architecture. Steel, glass, and concrete had been used well before 1900, but since then they have become the principal materials in most progressive buildings. The glass-sheathed metal frame of the tall office building has been used for other types, including houses. Improvements in the manufacture of concrete have made possible developments in reinforced concrete construction which have greatly enlarged the formal possibilities of the material. And in small structures, principally houses, the more traditional materials of wood, brick, and masonry, often in the form of concrete blocks, have been used in untraditional ways. But while any structural system and the material it requires inevitably influence the form of a building, they are still technical means for architectural decisions which must be made by an architect. The earlier conflict between the claims of the engineer as builder and of the architect as designer tends toward a resolution. No longer does the architect merely provide a façade in the most popular current revival of historical styles, as he so often did in the nineteenth century, to hide a space enclosed by metal, concrete, and glass (plate 155). Fortified by his knowledge of the most advanced engineering techniques, he discovers the design which best integrates structure with function. Pier Luigi Nervi, the distinguished Italian engineer, insists that no architectural form is valid unless it can be constructed, which is incontrovertibly true, and that architectural beauty is not contingent but inevitable when the conditions of function, structure, and economy have been perfectly met. However, Nervi's own superbly logical work (plate

397) demonstrates that his choice of a particular structural system is a critical element in the appearance, and consequently in the style, of his buildings. It is possible to imagine other choices which, although also followed to equally logical conclusions, would have led to quite other, less aesthetically satisfactory solutions.

The first indications of a widespread understanding of the new architectural problems appeared in Europe just before the First World War and became conspicuous immediately afterwards. The term *International Style* was first used in 1932 to identify certain trends which during the second quarter of the century spread from Holland, Germany, and France as far as the Soviet Union, the United States, and Japan.[1] The widespread geographical occurrence of this kind of building is incontestable. That it constituted a distinct style in modern architecture has been disputed, although the facts remain that a particular mode of design, based on a series of consistent proportional relations among plan, structure, space, and visual effects, did appear in Europe immediately after the First World War, and that despite many modifications, certain aspects of this mode are still effective in much contemporary architecture. For those reasons, if for no other, the architecture of the so-called International Style must be studied, not only for itself but as a major source of much contemporary building.

The characteristics of the style are immediately apparent in the plan, structure, and visual effects of its principal examples. In contrast to the symmetrical and axial planning traditional in Europe, interior spaces were often continuous within the major areas, opening into one another rather than separated by closed and rigid walls. Cantilever construction through the use of ferro-concrete floor slabs supported on metal posts permitted the walls to be replaced by larger windows or even by glass continuous from floor to ceiling. On the exterior, the masses of the building were arranged according to the distribution of the interior volumes and were punctuated by doors and windows wherever required by the functions of the spaces inside. The resulting very untraditional irregularity of the façade was to some extent controlled by the repetition of elements similar in size or in proportion wherever a modular system of construction prevailed. To that extent the design was based upon such nonaesthetic factors as social utility or simplicity and economy of construction. The enclosure of space with a minimum of material gave the masses a generally cubical and rectangular character which was additionally emphasized by two aesthetic decisions—

the rejection of all extraneous ornament and a preference for the neutral surfaces of glass and of flat, smoothly finished stucco. Walls were occasionally painted in solid colors, but white or near-white surfaces were more usual. Although the International Style was often denounced as harsh and crude, or too uniform and impersonal, its positive qualities of clarity, coherence, and precision have prevailed, particularly when modified in less doctrinaire directions.

The structural principles of reinforced concrete, the material basic for most International Style buildings, were established early in the twentieth century by the French architect Auguste Perret (1874–1954). In Paris in an apartment house on the Rue Franklin (1903) and in the Garage Ponthieu (1905–1906; plate 312), the reinforced concrete structure was revealed on the façade of each building as an open framework filled with glass or ceramic panels. The elegantly logical expression of the strength and lightness of such construction was not, however, matched by a comparable clarity of design. Perret's concrete and glass church of Notre Dame at Le Raincy (1922–1923) amounted to a spare but literal translation of Gothic structure into concrete, while as early as 1910–1913 in his Théâtre des Champs-Elysées in Paris the concrete structure was muffled by semi-Classic details. Perret later was the principal architect for the rebuilding of Le Havre

312. AUGUSTE PERRET.
Garage Ponthieu, Paris.
1905–6

313. PETER BEHREN
AEG Turbine Factory, Berli
1908–

after the Second World War, but his work, which includes a new city hall, was repetitive and dry.

The spatial possibilities of concrete were almost immediately and more vigorously explored by the German architect Walter Gropius (1883–1969) and the Swiss architect long resident in France, Charles-Édouard Jeanneret, called Le Corbusier (1887–1965). Certain aesthetic principles were also formulated in Holland during the First World War by the Dutch architect J. J. P. Oud (1890–1963), who had been experimenting with nonstylistic design just before 1914 when it became apparent that the decorative bias of Art Nouveau and Jugendstil, even in the hands of such gifted architects as the Dutch H. P. Berlage (1856–1934) or the German Peter Behrens (1868–1940), in whose office both Gropius and Le Corbusier worked for a time, was inadequate for the reform of

architectural theory and practice, a reform urgently demanded by the new social and economic conditions of modern industrial society. Berlage's Amsterdam Stock Exchange of 1897–1903 and Behrens' AEG Turbine factory in Berlin (1908–1909; plate 313) were notable for their bold use of metal and glass covering large interior spaces whose functions were entirely contemporary, but in the masonry exteriors of both buildings there was still a conscious striving for monumentality reminiscent of the past.

The earliest work of the younger generation thus can be seen partly as a reaction against the subjective character of Art Nouveau. The Steiner House of 1910 by Adolf Loos (plate 180) now seems a prophetic prototype of this insistence on simple cubical masses without decorative embellishments. One of the first and clearest examples of the new mode was the Fagus

shoe last factory of 1911 at Alfeld-an-der-Leine (plate 314) by Walter Gropius in association with Adolf Meyer (1881–1929). In industrial building there was less obligation to use historical styles, because industrial processes would only be hampered when performed in structures whose original purposes had been entirely different. In solving the problem of housing machines and workers Gropius emphasized clarity, cleanliness, and light. The walls were no more than glass curtains separated by metal panels between the stories. The internal supporting piers were still placed at the plane of the walls and were expressed externally by vertical strips of brick, but the omission of piers at the corners made it clear that the controlling materials were glass and metal, not masonry, and that the space

was thought of as a transparent volume, not an opaque mass.

In Holland J. J. P. Oud was briefly a member of De Stijl and shared in the promulgation of Mondrian's and Van Doesburg's theories of abstract art. The only work he actually executed in the strict De Stijl manner was the façade of the Café de Unie in Rotterdam (1924–1925; destroyed 1940; plate 315) which was treated as a two-dimensional design much like Mondrian's paintings. His ability to develop De Stijl principles in three dimensions can be seen in an unexecuted project of 1919 for a factory at Purmerend (plate 316). The principal masses were still heavy and monumental. More advanced were the projecting roofs above the band of windows in the manner of

314. WALTER GROPIUS. Fagus Shoe Factory, Alfeld-an-der-Leine, Germany. 1911

315. J. J. P. Oud.
Café de Unie, Rotterdam,
The Netherlands. 1924–25.
Destroyed 1940

316. J. J. P. Oud. Project for a Factory at Purmerend, The Netherlands. 1919

317. **Gerrit Rietveld**. Schröder House, Utrecht, The Netherlands. 1924

318. **Gerrit Rietveld**.
Plans, Schröder House, Utrecht
above, right: ground floor
below, left and right:
Alternate arrangements of
upper floor

STUDIO WORKING SLEEPING

READING HALL KITCHEN-DINING-LIVING

W.C.

N

0 5 10 FEET
0 1 2 3 METERS

BALCONY W.C.

STORAGE WORK-SLEEPING HALL BATH SLEEPING BALCONY

ST.

WORK-SLEEPING LIVING-DINING

BALCONY

Frank Lloyd Wright, whose Prairie architecture had been published in Europe in 1910 and 1915. Still freer from tradition was the central portion where the doors, windows, and segments of the roofs and walls of the manager's house became a complex interpenetration of solids and voids recalling those in Cubist paintings of a few years earlier. The boldly projecting walls set at right angles to the façade resemble Wright's treatment of the chimney at the Robie House (plate 171), but Oud manipulated his elements more adventurously, almost as abstract sculpture, and well before Vantongerloo reached a comparable point (plate 232). In his low-cost housing at the Hook of Holland in 1924–1927 the precise fenestration in the unadorned surfaces was in the De Stijl manner, but the rounded corners indicated that he was looking for a more relaxed geometry within the general aesthetic of the International Style.

The architect whose work developed most consistently within De Stijl principles was Gerrit Rietveld (1888–1964). He had been trained as a cabinetmaker, and some of his furniture designs, including a painted wooden chair of 1918, were the first and most influential applications of De Stijl principles to interior design. Although his Schröder House at Utrecht (1924; plates 317, 318) was actually very small and partially constructed of brick and wood, as well as of concrete, it seemed from the exterior far more spacious, as if the flat planes of Mondrian's paintings had become detached and were expanding in several directions. On the interior the upper floor could be used as a single space or divided by sliding panels into separate areas for living, dining, and sleeping.

The influence of De Stijl principles on modern architecture was actually greater outside Holland than within, where there was strong conservative opposition as well as vigorous competition, especially in Amsterdam, from architects using the traditional materials of brick and tile, often with considerable Expressionist feeling in the decorative details.

De Stijl ideas soon appeared at the Bauhaus in Weimar, Germany, founded in 1919 by Walter Gropius to combine the teaching of the so-called fine arts with practical training in architecture and the industrial arts and crafts. The instruction first offered at the Bauhaus was influenced by contemporary German Expressionism, but this was modified, especially after Van Doesburg settled in Weimar in 1921 as an unofficial lecturer and counselor to the students. The Bauhaus staff always discounted De Stijl influence, but a comparison of certain of their products, notably the chairs designed by Marcel Breuer and Josef Albers, with Rietveld's chair of 1918 leaves little doubt that the rectilinearity of De Stijl, its clarity of expression and integration of function, structure, and material proved persuasive. Gropius' own architecture immediately after the war had been strongly tinged with Expressionist elements, but by 1922 in his competition design for the Chicago Tribune Tower and in 1924 in a project for an academy of philosophy at Erlangen, again with Adolf Meyer, he had eliminated all decorative detail in favor of a frank expression of structure and mass. In his design of 1925–1926 for the new building of the Bauhaus at Dessau he achieved his most direct and influential statement of the new mode. As seen from the air (plates 319, 320), the different functions of the building were expressed in plan and elevation and just as clearly interrelated through the passage of one mass into another. At the right are the administrative offices and classrooms, relatively small interior volumes expressed internally by the continuous bands of windows on each story. This wing is extended by bold ferro-concrete construction as a bridge across an intervening street to meet the workshop and studio block at the upper left. In treating this as a completely glazed volume, Gropius refined the concept of the glass curtain wall hung from an interior frame as first seen in the Fagus factory. Opposite this, the combined auditorium and dining room extended to the dormitory composed of five stories of one-room apartments, each with its balcony and large window. Since there was nothing specifically regional or national about the building, it might just as well have been built elsewhere than in Germany, and so it may be described as belonging to an international style. And indeed the Bauhaus building, no less than the rationally integrated curriculum in which the study of design was at every stage correlated with the use of actual materials, had an incalculable influence beyond the frontiers of Germany. It was in a way a tribute to its success that, after they had closed the school, the Nazis felt obliged to distort the building by adding pitched and gabled roofs. Long neglected and sadly dilapidated, it is now being restored by the East German government.

For a few years in the 1920s there were important exchanges of ideas between Western European countries and the Soviet Union. In 1927 Kasimir Malevich (see above, pp. 233, 246) lectured on Suprematism at the Bauhaus and showed plaster models of his theoretical studies of architecture, similar to the projects of De Stijl and to Gropius' work. El Lissitzky (see above, p. 235), an energetic propagandizer for the new architecture, spread word of it in the Soviet Union after several visits to Germany in the 1920s.

319. WALTER GROPIUS.
Aerial view of the Bauhaus,
Dessau, Germany. 1925–26

320. WALTER GROPIUS.
*General Plan of First Floor,
The Bauhaus, Dessau*

In his own projects for tall office buildings he extended the perspective spaces he had explored in his *Proun* paintings (colorplate 38). Horizontal blocks were to be cantilevered from huge piers to a distance probably impossible to construct at that time. His enthusiasm, however, was effective, and in the state architectural offices in Moscow a number of buildings were designed which were far ahead of their time and place, like the project by A. Siltschenko for an office building for the ministry of industries (plate 321). In their exploitation of steel and glass, of cantilever construction, and of circular plans they were not matched until years later, and then only in other countries. After the death of Lenin in 1924, the hardening of the doctrine of socialist realism prevented the execution of all but a few, and on the whole the more timid, of the new designs.

321. A. SILTSCHENKO.
Project for an office building,
Moscow. c. 1925

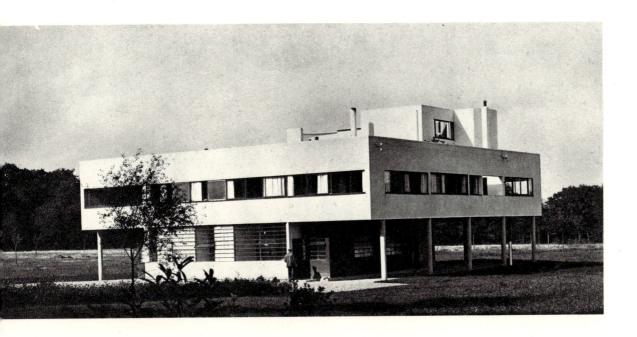

Significant but very different contributions to the definition of the International Style were made in the late 1920s and early 1930s by Le Corbusier and by the German architect Mies van der Rohe (1886–1969). Mies refined and intensified it in glass and steel to a point of crystalline clarity and precision. Le Corbusier, on the other hand, constantly developed new concepts of integrated function and structure, particularly in reinforced concrete. As early as 1914 with his Domino system of slabs supported on slender columns regularly spaced, and with some set well within the perimeter of the slabs, he created a new kind of house, basically boxlike, with a flat roof to be used as a terrace and with the living areas on the second and upper floors so that the supporting posts could be exposed below as *pilotis*, allowing light and air to enter at the ground level. Simultaneously the plan was freed from the restrictions imposed by interior bearing walls, and the facades were freely composed in terms of whatever openings were required. The proportions of the façades were designed according to his theory of regulating lines (*tracés régulateurs*) derived from the Golden Section as well as from his interest in preserving a human scale, later embodied in the proportional system he called the modulor.[2]

Le Corbusier's first designs for a standardized house,

the Citrohan projects of 1920 and 1922, exemplified his belief that the house is "a machine to be lived in," not in the sense that it is an impersonal mechanistic product, but that it should be as efficiently constructed from standard mass-produced parts and as logically designed for its functions as any modern machine, typewriter, or automobile. In addition to the exposed ground story and the roof terrace, the Citrohan project included a two-story living room which Le Corbusier incorporated in many of his houses.

The climactic example of Le Corbusier's early private residences was the Villa Savoye at Poissy, near Paris (1929–1931; plate 322). The house, which is now derelict, appeared as a neat box set on the thinnest of *pilotis* and pierced by horizontal bands of windows so that the view of the surrounding woods and fields would be visible from every room. On the principal story, an uncovered living space occupied a third of the floor area, with a ramp rising to the roof where spaces for sun-bathing were protected from the prevailing winds by sections of wall curved in plan. The precise articulation of every part and the coherence of the whole can properly be called Classic and may remind us that Greek architecture was always an inspiration for Le Corbusier. But the totally twentieth-century character of the Villa Savoye was

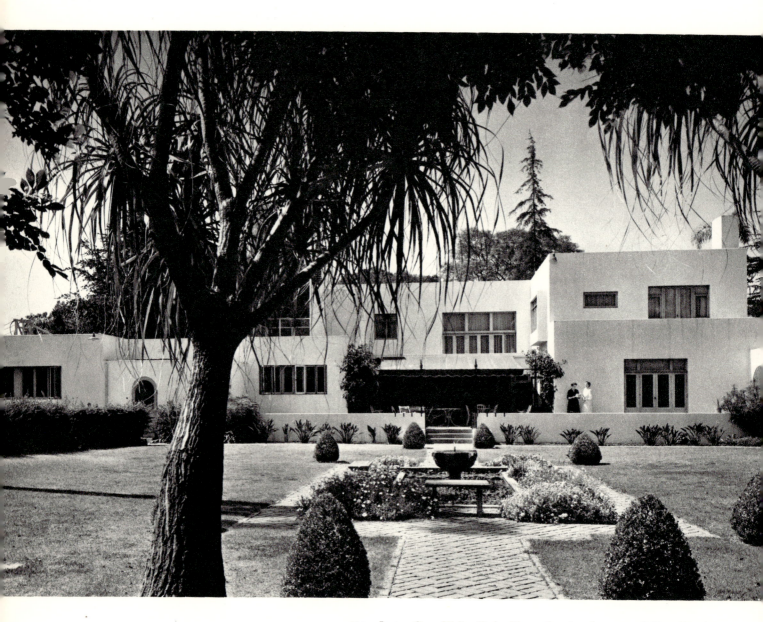

323. IRVING GILL. Walter Dodge House, Los Angeles. 1915–16. Demolished 1970

a product of his admiration for the clean, functional forms of automobiles, steamships, and airplanes and the exact geometry of turbines and grain elevators. Illustrations of such objects had accompanied the argument in his treatise of 1923, *Vers une Architecture* (*Towards a New Architecture*), perhaps the most influential of his writings.

Le Corbusier, who was also a painter (see above, p. 215), was interested in the aesthetics of De Stijl. The spacing of the mullions in his windows and of the windows in his walls often resembles Mondrian's grids. He was also aware of Van Doesburg's and Rietveld's architectural projects which were exhibited in Paris in the 1920s. Even in his last works, the spacing of the horizontal and vertical elements and of the windows set within deep frames has its sources in De Stijl design. And in his later paintings he developed complex interrelations of forms and spaces, ultimately to be traced to the multiple spaces of Cubism and having close parallels in the richly plastic interpenetrations of exterior and interior spaces in his architecture.

Since for Le Corbusier, as for many contemporary architects, buildings for human use cannot exist apart from their human and natural environment, he was always concerned with the theory and practice of town planning. His first project of 1922 for a City of Three Million Inhabitants, refined in 1930 as the Ville Radieuse, was based on a rigidly abstract and geometric plan, but the concept of clusters of tall office buildings surrounded by lower apartment houses so spaced that at least 85 per cent of the ground could be landscaped has become integral to much subsequent planning. In the Voisin Plan of 1925 for Paris, and again in a plan seen at the Exposition of 1937, he proposed to reclaim the slum quarters north of the Louvre by building tall apartment houses widely spaced in green parks. Radical as the program seemed at the time, it would not have required the demolition of any historical monuments, and it offered many solutions for similar situations today.

In the United States the incidence of the International Style was at first sporadic, but as early as 1906 the California architect Irving Gill (1870–1936), who had worked with Adler and Sullivan in Chicago, reduced his buildings to spare cubes relieved only by doors and windows. His Wilson Acton Hotel of 1908 and Ellen Scripps House of 1917, both at La Jolla, and the Dodge House of 1915–1916 at Los Angeles (plate 323) were very close to the work of Adolf Loos, but Gill was probably inspired by the cubical and sparsely ornamented early adobe mission architecture of California. Within the next decade two Austrians,

Rudolph Schindler (1887–1953) and Richard Neutra (1892–1970), who had come to this country in 1913 and 1923 respectively, settled in California. They had both known Loos in Vienna and had worked for a time with Frank Lloyd Wright, yet each discovered his personal manner within the technological and stylistic principles of contemporary European architecture. In 1926 Schindler designed a summer house for Dr. Philip Lovell at Newport Beach as a naked concrete frame with glass walls (plate 325). The interpenetrations of the exposed structural members resembled Wright's work, but the logic was more resolute and the textures harsher than Wright would have permitted, while the structural statement was more aggressive than any Le Corbusier had yet made.

Neutra's first important commission in Los Angeles was another house (1927–1929; plate 324) for Dr. Lovell. This time the four-story steel frame, partly supported by cables, was suspended over a steep hillside. Projecting terraces and the alternation of covered porches with glass and stucco-covered metal panels broke up the underlying boxlike mass. It is tempting to think that if, during his work with Wright, Neutra may have learned how to avoid the bleaker aspects of the International Style, Wright in turn may have learned from Neutra's houses how to handle the flat white planes of contemporary European architecture for one of his most remarkable achievements, paradoxically the one where he came closest to that European modernism he so often denounced.

Falling Water, Wright's house of 1936 at Bear Run, Pennsylvania, for Edgar J. Kaufmann, hangs, like the Lovell House, on a steep slope, and in this instance over a waterfall (plate 326). In a familiar but somewhat atypical view from the stream below, it appears as a series of massive slabs (thickened by the edges of the white stucco parapets of the terraces) dramatically cantilevered over the rocks and the water. The house is actually not large, having only four bedrooms, but each room has its own terrace, so that the exterior appears more complex than the plan would seem to warrant. The outer walls of each room are of glass, while the vertical bearing walls are of rock from the stream. Wright had resolved two contradictory terms of contemporary architecture in one supremely integrated statement. In the union of abstract artistic order and natural facts, Falling Water is profoundly and characteristically Wrightian, "organic," even romantically American, but the superbly intricate composition of the vertical and horizontal planes shows that when he wished to, he could respect the austere intellectual Classicism of an international "state of mind." In his later residences

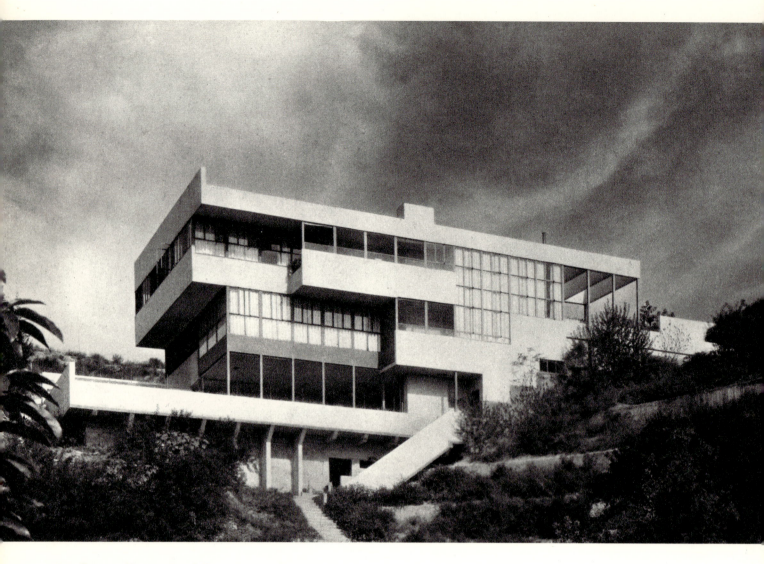

324. RICHARD NEUTRA. Lovell House, Los Angeles. 1927-29

325. RUDOLPH SCHINDLER. Lovell Beach House, Newport Beach, California. Designed 1926

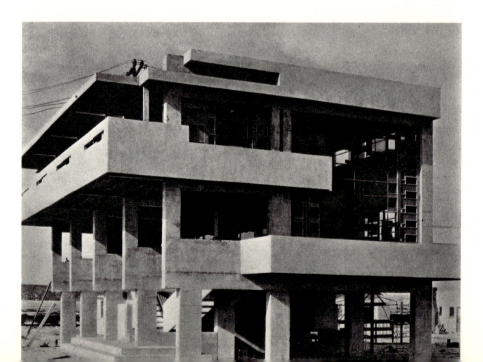

Neutra was less intellectual and less austere, using richer materials and more closely relating the interiors with the landscape. His country houses in California are outstanding instances of the acclimatization of the International Style to the American West (plate 327).

Not until the end of the 1930s was the East prepared to accept the consequences of European modernism. The glass and stucco façade of the new building of 1939 for the Museum of Modern Art, by Edward Durell Stone (born 1902) and Philip L. Goodwin (1885–1958), was the first of its kind in New York, and significantly so, for in 1932 the Museum had held the first exhibition of the new architecture for which the term *International Style* had been created. Yet slow as this country was to adopt or even to understand it, the first skyscraper in the style had been erected in Philadelphia in 1932. This was the Philadelphia Savings Fund Society (plate 328) by George Howe (1886–1955) and William Lescaze (1896–1969). The exposure of the steel columns on the sides and the expanse of glass in the tall rectangular tower· were bold expressions of structure for the time, as were the continuous bands of windows turning the corner of the marble-clad, two-story base. Only the indecisive juncture of the base and tower suggested that the search for structural logic had been compromised by having to provide a decoratively symbolic environment for the bank.

The fascist tyrannies which halted the development of progressive building in Europe were responsible for the ultimate success of modern architecture in this country. Among the distinguished European artists who came to the United States after it became impossible for them to work at home were the Germans Walter Gropius, Mies van der Rohe, and Eric Mendelsohn (1887–1953) and the younger Hungarian architect Marcel Breuer (born 1902), who had been one of Gropius' first students at the Bauhaus.

Mendelsohn, who had worked in England and Israel before coming to this country, has often been considered one of the pre-eminently Expressionist architects of Germany, and it is true that in his Einstein Observatory of 1920 he used concrete with a freedom which seemed at the time too insistently pictorial, although now one would be inclined to admire his truly precocious understanding of the material. Mendelsohn was as aware as his contemporaries of the expressive and structural possibilities of steel and glass, but unlike them he had no fear of curves. They occur in the sweeping façades and rounded corner pavilions of his most notable work in

327. RICHARD NEUTRA. James E. Moore, Jr., House, Ojai, California. 1952

328. GEORGE HOWE and WILLIAM LESCAZE. Pennsylvania Savings Fund Society Building, Philadelphia. 1932

Germany, a series of department stores (now destroyed) in Stuttgart, Chemnitz, and Breslau (plate 329). Mendelsohn came to the United States in 1941 and practiced in San Francisco, where his Maimonides Hospital of 1946–1950 was perhaps his most successful design, although the open-air terraces with their curved projections have since been enclosed. His several synagogues, especially in St. Louis (1946–1950) and Cleveland (1946–1952), contributed to the advance of modern religious architecture in this country.

In 1937 Walter Gropius was appointed professor of architecture at Harvard and served as chairman of the department from 1938 until 1952. He and Breuer introduced hundreds of young architects to the basic doctrines of European functionalism as they had been worked out at the Bauhaus. Gropius was a forceful teacher, and his experience in a variety of fields— housing at several economic levels, and prefabrication among them—made him aware of the architect's responsibility to what he has called, in a volume of essays, "the scope of total architecture." His own work may seem to lack individuality, a quality perhaps excessively prized by clients and critics in contemporary America, but that this is a fundamental personal characteristic is proven by his preference for working in association with others. With his own firm, The Architects Collaborative, which he founded in 1946, he designed the Graduate Center at Harvard (plate 330). Here the individual blocks of dormitories and recreation halls are individually so spare as to seem almost featureless, but they are arranged so as to create interior spaces, not entirely enclosed as courts, but serenely set off from the encroaching city. The whole complex was a notable advance in the acceptance of modern architecture by a university heretofore committed, as in its residential houses of

329. ERIC MENDELSOHN.
Petersdorf Department Store, Wroclaw, Poland (formerly Breslau, Germany). 1926–27

330. WALTER GROPIUS. Graduate Center, Harvard University, Cambridge, Massachusetts. 1949-50

the 1930s, to the perpetuation of Neoclassic and Colonial traditions.

In his first houses in this country Gropius adapted the aesthetic of the Bauhaus to the American scene. Although the principles were the same, in that the exterior of the house was the logical consequence, within a rectilinear and cubical envelope, of the exigencies of the plan, by using such traditional American materials as vertical wood siding, fieldstone, and native brick he identified the old forms with the new locale. His own house of 1937 at Lincoln, Massachusetts, shows an openness and relaxation very different from the tight authority of the houses he had designed for himself and the Bauhaus faculty at Dessau.

Early in his career Mies van der Rohe insisted that form should not be an end in itself and that the architect's primary obligation was to discover and state the function of each building. For himself, he was not concerned with problems of abstract form, but only with problems of building, and he demanded that the architectural profession recognize the industrialization of the processes of construction. In his own work he had always taken mass-produced materials at their face value, so to speak, never concealing the character and shape of brick, glass, and manufactured metal parts. So flawless, however, was his sense of form that as much as any other architect he created the architectural image of the twentieth century. In the purity of their design, as well as in the subtlety of their structure, his buildings represent the climax of the formal aesthetic basic to what has been called the International Style.

When Mies came to this country in 1938 to become

331. MIES VAN DER ROHE.
German Pavilion,
Barcelona Exposition. 1929

332. MIES VAN DER ROHE.
Plan of German Pavilion,
Barcelona Exposition

Colorplate 53. Ludwig Mies van der Rohe. Illinois Institute of Technology, Chicago. Chemistry Building (left), and Metallurgy and Chemical Engineering Building (right). 1946

Colorplate 54. ARSHILE GORKY. *The Liver Is the Cock's Comb*. 1944. Oil on canvas, 73 × 98 1/2″. Albright-Knox Art Gallery, Buffalo, N.Y. Gift of Seymour H. Knox

director of the department of architecture at the Armour Institute in Chicago, now the Illinois Institute of Technology, he had actually built very little. After his simplified but faintly Classic early suburban houses there were several projects, among them two for tall office buildings completely sheathed in glass, which have been among the most influential of all modern designs. Then in 1929 came the sudden perfection of his German Pavilion for the Barcelona Exposition that year (plates 331, 332). This small building, created for a temporary purpose and long since demolished, has become, with the Villa Savoye, a paradigm of modern architecture. Since it was to be used only in the summer, the interior space was not enclosed by walls, nor were the walls within more than space dividers—thin planes of onyx, marble, and of tinted, transparent, and opaque glass. The space was thus continuous beneath the single hovering plane of the roof slab, passing imperceptibly from the open travertine terrace past the dividing screens to the enclosed pool at the far end, open to the air above the surrounding green marble walls. Never before, not even in the work of Le Corbusier, had space been so precisely and so elegantly defined by so few planes, and those in such rich materials. Mies often insisted that "less is more," and in the Barcelona Pavilion there were no decorative distractions to disturb the experience of its open-ended space. Shortly afterwards the plans and spaces of the pavilion were adapted for the Tugendhat House at Brno, Czechoslovakia, and for a house at a building exposition in Berlin, where it attracted much attention.

In 1940 Mies was commissioned to plan the campus and design the buildings for the new Illinois Institute (colorplate 53; plate 333) to be erected on eight blocks cleared in the slums of Chicago's South Side, to which it provides a startling contrast through the clarity and power of a supremely sensitive yet intellectual order. The rectangular buildings, based on a constant module, and of similar materials and construction but varying in length, width, and height, were grouped along a central axis but subtly related to each other, the spaces between them being multiples of their modules. In each, the structural steel, within the limits of fireproofing, appeared as a frame enclosing panels of glass or brick based on a modular bay

of twenty-four square feet and its twelve- and six-foot subdivisions. The bold patterns of lines in black metal defining the panels of brick and glass were very close to Mondrian's grids, and Mies's appreciation of De Stijl was also apparent in the plan of the whole, where the position of the buildings could be compared with the detached sliding rectangles in Van Doesburg's compositions. Stripped of every extraneous detail the buildings might, by the unwary, be mistaken for factories or warehouses until the eye recognized the inimitable and unfaltering sense of proportion.

Mies continued his search for proportional perfection in a series of tall buildings beginning with the Promontory Apartments of 1949 and the 860 Lake Shore Drive Apartments of 1951, all in Chicago. The two buildings in the latter group are set at an angle to each other so as to produce maximum tensions between blocks otherwise identical in shape and height. The search reached its climax in the Seagram Building on Park Avenue in New York (plates 334, 335), designed in 1958 in association with Philip Johnson (born 1906). Set back one hundred feet from the street, the building rises in majestic isolation, the dull bronze piers and mullions defining the compact harmony of its mass.

The architecture of Mies van der Rohe is inimitable, but it has been widely influential. Philip Johnson, the first and most devoted of Mies's American followers, designed his own house in New Canaan, Connecticut, in 1948 as a pavilion with transparent glass walls held in a taut metal frame (plate 336). With no opaque walls, the house became notorious as "the glass box," and it is true that the program could only have satisfied a particular individual, but Johnson went on to incorporate its matchless proportions in houses for other clients who required a less extreme simplification of living space and services. For another special occasion, a small guest house in New York now owned by the Museum of Modern Art, he domesticated the spaces of the Barcelona Pavilion with such distinction that it has become possibly the most important single influence in contemporary interior design (plate 337).

The influence of Mies is also apparent in much of the best commercial and institutional work of the firm

333. MIES VAN DER ROHE.
Block Plan of Illinois Institute of Technology, Chicago

334. MIES VAN DER ROHE and PHILIP JOHNSON.
Seagram Building, New York. Designed 1958

335. MIES VAN DER ROHE and PHILIP JOHNSON.
Plan of Seagram Building, New York

of Skidmore, Owings, and Merrill, whose principal designer, Gordon Bunshaft (born 1909) was responsible for Lever House (1952), across Park Avenue from the Seagram Building. It is sheathed entirely in glass, much as Mies had projected in 1919, but the horizontal spandrels of opaque green glass intersect and slow its verticality. It was also the first tall building in New York not to occupy all the available land. His branch bank for the Manufacturers Hanover Trust Company of 1953–1954 at Fifth Avenue and 43rd Street was one of the first structures in New York to break with the tradition that financial institutions must look like impregnable temples. In a similar manner, but vastly larger, are the same firm's Union Carbide Building (1957–1960) and Chase Manhattan Bank (1957–1961), both in New York. The latest example of this manner are the twin hundred-story blocks projected by Minoru Yamasaki (born 1912) for the World Trade Center in lower Manhattan (plate 338).

The formal principles of the International Style, which had begun by way of experiments in metal and concrete construction and the introduction of large areas of glass in windows and walls of modest struc-

336. PHILIP JOHNSON. Philip Johnson House, New Canaan, Connecticut. 1948–49

337. PHILIP JOHNSON.
Rockefeller Guest House,
Museum of Modern Art,
New York. 1950

tures from the Fagus factory to the Villa Savoye, have inspired some of the most characteristic buildings of modern times, however different they may be from the Barcelona Pavilion and the Bauhaus. Given not only the quantity but also the quality of this kind of architecture, it is not fair to say that it represents only an aspect of the modern movement, or that it has been too exclusively dominated by an aesthetic of pure form. It is true that considerations of structure, except in the work of Le Corbusier, have not been of primary concern, and that the basically rectangular and cubical masses of such buildings are most economically executed in the by now comparatively conventional techniques of the metal cage and the flat concrete slab. On the other hand, none of the leaders has ever ignored the possibilities of structural experimentation, and were the style, even were it possible, only an investigation of the aesthetics of form, it could never have accounted for so constant and so significant a current in contemporary architecture, one which is by no means yet exhausted.

338. MINORU YAMASAKI.
Project for World Trade Center,
New York. 1965

Painting and Sculpture since 1945

During the years between the First and Second World Wars the discoveries in abstract and nonobjective art, which had been made before 1920 by Kandinsky in Munich, by Mondrian and the De Stijl group in Holland, and by the Russian Constructivists, were developed throughout Western Europe and, toward the end of the period, in the United States. The six years of World War II inevitably interrupted this process. The School of Paris, which between 1920 and 1940 had seen some of the greatest triumphs of the modern movement in the work of painters and sculptors from many countries other than France—Picasso, Gris, Brancusi, Lipchitz, and Ernst, to name only a few—was dissolved when many artists returned to their own countries or sought refuge in England and America. Although Paris remains one of the world's principal centers of artistic activity, the pre-eminent position it held between 1850 and 1940 has been challenged since 1945 by new manifestations elsewhere, and by the unexpected emergence of a new kind of abstract art in the United States.

Between 1945 and 1960 the most progressive art was created within the aesthetic postulates of nonobjective abstraction, and it is not too much to say that during those fifteen years representational art was almost ignored, at least by critics and collectors if not by the general public. During that time even the continued existence of Realism was questioned, although as recently as 1966 the American Realist painter Andrew Wyeth (born 1917) earned a popular success equaled by few abstract artists. Wyeth, however, has been an exception. The widespread public interest in his art has sometimes had other than artistic sources. His astringent evocation of rural America (plate 339), presented with a brilliant sharp-focus technique, is in the tradition of Burchfield and Grant Wood, and could be considered one of many efforts to preserve the traditional character of American society in the face of the accelerated material expansion of the country and the accompanying ruthless disregard for the values of an earlier day. Entirely contemporary, however, are the overtones of psychic distress in Wyeth's work, in some ways much like the discontent underlying the presentation of American life in the writings of Edgar Lee Masters and Sherwood Anderson.

For older artists, here and abroad, especially those of the generation born between 1900 and 1920, Picasso has remained the most convincing master of an abstract figural style, but his successes have been fewer as he has continued to rework the technical devices of Synthetic Cubism, often in series of paintings based upon familiar works by Delacroix, Velázquez, and Manet. The content of figural art was also af-

339. ANDREW WYETH. *Weather Side*. 1965. Tempera on board, 48 × 28″. Collection Mr. and Mrs. Alexander M. Laughlin, New York

fected by the intellectual irony and emotional frustration, at times approaching anguish, which can be associated with existentialist philosophy. In the paintings of the English artist Francis Bacon (born 1910) these tendencies have been brilliantly exposed. Whether the figure is a Renaissance pope, derived from Velázquez' urbane *Innocent X* but with his features distorted in an agonizing scream, or a mutilated lump of flesh hanging from the Cross, the implications are inescapable that man is alone in a world he never made (plate 340). Bacon parodies the brushwork of the old masters as well as their images, but his pitiful creatures, victimized as much by moral ambiguities as by external calamity, are wholly contemporary, based as they often are on newspaper photographs of violent events, and made the more disturbing by his ambiguous perspectives.

Such interpretations of the figure, however, were exceptions in a scene dominated by Abstract Expressionism. The term had been used earlier to describe Kandinsky's nonfigurative work from 1910, but now it commonly refers to the new developments in American painting since 1945. These have had their source in the work of two painters, Arshile Gorky (1904–1948), born in Armenia but brought to the United States as a child, and the German artist Hans Hofmann (1880–1966), who settled in New York in 1932. Gorky never went abroad, but he was deeply influenced by reproductions of modern painting, especially Picasso's, and gradually moved from a simplified representational style to abstract configurations, at first much like Picasso's, but eventually more organic in the manner of Miró. From Miró he adopted a free, almost automatic movement of the hand which encouraged him to retain upon the canvas, and as part of the composition, the accidents of execution—paint drippings, stains, and splatters. But Gorky's abstract forms belonged partly to the past, because they appeared as if set against a deep background or within a defined space, even if the space had been created only by its colors and, like Kandinsky's, was without reference to the actual space beyond the picture's boundaries. Gorky was also aware of Surrealism and its literary associations. In some of his finest works the titles, like *The Liver Is the Cock's Comb* (colorplate 54), are ambiguous verbal metaphors complementary to the painted ones.

Hofmann had been in Paris between 1904 and 1914 before establishing a successful art school in Munich. He thus experienced at first hand the seminal movements of the twentieth century—Fauvism, Cubism, and German Expressionism, particularly in the work of Kandinsky. Occasional references to these can be

340. Francis Bacon. *Study for Crouching Nude.* 1952. Oil on canvas, 78 × 54″.
The Detroit Institute of Arts

found in his own work, but his synthesis, if such it can be called, was highly original. When he began painting again in the early 1940s, after a lengthy interval devoted almost exclusively to drawing, he destroyed the lingering contradictions that can be seen even in Delaunay and Kandinsky, between form and space, between painting and drawing, and, most significantly, between painting as a process and the product as a painting. Earlier than Gorky and Pollock he poured and dribbled paint upon the canvas and allowed the uncorrected brushstroke, however brusque, to remain as a witness of the painter's presence. Henceforth for Hofmann, and for many of his students, the painted surface, charged with its burden of agitated pigment, became simultaneously form, space, and content. The totally abstract image was the result of a totally pictorial activity from which it could not be separated, visually or intellectually (colorplate 55).

Now that his work can be considered as a whole, it is possible to think that Hofmann was an informed and conscientious, but not particularly sensitive, colorist. Too often he relied, like Kandinsky, on simple oppositions of primaries and complementaries—blues and oranges against reds and greens—and in many of his compositions there are unresolved conflicts between geometrical and free shapes. But he was an inspiring teacher who more than anyone else initiated the transformation of abstract art from the invention of images, drawn before they were colored, to their creation in the process, or action, of painting.

The term *Abstract Expressionism* is self-explanatory. Such paintings are not only abstract but, in their individuality of forms, power of color, and apparent violence of brushwork, are unmistakably expressive, even instinctively self-expressive, rather than rationally premeditated. The rejection of preliminary preparations, and the insistence upon a spontaneous confrontation of the hand holding the brush with the canvas in front of it, can be traced to the Surrealists' emphasis upon automatic procedures for the revelation of "true psychic reality," and beyond that to the Dadas' investigation of accident and chance. Several leading Surrealists were in New York during the war years, including Breton, André Masson, who had been one of the first to scatter sand over tacky surfaces, and Max Ernst, who once at least, in 1942, let paint drip from a can swinging from a cord (in the painting later known as *Young Man Intrigued by the Flight of a Non-Euclidian Fly*, now in a private collection in Zurich (plate 341). Certainly the Surrealist component in Abstract Expressionism is considerable, but it has been more a matter of seeking the release of pictorial energies than of finding visual counterparts for verbal metaphors in the manner of Magritte, Dali, or even Tanguy.

Jackson Pollock (1912–1956) was the first to project such abstract imagery on a monumental scale, and with incomparable technical bravura. For him each painting became the arena for intense physical activity. As the brushstroke lengthened to include the sweep of the whole arm, the canvas had to be increased in size until the image, no longer to be seen as anything other than itself, became identical with the process of its creation. The term *Action Painting*, first used by the critic Harold Rosenberg in 1952,[1] calls attention to the visual evidence of this often tempestuous engagement between the painter and his means of expression. Pollock quickly became notorious for the great size of his canvases and for his unorthodox methods of dripping very liquid paint from the brush, spattering it with a stick or dribbling it from a can, and then scattering sand and pebbles over the wet surface. But the final product was never the fortuitous result of an encounter with chance. Although he could not foresee the exact fall of each drop of paint or grain of sand, the decision to let them fall was an artistic one, and the superimposed and swirling patterns they assumed are the consequence not of accident but of highly complex rhythmic gestures (plate 342). Now that the first shock of apprehension has passed, Pollock's paintings appear less aggressive than they did, more like systematic responses to basic artistic decisions.

Pollock's work has been crucial for modern painting, but as early as 1943, when he held his first one-man exhibition in New York at Peggy Guggenheim's gallery, Art of This Century, other artists were also trying to escape from the small-scaled derivative abstractions based on Cubist or geometrical precedents which were the stock-in-trade of contemporary American abstraction. Through Pollock's example and the intellectual leadership of the painter Robert Motherwell (born 1915), the so-called New York school of abstract painting came into existence. It was never a school in either the literal or figurative sense, but rather, a group of painters with common interests and enthusiasms who shared their discoveries while preserving their independence. Some, like Willem de Kooning (born 1904) and Franz Kline (1910–1962), developed Hofmann's slashing brushstroke and coruscated surfaces, although with a difference. Despite his unpremeditated technique, which allows changes of direction and of intention to remain visible on the surface of the canvas, De Kooning is a delicate colorist. Even when he includes raw newsprint, the textural and coloristic distinctions are

Colorplate 55. HANS HOFMANN. *Effervescence.* 1944. Oil, india ink, casein, and enamel on wood panel, 54 1/8 × 35 1/
University Art Museum, University of California, Berkeley

Colorplate 56. WILLEM DE KOONING. *Woman IV*. 1952–53. Oil on canvas, 59 × 46 1/4″. Nelson Gallery-Atkins Museum, Kansas City, Mo. Gift of William Inge

Colorplate 58. ADOLPH GOTTLIEB. *Glow.* 1966. Oil on canvas, 90 × 72″. Collection the Artist

341. MAX ERNST.
*Young Man Intrigued by the Flight
of a Non-Euclidean Fly*. 1947. Oil on canvas,
32 1/4 × 26″. Collection Dr. W. Loffler, Zurich

342. JACKSON POLLOCK.
Number 29. 1950. Oil paint, wire mesh, string,
shells, and pebbles on glass, 48 × 72″.
National Gallery of Canada, Ottawa

343. ROBERT MOTHERWELL. *Elegy to the Spanish Republic, No. LV.* 1955–60. Oil on canvas, 70 × 76 1/8″.
Cleveland Museum of Art. Contemporary Collection

344. Franz Kline. *Wanamaker Block*. 1955. Oil on canvas, 78 1/2 × 71". Collection Richard Brown Baker, New York

meaningful. Nor has De Kooning always been an entirely abstract painter. As late as 1942 he alternated between simplified figures, not unlike those of Picasso's Classic period, and curvilinear abstractions related both to Picasso and Miró. From 1950 in his paintings of women, the female figure emerges from the collision of abstract shapes and brushstrokes, violently distorted and grimacing in the manner of a movie advertisement, and almost on the scale of a billboard (colorplate 56). In such works, as in others with perplexing titles like *Police Gazette* or *Gotham News,* De Kooning seems to comment on the garish light and color of urban existence.

Something of the same oblique references to the contemporary American scene can be felt in the black-and-white images of Franz Kline. His brush, sometimes as wide as a housepainter's, scored the canvas with exceptional speed, leaving in its wake forms as condensed as oriental calligrams but as taut as structural steel. Like many Americans Kline was not a colorist, and he weakened his work when he added color, even tentatively, to his powerful oppositions of black and white. But in his manipulations of light and dark there are intricate passages where figure and ground change place, and at his best there was an authentic inevitability about the position of each stroke (plate 344).

Other painters were not so aggressive in their assault upon the canvas and the spectator. Robert Motherwell learned less from the practice of Hofmann than from the example of Matisse. In his deft and delicate collages, as well as in the series of large paintings under the title *Elegy to the Spanish Republic,* now numbering more than one hundred, he has worked with a few large shapes and no more than one or two colors with black and white (plates 343, 345). The somber mood of these antifascist memorials is no less impressive than the skill with which Motherwell slides one plane behind another, achieving within the general concept of Later Cubism an exceptionally French yet very personal contribution to American art.

Although much progressive American painting of the 1950s has been described as Abstract Expressionist, not all of it was totally abstract, Expressionist, or even created within the dialectic of action painting as practiced in New York. On the West Coast Mark Tobey (born 1890) developed the delicate skeins of "white writing" with which he created small-scaled but densely woven spaces. The lyric quality of his work won him European recognition when he was awarded a prize at the Venice Biennale of 1958, the first American painter to be so honored since Whistler in 1895. A younger painter, Sam Francis (born 1923), has worked on a much larger scale, adapting Pollock's technique of dripped paint to tighter and more decorative patterns. Through his long residence abroad, Francis became an important influence on the development of abstractly Expressionist painting in Europe. Clyfford Still (born 1904), who worked for many years in San Francisco, discovered that the new abstract image was inseparable, not only from the

345. HENRI MATISSE. Interior of the Chapel of the Rosary, Vence, showing the Stations of the Cross. 1947–51

346. CLYFFORD STILL. *1950—A*. 1949. Oil on canvas, 92 × 67″. Collection Mr. and Mrs. Ben Heller, New York

activity of the brush, but also from the total character of the painted surface, of the structure of the pigment itself. His harsh colors, often in painful contrasts of hue and intensity, and hung like quivering curtains across the thinnest of pictorial spaces, are torn to disclose, like wounds in a hurt surface, strange darknesses within (plate 346).

Quite another, and individual, kind of colored space was created by Mark Rothko (1903–1970), who followed a process of reduction and simplification, gradually purging his canvases of all vestiges of "memory, history, or geometry" ("obstacles," as he called them, "between the painter and the idea"),[2] until, as the canvases grew larger and larger, nothing was left but two rectangular shapes, one above the other and both almost as wide as the canvas itself. As the relations in hue and value between the colored rectangles, and between them and the ground, came closer and closer in similarities of yellow and orange, coral and rose, or maroon and black, the spreading shapes seemed to hover in an immense, indefinable space (colorplate 57). The effect is often that of a landscape, but a landscape of the mind, not of the natural world. Only when nothing is left but one rectangle, and the color grows dark and turgid, as in the huge, dull red forms almost filling the backgrounds of his work, has the conceptual idea seemed to dominate what in the later 1950s had been an exceptionally sensitive and elusive perceptual experience. By concealing all evidence of brush or palette knife, and by saturating the ground with thin washes of pigment, Rothko anticipated the stained canvases of the 1960s.

Although the formal configurations of the new painting—Pollock's rhythmic swirls, Still's and Rothko's flat planes of color—required a new definition of the image in modern art, to the degree that it had become inseparable from its form and the process of creating that form (a metaphor of itself, as it were), the making of images has not been entirely neglected. The biomorphic structures of William Baziotes (1912–1963) and the totemic shapes in the early paintings of Adolph Gottlieb (born 1903) can be traced to their admiration of Miró and Klee. In time such images lost their specific identities, but even as shapes devoid of representational reference they acquired "meanings" as form. Gottlieb acknowledged their expressive qualities when he stated that he was "concerned with the problem of projecting intangible and elusive images that seem to me to have meaning in terms of feeling."[3] And among the most effective images in modern painting are those which Gottlieb opposes to each other: the bright circular disc floating above a cluster of dark irregular brushstrokes, suggesting the basic contrasts in human experience between order and disarray, possession and loss (colorplate 58).

The content as well as the technique of the new American sculpture had much in common with Abstract Expressionist painting. The most conspicuous technical factor was the rejection of the traditional and cumbersome materials of stone and bronze for welded metals and the newer alloys, which are malleable at lower temperatures and permit the sculptor to work without reference to preliminary models, or even, in many instances, to drawings or painted sketches. The result was an immediate and intimate identification of the sculptor with his materials, which in many respects resembled the Action Painter's assault upon his canvas, so that valid comparisons can be made between the wracked shapes in the early constructions of Herbert Ferber (born 1906), one of the first to work directly in metal, and the broken forms in Pollock's later paintings (plate 347). Also fundamental to both sculpture and painting has been the primary thesis of abstract art: that the image need owe nothing to the natural world and can be apprehended entirely as a thing in itself. The sculptor, however, has been somewhat less willing than the painter to present his work only in its own terms. Perhaps because a three-dimensional object is always present in the actual physical space of our lives and, unlike a painting, cannot ever be considered totally "abstract," many sculptors have given their most nonobjective work titles which enlarge their expressive context through associations with the "obstacles" of memory, of history, and of myth.

The conjunction of intuitive, often peremptory sculptural action with an abstract, but psychologically expressive, content could be seen as early as 1949 in the work of David Smith (1906–1965), whose workshop at Bolton Landing, New York, was more a forge than a conventional studio. In *Blackburn: Song of an Irish Blacksmith* (plate 348) the metal parts have been welded together rather than cast from a clay or plaster model. That certain flat shapes and rods have something of the abstractly organic quality which Smith, like Gorky, admired in Picasso and Miró is perhaps less important than that others had been found among the discarded agricultural machinery rusting in the pastures where Smith worked. He was one of the first after Duchamp to use prefabricated elements, but in his work they lost their utilitarian associations when they were absorbed into the total sculptural form. Only later, and in others' hands, was junk allowed to remain just junk (pp. 387, 390). Smith, on the contrary, transformed his materials, creating open structures whose imaginative invention was matched by their

347. HERBERT FERBER. *Wall Sculpture.* 1953. Soldered copper and lead, 72 × 72″. Collection Mr. and Mrs. Lawrence H. Bloedel, Williamstown, Mass.

348. DAVID SMITH.
Blackburn: Song of an Irish Blacksmith
1949–50. Iron and copper, height
46 1/2″. Wilhelm Lehmbruck
Museum, Duisburg, Germany

free and powerful design (plate 349; colorplate 59).

The range of expression, as of technique, in direct metalwork is immense. About 1945 Theodore Roszak (born in Poland 1907) abandoned sleek but emotionally unprofitable nonobjective constructions for brazed and welded steel, the surfaces scorched and pitted by fire and acid. Such forms, he has said, are "meant to be blunt reminders of primordial strife and struggle reminiscent of those brute forces that not only produced life, but in turn threatened to destroy it." So savagely expressive a program could easily lead a sculptor to neglect the resolution of emotion through form, but that is what Roszak achieves at his best, as

in *Whaler of Nantucket* (plate 351), with its menacing implications, conveyed entirely by abstract shapes, of Ahab's mortal contest with his enemy.

Seymour Lipton (born 1903) and Ibram Lassaw (born 1913) have used less intractable materials, the former folding curved planes of sheet steel or monel metal, coated with glimmering bronze or nickel silver, into structures seemingly suggested by the organic growth of tropical plants and flowers (plate 350). Lipton has indicated that his sculptures evolve from the reaction of chance with feeling. Hence, being based on little in the way of preliminary drawings or sketches, the forms emerge, like the Action

Colorplate 59. DAVID SMITH. *Cubi XXVIII*. 1965. Stainless steel, 9′ × 9′ 4″. Norton Simon, In
Museum of Art, Fullerton, Calif.

Colorplate 60. ISAMU NOGUCHI. *Kouros*. 1944–45. Marble, height 9′ 9″.
The Metropolitan Museum of Art, New York

349. DAVID SMITH. *Cubi XVII*. 1963. Stainless steel, 8′ 11 3/4″ × 5′ 4 3/8″. Dallas Museum of Fine Arts, Dallas, Texas. The Eugene and Margaret McDermott Fund

350. SEYMOUR LIPTON. *Jungle Bloom.* 1954.
Bronze on steel, 20 1/2 × 31".
Yale University Art Gallery, New Haven,
Conn. Gift of Susan Morse Hilles

351. THEODORE ROSZAK.
Whaler of Nantucket. 1952–53.
Steel, 34 1/2 × 45 1/2".
The Art Institute of Chicago

Painter's, from his sculptural activity. Lassaw, also a convert from nonobjective construction, uses alloys which melt at low temperatures so that the metals flow and drip from skeletal armatures. A more exotic fantasy has appeared in recent works, where he has stained and brazed the metals until they glow with a weird brilliance reminiscent of primitive forms of organic life, such as sponges and corals.

Isamu Noguchi (born 1904) has had a longer career and has stood apart from the expressive concerns of the 1950s. He was one of the first American sculptors to work abstractly in the 1930s, and he has continued to explore the possibilities of abstract design ever since, often with disconcerting changes of manner. Whether working in metals, stone, or terra cotta, he is always a distinguished craftsman, not surprisingly, given his oriental heritage. Among his more memorable works are the tall kouroi figures with their abstract references to archaic Greek art (colorplate 60), carved in flat, interlocking sections of pale pink marble. Noguchi has also created a number of sculpture gardens and courts (Paris, UNESCO Headquarters; New York, Chase Manhattan Bank; Yale University, Beinecke Rare Book and Manuscript Library), bringing to the confinement of the contemporary urban environment something of the imaginative spaces of Japanese garden design.

In Europe the first decade and a half after the Second World War saw the continuance of older modes as well as the emergence of new developments, among which American abstract painting—known in England as Action Painting and in France as Tachisme (from *tache*, a spot of paint), or *art informel*—affected but did not dispossess the different national traditions. In France the long-established masters—Matisse, Braque, Picasso, and Chagall—continued to explore aspects of their personal styles with the richness of form and feeling sometimes granted to great artists in their old age. In his cut and pinned papers, made during a long illness, Matisse reached astonishing concords of color, while Braque, in his *Atelier* series of 1949–1956, deepened and enriched the multiple spaces of his earlier Cubism. Picasso continued his restless investigations of form and design, sometimes with diminished expressive content, but usually with dazzling technical assurance, perhaps most successfully in the fifteen variations of 1955 on Delacroix' *Women of Algiers* (plate 352), perhaps most disappointingly in a thin and flippant mural of 1957 for the UNESCO headquarters in Paris. In 1965 Chagall completed a new ceiling for the Paris Opera House, and in 1966 two large murals for the new Metropolitan Opera House in New York City. Shortly before

then he had mastered an entirely new technique for the design and construction of stained-glass windows for the cathedral at Metz, the United Nations Headquarters in New York, and the synagogue of the Hadassah–Hebrew University Medical Center in Jerusalem.

Compared with such protean activity the work of younger French painters often seemed derivative or tentative, a tasteful but conventional issue of Later Cubism, even if executed with the traditional refinement of French technique. In France, as elsewhere in Europe during these years, totally abstract art was not so prevalent as in the United States, perhaps because the millenial tradition of representational painting and sculpture could less easily be ignored. The conflicting claims of the two modes appeared in the work of the Russian-born Nicolas de Staël (1914–1955), who reached the limits of abstraction within a Late Cubist idiom of flat blocks of color, but without quite abandoning all vestiges of natural form. His can be seen as a premature but ill-fated attempt to recover, if not to retain, the visual concept of representation within a basically abstract idiom. Among his last works there are certain landscapes and still lifes in which a minimum of colored shapes, richly and elegantly brushed, convey almost invisible messages of things and places from a world beyond the painting. But the difficulty of maintaining so precarious a balance between abstraction and nature may have contributed to the conflict which led to his suicide.

The continuing validity of the figure as a source of contemporary artistic expression was demonstrated by two sculptors and a painter working in postwar Paris. Alberto Giacometti (see above, p. 272), who had been a leading Surrealist sculptor in the 1930s, produced in 1947 his extraordinarily attenuated figures and fragmented arms and legs. Rarely satisfied with his own work, Giacometti relentlessly reduced them bit by bit—for he modeled in the traditional medium of clay—until little was left but an upright stick for the body, or a knife-sharp edge for the profile, as in his many portraits of his brother Diego. The results were as unexpected as they were impressive: wraiths of men and women seemingly urged toward nothingness by the individual's intolerable emotional isolation in modern society (plate 353). Much of the poignant distress his work communicates is the result of his preoccupation with the space around his figures and within which they try to act. Such space seems filled with the echoing emptiness of their physical and spiritual attrition. A more turbulent attitude informed the figural sculpture of Germaine Richier (1904–1959). More substantially fleshed than Giacometti's, her bronze men and women were also prey to maladies

353. ALBERTO GIACOMETTI.
Composition with Seven Figures and a Head. (The Forest).
1950. Painted bronze, height 22″.
The Reader's Digest Collection

352. PABLO PICASSO. *Women of Algiers.* 1955. Oil on canvas, 44 7/8 × 57 1/2″.
Collection Mr. and Mrs. Victor W. Ganz, New York

and malformations which sometimes drove them beyond the human toward the animal condition. As her figures became enmeshed in a tangle of bats' wings, spiders' webs, or blown and broken leaves, their intellectual as well as physical substance seemed to disintegrate.

The appearance of natural, found materials in the work of art is characteristic of the climactically important paintings of Jean Dubuffet (born 1901). He had long been interested in the productions not only of those who were academically inexperienced, like the naïve and Sunday painters, but even of those whose work could scarcely be considered art at all, having, like children's drawings and the work of the insane, quite other than artistic intentions. In 1949 Dubuffet exhibited his collection of such objects in

Paris under the title of *art brut* (an early and important use of the adjective to signify art that is coarse and crudely executed as well as expressively "brutal"). Dubuffet adopted the technical maladroitness of such brutish artifacts for his own paintings. On heavily impastoed grounds, with pigments the color of mud or offal mixed with plaster, cement, asphalt, sand, twigs, and pebbles, he crudely scratched and scored his grossly flattened and repulsively swollen bodies (plate 354). So intransigent a rejection of all conventional standards of artistic quality, so outrageous a substitution of the "ugly" for whatever can be considered its counterpart, not only called in question all *a priori* cultural values, but also, by ignoring any distinction between traditional materials and everything else, made the total environment and every

thing in it available to the artist. Thus Dubuffet, as much as anyone else, created the technical and critical presuppositions for the Junk Culture and Pop Art of the present.

The rude power of Dubuffet's art is apparent when his works are compared with those of other artists who have used debris of various kinds, or suggestions of it, for more decorative purposes. The Catalan Antoni Tàpies (born 1923) was one of the first artists from Spain to achieve an international reputation after the long decline of Spanish art following the Civil War of 1936–1939. His paintings, also heavily impastoed with plaster and cement as well as pigment, are intensely tactile; sensations of touch are fully as insistent as those of hue, given his customary palette of somber earthen colors (plate 355). But for all that, and for all the apparent technical crudity and suggestions of dilapidation and ruin, his works please primarily because of the exquisite adjustment of his touch to his materials. Even the enigmatic signs are bland, incapable of becoming symbols of apprehension or

doubt. A similar attitude can be found in the metal reliefs of the Hungarian-Swiss sculptor Zoltan Kemeny (1907–1965), whose clusters of objects, often sections in various sizes of metal tubes or other mass-produced industrial elements, are arranged with faultless discrimination.

Powerfully Expressionist and abstract design is characteristic of the group of northern European painters known as CoBrA (from the first letters of Copenhagen, Brussels, and Amsterdam), although the sources of their work are probably less the new Action Painting than the Expressionist tradition of Van Gogh, Munch, and Kokoschka. The most distinctive painters of the group have been the Dutch artists Karel Appel (born 1921) and Lucebert (born 1924), the Danish painter Asger Jorn (born 1914), and the Belgian Pierre Alechinsky (born 1927). Equally abstract painting, less expressively aggressive but as large in scale and as varied in form and execution, can be found in Germany in the work of, among others, Theodor Werner (born 1886), Ernst Nay

355. ANTONI TÀPIES. *Great Painting*. 1958. Oil and sand on canvas, 6′ 7″ × 8′ 6 5/8″. The Solomon R. Guggenheim Museum, New York

(1902–1968), and Fritz Winter (born 1905). In Italy, Afro (born 1912) develops intricate and delicately colored forms that seem to move within a space deeper than is usual in abstract art. Alberto Burri (born 1915), a surgeon who taught himself to paint while a prisoner of war in Texas, creates abstract designs with rough canvas and torn burlap as well as paint. His use of such materials was another anticipation of the discovery of junk in the later 1950s.

The phrase *Junk Culture* seems to have been used first in 1961 by the English critic Lawrence Alloway to identify constructions put together from discarded objects, whether whole or fragmentary. Two years later William Seitz defined the technical procedures of combining such materials as the "art of assemblage." In a comprehensive exhibition under that title at the Museum of Modern Art in New York, he traced the process from the first Cubist collages and Dada concoctions to the most recent manifestations. The earlier term better describes the expressive character of the majority of recent assemblages, whose origins may more easily be traced to Schwitters' enthusiasm for his discoveries in the wastebasket and gutter than to the Cubists' use of carefully cut and pasted papers as compositional devices abstractly formal in themselves. Similarly, the choice of such materials, almost entirely from the junkyard and scrap heap, has more affinities with the Dadas' defiantly antiartistic program than with the Cubists' indifference to the world beyond the picture frame. But to label Junk Culture as Neodada—a term which has also been used to describe Pop Art—is to blur the character of such work behind a conveniently ambiguous label, because the disturbing effect of much junk art has little to do with the Dadas' savage but paradoxically humorous attack on bourgeois values. In the new art there is little or no interest in the social scene as such, no condemnation of specific evils, no hint of possible cures. The malaise is less easily diagnosed; it is personal rather than public, its sources more psychological than economic. Perhaps one can define the difference between present art and the Dada past by saying that the convivial irony of the Dadas has been replaced by individual cynicism, the raucous laughter of the Cabaret Voltaire by the sense of man's ultimate isolation and absurdity. Such meanings arise not only from the materials selected, but also from the contexts in which they are presented. The Surrealists in the 1920s had shown that discrete or dissimilar objects gain new meanings when placed in unexpected juxtapositions (on the analogy of the *Gestalt* principle that the whole is greater than the sum of its parts). When the materials are abused and

broken remnants of other people's lives, associational meanings are projected which engage the spectator in a wide range of emotional reactions. That these so often fall within the spectrum of indifference, discouragement, or disgust suggests that the creators of such works have been touched by existentialist "nausea," the malady common to the inhabitants of great cities in the twentieth century.

356. JOHN CHAMBERLAIN. *Untitled.* 1960. Welded scrap metal, 20 × 16 × 12″. The Joseph H. Hirshhorn Collection

Junk Culture thrives only in an urban environment, where there is the highest rate of social as well as technological obsolescence. From abandoned scrap metal Richard Stankiewicz (born 1922) contrives his cumbersome but oddly elegant compositions, at times entirely abstract, at others with traces of Dada wit, as in the *Secretary*, which clasps a crumpled typewriter to its rusty boiler of a bosom. More sinister are the abstract arrangements of crushed automobile parts by John Chamberlain (born 1927). He is said to have introduced polychromy into metal sculpture, but neither Detroit's lurid pastels nor the irrelevant titles of his work can dissipate the discrepancy between the detachment of his artistic ends and the morbid source of his means (plate 356). Disgust is also

357. ROBERT MALLARY. *The Juggler*. 1962–63. Polyester, resin, Fiberglas. tuxedo, steel, and crushed stone, height 7 1/2′.
Allan Stone Galleries, New York

frequently the expressive effect of the complex assemblages of Robert Mallary (born 1917). His compositions of burned wood, crushed stone and sand, or clothing repulsively soiled and torn, the whole bound in polyester resins, have an austere artistic unity that almost but not quite dominates the misery of the materials (plate 357).

Only by indirection can such works be interpreted, as they well may be by historians to come, as invoking the general horrors of our age. For those who come upon them for the first time, as this generation has had to, what is more immediately apparent is the encoun-

ter of each individual with his own artistic problems. In other words, such works have had to be felt as art rather than read as history. Nor do they all communicate a common point of view. We may be living among ruins, but the ruins can have a certain elegance. The meticulous carpentry of Louise Nevelson (born 1900) rivals the paintings of Tàpies in decorative grace. When her wooden boxes, painstakingly filled with bits of old furniture, are sprayed with dull black paint and grouped by the dozen, often covering an entire wall, the effect is unexpectedly mysterious (plate 358). Each separate box is like a totem of our

Victorian yesterdays, while the whole remains an inexplicable comment on the passing of time. But when the boxes are painted uniformly white or gold instead of the funereal and impenetrable black, the result is more decorative than alarming.

The manipulation of junk has called attention to the existence of objects as independent artifacts, as things-in-themselves which can stand as surrogates for what had earlier passed as works of art. This new authority of the object contributed to the radically original work of two artists, Robert Rauschenberg (born 1925) and Jasper Johns (born 1930), who effected the transition from Abstract Expressionism to Pop Art. In Rauschenberg's early paintings the pigments were treated as flat washes, rapidly and broadly brushed in the manner of De Kooning but with the color areas more loosely related. By 1952 he had begun to attach actual objects to his canvases in what he calls combine-paintings. Unlike traditional collages, in which the "personality" of the applied elements was subordinated to the total design, Rauschenberg's articles of clothing and furniture, his bottles, stuffed birds, or shabby pillows, by maintaining their individuality tended to disrupt if not defeat the spectator's attempt to discover any formal logic in a given sequence of images (plate 360). Such compositional dispersion—the apparent incompatibility of different elements and their refusal to coalesce as a coherent visual metaphor—is characteristic of much contemporary painting, and of some architecture as well. Rauschenberg's titles are of little help, seeming to refer to remembered experiences beyond the reach of the spectator or even the occasion of the painting itself. Perhaps no difficulties would arise were the

components nonrepresentational and the whole therefore, by definition, abstract. But when recognizable images appeared, in the form of newspaper photographs printed in different sizes from silk screens, the tension became acute between the banality and at times the brutal realism of the photographs and the abstractly painted areas. Never before, it seemed, had the difference between everyday realism and artistic reality, traditionally illusionistic, been so nakedly exposed. Rauschenberg's frequently quoted statement that he tries "to operate in the area between art and life"[4] can be understood as more than a tidy epigram. He has posed the unanswerable question of the relation of art to life by combining both in works where the actual objects—the memorable stuffed goat with a rubber tire around its middle—were no more "real" than the abstract passages of paint.

Jasper Johns has stated the same problem, but in a disconcertingly direct way. His first works to attract attention were the flag and target paintings in which the subject, so commonplace as to have previously been unnoticed in life, was presented as a visual fact complete and absolute in itself. Save that certain flags were delicately painted in the novel medium of gray encaustic over newsprint, the transference of the object from life to art was accomplished with nothing in the way of modeling, perspective, or atmospheric ambiance that might have placed it in a conventional context related to the spectator's habitual vision. The clue to these unassuming but incomprehensible paintings lay in the fact that there was nothing to comprehend. The flag was a picture of a flag, the target of a target. Solicitations to patriotism or a shooting match were not in order.

Shortly afterwards Johns devised variations on such absolute visual facts in his paintings of numbers (although signifying little as form, stenciled numerals have considerable visual presence when aligned in rows), or of maps with the name of each state carefully lettered, or of colors, in which the name of each color might be painted in another. But since a painting of anything at all, no matter how painstakingly literal, is always an illusion of that thing and not the thing itself, Johns turned to sculpture to shorten the distance between art and life. To make the artistic object as absolutely factual as possible, he had cast in bronze, which he then painted, such objects as a flashlight, a light bulb, two beer cans, and, most misleading of all, a fistful of dirty paintbrushes thrust into an empty coffee tin (plate 359).

Johns's target and painted paintbrushes and Rauschenberg's combine-paintings can now be seen to belong to a new mode of painting and sculpture,

359. JASPER JOHNS. *Painted Bronze.*
1960. Height 13 1/2". Collection the Artist

360. ROBERT RAUSCHENBERG. *Double Feature*. 1959. Mixed media, 90 3/4 × 52″. Collection Mr. and Mrs. Robert C. Scull, New York

361. ROBERT INDIANA. *The Demuth American Dream No. 5.* 1963. Oil on canvas, five panels, each 4 × 4′.
The Art Gallery of Ontario, Toronto. Gift of the Women's Committee Fund, 1964

one which within months made Abstract Expressionism, despite the immense talents still contributing to it, seem like a lost cause. What the two artists had done had long been expected, although not in quite this way; namely, that Realism would return to progressive art after the fifty-year dominance of abstraction. Realism had returned, not from within the abstract process itself, but from the least respectable areas of image-making—from newspaper photography, from household objects, and from the communications media, especially from advertising in all its forms and at the lowest levels of visual appeal.

The realistic presentation of immediately recognizable, mass-produced objects, drawn from what has been described as twentieth-century urban folk art, and symbolic of the widest public participation, suggested the name for the new art. The first comprehensive exhibition in the United States, held at the Sidney Janis Gallery in New York in October, 1962, was called The New Realists, but that term, previously used in Paris by a group of abstract artists, was quickly supplanted by Pop Art. The word *Pop* had first been used in 1954 by the English critic Lawrence Alloway with reference to such widely disseminated images of "popular culture" as advertisements, billboards, movie posters, illustrations in magazines of mass circulation, and the like. Eight years later it was enlarged to include work derived from such images and the techniques of their production. Possibly the first actual example of Pop Art was a collage of 1956 by the English painter Richard Hamilton (born 1922) with the ironic title *Just What Is It That Makes Today's Homes So Different, So Appealing?* The elements, clipped from American magazines, included male and female nudes in a nondescript room furnished with total banality. The unmistakable origin of each object could be considered a comment on American materialism, but to do so would be to ignore the materialistic bias of every contemporary industrialized culture. Hamilton and others, like the painter Peter Blake (born 1932), who had used postcards and other Pop objects as early as 1954, have continued working in such mixed media, but their isolated efforts were at first no match for Abstract Expressionism, which reached its climax in England with the exhibitions of Jackson Pollock at the Whitechapel Gallery in 1958, and of the New American Painting, exclusively abstract and Expressionist, which was circulated by the Museum of Modern Art in several European countries in 1958–1959. By 1961, however, the emerging popular Realism was apparent in the Young Contemporaries exhibition of work by British art students. Meanwhile, in New York a younger generation,

encouraged by Rauschenberg and Johns, was preparing for its first appearance, which occurred in a number of one-man exhibitions during the winter of 1961–1962, and at the Janis Gallery the following autumn.

Robert Indiana (born 1928) was, after Johns, the first American painter to state the new imagery with the unmodulated force and clarity of a traffic sign. His means are only apparently simple, for the hand dares not falter that draws and colors with such precision, nor are his images as mindless as they at first appear. Indeed, in his work more than in most of his contemporaries', the rebuke to American materialism is more than glancing, as in *The Demuth American Dream No. 5* (1963; plate 361). The injunctions to the dreamer to err, eat, hug, and die are obvious; subtler are the references in the repeated "5s" to Charles Demuth's painted homage to William Carlos Williams' poem "I Saw in Gold the Figure Five" (now in the Metropolitan Museum, New York), which is among the most authentic statements of American urban experience by any artist of the generation older than Indiana.

Less complex and literary images occur in the work of James Rosenquist (born 1933) and Roy Lichtenstein (born 1923), whose sources are those ubiquitous areas of visual information and emotional experience, the billboard and the comic strip. Rosenquist had actually painted billboards when not in art school, and he has taken over into his most successful work not only the overwhelming scale of such painting and its blatant technical tricks for making forms carry at a distance, but something of the equivocation of forms seen in passing without the accompanying legends being understood (plate 362). Lichtenstein, on the other hand, magnifies the very small, sometimes no more than a detail of a comic strip showing the head and shoulders of the figures, but with the lettering of the spoken words intact (plate 363). Flesh tones and backgrounds are usually treated with an enlargement of the Ben-Day screen of fine dots, which accounts for the modeling. Lichtenstein uses a stencil which enlarges the dots to the size of a dime, creating, it must be admitted, a compelling effect of monotonous repetition which intensifies the hypnotic impact of these enormous faces, distorted by violent emotions but projected by emotionless, almost mechanical means.

In the work of Andy Warhol (born 1931) the mechanical means have led to the separation of the artist as maker, as craftsman, from the thing made. Warhol has said that he wishes he were a machine, and in his Brillo boxes of 1964 he almost achieved his goal. Wooden boxes, manufactured to his order and

362. JAMES ROSENQUIST. *Two 1959 People*. 1963. Oil on canvas with objects, 72 × 93″.
Brandeis University Art Collection, Waltham, Mass. Gevirtz-Mnuchin Purchase Fund

363. ROY LICHTENSTEIN. *Forget It! Forget Me!* 1962. Magna and oil on canvas, 79 7/8 × 68″.
Brandeis University Art Collection, Waltham, Mass. Gevirtz-Mnuchin Purchase Fund

of the same size as the cardboard ones used commercially, were silk-screen printed in exact facsimile of the lettering on the original cartons (there were also Campbell's Soup and Heinz Ketchup boxes, in quantity). Before that Warhol had been known for his paintings of soup cans (colorplate 61) and of Coca Cola bottles repeated row on row, and for his silk-screen images of Marilyn Monroe, washed with lurid colors. As much as any he succeeded, almost at once, in directing our attention to the particular, if not peculiar, qualities of the most frequently experienced images in modern life.

The distinctions between art and life, as well as those between the conventional categories of painting and sculpture, have also been minimized by Tom Wesselmann (born 1931), who surrounds his schematic silhouettes of "The Great American Nude" with actual television sets, Venetian blinds, and the trophies of the supermarket. His still lifes are paradigms of suburban conformities (plate 364). A similar obsession with consumer goods occurs in the work of Jim Dine

(born 1935), who has attached objects—conspicuously bathroom fixtures—to scantily brushed canvases. Dine was one of the inventors of Happenings, which can perhaps be described as semi-spontaneous dramatic occasions—charades, so to speak, without the clue words—which require the spectator's participation in unpredictable, inexplicable, often disrupting events. Dine soon abandoned Happenings for paintings, but such attempts to narrow the gap between art and life have been carried on by Allan Kaprow (born 1927; plate 379), who is also a well-known abstract painter.

Three sculptors must also be mentioned. Claes Oldenburg (born 1929) is known for his monstrously enlarged and brightly painted plaster replicas of ordinary food—pies and pastries, hamburgers, hot dogs, and ice cream cones—and for his gigantic but grotesquely limp imitations in vinyl of such everyday things as light switches, typewriters, and toilets. Such mammoth objects may look like cynical comments on the vulgarity and waste of an affluent society, but only an absolute mastery of scale could endow their

364. TOM WESSELMANN. *Great American Still Life, No. 19.* 1962. Mixed collage on Masonite, 48 × 60″. Collection Mr. and Mrs. Burton G. Tremaine, Meriden, Conn.

Colorplate 61. ANDY WARHOL. *Campbell's Soup*. 1965. Acrylic and silkscreen enamel on canvas, one of four panels, each 36 × 24″.
Leo Castelli Gallery, New York

Colorplate 62. CLAES OLDENBURG. *Giant Hamburger*.
1962. Painted sailcloth stuffed with foam rubber, 52 × 84″.
The Art Gallery of Ontario, Toronto

365. GEORGE SEGAL. *The Bus Driver*. 1962. Plaster over cheesecloth with parts of an actual bus, height overall 6′ 3″. The Museum of Modern Art. New York. Philip Johnson Fund

banalities with such spatial presence (colorplate 62). The sculptures of George Segal (born 1924), like dead-white plaster casts of living people, seem uncannily lifelike when put beside objects from their real-life environment (plate 365). The plaster bus driver, for instance, sits beside an actual coin box. And sometimes, as in the man changing the letters on a movie-house marquee, Segal communicates the inarticulate poignance of a humdrum gesture or a drab existence. The sculpture of Marisol (born 1930) sometimes incorporates Pop objects, but its content is more sophisticated and its oblique social references more caustic. Upon the wooden blocks or cylinders, which are the torsos of her figures, Marisol wittily pencils in limbs and features, or adds them in plaster casts. The fact that the faces of the female figures are often her own adds an eerily introspective dimension.

At this point in time the qualitative judgment of Pop Art is lined with pitfalls for the critic. Since the content as well as the technique of such work is based on the utterly commonplace, on the vulgar and the banal, and, consequently, on much that has heretofore been considered irrelevant to artistic experience, vulgarity and banality must be taken as positive assets, although no system of aesthetics has yet been devised for determining what degree of the "bad," so to speak, is "good." But the visual power of certain works is inescapable, at least to the degree that they force the spectator into unexpectedly intense confrontations with the most familiar situations of daily life. For the present, at least, these visual objects which constantly assault us cannot easily be ignored. Because of Pop Art we respond to them, whether we loathe them or, even against our will, discover that we like them.

Although Abstract Expressionism dominated painting in the United States through the 1950s and was influential elsewhere in the world, there was another

movement, continuous and concurrent, that emerged in the early 1950s as a major mode of pictorial and sculptural expression. This was the tradition of geometrically abstract art which had originated in Russian Constructivism and Dutch De Stijl, and whose most distinguished exponents had been Malevich, Kandinsky, and Mondrian. At the time of his death in 1944 Mondrian seemed, in such paintings as *Victory Boogie-Woogie*, to have become disillusioned with his austere aesthetic. Hindsight now suggests that, quite to the contrary, he may have come, even if unknowingly, to the threshold of a new development in which the optical perception of color, rather than concepts of geometrical form, would be the principal concern. By breaking his familiar lines into small blocks of red, blue, and yellow, he had taken the first step toward an art based on the contrast and interaction of color and on the peculiarities of visual perception.

Josef Albers (born 1888), German-born and trained at the Bauhaus but resident in the United States since 1933, has been a principal agent in this country for the continuation of geometrical abstraction, now often described as hard-edge painting, or as post-painterly abstraction, to indicate the rejection of the intensely personal gestures and turbulent surfaces of Abstract Expressionism. Albers' exhaustive theoretical and practical studies of the structure of color perception, disseminated by his teaching as well as by his own painting, have been fundamental for the development not only of hard-edge painting but of an art of optical perception, or Op Art, as it has been called for the past few years. Albers has always insisted that the source of art is in "the discrepancy between physical fact and psychic effect,"[5] and he has spent a lifetime exploring ways to deceive the eye through perspectival ambiguities, and to "swindle" it (the verb is his own) by exploiting our sensitivity, and also our insensitivity, to very close distinctions in hue, tone, and value. In the series *Homage to the Square*, begun in 1950 and now numbering many hundreds of paintings, he has created the most varied perceptual experiences through changes of color within an unvarying scheme of three or four superimposed and diminishing squares (plate 366). Ad Reinhardt (1913–1967) pushed on in the opposite direction, from light to darkness, until the eye could scarcely discriminate between his yellows, reds, greens, and purples, so close had they been brought toward black. Lastly, only black remained so that the cruciform shape within the painting is only visible when a raking light reveals the differing directions of the brushstrokes.

Among Mondrian's followers in this country, the

most accomplished have been the Swiss painter Fritz Glarner (born 1899), Ilya Bolotowsky (born 1907), and Burgoyne Diller (1906–1965). They abandoned Mondrian's grids as too restrictive and disposed the canonical red, yellow, and blue rectangles with more freedom. The younger hard-edge painters, while retaining the impersonal surfaces and crisply defined contours of earlier geometrical abstraction, have tended, on the whole, to reduce the number of elements, often to a solitary shape, while increasing the visual variety of their works by ignoring the limitations of Mondrian's color. Leon Polk Smith (born 1906), Alexander Liberman (born 1912), and Ellsworth Kelly (born 1923) use extremely simple shapes, often circular or slightly curved, against backgrounds of a single color (plate 367). Before such formal paucity the spectator discovers that the visual interest of their work lies, not in the contrast between form and space (for there are no forms *in* space), but between the bright unmodulated areas which may be so strong as to cause form and ground to seem to change places.

This reliance on color as a primary means, with the consequent suppression of formed or shaped elements, is most conspicuous in the work of Morris Louis (1912–1962) and Kenneth Noland (born 1924). Both painters have taken advantage of the wide range of brilliant hues in the new plastic water-paints, and by allowing them to soak into unprimed canvas, in the way Pollock stained his black-and-white canvases of 1950–1951, they have preserved the colors at their full saturation and created new visual and tactile effects. Before his untimely death Louis had produced a series of paintings in which narrow stripes of color run from top to bottom of tall vertical canvases, a method which has been continued in a lateral direction in recent years by Gene Davis (born 1920) in very large canvases filled with vertical stripes from end to end (plate 368). In his last works Louis left large portions of the canvas unstained, grouping the stripes on the bias in each lower corner. The visual and tactile effects of raw canvas are also integral to Noland's painting, although the brilliantly colored alternating stripes, which have begun to spread laterally across very wide canvases, at first were concentrated in such compact and powerful images as concentric targetlike circles, chevrons, and flattened horizontal lozenges (colorplate 63).

The work of an older artist, Barnett Newman (1905–1970), has been an important influence on much painting based on the contrast between minimal form and maximum color intensity. During the heyday of Abstract Expressionism he was working in the op-

366. JOSEF ALBERS. *Homage to the Square: With Rays.* 1959. Oil on Masonite, 48 1/8 × 48 1/8″. The Metropolitan Museum of Art, New York. Arthur H. Hearn Fund

367. ELLSWORTH KELLY. *Charter.* 1959. Oil on canvas, 95 1/2 × 60″.
 Yale University Art Gallery, New Haven, Conn. Gift of Helen W. Benjamin, in memory of her husband Robert M. Benjamin

368. GENE DAVIS. *Anthracite Minuet.* 1966. Synthetic polymer paint on canvas, 93 1/8 × 91 1/8″.
 The Museum of Modern Art, New York. Larry Aldrich Foundation Fund

posite direction, purging his canvases of all expansive gestures until he had reduced them to a single vertical stripe against a broad, slightly modulated ground. If his work was then ignored, it was because in it there seemed so little to see. Since then Newman has been recognized as a remarkable master of design, capable of placing one stripe of one color in such a way as to organize what otherwise would have been an inert ground, so that the spectator perceives an immense, unfathomable space. In 1966 Newman went further when he exhibited at the Guggenheim Museum his fourteen *Stations of the Cross* (plate 369), each consisting of one or two black stripes against a whitish unprimed canvas. These large, apparently empty paintings were difficult to reconcile with their portentous titles,

although Newman has insisted that they have a metaphysical if not a specifically religious significance. If it was difficult to say what that might be, nevertheless it was apparent, to those who looked long enough, that Newman's choice and placing of a handful of forms communicated a huge serenity.

Frank Stella (born 1936) shares with the hard-edge and color painters their concern with fundamental shapes and with certain problems of optical perception, as in his early black paintings in which the "chalk stripe" lines of unprimed canvas exposed between the black stripes approached invisibility. Like Johns, although abstractly, he has been concerned with the work of art as an absolute fact, deriving the form and content, if such there is, of each painting

369. BARNETT NEWMAN. *The Eighth Station.* 1964. Oil on canvas, 78 × 60″. From *The Stations of the Cross.* 1958–66. Estate of the Artist. Courtesy M. Knoedler and Co., New York.

from the congruity of its color pattern with its shape. After dividing the rectangular canvas by thin stripes parallel to its edges, he created oddly shaped canvases in which again the interior divisions corresponded to the overall form. Such paintings are visually compelling, like heraldic devices devoid of any adventitious references (plate 370).

In the work of the hard-edge and color painters there has been, strictly speaking, little or no play with optical illusions as such. The investigation of the artistic potentials of optical stimuli has been carried on in Europe by a number of artists, of whom the first for many years was the Hungarian painter Victor de Vasarely (born 1908), who has lived in Paris since 1930. He often works in black and white, and his optical paintings of linear perspective illusions are not unlike some of the earlier experiments of Josef Albers and his students at the Bauhaus. More vivid and complex optical effects have been developed by artists in many other countries, each independently exploring the still-inexplicable relations between retinal and psychological perception.

Among the most startling works in a survey of optical art, held at the Museum of Modern Art in 1965 under the title The Responsive Eye, were the paintings of the English artist Bridget Riley (born 1931). Her large black-and-white linear compositions, based on the illusory shimmer of *moiré* patterns, literally dazzled the eye of the beholder. More intense, even physically uncomfortable optical reactions occur when the spectator is confronted with contrasts of color as vivid as those used by Richard Anuszkiewicz (born 1930), who studied with Albers and develops his colors upon similarly rigid geometrical patterns.

Much optical art, whether two-dimensional or free-standing in the form of reliefs and constructions, creates effects of apparent movement, or requires the spectator to move past or around the object in order to experience the intended optical perceptions. Such implied or enforced motion has become actual as well as implic it inpresent-day kinetic art. As long ago as 1930 Alexander Calder (see above, pp. 316–335) set his wire and metal sculptures gently swaying in actual space, but it was long before anything appeared that was more than an imitation of his work. Recently the Swiss artist Jean Tinguely (born 1925) has created assemblages of metallic junk which he sets in spasmodic motion by electric motors. His constructions

370. FRANK STELLA. *Slieve More*. 1964.
Metallic powder and polymer emulsion
on canvas, 77 × 81 1/2″.
Leo Castelli Gallery, New York

have overtones of Dada irony, as in his large *Homage to New York* (plate 371), which intentionally destroyed itself by catching fire and falling apart before an invited audience in the garden of the Museum of Modern Art in March, 1960. The conclusion might be that our mechanistically oriented civilization has gone irremediably awry; but on the other hand, the American sculptor George Rickey (born 1907) has positively affirmed the virtues of mechanics in his exquisitely balanced stainless steel constructions (plate 372) which embody a knowledge and control of motion very different from Calder's mobiles, which

371. JEAN TINGUELY. *Homage to New York*. 1960. Assembled scrap metal, machinery, furniture, etc. Self-destroyed March 17, 1960, in the garden of The Museum of Modern Art, New York

372. GEORGE RICKEY. *Peristyle— Six Lines II*. 1966. Stainless, steel, six pieces, each height 10′. Collection Morton D. May, St. Louis, Mo.

373. CHRYSSA. *Fragments for the Gates to Times Square II.* 1966. Neon and Plexiglas, 43 × 34 × 27″. Pace Gallery, New York

are at the mercy of every wayward breeze. Light, too, of which we are more aware than ever before, is a medium susceptible to electronic modifications. Chryssa (born 1933) creates with fluorescent tubing compositions whose beauty belies their source in commercial advertising signs (plate 373).

During the past two centuries, in every period, the creators of what is now called modern art have been drawn toward extremes of technique and expression. Neoclassicism itself, despite a universal concern with the rationale of antique forms, was basically an emo-

tional response toward the discovery of the past. Half a century later, at the climax of Realism, no sooner were Millet and Courbet hailed as leaders of a new proletarian art than the doctrine of art for art's sake was announced. Throughout the twentieth century it has seemed that the advocates of art as an end in itself, as an activity owing no allegiance to any human or social concerns, have gained the day. But only as recently as 1962 the international triumph of Abstract Expressionism was immediately succeeded by the objective images of Pop Art, which, indeed, it may

374. TONY SMITH. *Die.* 1962. Steel, 6 × 6 × 6′. Private collection, New York

have generated in reaction against its own solipsistic exaggerations.

In the most recent American art, where the boundaries between the arts are dissolving in painted sculptures and shaped paintings, the most inventive and imaginative work is taking place at opposite ends of the technical, formal, and expressive spectrum. Tony Smith (born 1912) and Don Judd (born 1928), in searching for the purest possible form, have refined their three-dimensional constructions until only the minimum masses are left. Such art has even been described as "Minimal," but however apt the term may be to define a formal situation, it fails to convey the quality of the actual sculptures. By its size alone and its awesome blackness, Smith's vast cube (plate 374) challenges our restless human presence to be

still. The design and construction of Judd's glass and metal boxes (plate 375) could have been accomplished only within a highly technological culture, but their sleek perfection may be an artistic rebuttal to our complaisance in allowing technology to submerge us in pollution and squalor. The most startling contrast to such detachment occurs in the work of certain artists whose lack of interest in the poetics of pure form is equaled only by the formalists' indifference to expressive content. In his environmental assemblages Edward Kienholz (born 1927) explores the evils that society has chosen to ignore (plate 376). The effect at first is undeniably and vulgarly melodramatic, but only by such unmitigated realism could Kienholz convey such an excess of scorn. If one may, despite the artists' objections, think that Minimal art has a

375. DON JUDD. *Untitled*. 1966–68. Stainless steel and Plexiglas,
six boxes, each 34 × 34 × 34″, at 8′ intervals. Leo Castelli Gallery, New York

meaning inseparable from our times, one must also grant realists, such as Kienholz, an authentic artistic purpose.

The range of artistic production throughout the world has now become so vast, its procedures so various, its triumphs and failures so frequent, that in a text of this length no adequate summary of the most recent events is possible, just as a mere list of current names and dates would not be meaningful. Two areas of contemporary activity—kinetic and light art—are as difficult to describe as to photograph (plate 377). The quality of moving forms, of forms moving under controlled light, and of programmed compositions in light itself must be actually experienced by the spectator. The element of time that such arts embody, involving also the spatial experience of the environ-

ment, is another essential factor which can be neither described nor seen; it must be felt. Similarly, the activities of the earth artists (plate 378), whose projects envision, even if they do not always accomplish, the transformation of extensive areas of the geographical environment, elude persuasive photographic documentation.

The works of art heretofore considered in this chapter, which is to say, in general, those produced before the middle 1960s, can be qualified in terms of familiar artistic and aesthetic criteria. Yet, as Abstract Expressionist and Pop paintings grew larger and larger so that it was more difficult to think of them as easel paintings, and as works of sculpture lost their bases to become free-standing, they became objects existing independently of, even in contradic-

376. EDWARD KIENHOLZ. *The State Hospital*. 1964–66. Mixed media, Dwan Gallery, New York

tion to, the traditional artistic ambiance of the home, the gallery, or the museum. Since about 1965 new conceptions of the work of art as an object signifying only itself and accessible only to perceptual experience, and of the sequence of physical and psychological events occurring in what has been thought of as the creative process and the re-creative experience,

have led to what may possibly be the most radical revision of artistic production, consumption, and evaluation in history.

The work of art as an object can now be produced without regard to conventional standards of craftsmanship and expressive purpose, in theory, at least, outside any relation to artistic tradition and thus,

377. HOWARD JONES. *Skylight*. 1969. Brushed aluminum and light bulbs, programmed, 60 × 60 × 3′. Howard Wise Gallery, New York

378. MICHAEL HEIZER # 2/3. *Fifty-two Ton Granite Mass in Cement Depression, Silver Springs, Nevada.* August, 1969. 18 × 15 × 11′ mass, 51 × 16 × 9 1/2′ depression. Dwan Gallery, New York

seemingly, to our human history. For those who first saw Judd's steel boxes, they looked as utterly devoid of content, of expressive meaning, as an object could; but, although largely machine-made, they had been meticulously manufactured and, what is more important, artfully conceived. Their technical perfection, even if quasi-industrial, might belie the apparent elimination of expressive content. By contrast, the aggressive content of Kienholz' assemblages transfigured the ordinariness of his materials. Such polarities of form and content, even if they could ever be so separately signified, are only a critical convenience and are nonexistent in the most challenging recent work, where form is impermanent or immaterial and

Colorplate 63. KENNETH NOLAND. *Saturday Night.* 1965. Acrylic on canvas, diamond 60 × 60″.
Collection Mr. and Mrs. André Emmerich, New York

Colorplate 64. FÉLIX CANDELA. Restaurant at Xochimilco, Mexico. 1951

content elusive to the point of incomprehensibility. Process has displaced forming, order succumbs to chance and contingency, and materials and the controls for fashioning them may include anything that comes to hand or mind, including even the impalpable substance of thought itself.

When situations, or processes as ends in themselves, are substitutes for integral, coherent, discrete, and material forms (paintings and sculptures, for example), the chronicler of the present as it passes is at a disadvantage. Process as an activity consumes itself, and, as in a Happening (plate 379), the spare scenario and a few photographs of moments within the course of an activity convey little or nothing of the quality of the event. Even the event itself becomes less significant than the hermetic intention. At an exhibition of Art by Telephone, held at the Museum of Contemporary Art in Chicago in November-December, 1969, Dennis Oppenheim (born 1938) arranged that from five piles of different building materials placed on the museum floor, each of which corresponded to his own weight (158 pounds), so-and-so many ounces were to be added or removed each week as his weight varied, on the basis of information secured by telephoning the artist in New York. The visual interest of that weekly process of addition and subtraction must have been minimal and its results imperceptible, but the conceptual act had not entirely lost its human, all-too-human irony.

Before dismissing such situations as impudent jokes —and there are many like them at the present time— one must remember that even so ephemeral a "work of art" shares with all the arts of the past an inescapable metaphysical quality as an affirmation of being.

The artist still acts to shape, however shapelessly, his environment in order to register his apprehension of reality. If in the last third of the twentieth century that reality—physical, political, economic, social, or spiritual—seems to him sterile, inhumane, and heartlessly wasteful of human bodies and brains, should the artist be blamed for telling the truth as he sees it? William Carlos Williams, in reference to another art, once wrote that

> *It is difficult*
> *to get the news from poems*
> *yet men die miserably every day*
> *for lack*
> *of what is found there.*

If the appearance of much of the most inventive, interesting, disturbing, and disgusting works produced toward the end of the 1960s has often seemed exasperatingly inconsequential, their contents may, nevertheless, have significance as statements of the artist's disenchantment with a culture increasingly hostile or indifferent to the activities of the human spirit. By peremptorily rejecting familiar aesthetic presuppositions about artistic form, today's artists have at least obliged us to look for a new criticism based on a new aesthetic, one in which the bothersome problem of beauty can be ignored because beauty is no longer a relevant concern. On the positive side, they have compelled us to take stock of our own condition as they postulate in their objects and situations answers to the questions Gauguin first posed in his great painting of 1897, *Where Have We Come From? What Are We? Where Are We Going?*

European and American Architecture since 1945

The amount of new architecture constructed throughout the world during the past twenty years has surpassed in quantity that erected during any comparable, or even far longer, period in human history, given the need to rebuild the war-ravaged cities of Europe and Asia, to create new cities—often capitals for new countries—and to accommodate the expanding world population. Its quality, however, has been another matter. Although interesting buildings have appeared in almost every country, only a small proportion of new construction has been designed by architects, and even less by architects of talent. The rest has been hastily, often shoddily, thrown together by contractor-builders. Consequently the well-designed building is an exception in a sea of mediocrity, even if eclecticism is everywhere on the wane and the pioneering inventions of modern architecture have become the clichés of everyday construction. Such has been the fate of the International Style. The window wall, the corner window, and the continuous or strip window which appeared early in the century in the work of Wright, Gropius, and Le Corbusier have become commonplace in office and apartment buildings. The rectangularity basic to the design of Mies van der Rohe has been desensitized so that it can be applied by the acre, vertically and horizontally. To point, in a few pages, to some of the more remarkable developments of the past twenty years is thus to present a misleading picture of the actual situation. All too often the buildings which will be examined below exist in an environment of past or present architectural triviality.

The postwar period has also been marked by a reaction against the linear and geometrical severity of the 1920s and 1930s. Not that the International Style, as revised and developed through the mid-century, is not a viable method of design, nor that the principles set forth by its great practitioners are not still sound. The leading architects of the present day endorse the same search for a coherent and expressive integration of form and function, enlarged now by the refinement of certain structural methods and new materials.

These procedures converge in the investigation of the structural and formal potentials of reinforced concrete, the material characteristic of much recent construction. Its use for radically thin shell construction will be discussed below. Here it is worth noting that the extreme pliability of concrete, as opposed to the rigidity of structural steel, has led to the reappearance of curves, both in plane and section, which, whether in architecture or engineering, have profoundly affected the formal quality of much recent construction (plate 380). Parallel with this there

380. Elevated Highway, Berlin, Germany. 1963

occurred the fragmentation, or disassembling, of the International Style cube with its repetitive two-dimensional surfaces. The wall can now be treated as a series of separate panels, for windows as well as for solid areas, which can be placed at varying distances from the hypothetical plane of the façade, or even at right angles to it. The result is an emphasis upon three-dimensionality which was impossible when the

381. FRANK LLOYD WRIGHT. The Solomon R. Guggenheim Museum, New York. 1942–59. View of the spiral ramp

wall was treated merely as a thin skin of stucco or glass hung on a wood or metal frame. A further consequence of the fragmentation of the cube is that the structure and the relation of the materials to the structure are more frankly stated. A window, for example, released from its traditional frame, can become a translucent section of wall, often as a narrow vertical panel. Since it admits as much light as the conventional window, it allows the wall to be handled in broader, freer planes. Whether bearing or not, a wall can be treated as a plane detached in space, placed even at right angles to the plane of the window, or entirely separate from it. The result, in recent years, has been the creation of many buildings whose architectural logic has been discovered in the process of design, rather than deduced from a predetermined aesthetic, even one originally as bold and rational as that of the International Style. Much of the most interesting contemporary design can be seen as an answer to the basic question which the American architect Louis I. Kahn (born 1901) has said that he puts to each new architectural problem: "What form does the space want to become?"[1]

Three recent buildings, each an original and entirely mid-twentieth-century solution for the enclosure of space for specialized functions, exemplify important aspects of this development. The Solomon R. Guggenheim Museum in New York, the only structure in that city designed by Frank Lloyd Wright, was conceived as a circle in plan and a helix in three dimensions, with the interior circular ramp rising through six complete turns, each larger than the one below (plate 381). The building was originally designed in 1942–1943 but was not built until 1956–1959 after numerous modifications had been made to conform to the municipal building code. The whole now is neither so clear nor so subtle as Wright intended, and the smoothly stuccoed exterior has something of the makeshift character of such temporary examples of the International Style as exposition pavilions, but the interior is one of the boldest and most imaginative of Wright's concepts. It may not be entirely suited to its purposes, for it imposes arbitrary limitations on the exhibition of works of art, as Wright foresaw, but as an experience of continuous, expanding circular space it is unrivaled. Such space was Wright's primary consideration; neither structure nor material was thought significant in itself.

Wright's museum, for all the brilliance of its interior, could be thought functionally irresponsible. The contrary is true of the Richards Medical Research Building for the University of Pennsylvania (1957–

1961; plates 382, 383) by Louis I. Kahn. Here the working spaces are sheathed in glass and stacked by stories clearly separated from the seemingly freestanding towers which contain the service stairs, elevators, and intricate air-conditioning machinery for the biological laboratories. The massing of the towers recalls Wright's Larkin Building, and the alternation of glass, brick, and concrete resembles Le Corbusier's Maisons Jaoul (plate 386); but such reminiscences in no way compromise the originality of the massing, particularly in the separation of horizontally stacked and open "served" spaces from the monolithic opaque towers enclosing the "servant" areas. With convincing power and monumental scale Kahn found a symbolic as well as functional solution for a type of academic building which had often been indistinguishable from a factory or other commercial structure when it was not cloaked with irrelevant historical detail (as in the Tudor Sterling Chemistry Laboratories, of 1930, at Yale University).

Although in Kahn's building the alternation of glass and brick, as well as the vertical separation of voids and solids, effectively fragments the basically cubical mass, all the parts are still rectilinear and are derived from the traditional post-and-lintel structure. On the contrary, the controlling elements in the design and structure of the Trans World Airlines terminal (1956–1962) at John F. Kennedy Airport, New York, by Eero Saarinen (1910–1961) are curved in plan and section. Alone among the terminals at the airport this was conceived as a system of curving surfaces and molded spaces capable of enclosing large groups of people and of directing them to and from the planes (plate 384). On the exterior the symmetrical "butterfly" wings over the central concourse possibly fail to suggest the size of the whole building, but no such timidity of scale occurs within, where the central hall, opening toward the airfield through a great window, divides and disappears into the tunnels leading to the arrival and departure areas. The construction of the curving surfaces, which avoid simple verticals wherever possible, required mathematical calculations of the greatest complexity and could only have been executed in reinforced concrete. Not metal alone, and certainly neither brick nor stone, could have been easily or economically used for these continuously warped and turning surfaces. Saarinen also investigated the possibility of a structure curved in plan and section for his Ingalls Hockey Rink (1956–1959) at Yale University. The plan is determined as well as dominated by the huge catenary curve of the single, reinforced concrete arch spanning the long axis from which the

382. LOUIS I. KAHN. Alfred Newton Richards Medical Research Building, University of Pennsylvania, Philadelphia. 1957–61

383. LOUIS I. KAHN. *Plan of Richards Medical Research Building, University of Pennsylvania*

roof is supported by cables running to the low outer walls. Again Saarinen had created a new spatial experience, functionally expressive of the specialized purpose of the building and made possible by the structural potentials of reinforced concrete and steel cables in tension.

The increasing use of concrete in the postwar period can be traced in part to the work of Le Corbusier, who used it in a number of buildings after 1945, including some of the most influential he designed. He first revealed its potentials on a monu-mental scale in his Unité d'Habitation at Marseilles (1946–1952; plate 385), a massive block of two-story apartments separated by broad corridors serving as interior streets with shops and other facilities. The building stands on powerful *pilotis* (see above, p. 347) and carries on its terraced roof inventive concrete structures like immense abstract sculptures, concealing the ventilating stacks. By leaving the poured concrete surfaces throughout the building just as they emerged from the wood forms, he stressed the aggressively tactile texture of this newest of the major building

384. EERO SAARINEN. Interior of the Trans World Airlines Terminal, John F. Kennedy International Airport, New York. 1956–62

423

385. LE CORBUSIER. Unité d'Habitation, Marseilles, France. 1946–52

materials. Since the actual walls of this building are set back behind concrete sun-breaks, the exterior has a strongly plastic appearance. Space is no longer stopped by a sheer wall, as it had been in his earlier and smaller apartment houses, but penetrates deep into the long façades of the building. Plasticity is increased by the random disposition of the fenestration, apparently arbitrary, but actually carefully adjusted to the alternation within of small rooms, two-story living rooms, and balconies.

This powerful, more sculptural handling of material is characteristic of Le Corbusier's architecture after 1945. In place of the brilliant but brittle treatment of glass and stucco, as in the Villa Savoye, there appeared certain ideas about brick, stone, and especially concrete, implicit as far back as 1919 in the low curved vaults of his Maison Monol project, and worked out in a more intimate relation to nature in 1935 in a low-lying weekend house near Paris. Then in 1954–1956 came the Maisons Jaoul in Neuilly, again a double house, but on a difficult cramped site. For reasons of economy the materials were ordinary brick, common tile for the exposed interior vaults, and concrete for the massive lintels (plate 386). The basic pattern of verticals and horizontals is integral with Le Corbusier's entire work, but the more massive opposition of crude brick and rough concrete was unexpected in his residential architecture.

In 1950 Le Corbusier was commissioned to plan the new capital of the Punjab at Chandigarh and to design the major administrative buildings of which the Secretariat, the Assembly, and the High Court

have been completed. Because of the heat and the strong Indian sunlight, the interiors of the buildings are recessed behind sun-breaks, and in the High Court (plate 389) the rooms are set back behind the side walls and below the overhanging roof to increase the circulation of air. The concrete structure throughout was left exposed and rough. The effect of these buildings is intensely sculptural, as if the architect had molded his masses in some pliant substance, which indeed concrete is.

The suggestion that a building may be conceived as a sculptural object is even stronger in the pilgrimage church at Ronchamp (1950–1955; plates 387, 388) in the foothills of the Vosges. For reasons which had nothing to do with functional, in this instance liturgical, requirements, the walls were pulled and stretched, the thin reinforced concrete roof was pulled down over one corner like a collapsing sail, while the chapels were pushed upward as hooded towers serving as light shafts. The interplay of flat and rounded surfaces, with the seemingly impenetrable walls pierced with tiny windows randomly arranged, and the disparity of the façades are provocative, but the architectural rationale remains obscure. Because, as Le Corbusier said, "the requirements of religion have had little effect on the design, [so that] the form

386. LE CORBUSIER. Maisons Jaoul, Neuilly-sur-Seine, France. 1954–56

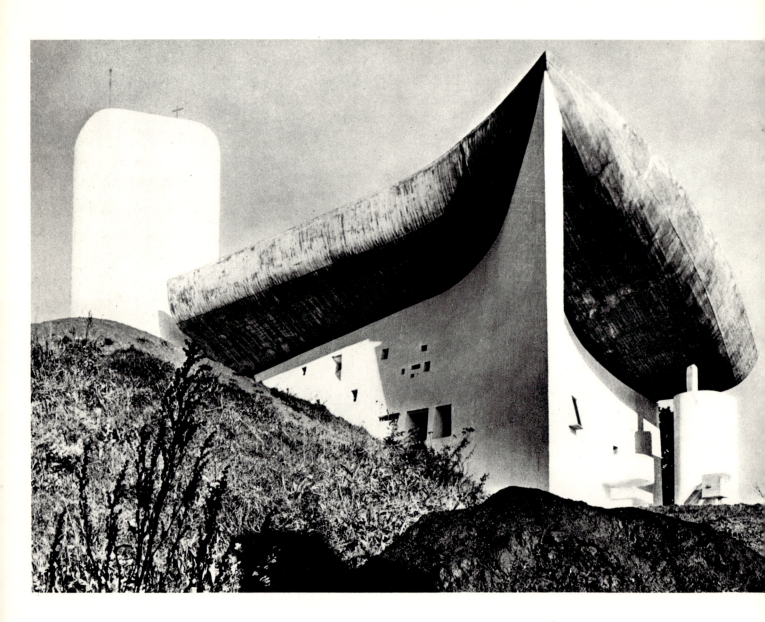

387. LE CORBUSIER. Notre-Dame-du-Haut,
Ronchamp, France. 1950–55

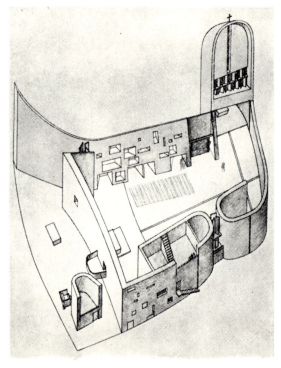

388. LE CORBUSIER. *Isometric Diagram of Notre-Dame-du-Haut,
Ronchamp*

389. LE CORBUSIER. High Court Building, Chandigarh, India. 1951–56

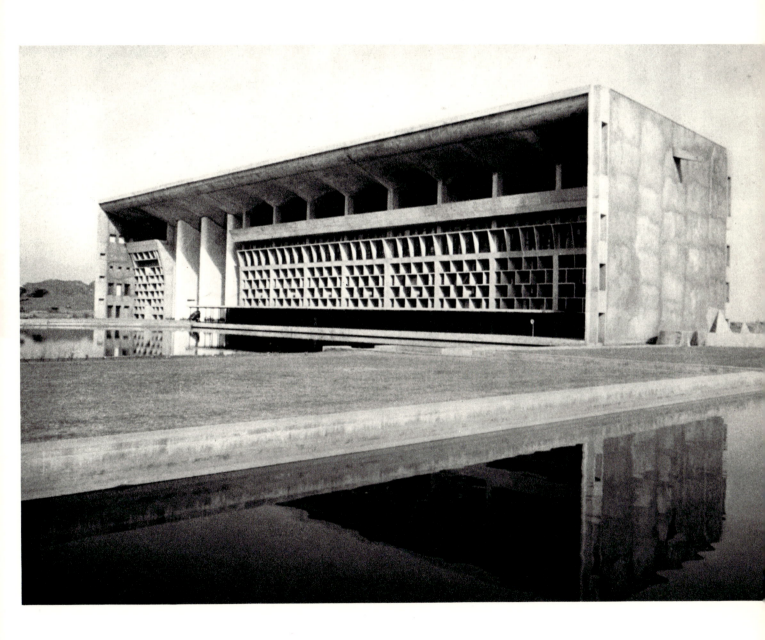

was an answer to a psycho-physiology of the feelings," one might think that he had succumbed to his own self-consciously aesthetic definition of an architect as one who "by his arrangement of forms realizes an order which is a pure creation of his spirit." But immediately afterwards, he designed the awesome abbey of La Tourette at Eveux-sur-Arbresle near Lyon with all his earlier command of architecture as "the masterly, correct, and magnificent play of masses brought together in light."[2]

Although in his lifetime Le Corbusier was one of the most renowned of contemporary architects and in recent years has been incontestably the most influential, especially upon the younger generation, his presence in this country can be seen only through his participation in the international committee responsible for the disappointingly dry and scaleless Secretariat of the United Nations in New York and in his Carpenter Center for the Visual Arts at Harvard University. The latter incorporates a number of his most personal, even idiosyncratic, devices, including a ramp rising through the center from one street to the next, but the site is unfortunately so confined that the merits of the building are difficult to see. In South America he acted as consultant with a group of Brazilian architects headed by Lúcio Costa (born 1902) and Oscar Niemeyer (born 1907) for the Ministry of Education and Health at Rio de Janeiro. Much of the design is familiar, from the *pilotis* and solid end walls to the rounded masses on the roof concealing the mechanical equipment. The prominent sun-breaks on the north side, a necessity in the equatorial climate, were used there for the first time, but they had already appeared in a project of 1933 for Algiers, and they were to be handled with incomparably more power and variety at Marseilles and Chandigarh.

Le Corbusier's influence can also be seen in Brasilia, the new Brazilian capital. Begun in 1956, this is the most ambitious as well as the most spectacular new city built in recent years. The gigantic and monumental, but very simple, plan by Lúcio Costa, roughly resembling the fusilage and wings of an airplane, culminates in the Plaza of the Three Powers, where Oscar Niemeyer's twin skyscrapers for the executive branch are flanked by the congress halls under a single low, flat roof but distinguished by shallow domes of which the one over the Assembly is inverted. Nearby the long flat roof of the Presidential Palace is supported by Niemeyer's characteristic pointed columns with widely flaring bases. The structural daring of these buildings has almost been their undoing. The ability to span ever wider spaces with prestressed concrete beams can end in an antiarchitectural weightlessness and so drastic a loss of human scale that such a building as the Supreme Court may at times seem no more than an enlargement of the preliminary model (plate 390). The search for an integrated architectural geometry, symbolic of governmental functions, has taken Niemeyer well beyond Le Corbusier's concern with the expression of structure, but his debt to the great European appears in the massive housing in the residential districts which are flatter, more schematic versions of Le Corbusier's Unités d'Habitation at Marseilles and elsewhere.

In Japan Kenzo Tange (born 1913) has found an original solution for the problem which has so often defeated non-European architects and artists in modern times, that of redefining traditional, indigenous styles and techniques in terms of the most advanced concepts of European design. In Tange's Kagawa Prefectural Offices at Takamatsu (1955–1958; plate 391), the post-and-lintel structure of

390. OSCAR NIEMEYER. Supreme Court Building, Brasilia, Brazil. 1958–60

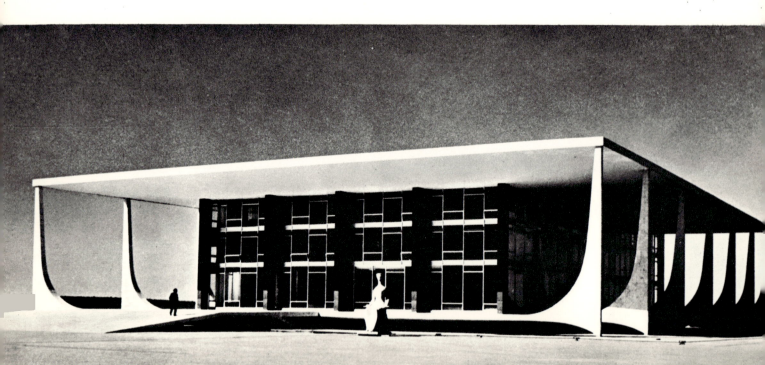

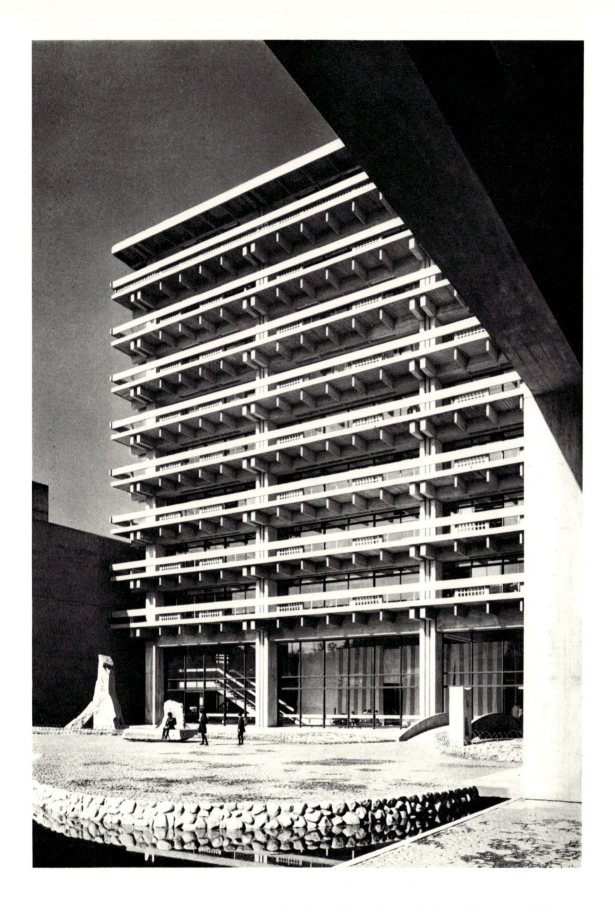

391. KENZO TANGE. Kagawa Prefectural Government Offices, Takamatsu, Japan. 1955–58

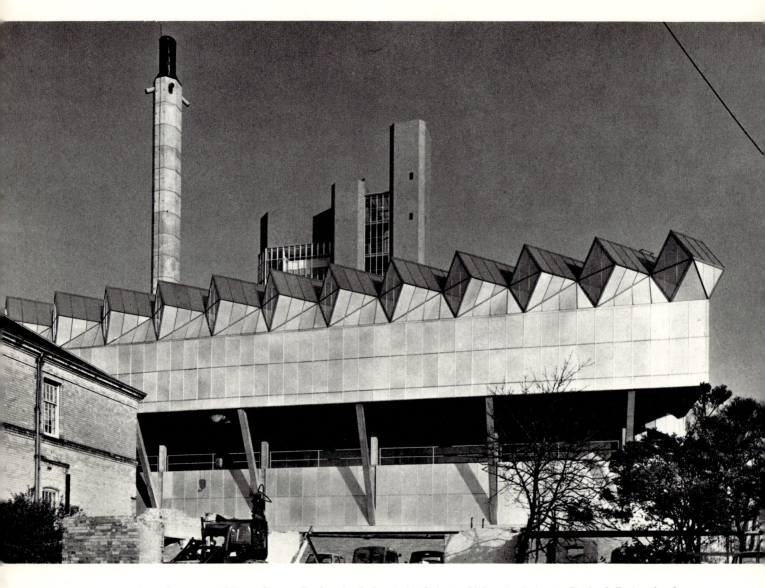

392. JAMES STIRLING and JAMES GOWAN. Engineering Laboratories, Leicester University, Leicester, England. Designed 1963

reinforced concrete, with the surfaces left unfinished, is unmistakably Le Corbusier's, but the proportional system and the delicate interlocking of the members recall the Japanese tradition of monumental architecture composed of many carefully fitted pieces of wood. With traditional Japanese sensitivity for the interrelation of man-made and natural objects and textures, Tange has combined rough natural boulders with his concrete surfaces, even using one as the base for the information·desk in the main hall.

In Europe Le Corbusier, with Mies, has been a dominant influence in a direction within modern architecture—it is too sporadic and diffuse to be defined as a movement—which has been called the New Brutalism. The phrase, which may be traced to Dubuffet's interest in *art brut* (see above, p. 385), as

well as to Le Corbusier's virtuoso treatment of exposed concrete (*béton brut*), was first used in England in 1953 by the architects Peter (born 1923) and Alison (born 1928) Smithson to define a more rigorous attitude toward design and construction than those currently practiced by the older and established British architects.[3] The hesitant semimodern work of the latter can be seen in the new cathedral at Coventry of 1954–1962 by Sir Basil Spence (born 1907), a building whose theatrical spaces and structure are conceived almost entirely as supports for the tapestries, stained glass, and sculpture by such contemporary artists as Graham Sutherland, John Piper, and Sir Jacob Epstein.

In the first Brutalist building in England, a school of 1954 at Hunstanton in Norfolk by the Smithsons,

Miesian virtues of axial symmetry and an elegant linear definition of the façades were as conspicuous as the frank expression of brick and steel and the "brutally" exposed pipes and conduits for the services. Slightly earlier Louis Kahn, in his new Yale University Art Gallery of 1950–1953, had combined a classic feeling for axial planning and crisp detailing of brick, metal, and glass with a ceiling of reinforced concrete tetrahedrons within which the heating and electrical ducts were visible. The same insistence on the undisguised statement of function, structure, and materials reached a notably bold expression in the engineering laboratories at Leicester University, England, designed by James Stirling and James Gowan in 1963. In the workshop block (plate 392) there is no concession whatever to the conventional symbols of academic purpose; yet the building, for all that, is not entirely utilitarian. The range of cubical skylights and the stepped towers of the laboratories and offices are composed with an unexpected feeling for the ordering of forms in space.

firm, The Architects Collaborative, which he founded in 1946. One of Gropius' earliest associates, the Hungarian-born architect Marcel Breuer (see above, p. 352), has also been a gifted teacher and just as wholeheartedly dedicated to the functionalist position. In his first houses in this country he made no concessions to abstract qualities of design; to him as much as to anyone we owe the economical single-pitched roof slanting from its highest point over the principal façade. When two such roofs were set opposite each other, as in his "bi-nuclear houses" of the 1940s, among them the Geller House of 1945 at Lawrence, Long Island (plate 393), the division into separate areas for social life and for sleeping was expressed in the massing, but the roofs themselves create, both within and without, awkward angular junctions in two and three dimensions. More important was the fact that Breuer had broken the magic spell of the international box and henceforward was to create more complex structures, which have immensely enlarged the expressive range of modern architecture.

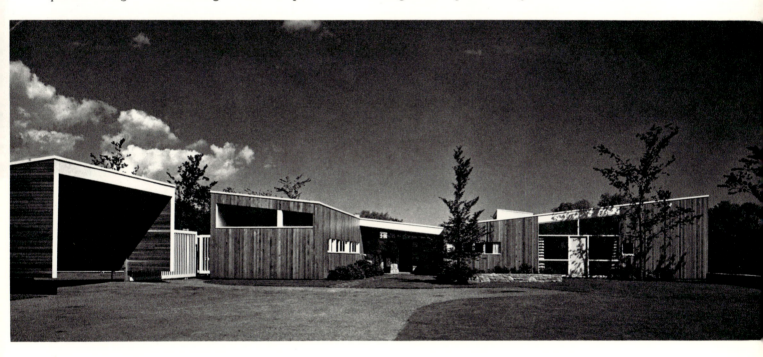

393. MARCEL BREUER. Geller House, Lawrence, Long Island. 1945

Brutalism, if indeed it is a separate stylistic category in modern architecture, is unthinkable outside the continuing tradition of twentieth-century functionalist doctrine, which in this country has been most rigorously and consistently set forth by Walter Gropius when he was head of the Graduate School of Design at Harvard and, since then, through his own

Breuer's ability to achieve a very personal version of the strictly functionalist, Brutalist aesthetic, can be seen in a more recent building, the auditorium and lecture hall for the University Heights campus of New York University. The exterior (1956–1961; plate 394) is determined by the interior dimensions and the pitch of the seats. Form here does follow function, in

394. Marcel Breuer. Lecture Hall, New York University, University Heights, New York. 1956–61

a Sullivanian sense, and the observer's aesthetic must be adjusted to account for it, since there is little likelihood that anything in the immediate past would have prepared him for so stark, even if so powerful, a formal solution to this particular problem.

The new Berlin Philharmonic Concert Hall, where many kinds of musical performances take place, is a less massive but no less functional auditorium, functional in the strict sense that the architectural form was deduced solely from the categorical imperatives of materials and use. The architect Hans Scharoun (born 1893), like Gropius a member of Germany's first modernist generation, decided that acoustical requirements alone should determine the proportions of the interior space, the exterior becoming little more than a close-fitting envelope for the interior. The result was a building apparently irrational as well as irregular from the outside; yet, as it appears in section,

it is internally a volume of exceptional spatial as well as visual complexity (plates 395, 396). No unusual structural techniques were required, and the concrete surfaces were left exposed but for a coat of white paint.

The strict application of structural logic in the development of three-dimensional forms as space enclosures has been carried even further by other notable designers whose study of materials and their structural potentials has led to the invention of new forms in which architectural quality, considered as a sensuous aspect of design, has been considered quite secondary and must usually be deduced from the rigor and clarity of the structure, itself the resolution of an engineering problem. For many years the Italian engineer Pier Luigi Nervi (born 1891) has been a leading exponent of the most rigorous structural rationalism. More than a generation ago, in his municipal stadium in Florence (1930–1932), he proposed,

432

395, 396. HANS SCHAROUN. Interior and Section of the Berlin Philharmonic Concert Hall, Berlin, Germany. 1956–63

397. PIER LUIGI NERVI. Aircraft Hangar, Italy. c. 1938–41. Destroyed

in opposition to the self-contained boxes of the International Style, a frank statement of reinforced concrete construction, and in his six aircraft hangars at Orvieto, Orbetello, and Torre del Lago (1937–1943; plate 397), destroyed in the Second World War, he proved that huge interior spaces could be rapidly and economically constructed with curved and precast concrete units, thereby eliminating the expense and rectilinear restrictions of wooden forms. To Nervi's mind the exceptional beauty of such utilitarian spaces enclosed by his deftly articulated vaulting ribs was only a by-product, even though an inevitable one, of engineering logic. Even the remarkable decorative patterns in his spreading vaults, which have been likened to the fibrous skeletons of gigantic lily pads, are, he insists, the direct expression of engineering principles, nothing more than "a rigid interpretation of structural necessities."[4]

In solving the problem of enclosing spaces vaster than any known or required before, Nervi resolved the baneful nineteenth-century dichotomy between architect and engineer. This can easily be seen in his Palazzetto dello Sport (1957; plate 398) created for the Olympic games in Rome. Between interior and exterior there is the same relationship of structural cause and visual effect which an earlier generation had sought, often in vain, in Gothic architecture. The low domical vault, composed of multiple precast members made up of layers of flexible steel mesh and wire sprayed with concrete, is braced on the exterior by powerful Y-shaped buttresses continuing the arc of the vault. As they emerge from under the skinlike roof, they state with unequivocal clarity their simultaneous functions of thrust and support.

It is regrettable that Nervi's reputation should so long have been limited to Italy and that so many of

his buildings should have been designed for unimportant and transient purposes, such as industrial expositions and sporting events. How well he could have resolved more monumental and symbolic problems can be sensed in his accordion-pleated auditorium for the UNESCO Headquarters in Paris, where he worked in collaboration with Breuer and Bernard Zehrfuss. In the United States he has designed only a bus terminal for the Port of New York Authority at the Manhattan approach to the George Washington Bridge.

Félix Candela (born in Spain 1910) has been largely responsible for a very different development in concrete construction. As a student he admired the work of the Spanish pioneer in reinforced and prestressed concrete, Eduardo Torroja (1899–1961), whose best-known structure may be the fluted roof daringly cantilevered over the stands of the Zarzuela Racetrack near Madrid (1935). Candela, who is also an accomplished mathematician, was inspired by Torroja's later hyperbolic vaults to develop in Mexico, where he has lived since 1939, his characteristic thin curved roofs, sometimes less than an inch thick. The immense strength of prestressed concrete permits the construction of roofs of double curvature, known as hyperbolic paraboloids, which despite their complex curving surfaces can be economically cast from forms built of straight sections of timber. Candela's roofs are often of unexpected complexity as well as elegance. In a restaurant pavilion at Xochimilco (colorplate 64), built in 1951 with Joaquín and Fernando Alvarez Ordoñez, eight groined vaults are

created by the meeting of four double-curving hyperbolic paraboloids.

In this country such construction has met with little interest, perhaps because the thinness of such a roof limits its use to one-story structures. But Candela's work as well as his ideas have been important contributions to new directions in the architecture of the 1960s. His buildings are deliberate criticisms of the International Style, which he felt had too often ignored the determining role of structural systems in favor of a narrow and materialistic interpretation of functionalism.

Among the new architectural images, few have broken so abruptly with tradition, even with the tradition of the new, nor offered such challenging potentials for the future as those created, either actually or theoretically, by the American R. Buckminster Fuller (born 1895). Since he had no professional training either as architect or engineer, he may be described as an inventor or, better, as a philosopher of structure. All his life he has been searching for structural solutions for the environmental problems created by an expanding and changing society. In this search he has been committed to the essential premises of structural logic, the most efficient use of materials, and the most economical methods of mass production. In his first important project, the Dymaxion House (from "dynamic" and "maximum efficiency") (1927; plates 399, 400) the octagonal living floor was supported a full story above the ground by cables in tension from a central mast containing the mechanical equipment. So radical a

398. PIER LUIGI NERVI. Small Sports Palace (Palazzetto dello Sport), Rome. 1957

400. BUCKMINSTER FULLER.
*Elevation and Isometric View
of the Dymaxion House*

399. BUCKMINSTER FULLER. Project for the
Dymaxion House. 1927

401. BUCKMINSTER FULLER. United States Pavilion, Expo 67, Montreal, Canada. 1967

break with the traditional one-family house solidly settled on a small plot of land attracted little attention, but his mechanical and labor-saving devices, then far ahead of the times, have become commonplaces of modern living.

More significant was his invention of the geodesic dome, originally prompted by a commission from the Ford Motor Company for a dome ninety-three feet in diameter for its Detroit factory. For Fuller a dome, which can be expanded to encompass a considerable proportion of a sphere, provides a maximum enclosed

shelter within a minimum enclosing surface. This principle is implicit in the word *geodesic*, which Fuller took from the navigator's geometry of curved surfaces used in plotting great circle routes. Having discovered the ultimate form for his purposes, Fuller then devised a tetrahedral system of lightweight metal and cable construction inexpensive to manufacture and requiring very little time to erect. The functional as well as practical efficiency of such a dome for a variety of purposes has been demonstrated several times, in one 384 feet in diameter for the Union Tank Car

Company in Baton Rouge (1958), in the Climatron for the botanical gardens in St. Louis, and in those for the American pavilions in Moscow (1959) and at Expo 67 in Montreal (plate 401).

Fuller's imagination continues to run ahead of his actual accomplishments, for he has conceived a dome two miles in diameter to embrace central Manhattan. Beneath it millions of people could live and work in an unpolluted, air-conditioned atmosphere. He has also designed another structural system that he calls Tensegrity (tension integrity), in which cables are held in continuous tension by struts in discontinuous compression. The resulting open frames can be cantilevered over considerable distances, creating, like the geodesic domes, large sheltered environments.

By any definition Fuller's stripped spare domes are architectural forms, but it does not follow that he is primarily an architect or that the sum of his inventions exhibits the versatility of structure and form that is usually associated with an architectural system. He stands, rather, as the latest in the line of great engineers, like Paxton and Eiffel in the nineteenth century, whose structural vision eventually changed the course of architecture itself.

Neither the engineer's aesthetic, if such it could be called, nor the dogmas of modern architectural theory and practice, as they had been codified in the International Style, have been decisive factors in the design of many of the most interesting buildings erected since the mid-fifties. Occasionally such buildings have been adversely criticized as instances of an irrational cult of individuality; but if they can be considered as a whole, that is to say, if they do represent a new direction in contemporary architectural thought rather than a series of isolated solutions to particular problems, then they may indeed constitute a positive and progressive change in architectural theory and practice, and not merely a negative reaction against the taste of the preceding generation. If the buildings now to be considered may be described as symptomatic of a post-functionalist rather than an anti-functionalist aesthetic, in that each of them reveals an interest in the nature of materials, in the limitations as well as the potentials of structural systems, and in the obligation to state, if not slavishly to follow, function, nevertheless these three cardinal principles of earlier twentieth-century architecture are now thought of as means rather than as ends, as programmatic bases for a more personal expressiveness. The fact that the later work of Le Corbusier, from the Unités d'Habitation to Ronchamp and the Maisons Jaoul, has been the principal inspiration for the new architecture is as clear as the fact that so

many younger architects have categorically rejected the impersonality and anonymity of Miesian aesthetics. And just as the later architecture of Mies van der Rohe has created a Classicizing situation, in that it has tended toward a more consistent uniformity, so the later architecture of Le Corbusier offered a series of anti-Classic statements, so extraordinarily personal that they can be described as among the most "Romantic" of modern times.

One of the first and one of the most unexpected of the newer romantic structures was Taliesin West, Frank Lloyd Wright's winter home and school near Phoenix, Arizona (begun 1938; plate 402). Its formal and philosophic line of descent from his Wisconsin home, Taliesin East (begun in 1911, burned, rebuilt and enlarged several times during Wright's lifetime), would have been more immediately perceptible had not the intervening house for Edgar J. Kaufmann, Falling Water (plate 326), and a series of related, simpler residences seemed to indicate that Wright had accepted the geometrical design of contemporary European architecture. In Taliesin West, on the other hand, the low battered walls of red desert stone set in concrete, their angle of inclination echoing the pyramidal mountains nearby, and the boldly projecting rafters supporting colored sailcloth awnings above the living and working areas disposed on platforms of various heights, comprised a building that was both logically justifiable in Wright's terms of an organic architecture based upon environment, materials, and use, and at the same time totally in contrast to the conceptually abstract principles of much contemporary European architecture and its American derivatives.

Twelve years later at the farther end of Europe, the Finnish architect Alvar Aalto (born 1898), himself an important early contributor to the International Style with his admirably functional library at Viipuri (1927–1935; destroyed 1940), created a similar "Romantic" solution to a more public problem, the design of a town hall and municipal offices in 1950 for the Finnish community of Säynätsalo (plates 403, 404). There the platform is also important, for the council chamber and offices are entered from a high terrace approached from one side by a wide flight of steps. On the lower level are shops and other offices. More important for the future was Aalto's decision to express the different functions —council chamber, public library, offices—in small separate structures, creating a miniature town within a town, so to speak, as well as to use the indigenous and traditional materials of wood, brick, and stone. The total effect of the variety of forms and roof lines

402. FRANK LLOYD WRIGHT. Taliesin West, Phoenix, Arizona. 1938–59

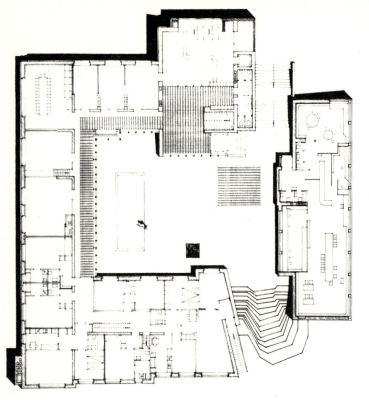

403. ALVAR AALTO.
*Plan of Community Center,
Säynätsalo, Finland*

404. ALVAR AALTO. Town Hall, Säynätsalo, Finland. 1950–52

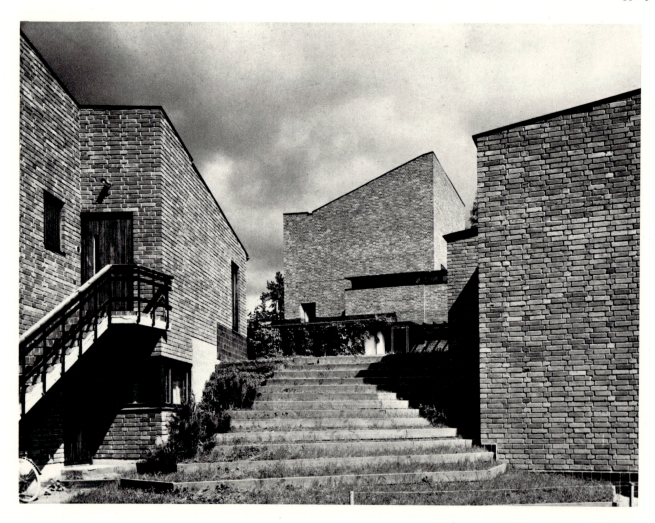

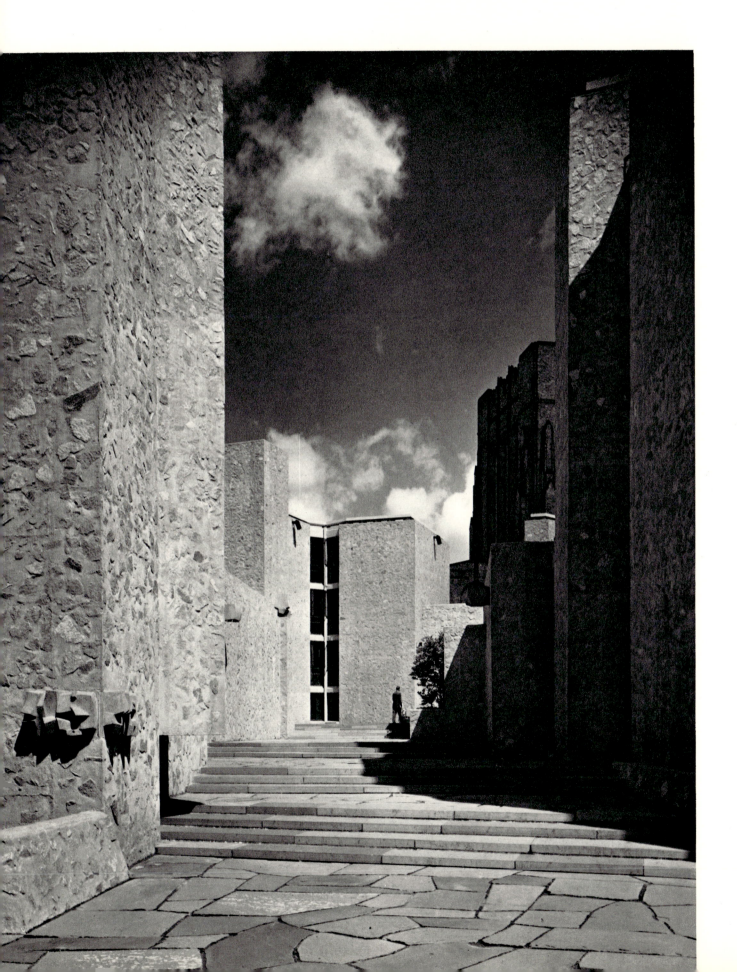

and the contrast of materials could easily have been merely picturesque, like much earlier twentieth-century Scandinavian architecture, notably the City Hall in Stockholm (1909–1923) by Ragnar Östberg (1866–1945), where a desire for formal continuity imposed a delicate but nonetheless overly decorative historicism. In Aalto's complex there were no vestiges of the historical past: plan, form, and detail had been freshly invented.

An extreme example of such personal but entirely contemporary Romanticism, which cannot be confused with traditional historicism, was Eero Saarinen's Ezra Stiles and Samuel Morse Colleges at Yale University (1958–1962; plate 405). Saarinen stated that the steep winding streets and slender towers of San Gimignano, Italy, were the source for his turning stepped walks and the two tall residential units rising beside the lower blocks. The effect of the rough walls of a yellowish aggregate, seemingly unbroken by the windows, which have been relegated to a few vertical bands at the edges of the planes, is undoubtedly dramatic, to some even theatrical, but this effect was carefully calculated. In addition to providing an instructive contrast with the planless and dilapidated urban areas on the fringe of the university, Saarinen so disposed the occasional views which open at the end of his twisting alleys that they frame and emphasize the already histrionic character of the existing Neo-Gothic buildings of the 1930s.

Saarinen's solution for a college dormitory may have looked idiosyncratic, but it was deduced from the implications of a specific problem, of which one of the functions was psychological—the creation of a visually meaningful environment for students. In his earlier Ingalls Rink at Yale, Saarinen had disdained historical prototypes for a building which could have none. And in both the rink and the colleges, form was determined by the integration of structure, materials, and function by a powerful architectural mind.

In other hands, personal solutions to given problems, however brilliant, have sometimes ended in superficial decoration. For the United States Embassy in New Delhi (1957–1959; plate 406) Edward Durell Stone (born 1902) enclosed the building behind a continuous, perforated cast-concrete screen which admits air while controlling the strong sunlight. The result was not only functionally ingenious for a particular climate, but appropriate in the Indian setting. When Stone again wrapped a screen around his circular United States Pavilion at the Brussels Exposition of 1958, the effect was properly festive for the occasion; but when it appeared on buildings of different purposes—for a medical center at Stanford

University (1957–1960) and a factory at Pasadena—what had once been persuasive became too much like a decorative formula. The same reservations might be made for the architecture of Minoru Yamasaki when he swathes his structures in ornamental metallic grilles. Even the massive twin towers of his World Trade Center in New York (plate 338) will rest on the seemingly frail attenuated arcades which have become his trademark.

The unbridled pursuit of personal expression can, of course, prove as misleading as the slavish acceptance of someone else's formula. It may still be too early to judge the unfinished opera house in Sidney, Australia, whose cost has so vastly exceeded the architect's expectations, but already it is clear that Jørn Utzon (born in Denmark 1918) overtaxed the structural system in order to serve the formal symbolism of the steep concrete roofs billowing like sails above the waters of Sidney harbor (plate 407). The Finnish architect Viljo Revell (1910–1964) also strove for a symbolic statement in his new City Hall at Toronto (1958–1965; plate 408). The composition is undeniably impressive, with the low, domed council chamber framed by the arcs of the office wings, but the decision to express the separate but related functions of city and county government imposed unnecessary hardships on those who use the building, because there is no communication between the two wings except at the ground level.

The search for a more individual expression need not, however, lead to decorative indulgence. The dialectic for a more flexible individualistic architecture is already at hand and has been clearly expressed by the Philadelphia architect Robert Venturi (born 1925). In writing of the "complexities and contradictions of architecture," he has said that he believes in "the need to consider the richness of experience within the limitations of the medium," that "contradictory relationships express tensions and give vitality," but that "complexity must be the result of the program."[5] It is just this feeling for the expression of a richer formal experience, within which tensions and contradictions, as in life itself, may visibly as well as structurally exist and qualify the result, that appears as a determining factor in much of the boldest and most interesting contemporary work.

Tension and vitality, as well as the complexities and contradictions of the new architecture, are abundantly demonstrated in the Art and Architecture Building at Yale University (1959–1963; plate 409) by Paul Rudolph (born 1918). Primary visual tensions are established by the contradictions between the massive concrete pylons and heavy crossbeams, reminiscent

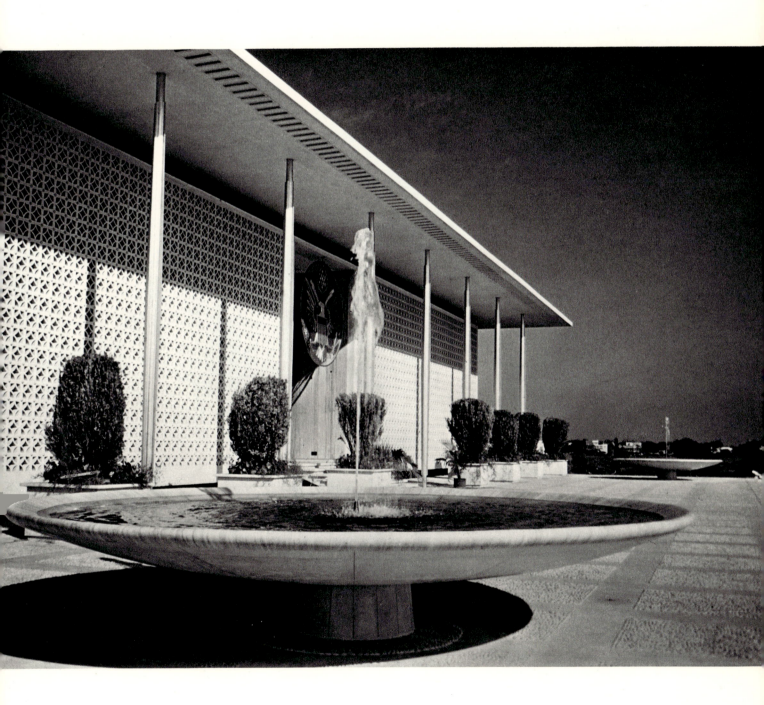

407. Jørn Utzon.
Opera House, Sydney, Australia.
Designed 1956

408. Viljo Revell.
Model for Toronto City Hall.
1958

409. PAUL RUDOLPH. Art and Architecture Building, Yale University, New Haven, Connecticut. 1959–63

of the New Brutalism, and the intricate glazed interpenetrations and elegant texture of the hand-hammered concrete surfaces within and without. The building also exemplifies the continuity of the modernist tradition within the continuing and often revolutionary search for a radically new design. The towering pylons, like Kahn's at the Richards Medical Research Building in Philadelphia (plate 383), recall Wright's Larkin Building, while the distinctions between rough and smooth concrete and between concrete and glass owe something to Wright and, perhaps more, to Cubist painting, as that had been given architectural formulation in the early Wrightian work of the Dutch De Stijl group, as in Oud's study for a factory at Purmerend (plate 316).

The complexity of the interior can be neither photographed nor described. The nine stories (two are below ground) are subdivided into thirty-seven different floor levels, with the interior volumes of exhibition hall, library, studios, and offices interconnecting at different levels to create entirely new and unexpected spatial situations. Here, in Venturi's sense, the complexity was truly the result of a program whose multiple requirements could not easily be solved by conventional boxlike areas. If to some Rudolph's building may seem willfully idiosyncratic

(a quality it shares with Le Corbusier's Carpenter Center at Harvard, a structure for a similar purpose), and if it is true that it does not function with equal success for each of its several purposes, it is nonetheless a challenging instance of a remarkable gift which Rudolph has demonstrated on other occasions, especially in his private residences, for the invention of new masses and, within them, of new spaces.

The aesthetic as well as structural potentials of concrete continue to be developed with force and originality in buildings for many different purposes. In designing the National Center for Atmospheric Research, I. M. Pei (born 1917) used native red sandstone in a concrete aggregate, so that in color the building seems to rise naturally from its site high in the Rocky Mountains (plate 410). The functional requirements of the laboratories are boldly expressed in the asymmetrical disposition of the masses, deeply interpenetrated by the windows recessed beneath boldly projecting hoods. Form here is clearly the result of a logical integration of structure and function controlled at every point by an intuitive feeling for proportion and scale.

The fact that lately so many of the most significant new buildings in the United States have been commissioned by college and university authorities argues

410. I. M. PEI. National Center for Atmospheric Research, Boulder, Colorado. 1967

for the sympathetic acceptance of the principles of modern architecture in what but a few decades ago were the strongholds of conservative tradition, as may be seen by looking from the familiar Neo-Gothic and Neo-Georgian residential halls and laboratories to recent buildings on the same campuses. In place of the heterogeneous stylistic traditionalism once obligatory for institutions dedicated to the preservation of past knowledge, many of the new buildings boldly state an academic commitment to the contemporary world. The contrast with the innate conservatism of the majority of commercial and industrial architecture of the past decade is startling. In New York City, the center of so much intellectual and artistic experiment, little or no experimental architecture has been built since the Guggenheim Museum (plate 381). Most office buildings repeat the standard formula of a skin of glass and plastic panels wrapped around a metal cage. Among the recent tall buildings on Park Avenue which have replaced the sedate but stylistically homogeneous hotels and apartment houses built in the 1920s, only Lever House and the Seagram Building (plates 334, 335) have been notable, and then less for any structural novelties than for their partial use of the available land, whereby they have slightly relieved the growing congestion of midtown Manhattan. But that further refinement is still possible within a fixed formula Eero Saarinen proved in one of his last designs, the headquarters building for the Columbia Broadcasting System on the Avenue of the Americas at 52nd Street (plate 411). Because the projecting triangular dark granite spandrels, which run uninterruptedly the entire height, mask the windows of each side wall when the building is seen from an angle, the whole gains a quality of mass and solidity difficult to attain when the walls are exposed as flat screens.

There are economic as well as intellectual reasons for the mediocrity of much commercial building and for the more adventurous character of some academic architecture. Corporation executives, who must consider economy in construction and maintenance, tend to like the proven package, while academic authorities, for the same reasons, have sometimes taken incalculable risks. Because the cost of urban real estate can also inhibit experimental design, many of the most interesting commercial and industrial buildings are in suburban or country locations, a tendency first evident on a considerable scale in Eero Saarinen's General Motors Technical Research Center of 1949–1956 at Warren, Michigan.

Urban universities may also often be hard-pressed for land, but they have encouraged many new approaches to familiar problems. The Married Student

411. EERO SAARINEN. Columbia Broadcasting System Headquarters Building, New York. Designed 1961

412. José Luis Sert. Francis Greenwood Peabody Terrace (Married Student Housing), Harvard University, Cambridge, Massachusetts. 1962–64

Housing at Harvard by José Luis Sert (born Barcelona 1902), dean of the Graduate School of Design at Harvard, exemplifies concepts which have long been ignored by those responsible for the degrading monotony of so much low-cost housing here and abroad. The commanding appearance of Sert's Housing (1962–1964; plate 412) demonstrates his belief that "in terms of clusters of buildings on the scale in which we are going to build in the near future, sequence, size, and relationship will change, in terms of color, texture, and scale, when we think of things seen from a moving car or as a pedestrian."[6]

For the motorist on the opposite bank of the Charles River, the Housing is a constantly changing composition of three tall towers, the more various because the westernmost, by being placed at a slight angle to the other two, accommodates the group to the sweeping curve of river and drive. Despite the height of the twenty-two-story towers, a residential scale is achieved by joining them with low, seven-story blocks flanking two closed courts. Additional visual variety is gained by varying the fenestration of their façades according to orientation and view. Sert's uncompromising exposure of his inexpensive materials—concrete,

brick, and tile—may at first seem almost too ruthless, like the similarly harsh conflict of forms for the expression of multiple functions in his Law and Education Building for Boston University, eastward across the river. Repeated acquaintance with both groups proves that the strength of his work, and it *is* strong, derives from subtleties of proportion in the design of the parts as well as of the whole, and from a constant concern for the relation of abstract architectural form to human use.

With the exception of Le Corbusier's Maisons Jaoul (plate 386) the recent buildings here discussed have all been designed for institutional, commercial, and industrial, or other public purposes, such as mass housing. And they have, as a group, accounted for many of the principal new public functions of contemporary society. The private residence is not a new function, but it has rarely been the primary concern of many prominent architects. In the socialist countries of Eastern Europe the very concept of private housing is rejected, and it may well be that freedom for imaginative invention, which the creation of the best residential architecture has always required, can no longer be found except where there exists a reasonably free and prosperous economy. In the Western democracies, rising construction costs have encouraged the builder-contractor, whose designless houses, quickly erected in endless multiples of identical patterns, reached their climax, to mention only the most conspicuous American examples, in the senseless and insensitive Levittowns.

Two houses must suffice to demonstrate the variety of expressive form in contemporary American residential architecture. In a house on the shore at Mamaroneck, New York (plate 413), Ulrich Frantzen (born Germany 1921) placed three rectangular towers containing the lesser rooms and services around a two-story living pavilion, where the glass walls permit the integration of indoor and outdoor living so prized today. The dramatic contrast between open

413. ULRICH FRANTZEN. Lawrence Buttenwieser House, Mamaroneck, New York. 1962

and closed geometrical forms, and between opaque and translucent materials, is typical of Frantzen's ability to discover imaginatively new forms within a philosophy of abstract design ultimately to be traced to the masters of the International Style. An opposite but equally valid direction in contemporary American residential architecture can be seen in a house designed for his own use by Neil Astle (born 1933) in Omaha, Nebraska (plate 414). Wood, the most familiar material throughout the history of American architecture—and the only traditional material in the Prairie states—economically permits the maximum statement of each interior space as a separate external mass. But the cluster of masses is not so randomly

disposed as it looks, because the position and proportions of each has been determined by the interaction of material, structure, and plan. The result recalls Robert Venturi's admonition that complexity must arise only from the necessities of the program.

Such houses are principally found in suburban or country environments, now that the urban town house has almost disappeared because of the high cost of land and the need for multiple housing within the city. In the city itself the major concern since 1945 has been the elimination of slums and the rebuilding of the central core for administrative, institutional, and commercial use. The numerous urban renewal projects throughout the country have

414. Neil Astle. Residence of the Architect, Omaha, Nebraska. 1968–69

415. Kallmann, McKinnell, and Knowles. City Hall, Boston, Massachusetts, 1970

swept away many deteriorated areas—even if they have not replaced them with new construction of much distinction. In the older cities the conflict of interest between the economic and financial need for new buildings and the cultural obligation to preserve older ones with important historical and aesthetic associations is not easily resolved. In Philadelphia the juxtaposition of I. M. Pei's brittle high-rise housing on Society Hill (plate 416) with the remaining eighteenth- and early nineteenth-century buildings now isolated in open lots creates a disturbing loss of scale and of visual relevance. In Boston, on the other hand, the new Government Center rising in the North End preserves an appropriate urban density lightened by the broad plaza around the new City Hall (plate 415). The design for this building, the result of the first competition for an American city hall since 1915, by Gerhard Kallmann, N. M. McKinnell, and E. F. Knowles, is a radical departure from the general run of municipal architecture. The massive concrete framework, rising from a base of the familiar Boston red brick, owes much to Le Corbusier, especially to the abbey of La Tourette, in the contrast between the irregularly spaced piers below and the close rows of windows above, but the divisions between the stories have their own functional logic. The large lower story is open so that pedestrian traffic may move freely, not only into the building, but through it and out across the square. Above this, the different openings of the façade express the variety of ceremonial and public functions of the municipal officers. Above that are the rows of smaller offices.

Of the other buildings in the Center, the drily

416. I. M. PEI. Society Hill Apartments, Philadelphia. 1965

rectilinear federal office building by Walter Gropius and The Architects Collaborative, begun before the area as a whole was studied, has been included in the general plan. To the north will rise the Service Center, incorporating three separate blocks of offices by as many firms, with Paul Rudolph as co-ordinating architect of the triangular site. His hand may be felt in the dominating tower of exposed reinforced concrete with its circular Corbusian projections. The adjustment of the several buildings in the Government Center to the existing pattern of curved streets, to the simple surviving commercial buildings of the nineteenth century, and to such historical structures as Faneuil Hall, suggests that the general plan is an unusually sensitive accommodation of the necessities of modern times to the values of a unique urban tradition. As these buildings rise from the vast site cleared in the Boston slums, it is possible to think that from the dismemberment of the International Style and the extremities of the New Brutalism there is emerging an architecture more complex, as well as more refined, than any we have recently known. A brilliantly imaginative example of the kind of architecture which may lie ahead of us, and which may help to loosen, for the cities at least, the conventions of the glass and metal box, is the new building for the Ford Foundation in New York City by Kevin Roche and John Dinkeloo (plate 417), where behind the clean lines of the glass and dark brown granite façade lies an open space, planted with trees and shrubs and rising the full height of the building to a skylight. Behind it are the floors of offices whose window walls look down into a natural environment unique in the metropolis.

7. KEVIN ROCHE and JOHN DINKELOO. Ford Foundation Building, New York. 1967

Notes

1 ROMANTIC CLASSICISM

1. For the history and present condition (unfortunately now actually ruinous) of this most famous of French artificial ruins, see Olivier Choppin de Janvry, "Avant que disparaisse à jamais le Désert de Retz," *L'Oeil*, No. 151–53, September, 1967, pp. 30–41.
2. From Jefferson's report of a conversation with John Adams, recorded in his diary March 16, 1788. See P. S. Foner (ed.), *Basic Writings of Thomas Jefferson* (New York: Wiley Book Co., 1944), p. 288.
3. *The Papers of Thomas Jefferson*, ed. J. Boyd (Princeton University Press, 1950 —), VIII, 34–35; XI, 266.

2 ROMANTICISM AND ROMANTIC ART

1. G. F. Hegel, "Lectures on Aesthetics" (Heidelberg, 1818), in *The Philosophy of Hegel*, trans. B. Bosanquet and W. M. Bryant, ed. C. J. Friedrich (New York: Modern Library, 1954), p. 351.
2. "Thanatopsis" (1811), ll. 1–3.
3. "Childe Harold's Pilgrimage," III, 6: "Tis to create, and is creating live / A being more intense, that we endow / With form our feeling. . . ."
4. This *surtout de table* is now in the Walters Art Gallery, Baltimore. For Barye's discovery of an exotic, hence "romantic," imagery in Persian miniatures for the centerpiece, see G. H. Hamilton, "The Origin of Barye's Tiger Hunt," *Art Bulletin*, XVIII (1936), 249–57.
5. In *The Landscapes of Frederick Edwin Church: Vision of an American Era* (New York: G. Braziller, 1966) David C. Huntington has examined the expressive content of Church's landscapes and the cultural significance of Olana, recently designated a historic landmark.

3 FROM ROMANTIC REALISM TO NATURALISM AND IMPRESSIONISM

1. From Courbet's preface to the catalogue of his independent exhibition in 1855; English translation in

Gerstle Mack, *Gustave Courbet* (New York: A. A. Knopf, 1951), pp. 136–37.

2. From Courbet's letter to his students, December 25, 1861; partial English translation in Mack, *op. cit.*, pp. 162–63.
3. For the difficulties both critics and public encountered in "seeing" the new painting of the 1860s and 1870s, see G. H. Hamilton, *Manet and His Critics* (New Haven: Yale University Press, 1954).
4. Degas, quoted by George Moore in *Impressions and Opinions* (London: D. Nutt, 1891), p. 313.
5. Renoir to Mme Georges Charpentier, February (?), 1882, in Michel Robida, *Le Salon Charpentier et les impressionnistes* (Paris: Bibliothèque des Arts, 1958), p. 140.
6. For an account of the trial see E. R. and J. Pennell, *The Life of James McNeill Whistler* (2 vols; Philadelphia: Lippincott, 1908), chap. XIX.

4 POSTIMPRESSIONISM AND SYMBOLISM

1. The term was first used by the English critic Roger Fry for the title of his exhibition, "Manet and the Post-Impressionists," held at the Grafton Galleries, London, November, 1910—January, 1911.
2. For the possible effect of elapsed time during the creation of his work on Cézanne's technique, and the relation of the expressive results to contemporary philosophical speculations, see G. H. Hamilton, "Cézanne, Bergson, and the Image of Time," *College Art Journal*, XVI (1956), 2–12.
3. The most important contemporary treatise on the subject was Paul Signac's *D'Eugène Delacroix au Néo-Impressionnisme* (new ed., Paris: H. Floury, 1911).
4. Structural aspects of Postimpressionist art were stressed at the expense of expressive elements in Robert Rey's important formulation, *La Renaissance du sentiment classique* (Paris: G. Van Oest, 1931).
5. "Définition du Néo-traditionnisme," *Art et Critique*, August 23, 1890, reprinted in his *Théories, 1890–1910* (Paris: L. Rouart and J. Watelin, 1920), p. 1.
6. Musée Gustave Moreau, *Catalogue sommaire . . .* (Paris, n.d.), p. xiii.
7. Odilon Redon, *A Soi-même: Journal (1867–1915)* (Paris: H. Floury, 1922), p. 30.
8. For Rodin's treatment of the fragment as an artistic entity see J. A. Schmoll, *gen.* Eisenwerth, *Das Unvollendete als Künstlerische Form* (Bern and Munich: Francke, 1959).

5 ARCHITECTURE IN EUROPE AND THE UNITED STATES: 1850–1910

1. Louis Sullivan, "Ornament in Architecture" (1892), reprinted in *Kindergarten Chats and Other Writings* (New York: Wittenborn, Schultz, 1947), pp. 187–88.
2. Sullivan's dictum had been partly based on an analogy with natural processes: "Each one of these blooming trees has a function and the form of each follows that function with absolute fidelity." Thence he deduced that "good architecture must, first of all, clearly correspond with its function, must be its image." For his argument see *Kindergarten Chats*, pp. 42–49.

6 FAUVISM AND EXPRESSIONISM

1. For the earliest use of the word "expressionist" in this sense, see Peter Selz, *German Expressionist Painting* (Berkeley: University of California Press, 1957), p. 11.
2. The term seems to have been first used in 1906. See A. H. Barr, Jr., *Matisse: His Art and His Public* (New York: Museum of Modern Art, 1951), p. 56.
3. First published in *La Grande Revue*, Paris, December 25, 1908; English translation by Margaret Scolari in Barr, *op. cit.*, pp. 119–23.
4. See particularly Denys Sutton, *André Derain* (London: Phaidon Press, 1959), and the catalogue of the Arts Council's Derain exhibition in Edinburgh, 1967.

7 CUBISM AND FUTURISM

1. Dora Vallier, "Braque, la peinture et nous," *Cahiers d'Art*, XXIX (1954), 15.

2. The distinction between Analytical and Synthetic Cubism was first made by the painter Juan Gris in 1924 in a lecture at the Sorbonne, "On the Possibilities of Painting," reprinted in Douglas Cooper's English translation of Daniel-Henry Kahnweiler's *Juan Gris, His Life and Work* (London: Lund Humphries, 1947; New York: Valentin, 1947), pp. 129–44.

3. Guillaume Apollinaire, *The Cubist Painters: Aesthetic Meditations 1913* (New York: Wittenborn, Schultz, 1949), p. 18.

4. Kahnweiler, *op. cit.*, p. 138.

5. For the description of a slightly later but even more rigorous Cubist analysis of an object in space, leading to the unitary synthesis of multiple views, see G. H. Hamilton, "The Dialectic of Later Cubism: Villon's Jockey," *Magazine of Art*, November, 1948, pp. 268–72. The metaphysical implications of Cubist technique have been explored by Christopher Gray in *Cubist Aesthetic Theories* (Baltimore: Johns Hopkins Press, 1953).

6. For Marinetti's first Futurist manifesto in English translation see Joshua C. Taylor, *Futurism* (New York: Museum of Modern Art, 1961), pp. 124–25.

7. From Boccioni's "Technical Manifesto of Futurist Sculpture," reprinted in translation in Taylor, *op. cit.*, pp. 129–30.

8 ABSTRACT ART

1. *Discourses on Art*, ed. R. R. Wark (San Marino, Calif.: Huntington Library, 1959), p. 177.

2. "The School of Giorgione" (1877), frequently reprinted in his collection of essays, *The Renaissance: Studies in Art and Poetry.*

3. *The Complete Letters of Vincent van Gogh* (Greenwich, Conn.: New York Graphic Society, 1958), II, Letter 429 [Nuenen, autumn, 1885]; for Gauguin's statement see Maurice Denis, "L'Influence de Paul Gauguin," *Théories, 1890–1910*, pp. 166–78.

4. But see Daniel Robbins, "Vassily Kandinsky: Abstraction and Image," *Art Journal*, XXII (Spring, 1963), 145–47.

5. Malevich's ideas, as formulated for his course at the Bauhaus in 1926, will be found in his *Die gegenstandslose Welt*; English translation by Howard Dearstyne as *The Non-Objective World* (Chicago: Theobald, 1959).

6. Pevsner's and Gabo's Realist manifesto is reproduced in facsimile from the only known copy, now in the Yale University Library, in *Gabo: Constructions, Sculpture, Paintings, Drawings, Engravings* (Cambridge: Harvard University Press, 1957), opp. p. 151.

7. From "On Constructive Realism," Gabo's Trowbridge Lecture at Yale University (April, 1948), in K. S. Dreier, J. J. Sweeney, and N. Gabo, *Three Lectures on Modern Art* (New York, 1949).

8. Mondrian's ideas may be found in his important essays, *Plastic Art and Pure Plastic Art, 1937, and Other Essays, 1941–1943* (New York: Wittenborn, 1945).

9. From László Moholy-Nagy's manifesto of 1922, "The Dynamic Constructive System of Forces"; partially reprinted in English translation in *The New Vision* (New York: Norton, 1938), p. 138.

9 DADA AND SURREALISM

1. Hugo Ball, "Cabaret Voltaire" (broadside; Zurich, 1916).

2. For the analysis and evaluation of the *Large Glass*, see R. Hamilton and G. H. Hamilton, *The Bride Stripped Bare by Her Bachelors, Even: A Typographic Version* (New York: Wittenborn, 1960).

3. For Duchamp's ready-mades, see Walter Hopps, Ulf Linde, and Arturo Schwarz, *Marcel Duchamp: Ready-Mades, Etc., 1913–1964* (Paris: Le Terrain Vague, 1964).

4. The neologism "cervellités" occurs in Duchamp's note, "identifying / To lose the possibility of recognizing ..."; English translation in R. Hamilton and G. H. Hamilton, *op. cit.*, unpaginated.

5. The complete version of this essay was published in Breton's *Le Surréalisme et la peinture* (New York: Brentano's, 1945); partial English translation in his *What Is Surrealism?* ed. H. E. Read, "Criterion Miscellany," No. 43 (London: Faber & Faber, 1936).

6. From Breton's definition of Surrealism in his first Surrealist manifesto, frequently reprinted, as in *Les Manifestes du Surréalisme* (Paris: J. J. Pauvert, 1962).

7. Max Ernst, *Beyond Painting, and Other Writings by the Artist and His Friends* (New York: Wittenborn, Schultz, 1948), pp. 7–8.
8. Max Ernst, "Les Mystères de la forêt," *Minotaure*, Nos. 5–6, 1934; quoted in *Max Ernst* (New York: Museum of Modern Art, 1961), p. 17.
9. *The Secret Life of Salvador Dali* (New York: Dial Press, 1942), p. 272.
10. André Breton, *What Is Surrealism?* (London, 1936), p. 64.

10 AMERICAN PAINTING: 1900–1940

1. Arthur G. Dove, "A Way to Look at Things" (1925), in Frederick S. Wight, *Arthur G. Dove* (Berkeley: University of California Press, 1958), p. 50.
2. Charles Sheeler, "A Brief Note on the Exhibition," in *Paintings, Drawings, Photographs* (New York: Museum of Modern Art, 1939), p. 10.
3. Stuart Davis, in E. C. Goossen, *Stuart Davis* (New York: G. Braziller, 1959), p. 21.
4. Edward Hopper, "Notes on Painting," in *Edward Hopper* (New York: Museum of Modern Art, 1933), p. 17.

11 EUROPEAN AND AMERICAN SCULPTURE: 1900–1940

1. The *Age of Bronze* (the present title, with its overtones of Darwinian anthropology, is itself symbolic) was first exhibited in 1877 as *The Vanquished*, apparently in reference to the defeat of France in the Franco-Prussian War of 1870.
2. Clive Bell, *Art* (New York: Putnam's, 1958), p. 17.
3. André Gide, "Promenade au Salon d'Automne," *Gazette des Beaux-Arts*, XXXIV (1905), 476.
4. *On My Way: Poetry and Essays, 1912 . . . 1947* (New York: Wittenborn, Schultz, 1948), p. 50.

12 TWENTIETH-CENTURY ARCHITECTURE: THE INTERNATIONAL STYLE

1. The term was suggested by Alfred H. Barr, Jr., then director of the Museum of Modern Art, New York, for an exhibition of modern architecture organized by Henry-Russell Hitchcock and Philip Johnson at the museum in 1932. See H.-R. Hitchcock and P. Johnson, *The International Style: Architecture Since 1922* (New York: Norton, 1932).
2. Le Corbusier, *The Modulor: A Harmonious Measure to the Human Scale Universally Applicable to Architecture and Mechanics* (2 vols.; London: Faber & Faber, 1954–58).

13 PAINTING AND SCULPTURE SINCE 1945

1. H. Rosenberg, "American Action Painters," *Art News*, December, 1952, pp. 22–23.
2. From a statement by Rothko in *Fifteen Americans* (New York: Museum of Modern Art, 1952), p. 18.
3. From a statement by Gottlieb in *The New American Painting* (New York: Museum of Modern Art, 1959), p. 36.
4. From a statement by Rauschenberg in *Sixteen Americans* (New York: Museum of Modern Art, 1959), p. 58.
5. From a statement by Albers in *Josef Albers: Paintings, Prints, Projects* (New Haven, Conn.: Yale University Art Gallery, 1956), p. 43.

14 EUROPEAN AND AMERICAN ARCHITECTURE SINCE 1945

1. Vincent Scully, *Louis I. Kahn* (New York: G. Braziller, 1962), p. 22.
2. Le Corbusier, *Towards a New Architecture* (London: John Rodker, 1927), p. 31. See also Le Corbusier, *The Chapel at Ronchamp* (New York: Praeger, 1958).
3. For the history and use of the term see Reyner Banham, *The New Brutalism, Ethic or Aesthetic?* (New York: Reinhold, 1966).

4. Nervi's introduction to *Pier Luigi Nervi: Buildings, Projects, Structures, 1953–1963,* trans. G. Nicoletti (New York: Praeger, 1963), pp. 6–9, is a concise statement of his insistence on the importance of a logical and economic structural system, in opposition to academic and arbitrary formalism.
5. Robert Venturi, *Complexity and Contradiction in Architecture* (New York: Museum of Modern Art, 1966).
6. José Luis Sert in Paul Heyer, *Architects on Architecture: New Directions in America* (New York: Walker, 1966), p. 250.

Bibliography

GENERAL

Arnason, H. H. *History of Modern Art: Painting, Sculpture, Architecture.* New York: Abrams, 1968.

Cassou, J., Langui, E., and Pevsner, N. *Gateway to the Twentieth Century: Art and Culture in a Changing World.* New York: McGraw-Hill, 1962.

Chipp, H. B. *Theories of Modern Art: A Source Book by Artists and Critics.* Berkeley and Los Angeles: University of California Press, 1969.

Delevoy, R. L. *Dimensions of the 20th Century, 1900–1945.* Translated by S. Gilbert. Cleveland: (Skira) World, 1965.

Giedion, S. *Space, Time and Architecture: The Growth of a New Tradition.* Cambridge: Harvard University Press, 1941; 4th ed. 1962.

Gray, C. *The Great Experiment: Russian Art, 1863–1922.* London: Thames & Hudson, 1962.

Haftmann, W. *Painting in the Twentieth Century.* 2 vols. New ed. New York: Praeger, 1965.

Hitchcock, H.-R. *Architecture: Nineteenth and Twentieth Centuries.* ("Pelican History of Art.") Baltimore: Penguin Books, 1958; 2nd ed. 1963.

Hofmann, W. *The Earthly Paradise: Art in the Nineteenth Century.* Translated by B. Battershaw. New York: G. Braziller, 1961.

————. *Turning Points in Twentieth-Century Art: 1890–1917.* New York: G. Braziller, 1969.

Larkin, O. *Art and Life in America.* New York: Rinehart, 1949. Rev. ed. New York: Holt, 1960.

Licht, F. *Sculpture: 19th & 20th Centuries.* Greenwich, Conn.: New York Graphic Society, 1967.

Novotny, F. *Painting and Sculpture in Europe, 1780 to 1880.* ("Pelican History of Art.") Baltimore: Penguin Books, 1960.

Ponente, N. *The Structures of the Modern World, 1850–1900.* Cleveland: (Skira) World, 1965.

Sylvester, D. *Modern Art, from Fauvism to Abstract Expressionism.* New York: Watts, 1965.

1 ROMANTIC CLASSICISM

Friedlaender, W. *David to Delacroix.* Translated by R. Goldwater. Cambridge: Harvard University Press, 1952.

Gardner, A. T. *Yankee Stonecutters: The First American School of Sculpture, 1800–1850.* New York: Columbia University Press, 1945.

Hamilton, G. H. *The Art and Architecture of Russia.* ("Pelican History of Art.") Baltimore: Penguin Books, 1954. Parts IV and V.

Hamlin, T. *Greek Revival Architecture in America.* New York: Oxford University Press, 1944.

Hawley, H. *Neo-Classicism: Style and Motif.* Cleveland Museum of Art, 1964.

Honour, H. *Neo-Classicism.* Harmondsworth, Middlesex: Penguin, 1968.

Kaufmann, E. *Architecture in the Age of Reason: Baroque and Post-Baroque in England, Italy, and France.* Cambridge: Harvard University Press, 1955.

Lees-Milne, J. *The Age of Adam.* London: B. T. Batsford, 1947.

Piranesi. Northampton, Mass.: Smith College Museum of Art, 1961.

Rosenblum, R. (ed.). *Ingres.* New York: Abrams, 1967.

———. *Transformations in Late Eighteenth Century Art.* Princeton University Press, 1967.

Summerson, J. *Architecture in Britain, 1530 to 1830.* ("Pelican History of Art.") Baltimore: Penguin Books, 1954; 4th rev. ed. 1963. Parts IV and V.

2 ROMANTICISM AND ROMANTIC ART

Andrews, K. *The Nazarenes: A Brotherhood of German Painters in Rome.* Oxford: Clarendon Press, 1964.

Brion, M. *Romantic Art.* New York: McGraw-Hill, 1960.

Clark, K. *The Gothic Revival, an Essay in the History of Taste.* New York: Scribner, 1929. 3rd ed. New York: Holt, 1962.

Flexner, J. T. *That Wilder Image: The Painting of America's Native School from Thomas Cole to Winslow Homer.* Boston: Little, Brown, 1962.

Hitchcock, H.-R. *Early Victorian Architecture in Britain.* 2 vols. New Haven: Yale University Press, 1954.

Huyghe, R. *Delacroix.* Translated by J. Griffin. New York: Abrams, 1963.

Ironside, R. *Pre-Raphaelite Painters.* London: Phaidon Press, 1948. New York: Oxford University Press, 1948.

Keyser, E. *The Romantic West, 1789–1850.* Translated by P. Price. Cleveland: (Skira) World, 1965.

Reynolds, G. *Constable, The Natural Painter.* New York: McGraw-Hill, 1965.

Richardson, E. P. *American Romantic Painting,* ed. R. Freund. New York: E. Wehye, 1944.

Rothenstein, J., and Butlin, M. *Turner.* New York: G. Braziller, 1964.

3 FROM ROMANTIC REALISM TO NATURALISM AND IMPRESSIONISM

Bazin, G. *Corot.* 2nd ed. Paris: P. Tisné, 1951.

Goodrich, L. *Thomas Eakins, His Life and Work.* New York: Whitney Museum of American Art, 1933.

———. *Winslow Homer.* New York: Whitney Museum of American Art, 1944. 2nd ed. New York: G. Braziller, 1959.

Gustave Courbet, 1819–1877. Boston: Museum of Fine Arts, 1960.

Herbert, R. L. *Barbizon Revisited.* Boston: Museum of Fine Arts, 1962.

Manet. Philadelphia Museum of Art, 1966.

Nochlin, L. (ed.). *Impressionism and Post-Impressionism, 1874–1904: Sources and Documents.* Englewood Cliffs, N.J.: Prentice-Hall, 1966.

———. *Realism and Tradition in Art, 1848–1900: Sources and Documents.* Englewood Cliffs, N. J.: Prentice-Hall, 1966.

Rewald, J. *Camille Pissarro.* New York: Abrams, 1963.

Degas Sculpture. Translated by J. Coleman and N. Moulton. New York: Abrams, 1957.

———. *The History of Impressionism.* Rev. ed. New York: Museum of Modern Art, 1961.

Seitz, W. C. *Claude Monet.* New York: Abrams, 1960.

Sloane, J. C. *French Painting Between the Past and the Present: Artists, Critics, and Traditions, from 1848 to 1870.* Princeton University Press, 1951.

Sutton, D. *James McNeill Whistler: Paintings, Etchings, Pastels & Watercolours.* London: Phaidon Press, 1966.

4 POSTIMPRESSIONISM AND SYMBOLISM

Benesch, O. *Edvard Munch*. Translated by J. Spencer. London: Phaidon Press, 1960.
Champigneulle, B. *Rodin*. New York: Abrams, 1967.
Chassé, C. *The Nabis and Their Period*. London: Lund Humphries, 1969.
Elsen, A. E. *Rodin*. New York: Museum of Modern Art, 1963.
Goldwater, R. *Paul Gauguin*. New York: Abrams, 1957.
Haesaerts, P. *James Ensor*. Translated by N. Guterman. New York: Abrams, 1959.
Homer, W. I. *Seurat and the Science of Painting*. Cambridge: M. I. T. Press, 1964.
Huisman, P., and Dortu, M. G. *Lautrec by Lautrec*. Translated by C. Bellow. New York: (Studio) Viking, 1964.
Lövgren, S. *The Genesis of Modernism: Seurat, Gauguin, Van Gogh and French Symbolism in the 1880's*. Stockholm: Almqvist & Wiksell, 1959.
The Nabis and Their Circle. Minneapolis Institute of Arts, 1962.
R. L. Herbert. *Neo-Impressionism*. New York: Solomon R. Guggenheim Museum, 1968.
Odilon Redon, Gustave Moreau, Rodolphe Bresdin. New York: Museum of Modern Art, 1962.
Rewald, J. *Post-Impressionism from Van Gogh to Gauguin*. 2nd ed. New York: Museum of Modern Art, 1962.
Schapiro, M. (ed.). *Paul Cézanne*. 3rd ed. New York: Abrams, 1965.
———. *Vincent van Gogh*. New York: Abrams, 1950.
Tralbaut, M. E. *Vincent van Gogh*. New York: (Studio) Viking, 1969.

5 ARCHITECTURE IN EUROPE AND THE UNITED STATES: 1850–1910

Burchard, J., and Bush-Brown, A. *The Architecture of America: A Social and Cultural History*. Boston: Little, Brown, 1961.
Condit, C. *The Chicago School of Architecture*. University of Chicago Press, 1964.
Gifford, D. (ed.). *The Literature of Architecture: The Evolution of Architectural Theory and Practice in Nineteenth-Century America*. New York: E. P. Dutton, 1966.
Hitchcock, H.-R. *The Architecture of H. H. Richardson and His Times*. Rev. ed. Hamden, Conn.: Archon Books, 1961.
Meeks, C. L. V. *The Railroad Station: An Architectural History*. New Haven: Yale University Press, 1956.
A Monograph of the Work of McKim, Mead & White. 4 vols. New York: (Architectural Book Co.) Hastings House, 1915–25.
Morrison, H. *Louis Sullivan: Prophet of Modern Architecture*. New York: Museum of Modern Art, 1935. Gloucester, Mass.: Peter Smith, 1952.
Pevsner, N. *Pioneers of Modern Design, from William Morris to Walter Gropius*. Rev. ed. Harmondsworth, Middlesex: Penguin Books, 1964.
Schmutzler, R. *Art Nouveau*. Translated by E. Roditi. New York: Abrams, 1964.
Scully, V. *The Shingle Style: Architectural Theory and Design from Richardson to the Origins of Wright*. New Haven: Yale University Press, 1955.
Turnor, R. *Nineteenth Century Architecture in Britain*. London: B. T. Batsford, 1950.

6 FAUVISM AND EXPRESSIONISM

The Blue Rider Group. With an introduction by H. K. Röthel. Edinburgh: Royal Scottish Academy, 1960.
Courthion, P. *Georges Rouault*. New York: Abrams, 1962.
Gustav Klimt and Egon Schiele. New York: Solomon R. Guggenheim Museum, 1965.
Haftmann, W. *Emil Nolde*. Translated by N. Guterman. New York: Abrams, 1959.
Leymarie, J. *Fauvism: Biographical and Critical Study*. Translated by J. Emmons. Cleveland: (Skira) World, 1959.
Muller, J. E. *Fauvism*. New York: Praeger, 1967.
Myers, B. S. *The German Expressionists: A Generation in Revolt*. New York: Praeger, 1957.
Painters of the Brücke. London: The Tate Gallery, 1964.
Roh, F. and J. *German Art in the 20th Century*. Greenwich. Conn.: New York Graphic Society, 1968.

Russell, J. *The World of Matisse, 1869–1954*. New York: Time-Life Books, 1968.

Selz, P. *Max Beckmann*. New York: Museum of Modern Art, 1964.

Wingler, H. M. *Oskar Kokoschka: The Works of the Painter*. Translated by F. Budgen *et al*. Salzburg: Galerie Welz, 1958.

7 CUBISM AND FUTURISM

Barr, A. H., Jr. *Picasso: Fifty Years of His Art*. New York: Museum of Modern Art, 1946.

Carrieri, R. *Il Futurismo*. Milan: Edizioni del Milione, 1961.

Daix, P., and Boudaille, G. (eds.). *Picasso: The Blue and Rose Periods, 1900–1906*. Translated by P. Pool. Greenwich, Conn.: New York Graphic Society, 1966.

Drudi Gambillo, M., and Fiori, T. *Archivi del Futurismo*. 2 vols. Rome: De Luca, 1958–62.

Fernand Léger, 1881–1955. Paris: Musée des Arts Décoratifs, 1956.

G. Braque. ("Catalogues of Exhibitions," Vol. VII.) Arts Council of Great Britain, 1956.

Golding, J. *Cubism: A History and an Analysis, 1907–1914*. New and revised edition. London: Faber & Faber, 1959.

Martin, M. W. *Futurist Art and Theory, 1909–1915*. New York: Oxford University Press, 1968.

Rosenblum, R. *Cubism and Twentieth-Century Art*. New York: Abrams, 1961.

8 ABSTRACT ART

Blanshard, F. B. *Retreat from Likeness in the Theory of Painting*. 2nd ed. New York: Columbia University Press, 1949.

Gabo: Constructions, Sculpture, Paintings, Drawings, Engravings. Cambridge: Harvard University Press, 1957.

Grohmann, W. *Wassily Kandinsky: Life and Work*. Translated by N. Guterman. New York: Abrams, 1958.

Jaffé, H. L. C. *De Stijl, 1917–1931: The Dutch Contribution to Modern Art*. Amsterdam: Meulenhoff, 1956.

Paths of Abstract Art. Cleveland Museum of Art, 1960.

Rickey, G. *Constructivism: Origins and Evolution*. New York: G. Braziller, 1967.

Seuphor, M. *Abstract Painting: Fifty Years of Accomplishment from Kandinsky to the Present*. Translated by H. Chevalier. London: Prentice-Hall International, 1962.

———. *Piet Mondrian: Life and Work*. New York: Abrams, 1956.

Wingler, H. M. *Das Bauhaus, 1919–1933: Weimar-Dessau-Berlin*. Bramsche: Rasch, 1962.

9 DADA AND SURREALISM

Dupin, J. *Miró*. Translated by N. Guterman. New York: Abrams, 1962.

Gershman, H. S. *The Surrealist Revolution in France*. Ann Arbor: University of Michigan Press, 1969.

Giedion-Welcker, C. *Jean Arp*. Translated by N. Guterman. New York: Abrams, 1957.

Jean, M., and Mezei, A. *The History of Surrealist Painting*. Translated by S. W. Taylor. New York: Grove Press, 1960.

Lebel, R. *Marcel Duchamp*. Translated by G. H. Hamilton. New York: Grove Press, 1959.

Motherwell, R. (ed.). *The Dada Painters and Poets: An Anthology*. New York: Wittenborn, 1951.

Richter, H. *Dada: Art and Anti-Art*. New York: Abrams, 1970.

Rubin, W. S. *Dada and Surrealist Art*. New York: Abrams, 1969.

Russell, J. (ed.). *Max Ernst*. New York: Abrams, 1967.

Schmalenbach, W. *Kurt Schwitters*. New York: Abrams, 1970.

Schwarz, A. *The Complete Works of Marcel Duchamp*. New York: Abrams, 1969.

Soby, J. T. *Giorgio de Chirico*. New York: Museum of Modern Art, 1955.

———. *Paintings, Drawings, Prints: Salvador Dali*. New York: Museum of Modern Art, 1941; 2nd rev. ed. 1946.

Surrealism. New York: Museum of Modern Art, 1968.

Sylvester, D. *Magritte*. New York: Praeger, 1969.

Waldberg, P. *René Magritte*. Brussels: De Rache, 1965.

10 AMERICAN PAINTING: 1900–1940

Agee, W. C. "Synchromism and Color Principles in American Painting, 1910–1930." *Art in America*, October, 1965.

America & Alfred Stieglitz: A Collective Portrait. Garden City, N.Y.: Doubleday, Doran, 1934.

Baur, J. I. H. *Revolution and Tradition in Modern American Art.* Cambridge: Harvard University Press, 1951.

Brown, M. W. *American Painting from the Armory Show to the Depression.* Princeton University Press, 1955.

———. *The Story of the Armory Show.* Greenwich, Conn.: New York Graphic Society, 1963.

Friedman, M. *The Precisionist View in American Art.* Minneapolis: Walker Art Center, 1960.

Geldzahler, H. *American Painting in the Twentieth Century.* Greenwich, Conn.: (Metropolitan Museum of Art) New York Graphic Society, 1965.

Goodrich, L., and Baur, J. I. H. *American Art of Our Century.* New York: Whitney Museum of American Art, 1961.

Hunter, S. *Modern American Painting and Sculpture.* New York: Dell, 1959.

Janis, S. *They Taught Themselves: American Primitive Painters of the Twentieth Century.* New York: Dial Press, 1942.

New Horizons in American Art. New York: Museum of Modern Art, 1936.

Rose, B. *American Art Since 1900: A Critical History.* New York: Praeger, 1967.

11 EUROPEAN AND AMERICAN SCULPTURE: 1900–1940

Arnason, H. H. *Calder.* Princeton, N.J.: Van Nostrand, 1966.

Geist, S. *Brancusi, a Study of the Sculpture.* New York: Grossman, 1968.

George, W. *Maillol.* Greenwich, Conn.: New York Graphic Society, 1965.

Giedion-Welcker, C. *Contemporary Sculpture: An Evolution in Volume and Space.* Rev. ed. New York: Wittenborn, 1961.

Hammacher, A. M. *Evolution of Modern Sculpture: Tradition and Innovation.* New York: Abrams, 1969.

———. *Jacques Lipchitz: His Sculpture.* New York: Abrams, 1961.

James, P. (ed.). *Henry Moore on Sculpture.* New York: (Studio) Viking, 1967.

Modern Sculpture from the Joseph H. Hirshhorn Collection. New York: Solomon R. Guggenheim Museum, 1962.

Picasso's Sculptures. New York: Museum of Modern Art, 1967.

Read, H. *A Concise History of Modern Sculpture.* New York: Praeger, 1964.

Seuphor, M. *The Sculpture of This Century.* Translated by H. Chevalier. New York: G. Braziller, 1960.

12 TWENTIETH-CENTURY ARCHITECTURE: THE INTERNATIONAL STYLE

Architecture 1949–1965. Philip Johnson. New York: Holt, 1966.

Banham, R. *Theory and Design in the First Machine Age.* New York: Praeger, 1960.

Blaser, W. *Mies van der Rohe: The Art of Structure.* New York: Praeger, 1965.

Boesiger, W., and Girsberger, H. (eds.). *Le Corbusier, 1910–1965.* New York: Praeger, 1967.

Danz, E. *Architecture of Skidmore, Owings & Merrill, 1950–1962.* Translated by E. van Haagen. New York: Praeger, 1960.

Giedion, S. (ed.). *A Decade of New Architecture.* Translated by J. Haymoz. Zurich: Girsberger, 1951. New York: Stechert-Hafner, 1951.

Gropius, W. (ed.). *The Architects Collaborative 1945–1965.* New York: (Architectural Book Co.) Hastings House, 1966.

———. *The New Architecture and the Bauhaus.* Translated by P. M. Shando. New York: Museum of Modern Art, 1937.

Hitchcock, H.-R. *Modern Architecture, Romanticism and Reintegration.* New York: Payson & Clarke, 1929.

Joedicke, J. *A History of Modern Architecture.* Translated by J. Palmes. New York: Praeger, 1959.

Scully, V. *Modern Architecture: The Architecture of Democracy.* New York: G. Braziller, 1961.

Wingler, H. M. *The Bauhaus: Weimar, Dessau, Berlin, Chicago.* Cambridge: Massachusetts Institute of Technology Press, 1969.

13 PAINTING AND SCULPTURE SINCE 1945

Alloway, L. *Systemic Painting.* New York: Solomon R. Guggenheim Museum, 1966.

Brion, M., *et al. Art Since 1945.* New York: Abrams, 1958.

Burnham, J. *Beyond Modern Sculpture: The Effects of Science and Technology on the Sculpture of This Century.* New York: G. Braziller, 1968.

Geldzahler, H. *New York Painting and Sculpture: 1940–1970.* New York: Metropolitan Museum of Art, 1969.

Greenberg, C. *Art and Culture: Critical Essays.* Boston: Beacon Press, 1961.

Hess, T. B. *Abstract Painting: Background and American Phase.* New York: Viking, 1951.

Hill, A. (ed.). *Data: Directions in Art, Theory and Aesthetics.* Greenwich, Conn.: New York Graphic Society, 1969.

Kultermann, U. *The New Painting.* New York: Praeger, 1969.

———. *The New Sculpture: Environments and Assemblages.* London: Thames & Hudson, 1968.

Lippard, L., *et al. Pop Art.* New York: Praeger, 1966.

McShine, K. *Primary Structures.* New York: The Jewish Museum, 1966.

Popper, F. *Origins and Development of Kinetic Art.* Greenwich, Conn.: New York Graphic Society, 1969.

Ritchie, A. C. *Abstract Painting and Sculpture in America.* New York: Museum of Modern Art, 1951.

Rosenberg, H. *Artworks and Packages.* New York: Horizon, 1968.

Russell, J., and Gablik, S. *Pop Art Redefined.* New York: Praeger, 1969.

Sculpture in America Today. Los Angeles County Museum, 1967.

Seitz, W. C. *The Art of Assemblage.* New York: Museum of Modern Art, 1961.

———. *The Responsive Eye.* New York: Museum of Modern Art, 1965.

Selz, P. *The New Images of Man.* New York: Museum of Modern Art, 1959.

14 EUROPEAN AND AMERICAN ARCHITECTURE SINCE 1945

Alvar Aalto: Complete Works 1932–60. New York: Wittenborn, 1963.

Collins, P. *Concrete: The Vision of a New Architecture. A Study of Auguste Perret and His Precursors.* New York: Horizon, 1959.

Drexler, A., and Hitchcock, H.-R. (eds.). *Built in U.S.A.: Post-War Architecture.* New York: Museum of Modern Art, 1952.

Jacobus, J. *Twentieth-Century Architecture: The Middle Years, 1940–1965.* New York: Praeger, 1966.

Marcel Breuer: Buildings and Projects, 1921–1961. New York: Praeger, 1962.

McHale, J. *R. Buckminster Fuller.* New York: G. Braziller, 1962.

Saarinen, A. (ed.). *Eero Saarinen on His Work.* New Haven: Yale University Press, 1962.

Scully, V. *American Architecture and Urbanism: A Historical Essay.* New York: Praeger, 1969.

The Works of Pier Luigi Nervi. Translated by E. Priefert. London: Architectural Press, 1957. New York: Praeger, 1957.

Index

All numbers refer to pages. A number preceded by an asterisk refers to an illustration, with the colorplates further identified, thus: *317 (colorplate).

465

476

List of Credits

The author and publisher wish to thank the libraries, museums, and private collectors for permitting the reproduction of paintings, prints, and drawings in their collections. Photographs have been supplied by the owners or custodians of the works of art except for the following, whose courtesy is gratefully acknowledged.

A.C.L., Brussels (12); Helene Adant, Paris (345); Alinari, Florence (154); Andover Art Studio, Andover, Mass. (256, 311); Wayne Andrews, Grosse Pointe, Mich. (6, 10, 38, 142, 149); T. and R. Annan & Sons, Glasgow (178); Art Commission of the City of New York (59); Arts Council of Great Britain (307); Australian News and Information Bureau, New York, N.Y. (403); Avery Architectural Library, Columbia University, New York, N.Y. (16); Avon Studios, Newport, R.I. (30); Oliver Baker, New York, N.Y. (344); Bibliothèque Nationale, Paris (9); Bildarchiv Foto Marburg, Marburg-Lahn, Germany (22, 173); Bildarchiv, Rheinisches Museum, Cologne, Germany (290); E. Irving Blomstrann, New Britain, Conn. (227); Ferdinand Boesch, New York, N.Y. (373); Trustees of the Boston Public Library (141); The Bostonian Society (133); Brassai, Paris (306); Brazilian Govt. Trade Bureau, New York, N.Y. (389); Marcel Breuer & Assoc., New York, N.Y. (364, 390); Buffalo and Erie County Historical Society (172); Ilse Buhs, Berlin (392); Rudolph Burkhardt (363, 370); Barney Burstein, Boston (413); Leo Castelli Gallery, New York, N.Y. (359, 360); Chevojon, Paris (157); Chicago Architectural Photo Co. (151, 159–63, 165–69); Geoffrey Clements, New York, N.Y. (346); Columbia Broadcasting System, New York, N.Y. (408); Columbus Area Chamber of Commerce, Columbus, Ohio (24); Currier Gallery of Art, Manchester, N.H. (261); A. Devaney, Inc., New York, N.Y. (145); Walter Drayer, Zurich (341); Deutsche Fotothek, Dresden (54); John Ebstel (379); Encyclopedia of Modern Architecture (393); Fishbach Gallery, New York, N.Y. (374); Agnew Fisher, Greenwich, Conn. (88); Fototechnische Dienst, Gemeente Werken, Rotterdam (315); Ulrich Frantzen & Assoc., New York, N.Y. (410); French Government Tourist Office, New York, N.Y. (14, 138); Fuchs-Hoepffner, Hamburg (289); Office of Buckminster Fuller (396); David Gahr, New York, N.Y. (371); Philip Gendreau, New York, N.Y. (144, 153); Photoatelier Gerlach, Vienna (179); The German Archaeological Institute, Rome (2); G. Gherardi-A. Fiorelli, Rome (395); Giraudon, Paris (5, 52, 76, 121, 136); GM Photographic, Detroit, Mich. (225); Gottscho-Schleisner, New York, N.Y. (158); Pedro E. Guerrero, New York, N.Y. (399); The Solomon R. Guggenheim Museum, New York, N.Y. (209, 235, 378); Juan Guzman, Mexico City (colorplate 64); Hans Hammarskiold/Tio, Stockholm (222); Harvard University News Office, Cambridge, Mass. (330); Heikki Havas, Helsinki (400, 405); Hedrich-Blessing, Chicago (171); Lucien Hervé, Paris (382–85); Historical Pictures Service, Chicago (143); Martin Hürlimann, Zurich (27); The Philip Johnson Office, New York, N.Y. (336); Peter A. Juley & Son, New

York, N.Y. (282); A.F. Kersting, London (3, 4, 17, 21, 40, 147); Ralph Kleinhempel, Hamburg (55, 192); M. Knoedler, New York, N.Y. (183, 339); Samuel Kootz, New York, N.Y. (347); Sam Lambert, London (388); Landesgalerie, Hanover (238); W. S. Lewis, Connecticut (36); Library of Congress, Washington, D.C. (7, 134, 140); V. Loginov, Novosti Press Agency, Moscow (19); Mr. and Mrs. Milton Lowenthal, New York, N.Y. (270); Luckhaus Studio, Los Angeles (324); Marlborough Fine Art, Ltd., London (232); Marlborough-Gerson Gallery, New York, N.Y. (304, 342); A. and R. Mas, Barcelona (45, 47, 176); Robert Mates, New York, N.Y. (369); Pierre Matisse Gallery, New York, N.Y. (354); Paul Mayen (326); Mrs. Eric Mendelsohn, San Francisco (329); Joseph Molitor, Ossining, N.Y. (328, 406); Musées de la Ville de Strasbourg (231); The Museum of British Transport' London (155); Museum of the City of New York (164); Museum of Modern Art, New York, N.Y. (204, 214, 252, 305, 317, 319, 325, 331, 337); Rush J. McCoy, Golden, Colo. (411); National Buildings Record, London (39, 137); National Film Board of Canada (42); National Park Service, U.S. Dept. of the Interior (8, 26, 146); Richard Nickel, Park Ridge, Ill. (colorplate 53); Novosti Press Agency, Moscow (20); Office of the City Representative, Philadelphia (139;)

Mr. and Mrs. William S. Paley, New York, N.Y. (286); Philadelphia City Planning Commission (412); Philadelphia Museum of Art (73, 96, 127); Phillips Studio, Philadelphia (5); Eric Pollitzer, New York, N.Y. (362); The Port of New York Authority (338); Nathan Rubin, New York, N.Y. (248, 250); A. Renger-Patzsch, Wamel-Dorf über Soest, Germany (314); San Francisco Museum (70); Charles R. Schulze, New Haven, Conn. (41); Schweizerisches Institut, Zurich (33); The Scottish Tourist Board, Edinburgh (23); Der Senator für Bau und Wohnungswesen, Berlin (377); Sert, Jackson & Assoc., Cambridge, Mass. (409); Service Photographique, Versailles (13, 35, 48, 77, 78, 300); Julius Shulman, Los Angeles (323, 327); Mr. and Mrs. Jerome Stern, New York, N.Y. (253); Dr. Franz Stoedtner, Dusseldorf (312, 313); Ezra Stoller, Mamaroneck, N.Y. (150, 334, 402, 407, 414); Edward Durell Stone, New York, N.Y. (404); Adolph Studly, North Bergen, N.J. (303); Office of Kenzo Tange, Tokyo (387); Thomas Photos, Oxford (152); TWA Public Relations (381); O. Vaering Foto (104); Van Ojen, The Hague (316); Vasari s.p.a., Rome (394); Vermont Development Dept., Montpelier, Vt. (25); Victoria and Albert Museum, London (156); John F. Waggaman, La Jolla, Calif. (131); Herb Weitman, St. Louis, Mo. (372); Galerie Welz, Salzburg (197).